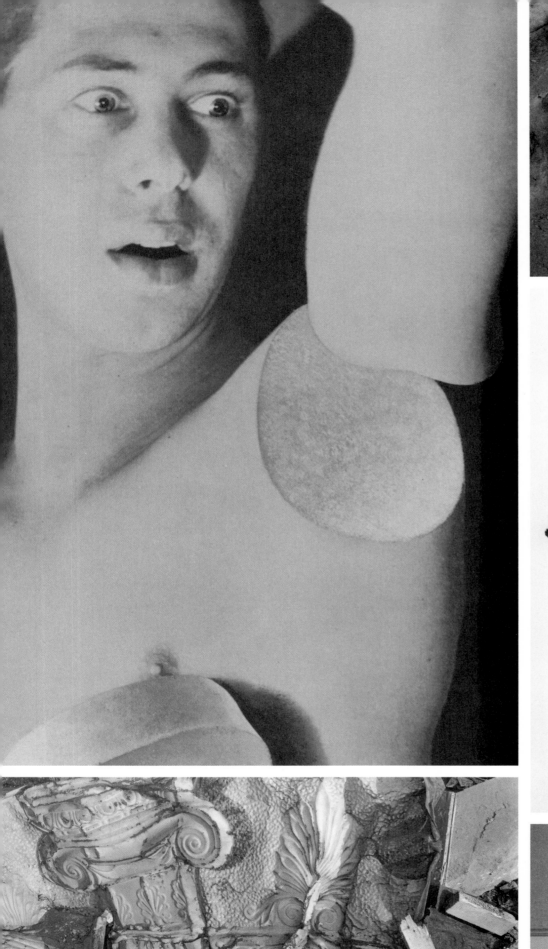

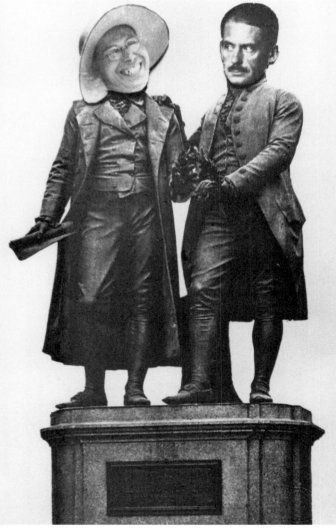

THE ORIGINAL COPY: PHOTOGRAPHY OF SCULPTURE, 1839 TO TODAY

Roxana Marcoci
with essays by Geoffrey Batchen and Tobia Bezzola

THE ORIGINAL COPY

PHOTOGRAPHY OF SCULPTURE, 1839 TO TODAY

The Museum of Modern Art, New York

Published in conjunction with the exhibition *The Original Copy: Photography of Sculpture, 1839 to Today*, at The Museum of Modern Art, New York (August 1–November 1, 2010), organized by Roxana Marcoci, Curator, Department of Photography.

The exhibition will travel to the Kunsthaus Zürich (February 25–May 15, 2011) under the title *FotoSkulptur. Die Fotografie der Skulptur 1839 bis heute*.

The exhibition is made possible by The William Randolph Hearst Endowment Fund. Additional support is provided by David Teiger.

Produced by the Department of Publications, The Museum of Modern Art, New York

Edited by David Frankel
Designed by Takaaki Matsumoto, Matsumoto Incorporated, New York
Production by Marc Sapir
Printed and bound by CS Graphics Pte Ltd., Singapore

This book is typeset in Helvetica LT Std & Janson Text LT Std. The paper is 157 gsm Nireus Silk

Published by The Museum of Modern Art, 11 W. 53 Street, New York, New York 10019

Library of Congress Control Number: 2010922102
ISBN: 978-0-87070-757-5

Distributed in the United States and Canada by D.A.P./Distributed Art Publishers, Inc., New York
Distributed outside the United States and Canada by Thames & Hudson Ltd, London

A German-language edition of this book has been published by Hatje Cantz Verlag and the Kunsthaus Zürich under the title *FotoSkulptur. Die Fotografie der Skulptur 1839 bis heute*.

Front cover, clockwise from top: Erwin Wurm, *One Minute Sculptures*, 1997–98; see p. 236. Horst P. Horst, *Costume for Salvador Dalí's "Dream of Venus"*, 1939; see p. 184. Charles Nègre, *Le Stryge*, c. 1853; see p. 132.

Back cover, clockwise from left: Rachel Harrison, *Voyage of the Beagle*, 2007; see p. 183. Alois Löcherer, *Der Transport der Bavaria auf die Theresienwiese*, 1850; see p. 130. Johannes Theodor Baargeld, *Typische Vertikalklitterung als Darstellung des Dada Baargeld*, 1920; see p. 215.

Front endpapers, clockwise from top left: Théodule Devéria, *Memphis. Sérapéum grec*, 1859; see p. 57. Frances Benjamin Johnston, *Eastern High School, Washington, D.C.*, c. 1899; see p. 49. Maxime Du Camp, *Ibsamboul, colosse occidental du Spéos de Phrè*, 1850; see p. 56. Iwao Yamawaki, *Articulated Mannequin*, 1931; see p. 191. Josef Koudelka, *France*, 1973; see p. 134. Hannah Wilke, *S.O.S.—Starification Object Series*, 1974–82; see p. 218.

Front endpapers, verso, clockwise from top left: Herbert Bayer, *Menschen unmöglich*, 1932; see p. 196. Adam Clark Vroman, *Pueblo of Zuni (Sacred Shrine of Taayallona)*, 1899; see p. 59. Hans Finsler, *Gropius und Moholy-Nagy als Goethe und Schiller [v.r.n.l.]*, 1925; see p. 216. Alfred Stieglitz, *Picasso-Braque Exhibition at "291"*, 1915; see p. 62. Walker Evans, *Stamped Tin Relic*, 1929; see p. 136.

P. 2, clockwise from top left: Umbo, *Das nueste Angebot en profil*, 1928; see p. 197. Gilbert & George, *Great Expectations*, 1972; see p. 231. Charles Nègre, *Angel of the Resurrection on the Roof of Notre Dame*, 1853; see p. 58. Jan De Cock, *Studio Repromotion 1563*, 2009; see p. 69. William Henry Fox Talbot, *Bust of Patroclus*, before February 7, 1846; see p. 44.

Pp. 10–11, clockwise from left: Gabriel Orozco, *Cats and Watermelons*, 1992; see p. 181. Walker Evans, *Votive Candles, New York City*, 1929–30; see p. 191. Peter Fischli and David Weiss, *The Three Sisters*, 1984; see p. 178. Anselm Kiefer, *Besetzungen*, 1969; see p. 147. André Kertész, *Marionnettes de Pilsner*, 1929; see p. 192. John B. Greene, *Statue Fragments, Museum of Cherchell*, 1855–56; see p. 57.

Pp. 36–37, clockwise from top left: Erwin Wurm, *One Minute Sculptures*, 1997–98; see p. 236. Eugène Atget, *Saint-Cloud*, 1922; see p. 82. Robin Rhode, *Stone Flag*, 2004; see p. 239. Christo, *441 Barrels Structure—"The Wall" (Project for 53rd between 5th and 6th Avenues)*, 1968; see p. 152. Man Ray, *Noire et blanche*, 1926; see p. 200. Jindrich Štyrský, untitled, 1930s; see p. 207. Claude Cahun, untitled, c. 1925; see p. 198.

Pp. 240–41, clockwise from top left: Bas Jan Ader, *On the Road to a New Neo-Plasticism, Westkapelle, Holland*, 1971; see p. 237. Laura Gilpin, *George William Eggers*, 1926; see p. 208. Eugène Atget, *Versailles, vase*, 1906; see p. 76. Rachel Harrison, *Voyage of the Beagle*, 2007; see p. 183. Robert Gober in collaboration with Christopher Wool, *Untitled*, 1988; see p. 177. Maurice Tabard, *Test for the film "Culte Vaudou," Exposition 1937*, 1936; see p. 213. Constantin Brancusi, *L'Oiseau*, c. 1919; see p. 101. Manuel Alvarez Bravo. *Plática junto a la estatua*, 1933; see p. 188.

Back endpapers, clockwise from top left: André Kertész, *Thomas Jefferson*, 1961; see p. 65. André Kertész, *African Sculptures*, 1927; see p. 66. André Kertész, *At Zadkines*, 1926; see p. 67. Unknown photographer, untitled, 1921; see p. 139. Clarence John Laughlin, *The Eye That Never Sleeps*, 1946; see p. 195. Tod Papageorge, *Alice in Wonderland*, 1978; see p. 145. Hans Bellmer, *The Doll*, 1935–37; see p. 194. Eugène Atget, *Saint-Cloud*, 1923; see p. 77.

All of the photographs reproduced on the pages above are shown there as details, in actual size, but are complete in the book's plates.

Printed in Singapore

CONTENTS

LENDERS TO THE EXHIBITION

National Media Museum, Bradford
Museum of Contemporary Art, Chicago
Museum Ludwig, Cologne
Scottish National Gallery of Modern Art, Edinburgh
Amon Carter Museum, Forth Worth
The J. Paul Getty Museum, Los Angeles
Robert Mapplethorpe Foundation, New York
The Metropolitan Museum of Art, New York
The Museum of Modern Art, New York
Solomon R. Guggenheim Museum, New York
Whitney Museum of American Art, New York
National Gallery of Canada, Ottawa
Bibliothèque nationale de France, Paris
Centre Pompidou, Musée national d'art moderne/Centre de
 création industrielle, Paris
Fondation Henri Cartier-Bresson, Paris
Musée Rodin, Paris
Société française de photographie, Paris
Philadelphia Museum of Art
Museum Boijmans van Beuningen, Rotterdam
Library of Congress, Prints & Photographs Division,
 Washington, D.C.
Kunsthaus Zürich

Eleanor Antin, courtesy Ronald Feldman Fine Arts, New York
Collection Timothy Baum
Sibylle Bergemann/Ostkreuz Agentur der Fotografen, Berlin
Collection Barbara Bertozzi Castelli
The Bluff Collection, LP
The Steven and Alexandra Cohen Collection
Jan De Cock
Collection Carla Emil and Rich Silverstein
Collection Larry Fink
Peter Fischli and David Weiss, courtesy Matthew Marks

Gallery, New York
Cyprien Gaillard, courtesy Laura Bartlett Gallery, London/
 Bugada & Cargnel, Paris
Glenstone
David Goldblatt, courtesy The Goodman Gallery, Johannesburg
Brent R. Harris
Collection Jon and Joanne Hendricks
Collection Rosalind and Melvin Jacobs
Collection Daile Kaplan and Donna Henes
Hans P. Kraus, Jr.
An-My Lê
Collection Aaron and Barbara Levine
Collection Steven Manford, Toronto
Raquelín Mendieta Family Trust, courtesy Galerie Lelong,
 New York
Collection Jacqueline Matisse Monnier
Lorraine O'Grady, courtesy Alexander Gray Associates, New York
Dennis Oppenheim
Collection Sylvio Perlstein, Antwerp
Private collection
Private collection, courtesy Sean Kelly Gallery, New York
Private collection, New York
Private collection, San Francisco
Collection Pamela and Arthur Sanders
Richard and Ellen Sandor Family Collection
The Beth and Uri Shabto Collection, courtesy Edwynn Houk
 Gallery, New York
Andrew Strauss
Collection Jill Sussman and Victor Imbimbo
Collection Jindrich Toman
Thomas Walther Collection

Edwynn Houk Gallery, New York
Francis M. Naumann Fine Art, New York

The Museum of Modern Art is proud to present *The Original Copy*, a fascinating account of a rich history of relationships between photography and sculpture that dates back to the younger medium's invention. Since its birth in the first half of the nineteenth century, photography has offered extraordinary possibilities of documenting, interpreting, and reevaluating works of art for both study and pleasure. Sculpture was among the first such subjects it treated. Underscoring the Museum's commitment to the scholarly reassessment of pivotal ideas in art, this exhibition and book provide an unprecedented exploration of one medium's critical role in the analysis and creative redefinition of another. More specifically, *The Original Copy* expands the possibilities of photography to probe received ideas about how sculpture should be understood.

The exhibition and book were conceived by Roxana Marcoci, Curator, Department of Photography, who organized them around distinct conceptual ideas. Examining the rich historical legacy of photography, and the aesthetic shifts that have taken place in the medium over the last 170 years, she also built on extensive conversations and collaborations with living artists to explore its uses within contemporary art practice. At the same time she asked the question "What is sculpture?," tracing it through a selection of 300 outstanding pictures that tap on a broad spectrum of expressions, ranging in subject from inanimate objects to the performing human body.

The Original Copy incorporates impressive groups of works by many key figures of modernist and avant-garde art. On behalf of the Trustees and the staff of the Museum, I wish to thank the extraordinary group of private individuals and museum colleagues who have allowed us to borrow precious works from their collections for this exhibition. We are delighted that in 2011, after its presentation at The Museum of Modern Art, the exhibition will travel to the Kunsthaus Zürich, and extend our warmest wishes to Christoph Becker, Director, and Tobia Bezzola, Curator, for their partnership in this venture. Finally, this is an excellent occasion to thank MoMA's spirited and generous Committee on Photography. We look forward to celebrating *The Original Copy* with them and with enthusiastic audiences through the exhibition's international presentation.

Glenn D. Lowry
Director, The Museum of Modern Art

ACKNOWLEDGMENTS

This exhibition and publication were realized thanks to the collaboration and support of many friends and colleagues both within and outside The Museum of Modern Art. The exhibition is supported by The William Randolph Hearst Endowment Fund and David Teiger, to whom I owe my greatest debt of gratitude.

My heartfelt thanks go to the exhibition's lenders, whose generosity made the project possible. I specifically want to thank the following lenders of major bodies of work: Ron Tyler, Director, Amon Carter Museum, Fort Worth; Bruno Racine, President, Bibliothèque nationale de France, Paris; Martine Franck, President, and Agnès Sire, Director, Fondation Henri Cartier-Bresson, Paris; Judith Keller, Senior Curator of Photographs, The J. Paul Getty Museum, Los Angeles; Richard Armstrong, Director, Solomon R. Guggenheim Museum, New York; Christoph Becker, Director, Kunsthaus Zürich; Helena Zinkham, Chief, Prints & Photographs Division, Library of Congress, Washington, D.C.; Joree Adilman, Foundation Manager, Robert Mapplethorpe Foundation, New York; Thomas P. Campbell, Director, The Metropolitan Museum of Art, New York; Alfred Pacquement, Director, Centre Pompidou, Musée national d'art moderne–Centre de création industrielle, Paris; Sjarel Ex, Director, Museum Boijmans Van Beuningen, Rotterdam; Kasper König, Director, Museum Ludwig, Cologne; Marc Mayer, Director, National Gallery of Canada, Ottawa; Colin Philpott, Director, National Media Museum, Bradford; Dominique Viéville, Director, Musée Rodin, Paris; Madeleine Grynsztejn, Director, Museum of Contemporary Art, Chicago; Timothy Rub, Director, Philadelphia Museum of Art; Simon Groom, Director, Scottish National Gallery of Modern Art, Edinburgh; Michel Poivert, President, Société française de photographie, Paris; and Adam Weinberg, Director, Whitney Museum of American Art, New York.

I owe an immensurable debt to the private lenders, artists, and their galleries and studio representatives who were willing to make works available to the Museum's audience: Eleanor Antin and Ronald Feldman Fine Arts, New York; Collection Timothy Baum; Sibylle Bergemann/Ostkreuz Agentur der Fotografen, Berlin; The Bluff Collection, LP; Collection Barbara Bertozzi Castelli; The Steven and Alexandra Cohen Collection; Jan De Cock; Carla Emil and Rich Silverstein; Larry Fink; Fischli/Weiss and Matthew Marks Gallery, New York; Cyprien Gaillard and Laura Bartlett Gallery, London/Bugada & Cargnel, Paris; Glenstone; David Goldblatt and The Goodman Gallery, Johannesburg; Brent R. Harris; Collection Jon and Joanne Hendricks; Edwynn Houk Gallery, New York; Collection Rosalind and Melvin Jacobs; Collection Daile Kaplan and Donna Henes; Sean Kelly Gallery, New York; Hans P. Kraus, Jr.; An-My Lê; Aaron and Barbara Levine; Collection Steven Manford; Collection Jacqueline Matisse Monnier; Raquelín Mendieta Family Trust and Galerie Lelong, New York; Francis M. Naumann Fine Art, New York; Lorraine O'Grady and Alexander Gray Associates, New York; Dennis Oppenheim; Collection Sylvio Perlstein; Collection Pamela and Arthur Sanders; Richard and Ellen Sandor Family Collection; The Beth and Uri Shabto Collection; Andrew Strauss; Collection Jill Sussman and Victor Imbimbo; Collection Jindrich Toman; Thomas Walther Collection; and other private collectors.

The project is indebted for its quality to extraordinary colleagues who shared expertise and suggestions. My warmest thanks go to Sylvie Aubenas, Quentin Bajac, Peter Barberie, Martin Barnes, Geoffrey Batchen, Tobia Bezzola, Jennifer Blessing, Toni Booth, Adam Boxer, Clément Chéroux, Susan Cooke, Malcolm Daniel, Laure de Buzon-Vallet, Julia Dolan, Patrick Elliott, Sylvester Engbrox, Paul B. Franklin, Elyse Goldberg, Sarah Gordon, Sarah Greenough, Mark Haworth-Booth, Virginia Heckert, Jon Hendricks, Michael Jerch, Elizabeth Kujawski, Anne Lyden, Peter MacGill, Juliet Myers, Jennifer Mundy, Francis M. Naumann, Hélène Pinet, Françoise Reynaud, John Rohrbach, Didier Schulmann, Peter Stevens, Jonas Storsve, Ann Thomas, Pauline Vermare, and Matthew S. Witkovsky.

The exhibition travels to the Kunsthaus Zürich, and I am grateful for the collaboration of our superb colleagues there: Christoph Becker, Director; Tobia Bezzola, Curator; Franziska Lentzsch, Head of Exhibition Organization; Gerda Kram, Registrar; and Esther Braun-Kalberer, Exhibition Organizer.

At The Museum of Modern Art, I would foremost like to thank our director, Glenn D. Lowry, who supported the project from its inception. His counsel, encouragement, and astute scholarly insights are always invaluable. Not only did Peter Galassi, Chief Curator of Photography, share his vast knowledge of photography with me but his fine judgment was a source of inspiration. I am deeply grateful to Ann Temkin, The Marie-Josée and Henry Kravis Chief Curator of Painting and Sculpture; Connie Butler, The Robert Lehman Foundation Chief Curator of Drawings; Barry Bergdoll, The Philip Johnson Chief Curator of Architecture and Design; Deborah Wye, The Abby Aldrich Rockefeller Chief Curator of Prints and Illustrated Books; and Milan Hughston, Chief of Library and Museum Archives, for generously lending works from their departments. I deeply appreciate the sustained support of Kathy Halbreich, Associate Director; Jennifer Russell, former Senior Deputy Director for Exhibitions; Peter Reed, Senior Deputy Director for Curatorial Affairs; and James Gara, Chief Operating Officer.

The Publications Department joins me in thanking the authors who contributed to this book, and whose essays proved so insightful: Geoffrey Batchen, Professor of the History of Photography and Contemporary Art at the Graduate Center of the City University of New York, and Tobia Bezzola, Curator, Kunsthaus Zürich. The thoughtful and expert direction of Christopher Hudson, Publisher, and Kara Kirk, Associate Publisher, merits special recognition. I cannot begin to convey my admiration for the editing skills of David Frankel, Editorial Director, which are both elegant and scrupulous. Heartfelt thanks go to Marc Sapir, Production Director, for his unmatched professionalism in the production of the book. My deep appreciation goes to Takaaki Matsumoto and his talented team at Matsumoto Incorporated for conceiving such a smart and imaginative design. We are extremely pleased that Hatje Cantz is publishing the book's German edition and salute their entire staff for their customary outstanding skill.

Marina Chao, Curatorial Assistant, has played an inestimable role. Her attention to detail, creative thinking, and tireless sense of responsibility throughout this complex project have my respect and admiration. I also salute my departmental colleagues Susan Kismaric, Curator, Sarah Meister, Curator, and Eva Respini, Associate Curator, for their excellent advice and much-needed encouragement. Leslie J. Ureña, Curatorial Assistant, provided major support with research and copyright issues. I also thank Anastasia Aukeman, former Newhall Curatorial Fellow, for her research assistance in the early phase of the project. Several curatorial interns assisted with administrative and research tasks; I would especially like to thank Joy Kim and Camille Pène for their exceptional work.

An exhibition requires the professional partnership of many people. Michael Margitich, Senior Deputy Director for External Affairs, and Todd Bishop, Director of Exhibition Funding, were invaluable in finding funding for this institution and its programs. In the Department of Communications, Kim Mitchell, Chief Communications Officer, Daniela Stigh, Assistant Director, and Meg Blackburn, Senior Publicist, worked with Julia Hoffmann, Creative Director, Graphic Design and Advertising, on creatively disseminating information about the exhibition. In the Department of Special Programming and Events, Nicholas Apps, Director, and Paola Zanzo-Sahl, Associate Director, did superb work.

In the Department of Exhibitions, Maria DeMarco Beardsley, Coordinator, and Carlos Yepes, Associate Coordinator, oversaw the exhibition's logistics with ingenuity and diplomacy. Special thanks go to Ramona Bannayan, Director, Department of Collection Management and Exhibition Registration, and to Susan Palamara, Registrar, who managed the handling and transport of the works with exemplary proficiency. Jerome Neuner, Director, and Betty Fisher, Production Manager, Exhibition Design and Production, conceived a creative, refined, and clear exhibition design, highlighting individual works while making a comprehensible installation. Lee Ann Daffner, Photography Conservator, devoted the utmost expertise and care to the condition of nearly 300 works, and Lynda Zycherman, Sculpture Conservator, Karl Buchberg, Senior Conservator, and Scott Gerson, Assistant Paper Conservator, provided insights into the care of all the works entrusted to us. Peter Perez, Foreman of the Frame Shop, offered invaluable skill in the framing of the works. Rob Jung, Manager of Art Handling and Preparation, and his staff of preparators handled the show's installation beautifully.

Michelle Elligott, Museum Archivist, Jennifer Tobias, Librarian, and David Senior, Bibliographer, extended invaluable assistance in our research. Wendy Woon, Deputy Director for Education, Pablo Helguera, Director, Adult and Academic Education, and Laura Beiles, Associate Educator, Adult and Academic Programs, ably organized a panel discussion in conjunction with the exhibition. Ingrid H. Y. Chou, Assistant Director, Claire Corey, Production Manager, and Brigitta Bungard, Design Manager, Department of Graphic Design, designed signage with aplomb. Allegra Burnette, Creative Director, Digital Media, conceived an innovative Web site for the exhibition. In Imaging Services, Erik Landsberg, Head of Collections Imaging, Robert Kastler, Production Manager, Roberto Rivera, Production Assistant, and the collections photographers met our photography needs under tight deadlines. Nancy Adelson, Deputy General Counsel, provided invaluable advice regarding the rights of reproduction of artworks.

The encouragement, forbearance, and perceptive comments of Natalie Musteata and Cristian Alexa have guided me from the exhibition's inception to its realization, and have graced every moment in my life.

Roxana Marcoci
Curator, Department of Photography

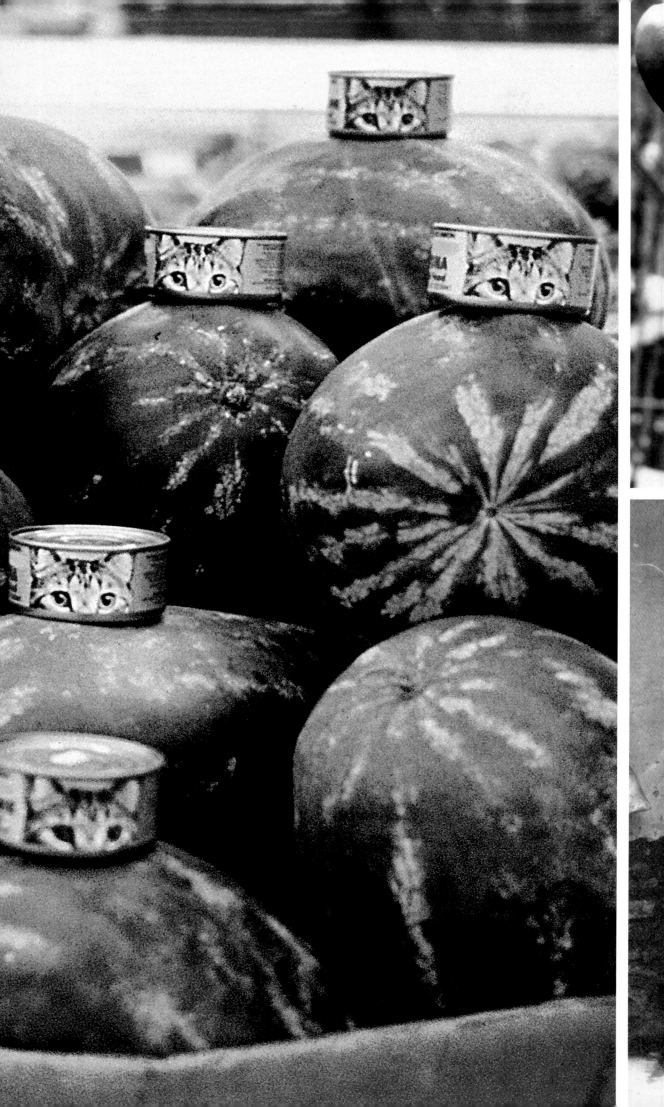

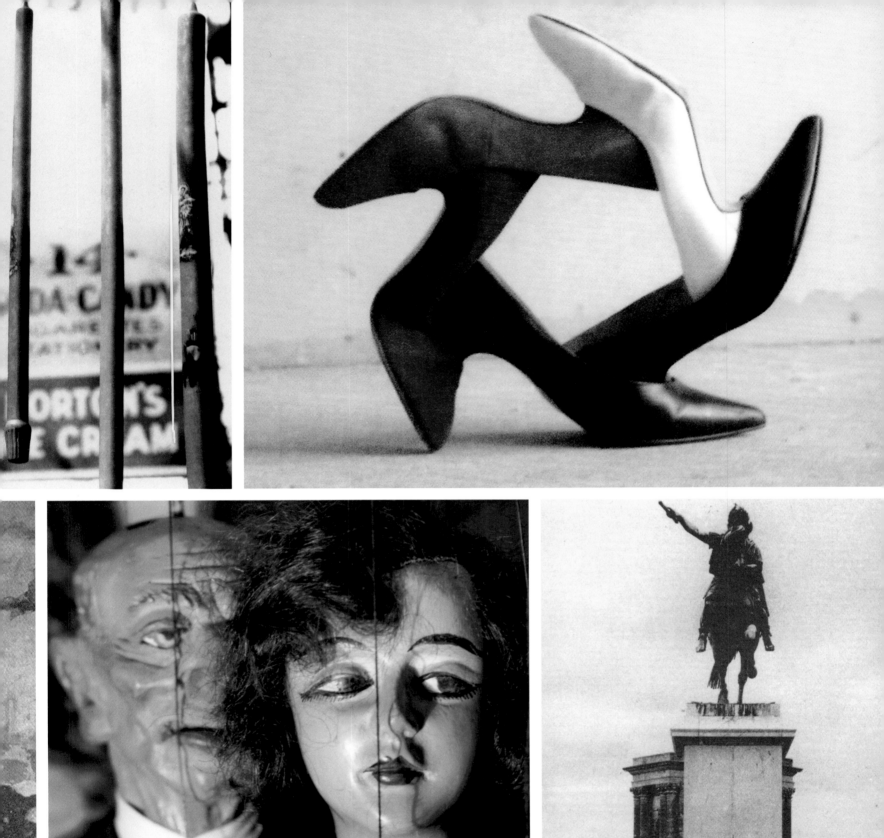
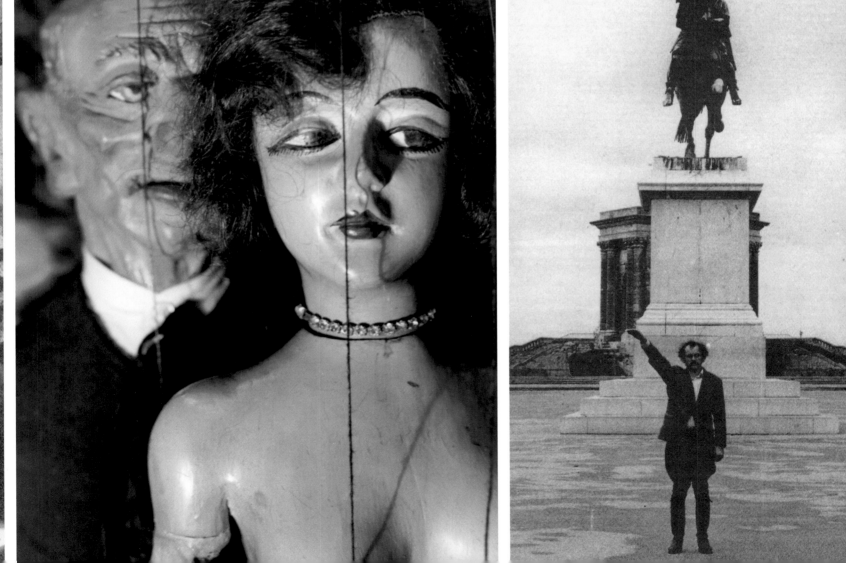

THE ORIGINAL COPY: PHOTOGRAPHY OF SCULPTURE, 1839 TO TODAY

ROXANA MARCOCI

Under what circumstances does a copy become an original? The advent of photography in 1839, when aesthetic experience was firmly rooted in Romanticist tenets of originality, brought into focus the critical role that the copy plays in the perception of art. The poet and critic Charles Baudelaire, in his famous diatribe against photography, "The Salon of 1859," expressed contempt for his mechanically progressive age, denouncing photography's reproductive qualities and the popular notion that art and truth lie in the replication of the physical world. Although Baudelaire was quite willing to sit for photographic portraits by Etienne Carjat, Charles Neyt, and Nadar, he criticized the new medium for encroaching on art and the world of imagination. His view typifies one reaction of nineteenth-century aestheticians toward the camera's automatism, its liberation of the hand from the image, its presumed exclusion of authorial intention, and its potential production of an infinite stream of copies. But if the photograph's reproducibility challenged the aura attributed to the original, it also reflected a very personal form of perception and offered a model for dissemination that would transform the entire nature of art. The questions of *how* to see—rather than *what* to look at—and how to communicate are at the crux of photography's capacity for artistic experimentation. The aesthetic singularity of the photograph, the archival value of a document bearing the trace of history, and the combinatory capacity of the image, open to be edited into sequences in which it mixes with others—all these contribute to the status of photography as both an art form and a medium of communication.[1]

From the beginnings of photography, Sabine T. Kriebel notes, some hailed it as "the most important and perhaps most extraordinary triumph of modern science."[2] Edgar Allan Poe wrote that phrase in 1840, just a year after Louis-Jacques-Mandé Daguerre had made public the invention he named after himself. For Poe, science was a source of imagination. As Kriebel writes, he "took pleasure in the fact that the daguerreotype could capture inaccessible heights and lunar charts, ciphers of his own imaginative sensibility."[3] Daguerre too saw the medium as a visionary tool: "The daguerreotype," he said, "is not merely an instrument which serves to draw nature" but one that "gives her the power to reproduce herself."[4] Man Ray would echo this view in 1926, writing that "photography is not limited to the role of copyist. It is a marvelous explorer of the aspects that our retina never records."[5] Photography's creative potential lies in its power to bring forth or make manifest that which would go otherwise unnoticed. Copying of this peculiar kind has been not only a stimulus to artistic experiment but part of its origins, and Poe, Daguerre, and Man Ray are but a few of the writers and artists who have called attention to the radical role that photography plays in documenting, interpreting, and altering our understanding of the objects it represents.[6]

This study focuses on a specific class of visual images—images of sculpture—to consider how the one medium has been implicated in the creative reproduction and analysis of the other. From its inception, photography offered an unprecedented way to examine works of art for further study. Through crop, focus, angle of view, degree of close-up, and lighting, as well as through ex post facto techniques of darkroom manipulation, collage, montage, and assemblage, photographers not only interpret artworks but create stunning reinventions of them. Through a selection of nearly 300 pictures by more than 100 artists from the nineteenth century to the present, this study looks at how photography has expanded the ways in which we encounter and understand sculpture.

Photography is the primary medium of analysis in the modern discipline of art history. For Donald Preziosi, in fact, "Art history as we know it today is the child of photography."[7] Thinking through images—rather than through written or oral transmission—is an activity firmly rooted in the collective art-historical imagination. If the camera is an "archiving machine,"[8]

one of photography's critical functions is to ensure the survival of objects from every period and every place. Sculpture was among the first such subjects to be treated in the history of photography. There were many reasons for this, including the immobility of sculpture, which suited the long exposure times needed with the early photographic processes, and the desire to document, collect, publicize, and disseminate objects that were not always portable.

In his 1935 essay "The Work of Art in the Age of Mechanical Reproduction," Walter Benjamin argued that the rise of the reproducible artwork had resulted in a withering of the traditional cult-value of the original, since mechanical reproduction "substitutes a plurality of copies for a unique existence." Yet "in permitting the reproduction to meet the beholder . . . in his own particular situation, it reactivates the object reproduced."[9] In 1936, shortly after reading Benjamin's essay,[10] the novelist and politician André Malraux, who would later become France's first minister of culture (1959–69), praised the capacity of photography to archive, exhibit, and distribute images of art. For Malraux, photography served as a mnemonic device, enabled cross-cultural analysis among widely diverse sculptural objects, and democratized art by dislodging the original from its context and relocating it close to the viewer. In fact, as David Campany points out, "Malraux argued that it was the destiny of the art of antiquity to be redefined by modernity, first by being displaced into museums, then disseminated via the printed page."[11] In his 1947 book *Le Musée imaginaire*, which famously advocated a pancultural "museum without walls," Malraux postulated that art history, and the history of sculpture in particular, had become "the history of that which can be photographed."[12] In 1952–54

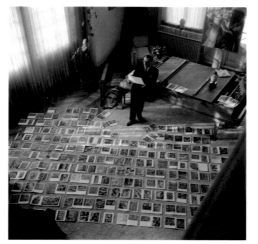

fig. 1. André Malraux at his home in Boulogne-sur-Seine, France, selecting photographs for *Le Musée imaginaire de la sculpture mondiale*, 1953

he published the two-volume picture book *Le Musée imaginaire de la sculpture mondiale* (fig. 1), an encyclopedic photographic album of 700 sculptures. The book was organized in sequences, each presenting a number of sculptures in poignant close-ups and from singular viewpoints, techniques borrowed from the art of cinema. (As Beaumont Newhall had observed in 1938, "Photographs of portions of objects [close-ups] were most uncommon before the moving picture.")[13] In editing the sequences, Malraux had in mind a system of cinematic montage that kept the gaze in motion. This layout licensed him to establish stylistic and thematic links among sculptures from different epochs and cultures, links that had previously passed unnoticed and that he forged visually rather than verbally.

As early as 1851, the aspiration of creating a visual archive of art and architecture, which would fit into several bound volumes, had inspired organizations such as France's Comité des Monuments historiques and England's Antiquarian Photographic

Club to initiate surveys of national patrimonies by means of photography. Charles Nègre and Henri Le Secq had photographed sculpture in the cathedrals of Chartres, Amiens, and, in Paris, Notre Dame, while in London Roger Fenton and Stephen Thompson had been charged with documenting the ancient sculptures in the British Museum. The scholarly study of sculpture had come to be informed by such pictures, taken in their original locations or in museums. "At first," Geraldine A. Johnson contends, "photographers and their customers were satisfied with general views of individual sculptures. By the later nineteenth century, however, highlighting a sculpture's most interesting details through the use of close-ups and enlarged photographs of areas normally inaccessible to the average viewer became increasingly popular."[14] Although many of the pictures commissioned in the nineteenth century by national committees have gained considerably in historical value, the grand visual archives of twentieth-century art, which incorporate sculpture within their broad cultural and historical purviews, are the outcome of highly individual and distinctive aesthetic sensibilities. The significance of the landmark projects of Eugène Atget (plates 41–61), Walker Evans (plates 125, 127), Robert Frank (plate 115), Lee Friedlander (plates 120, 128, 132–37, 139), and David Goldblatt (plates 145–50) lies less in single images than in the orchestration of numbers of them. In fact many of their projects were conceived as books—Evans's *American Photographs* (1938), Frank's *Americans* (1958), Friedlander's *American Monument* (1976), and Goldblatt's *South Africa: The Structure of Things Then* (1998) and *Intersections* (2005) all articulate to different degrees the particular value of photography as a means to defining the cultural and political role of sculpture. Atget's work too was organized into categories, such as *L'Art dans le vieux Paris* (Art in old Paris), *Intérieurs parisiens* (Parisian interiors), *La Voiture à Paris* (Vehicles in Paris), and *Petits métiers* (Trades and professions), among others. Comparing Atget's detailed study of ancien régime interiors and outdoor scenes with the descriptive analysis of French society in Honoré de Balzac's magnum opus *La Comédie humaine*, Berenice Abbott wrote that Atget was "an urbanist historian, a Balzac of the camera, from whose work we can weave a large tapestry of French civilization."[15] The tapestry to which Abbott is referring included series of pictures of statues, monuments, and reliefs in the neighborhoods of Old Paris and its suburban environs. Atget's editorial albums would have a lasting impact on artists, notably Evans, who became familiar with his photographs in 1929, through Abbott. Grasping the implications of Atget's art, Evans praised his "lyrical understanding of the street, trained observation of it, special feeling for patina, eye for

revealing detail, over all of which is thrown a poetry."[16] Atget's example helped Evans to realize that the potential of photography resides not in individual pictures but in the conception of an open-ended oeuvre that reflects one's vision of a subject.

While Atget presented his work in themed albums, Evans thought of his pictures as part of a single, indivisible visual essay. From 1935 to 1937 he worked for the Resettlement Administration, later called the Farm Security Administration (FSA), photographing in the Southeastern United States. These were years of remarkable productivity for Evans, who met the FSA's objective—drawing attention to the rural poor of the Depression era—without losing sight of his personal quest: distilling various signs of street life, including billboards, rural architecture, roadside monuments, and commemorative sculpture, from tombs to statues of war heroes, into a cultural catalogue of modern America in the making. In 1938 Evans exhibited his American Photographs at The Museum of Modern Art, the first exhibition at this institution devoted to the work of a single photographer. In an afterword published in the book that accompanied the exhibition, his longtime friend Lincoln Kirstein cited Evans's astounding visual acuity for symbol-making: "His eye," Kirstein said, "is on symbolic fragments of nineteenth-century American taste, crumpled pressed-tin Corinthian capitals, debased baroque ornament, wooden rustication and cracked cast-iron moulding, survivals of our early imperialist expansion."[17] Each one of Evans's images contributed to an unmistakable definition of specific places and monuments, but when combined with the others, they collectively evoked "the sense of America."[18] His ability to assemble and sequence these images, which he had produced over a period of ten years, reveals the sensibility of an inborn film-maker. In fact Kirstein compares the book to Sergei Eisenstein's syntax of cinematic montage, in which one frame alters the sense of another. Evans's layout of American Photographs, Peter Galassi notes, helped to establish "the photographer's book as an indivisible unit of artistic expression," leading "to the development of a self-conscious practice that would be codified in the 1950s under the phrase 'body of work.'"[19]

Before inquiring further into the encounters between photograph, "cinematic" book with sequential arrangements of images, and exhibition, it is worth citing the cultural theorist Aby Warburg's iconological experiments with photographic layouts. Warburg was preoccupied with the role of photography in documenting civilization. In 1924 he began his most important work, a pictorial atlas titled Bilderatlas Mnemosyne (Mnemosyne picture-atlas), which he left unfinished at the time of his death, in 1929. The physical architecture of the Mnemosyne atlas

comprised seventy-nine large screens covered with black fabric. To each screen were pinned from ten to thirty photographs, disparate in their sources—artworks, advertisements, postage stamps, newspaper clippings—but grouped around shared themes, or around the formulas of emotional style that Warburg called pathosformel. The images, Louis Rose notes, "were visually related but separated by centuries of history," allowing Warburg to focus on the "common memory and energy which linked them across time."[20] Warburg's aim was to bring into focus recurrent motifs; the motif of "movement" or "performance," for example, based on gestural and physiognomic formulas, was of primary interest to him.

The Mnemosyne atlas, like Warburg's 60,000-book library, was organized according to "elective affinities" rather than chronologically or strictly thematically. Warburg himself called it an "iconography of intervals,"[21] since it was based on historical anachronisms and discontinuities. The sculptural motifs in plate 7 (fig. 2) of his atlas, for example, relate to the pathosformel

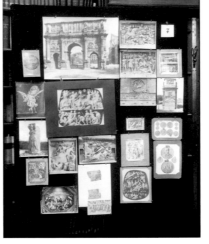

fig. 2. Aby Warburg. *Bilderatlas Mnemosyne*
(Mnemosyne picture-atlas), plate 7. October 1929.
Warburg Institute Archive

of "triumph," observed over the span of several centuries. The plate combines such images as the *Gemma Augustea* (Gem of Augustus), a low-relief cameo carved from Arabian onyx during the reign of the Roman emperor Caligula (37–41 A.D.); *Trajan in Battle*, a low relief from the large frieze on the Forum of Trajan in Rome (112 A.D.); *Apotheosis of Sabina*, a marble relief from the Arch of Portugal, Rome (also from the second century A.D.); and the south side of the Arch of Constantine, Rome (312–15 A.D.). Other plates offer similar jumps, cuts, and repetitions. In the view of Georges Didi-Huberman, Warburg assembled his nonlinear, relational montages of images to formulate an art history without "'influences' or the artistic 'progress' from the one to the other."[22] For Ernst Gombrich, the Mnemosyne atlas was a large work of synthesis in which every image is "charged with conflicting and contradictory forces," so that "the same 'pathos formula' spelt 'liberation' in one respect and 'degradation' in another," making it "most difficult for Warburg to present the complexity of his historical view in discursive language."[23] Warburg chose not to write on this material but instead to fiddle with photographs, reshuffling them in ever new combinations as he focused on one or the other of his themes. Informed by "the visual culture of cinema, magazines, and advertising," Martha Ward speculates, he sought "to expand the field of art history in the direction of photography's latest cultural uses":[24] in organizing the Mnemosyne atlas, he supplanted the slow-paced linearity of art-historical text with the fast-paced jump cut of visual montage. Warburg orchestrated the construction of a new temporality paced by looking at an assembled sequence of sculptures alongside a heterogeneous mix of other

images. Philippe-Alain Michaud, in his major study *Aby Warburg and the Image in Motion* (2004), notes that the photograph (the basic unit of motion pictures) was instrumental to Warburg's idea of transmission, taking over "the place traditionally reserved for the text" in art-historical discourse.[25] Warburg not only prioritized the visual over the textual but activated the images' latent effects through resonating juxtapositions, establishing a new model of interpretation for the artwork "in the age of its reproduction *in motion*."[26]

In the 1920s and '30s, the presentation of large groups of photographs by editing them into flexible arrangements or montagelike sequences was a serious undertaking not only for scholars such as Warburg and Malraux (although *Le Musée imaginaire* was published after World War II, Malraux's ideas on the photographic reproduction of sculpture were formulated in the mid-1930s) and for artists such as Evans, but also for Marcel Duchamp and Constantin Brancusi. In 1935, Duchamp began his *Boîte-en-valise (de ou par Marcel Duchamp ou Rrose Sélavy)* (Box in a valise [From or by Marcel Duchamp or Rrose Sélavy]; plate 103), a catalogue of his work to date. Featuring sixty-nine reproductions, including minute replicas of several readymades and one original work, the *Boîte-en-valise* combines the format of a retrospective exhibition with that of a loose-leaf album of photographs.[27] In using reproductions in this way, Duchamp sidestepped differences of material or scale to assemble his work as a single body. Challenging the idea of authorship and originality, he re-created (or duplicated) his oeuvre, then "copy-righted" it in the name of his female alter ego, Rrose Sélavy. Rather than use the quick photographic techniques then available, however, Duchamp opted to create his reproductions by combining collotype printing with the elaborate and refined method of pochoir, in which color is applied by hand with the use of stencils. He thus produced "authorized 'original' copies," blurring the boundaries between unique artwork and multiple.[28]

Duchamp's interest in photography's modes of reproducibility is linked to his protocinematic investigations of the same period. He first explored the notion of the eye as a camera in 1920, when he collaborated with Man Ray on a three-dimensional film made using an anaglyphic process, wherein two images shot from slightly different viewpoints are superimposed. (The system was similar to that of the stereoscopic photograph, which also produced the illusion of three-dimensionality.) Duchamp synchronized two movie cameras—the left supplied with a red glass filter, the right with a green one—and trained them on a spiral painted on a rotating hemisphere. He pursued related experiments with afterimages, creating his first optical machine, *Rotary Glass Plates (Precision Optics)*, in 1920. In Man Ray's photograph *Duchamp's Studio at 246 W. 73rd St., NYC.* (1920; plate 111), a section of Duchamp's body is indistinctly visible behind the motorized sculpture, along with an upside-down eye chart and a couple of readymades, including the kinetic *Bicycle Wheel* (1913).

In 1926, Duchamp's interest in optical and kinetic devices inspired him to make another three-dimensional film, but this time he did not use the anaglyphic process. Instead he filmed another rotary-disc work, *Discs Bearing Spirals* (1923), to make *Anémic Cinéma*. The title, an anagram in both French and English, reveals the methodology of the film: to make an object turn on itself. Duchamp conceived the final version of the rotary discs in 1935, when he produced the *Rotoreliefs* (1935), optical discs that revolve on a turntable, in another allusion to the anaglyph. He then photographically reproduced one of the *Rotoreliefs* on the same glass plate with an image of the *Rotary Glass Plates* (materializing his pursuit of three-dimensional effects in two-dimensional form) and included it in the *Boîte-en-valise*. With each item captioned but no additional text provided, Duchamp's *Boîte-en-valise* invites the reshuffling of its contents, so that while it is organized sequentially, it nonetheless escapes the fixity of the traditional book. In this way it involves a rethinking of the montage procedures that were prevalent during that period in films, photomontage, and the layouts of illustrated magazines. At the same time, with its reproductions of artworks—including readymades, kinetic sculptures such as *Rotary Glass Plates*, and mobile sculptures such as *Sculpture de voyage* (Sculpture for traveling, 1918; plate 106)—the *Boîte* creates an exhibition independently of original objects. The copies, in other words, had replaced the sculptures represented in them, "effectively confirming" Duchamp's suggestion, Johnson writes, that "in the future photography would replace all art."[29]

The most ambitious currents of avant-garde thought between the world wars were expressed through artworks that bore the obvious influence of photography and cinema. It is not surprising that Brancusi learned photography, and experimented with film stills, in order to show how his sculptures were to be looked at in both spatial and temporal terms. Ezra Pound characterized Brancusi's sculpture as "an entire universe of form," and said, "You've got to see it together. A system. An Anschauung."[30] Pound was referring to Brancusi's studio, and to the interplay there between sculptural works, pedestals, and the space around them. To understand the cumulative system of form that constitutes Brancusi's oeuvre one needs to look at his photographs.

In a picture of the studio from c. 1920 showing two versions of *Mademoiselle Pogany* (1912), one in polished bronze and the other in veined marble (plate 100), Brancusi presents the same motif in different materials and from different angles, a repetition that allows one version to renew the viewer's vision of the other. At the same time, the two versions participate in a broader play of forms with other sculptures on view—including *Le Commencement du monde* (Beginning of the world, 1920) and *La Petite Fille française* (Little French girl, 1914–18)—as well as with a varied group of square and cylindrical pedestals. The *Anschauung* of another, later studio view, dating from c. 1945–46 (plate 102), actually depends on the picture's conception as a photograph rather than as a photographic likeness. Here, the

polished surface of *Le Nouveau-Né* (The newborn, before 1923) is dramatically lit to reflect as an intense white blur, an effect that dissolves the sculpted form and transforms the studio into a vibrant space. That blur was absent from both the sculpture and the studio themselves; it exists only in the photograph. The identity of Brancusi's studio as it unfolded through photography is also pointedly expressed in a series of photographs from the 1930s of the marble *Le Poisson* (Fish, 1930). In a view from the side (plate 95), *Le Poisson* appears as a planar, horizontal form against an ascending group of Brancusi's Endless Column pillars, but in a view from the front (plate 94), the same sculpture appears as a vertical, rhomboidal shape, more like *L'Oiseau dans l'espace* (Bird in space, 1927). This metamorphosis corresponds to Brancusi's idea that "every sculpture is a form of motion."[31] The studio itself becomes an accumulation of sculptural forms and ideas induced to flow. Whether through scenography, lighting, and camera angle or through the sequencing of photographic frames, Brancusi makes explicit photography's capacity to formulate "optical manifestoes" in representing sculpture as animate form across space and time.[32]

The idea that an image could be "animated" is almost as old as the photographic medium, being part of discussions among contributors to *La Lumière*, the first European journal devoted solely to photography, as early as 1851. With the transition from the daguerreotype, which is borne on a metal plate, to photographs on paper, the image became more vibrant, instilled with interiority and movement. The Surrealists, who extolled photography's potential for the uncanny—for making something familiar look disquieting, resulting in a feeling of cognitive dissonance—were fascinated by this type of animist thinking. Photographs of sculptures, funeral effigies, wax dummies, dolls, and mannequins are heavily scattered through the pages of Surrealist magazines such as *La Révolution surréaliste* and *Minotaure*. Salvador Dalí's *Phénomène de l'extase* (The phenomenon of ecstasy; fig. 3), published in *Minotaure* in 1933, is a case study of the uncanny confusions that animate and inanimate forms can trigger in photographic works.[33] Dalí collaged all types of photographs in a gridlike configuration: details of "hysterical sculpture" in the buildings of Antonio Gaudí;[34] rows of ears snipped from the late-nineteenth-century manual compiled by the anthropometrist Alphonse Bertillon to help to identify criminals; close-ups of female heads in distinct states of erotic ecstasy; and, at the center, a detail of Bernini's statue *Ecstasy of Saint Teresa* (1647–52). The conjunction of these diverse photographic motifs induces a confusion about whether the female heads, with their upturned eyes and parted lips, are really alive, and, conversely, whether the ecstatic facial expression of a lifeless Baroque statue might not be animate.

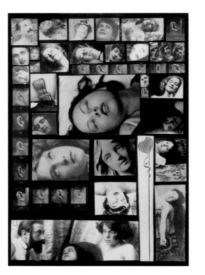

fig. 3. Salvador Dalí. *Phénomène de l'extase* (The phenomenon of ecstasy). 1933. Photomontage, 10 ⅝ x 7 �" (27 x 18.5 cm). Private collection, Paris

Man Ray, who was affiliated with the Surrealist group, probed similar ideas in memorable pictures such as *Noire et blanche* (Black and white, 1926; plate 216) and *Le Violon d'Ingres* (Ingres's violin, 1924; plate 217). And many other photographers, whether relatively independent or associated with schools or movements such as Dada, Surrealism, and the Bauhaus, staged scenarios or captured situations in which either lifeless objects appeared as animate things or live models seemed petrified into statues. A partial list of these photographers would include Sophie Taeuber-Arp, Hans Bellmer, Henri Cartier-Bresson, Manuel Alvarez Bravo, Claude Cahun, Jindrich Štyrský, Maurice Tabard, Umbo, Edward Weston, and Iwao Yamawaki. This almost erotic fixation on statues (as well as on the artist's model as living statue)—the so-called "Pygmalion effect"[35]—occurs in straight photographs (Laura Gilpin's *George William Eggers* [1926; plate 224] or André Kertész's *Marionnettes de Pilsner* [1929; plate 207], for example); in the results of darkroom alterations (Herbert Bayer's *Menschen unmöglich* [Humanly impossible, 1932; plate 212] or Clarence John Laughlin's *The Eye That Never Sleeps* [1946; plate 211]); and in constructed photographs, whether collages of cut-up pictures (Max Ernst's *Au-dessus des nuages marche la minuit* [Midnight passes above the clouds, 1920; plate 227] or Hans Finsler's *Gropius und Moholy-Nagy als Goethe und Schiller [v.r.n.l.]* [1925; plate 233]) or photomontages (Hannah Höch's *Mutter* [Mother, 1930; plate 228] or Johannes Theodor Baargeld's *Typische Vertikalklitterung als Darstellung des Dada Baargeld* [Typical vertical mess as depiction of the Dada Baargeld, 1920; plate 232]). Within the history of representation, the myth of Pygmalion is a parable not only of the relationship between model and copy but of the mechanical creation of a world in movement. The connections between Pygmalion (the creator of a sculpture that comes to life) and the idea that an image could be animated mine the possibilities of stasis and nonstasis, opening the photograph to cinematic forms of movement.

The impetus for artists to experiment with montage and dynamic modes of picture construction (Siegfried Kracauer called montage a "blizzard" of images) in the interwar years was largely due to the mass-media explosion of photographic images, which could be reproduced, cut, and reassembled in endless combinations.[36] Photomontage (the term "montage" comes from the German *montieren*, "to engineer") is an organizational system based on a fragmentary, composite syntax of pictures culled from newspapers and magazines. It creates meaning by juxtaposing different types of information and through anarchic disruptions in scale and perspective. Artists who worked in the medium early on, including George Grosz, John Heartfield, Raoul Hausmann, and Gustav Klutsis, have left conflicting accounts about who

"invented" it, and in fact the invention cannot be attributed to one person; but it is known that Hausmann and Höch were inspired to experiment with the technique after a summer holiday they took on the Baltic Sea in 1918. In the guest room of the fisherman's cottage they had rented, they saw a color lithograph showing five soldiers in different military uniforms; a picture of the head of the fisherman's son had been glued over each soldier's face. This kind of altered image was popular in German homes before and during World War I, serving as a connection between soldiers at the front and the loved ones they had left at home. When Hausmann saw these works, he would later acknowledge, the idea of making pictures from cut-up photographs struck him as a "thunderbolt,"[37] and Höch would preserve one of these military mementoes in her personal collection, labeling it *The Beginning of Photomontage* (fig. 4). Back in Berlin that September, the two artists began to explore the new technique, which, Brigid Doherty notes, marked "a conceptual shift in their understanding of what a picture could be."[38] Based on appropriation and photographic fragmentation as modes of representation, photomontage altered the conditions of originality and authorship in artistic production.

Discussing the social impetus of photomontage, Jacques Rancière points out that "it involves organizing a clash, presenting the strangeness of the familiar, in order to reveal a different order of measurement that is only uncovered by the violence of conflict."[39] Höch realized the activist power of photomontage. At the time, she was working as a designer for the Berlin publishing conglomerate Ullstein Verlag, which published popular magazines such as *Berliner Illustrirte Zeitung*, *Uhu*, and *Die Dame*. Höch started reshuffling images from these magazines to examine mass media representations of women in post–World War I Germany. Her politics engaged race and ethnography, and a prevailing theme in her work was the tension between the sexually liberated "New Woman," whose androgynous look reflected the period's deconstruction of rigid masculine and feminine identities, and the image of idealized femininity. For the mordant photomontages in her series *Aus einem ethnographischen Museum* (From an ethnographic museum, 1925–30), she combined cut-out pictures of the New Woman with others showing sculptures from non-Western societies (procured by the ethnographic museums of the series' title through colonial conquest) to expose the underlying racist, sanctimonious attitudes of patriarchal society in relation to ethnic and gender difference.

The role of photomontage in shaping mass consciousness only intensified after World War II and peaked during the period

fig. 4. German military memento, inscribed *Der Anfang der Fotomontage* (The beginning of photomontage) by Hannah Höch. c. 1897–99. Colored engraving and photomontage, 16 ¾ x 19 1⅝₆" (42.5 x 51.7 cm). Berlinische Galerie, Landesmuseum für Moderne Kunst, Fotografie und Architektur

of the Vietnam War. Höch's critique of the clichés of mass-media representation proved to have had a lasting influence on women artists, specifically on the generation emerging in the late 1970s and early '80s. Photomontage became relevant in the context of what an image could be as a "picture"[40]—that is, as a "palimpsest of representations, often found or 'appropriated,' rarely original or unique, that complicated, even contradicted, the claims of authorship and authenticity so important to most modern aesthetics."[41] A decade earlier, Roland Barthes had published *Mythologies* (1957; translated into English in 1972), in which he asserted that photography was not nature revealed—as imagined in the nineteenth century, when photography was seen as an instrument that gave nature "the power to reproduce herself"—but a form of "coded, historically contingent, ideological speech."[42] Artists such as Cindy Sherman (plate 140), Louise Lawler (plate 32), and Barbara Kruger (plate 1) made pictures that defanged preexisting images, questioning the mythologies of everyday life and the politics of representation.

Like Höch, Kruger once worked in the magazine world, becoming chief designer for Condé Nast's *Mademoiselle* in the mid-1960s and later being the art director for the fashion magazine *Harper's Bazaar*. Also like Höch, she uses photomontage as a medium of engaged address, appropriating mass-cultural imagery in the form of photographs taken mostly from mid-century American print-media sources, which she crops and over which she collages trenchant verbal statements inferring cultural criticism. Adopting the strategy of "direct address," Kruger includes the personal pronouns "your" and "my" in her texts to implicate the work's audience and to interrogate the ways in which photography reproduces tropes of male as viewer and female as viewed. As Craig Owens wrote, she probes "the *masculinity* of the look, the ways in which it objectifies and masters."[43] In *Untitled* (*Your Gaze Hits the Side of My Face*) (1981; plate 1), the words of the title's parenthetic phrase align vertically on the left side of a black-and-white photograph of a stone female bust. Attuned to pictorial and verbal rhetoric and to the formal strategies by which meaning is constructed and communicated, Kruger gives voice through the text to the image of the statuesque woman, breaking her silence and thus deflecting the assault of the viewer's gaze.

The last forty years mark photography's decisive entry into the art world. While continuing to be disseminated extensively in the rest of the public sphere (the immediacy with which images are distributed only increased with the arrival of digital technology), photographs also began to surface in the work of artists working in a wide range of practices. Photography played a

crucial role in recasting the idea of sculpture—whether traditional, conceptual, or performative—to involve an "expanded field."[44] In the late 1960s, seeking to liberate sculpture from the gallery and the museum, a group of artists including Robert Smithson, Michael Heizer, Dennis Oppenheim, Richard Long, and Gordon-Matta Clark began to intervene in abandoned industrial sites and far-flung landscapes (plates 158–61, 163). Their new conception of sculptural practice was contingent on the photographic lens; the camera took on an active role, interacting with the site, recording perspectives on it (aerial viewpoints, for example), and providing a sculptural attempt (as a mark on the surroundings) at a social analysis of the urban environment. In all of these cases the experience and interpretation of sculpture resides in the image. In the 1990s, artists such as Rachel Whiteread tapped into the similarity between photographic print and sculptural cast to take pictures or construct photographic collages of sculptural and architectural molds that invoke the lost presence of objects and sites (plate 164).

In the last few decades, photography has engaged with other fields involving its expansion both temporally and spatially. Gabriel Orozco (plate 190), Peter Fischli and David Weiss (plates 184–88), and Rachel Harrison (plates 191–200) have enlisted the camera to record chance encounters with found objects, which they declared sculpture, or to conceive "involuntary sculptures,"[45] recycling the humblest of cast-off materials into playful and poetic situations specifically staged for the camera. Like the Surrealists, they have used the agency of chance to bring about the unexpected, producing, as Man Ray put it, "accidents at will."[46] Sarah Hamill remarks that "in the hands of these sculptors, photography is made to convert matter into something animate and strange, something distant and ephemeral, giving its viewers a framework for reenvisioning the category of the sculptural as mobile and provisional, as an invented image."[47] In Equilibres (1984–87), Fischli/Weiss use the camera as co-conspirator, playing with suspension, equilibrium, and gravity in precariously balanced, makeshift sculptural assemblages, which they photographed on the brink of collapse. Erwin Wurm's series of One Minute Sculptures (1997–98; plates 257–60) are similarly governed, as Mark Godfrey puts it, by the camera's ability "to evoke not an era but an instant."[48] The seemingly ad hoc style of these time-based pictures of sculptures and gestural articulations suggests an affinity with that of other performances in which the artist's body is turned into a sculptural form.

Bruce Nauman, Bas Jan Ader, Eleanor Antin, Gilbert & George, and Ana Mendieta are just a few of the artists who have used their own bodies as a material like plaster or clay, staging performances with the photographic referent in mind. Focusing attention on what one can do with and through photography, they have used the camera not to document actions that precede the impulse to record them but as an agency that itself generates actions through its own presence. From the start, in other words,

these artists consider photography integral to the conception of the performance rather than a result of it. Nauman's pictures in the portfolio Eleven Color Photographs (1966–67; plates 250–53), for example, enact puns and wordplay to generate a series of activities: Waxing Hot (the artist's hands polish a bright red sculpture of the word hot), Bound to Fail (the artist's torso, seen from behind, is tethered with a thick rope), and Feet of Clay (the artist's feet are slathered with a soft brown clay). Each picture combines sculptural form, linguistic content, physical behavior, and photographic staging. Dan Graham points out that in Nauman's work, "The body in-formation is the medium. There is no longer the necessity of a material (other than the artist's body) for the mediation."[49] Turning the camera on himself, Nauman activates this corporeal material into a sculptural form that is at once humorous and illogical.

What links Ader's practice to Nauman's is a preoccupation with the absurd. In a four-picture sequence titled On the Road to a New Neo-Plasticism, Westkapelle, Holland (1971; plate 261), Ader, dressed in black, lies in the middle of a cobbled road leading to the lighthouse in Westkapelle, a frequent subject of Piet Mondrian's early works. The first frame shows only the artist; in the second he is lying on a square blue blanket; in the third, a yellow plastic gasoline can appears in the top left corner; and the fourth adds a red box. Playing with primary colors and with a simplified geometry of vertical and horizontal lines, and photographing himself as a debased sculptural object, Ader satirized the utopian ideal of harmony associated with De Stijl, the classic modernism of his native Holland. This expanded sense of sculptural practice with the body at its center is also articulated in the series of pictures that Mendieta executed in Iowa and in Oaxaca, Mexico (plates 247, 248). Here Mendieta covered her body with flowers, grass, rocks, and mud, combining ancient Mesoamerican rituals with contemporary earth art and performance. Like Gilbert & George, Mendieta experimented with the camera to extend performance into "living sculpture." The idea that the camera can at once extend a sculptural activity into performance and a performance into sculpture likewise informs Antin's "The Last Seven Days," from Carving: A Traditional Sculpture (1972; plate 262), a series of full-length shots, installed in grid formation, showing the artist's body from the front, back, and sides over a thirty-six day period in which she "sculpted" herself by dieting to lose ten pounds in weight. "Exploiting the idea that the camera could make an action outlive the moment," David Campany writes, "photography became the means by which the spirit of performance could be kept alive."[50]

By the mid-1990s and continuing into the first decade of the twenty-first century, distinct generations of artists, from Lawler to Robert Gober, from Guy Tillim to Cyprien Gaillard, from An-My Lê to Jan De Cock, and from Gillian Wearing to Robin Rhode were manipulating, expanding, and diversifying the creative and critical possibilities of photography to probe

what sculpture "is" and the received ideas about how sculpture should be understood. Defined as much by photography's own rich legacy as by the medium's uses within contemporary art practices, photography of sculpture engages not one but a broad spectrum of expressions. Through its 170-year history, the medium has remained open to experimental use by artists working in other mediums. As in its early age, when practitioners of this "New Art" came (as at that point they had to) from other fields—from science (William Henry Fox Talbot); from theater, or more specifically the Diorama, a theatrical device that anticipated the motion picture (Daguerre); from painting (Fenton, Nègre, and many others); and from sculpture (Auguste Rodin and his many collaborators)—today photography remains, as Mark Haworth-Booth notes, "hospitable to talents from elsewhere," that is, "from every discipline and point of view."[51] Photography and its relations with other artistic disciplines have been and continue to be full of twists and turns; and sculpture, meanwhile, in its expanded discursive field, stands in as-yet-unmapped, still-to-be-discovered relations to its photographic dimension. These relations allow us to envision how different practices contribute to the meaning of the image—an image that documents, invents, interprets, and invites ongoing transformations of its subject.

Notes

1. For a broader discussion of these interactions see Jacques Rancière, *The Future of the Image* (London and New York: Verso, 2007).

2. Edgar Allan Poe, quoted in Sabine T. Kriebel, "Theories of Photography: A Short History," in James Elkins, ed., *Photography Theory* (New York: Routledge, 2007), p. 6.

3. Kriebel, in ibid., p. 7.

4. Louis-Jacques-Mandé Daguerre, quoted in Barbara E. Savedoff, *Transforming Images: How Photography Complicates the Picture* (Ithaca: Cornell University Press, 2000), p. 48.

5. Man Ray, "Deceiving Appearances," in Christopher Phillips, ed., *Photography in the Modern Era: European Documents and Critical Writings, 1913–1940* (New York: The Metropolitan Museum of Art/Aperture, 1989), p. 12.

6. To copy and to create might be thought antithetical processes, yet artists have copied the works of their predecessors for centuries. Since the Renaissance, artists' copies have ranged from academic exercises, allowing them to experiment with, probe, and rival the art of the past, to more recent conceptual devices through which to question ideas of authorship and originality and to instate new artistic criteria. This interplay of operations is integral to what we call art.

7. Donald Preziosi, *Rethinking Art History: Meditations on a Coy Science* (New Haven: Yale University Press, 1989), p. 72.

8. Okwui Enwezor, *Archive Fever: Uses of the Document in Contemporary Art* (New York: International Center of Photography, 2008), p. 12.

9. Walter Benjamin, "The Work of Art in the Age of Mechanical Reproduction," in *Illuminations*, ed. Hannah Arendt, trans. Harry Zohn (New York: Schocken Books, 1969), p. 221.

10. Benjamin's essay "Das Kunstwerk im Zeitalter seiner technischen Reproduzierbarkeit" (The Work of Art in the Age of Mechanical Reproduction) was translated into French by Pierre Klossowski in 1936. André Malraux refers to it in his presentation "Sur l'héritage culturel," delivered in London that same year to the Association of Writers for the Defense of Culture. See T. J. Demos, *The Exiles of Marcel Duchamp* (Cambridge, Mass.: The MIT Press, 2007), p. 247, n. 31.

11. David Campany, *Photography and Cinema* (London: Reaktion Books, 2008), p. 64.

12. Malraux, quoted in Geraldine A. Johnson, "Introduction," in Johnson, ed., *Sculpture and Photography: Envisioning the Third Dimension* (Cambridge: at the University Press, 1998), p. 2. *Le Musée imaginaire* (translated into English as *The Museum without Walls*) was the first volume of a three-part work, *La Psychologie de l'art* (The psychology of art), which Malraux subsequently expanded and reissued in a single volume as *Les Voix du silence*, 1951, Eng. trans. Stuart Gilbert as *The Voices of Silence* (Garden City, N.Y.: Doubleday, 1953).

13. Beaumont Newhall, *Photography: A Short Critical History* (New York: The Museum of Modern Art, 1938), p. 89.

14. Johnson, *"The Very Impress of the Object": Photographing Sculpture from Fox Talbot to the Present Day* (Leeds: Henry Moore Institute, 1995), p. 3.

15. Berenice Abbott, *The World of Atget* (New York: Horizon Press, 1964), p. xxxi.

16. Walker Evans, quoted in Maria Morris Hambourg, "A Portrait of the Artist," in Maria Morris Hambourg, Jeff L. Rosenheim, Douglas Eklund, and Mia Fineman, *Walker Evans* (New York: The Metropolitan Museum of Art, and Princeton: at the University Press, 2000), pp. 21–22.

17. Lincoln Kirstein, "Afterword," in Evans, *American Photographs* (New York: The Museum of Modern Art, 1938; Fiftieth-Anniversary edition, 1988), p. 195.

18. John Szarkowski, *Walker Evans* (New York: The Museum of Modern Art, 1971), p. 20.

19. Peter Galassi, *Walker Evans & Company* (New York: The Museum of Modern Art, 2000), p. 21.

20. Louis Rose, *The Survival of Images: Art Historians, Psychoanalysts, and the Ancients* (Detroit: Wayne State University Press, 2001), p. 63.

21. Aby Warburg, quoted in Luis Pérez-Oramas, *An Atlas of Drawings: Transforming Chronologies* (New York: The Museum of Modern Art, 2006), p. ix.

22. Georges Didi-Huberman, "Knowledge: Movement (The Man Who Spoke to Butterflies)," in Philippe-Alain Michaud, *Aby Warburg and the Image in Motion*, 1998 (Eng. trans. New York: Zone Books, 2004), pp. 12–13.

23. E. H. Gombrich, *Aby Warburg: An Intellectual Biography* (Chicago: at the University Press, 1986), p. 285.

24. Martha Ward, "Art in the Age of Visual Culture: France in the 1930s," in Stephen W. Melville, ed., *The Lure of the Object* (Williamstown, Mass.: Sterling and Francine Clark Art Institute, 2005), p. 88.

25. Michaud, *Aby Warburg and the Image in Motion*, p. 278.

26. Didi-Huberman, "Knowledge: Movement," p. 12.

27. See Ward, "Art in the Age of Visual Culture," p. 87.

28. Hal Foster, Rosalind Krauss, Yve-Alain Bois, and Benjamin H. D. Buchloh, *Art since 1900: Modernism, Antimodernism, Postmodernism* (London: Thames & Hudson, 2004), p. 275.

29. Johnson, *"The Very Impress of the Object,"* p. 6.

30. Ezra Pound, quoted in Friedrich Teja Bach, *Brancusi: Photo Reflexion* (Paris: Didier Imbert Fine Art, 1991), p. 129. *Anschauung* is a term from Kantian philosophy, translated variously as "sense-perception" or "intuition"—direct perception unmediated by rational analysis.

31. Brancusi, quoted in ibid., p. 127.

32. Teja Bach, in ibid., pp. 134–35.

33. *Minotaure* no. 3/4 (December 14, 1933):77.

34. Salvador Dalí, "De la beauté terrifiante et comestible de l'architecture Modern style," *Minotaure* no. 3/4 (December 1933):72.

35. The phrase refers to Ovid's *Metamorphoses* and its story of Pygmalion, a sculptor who carves a statue of a woman out of ivory. After he falls in love with the statue, Venus brings it to life.

36. Siegfried Kracauer, "Photography," in *The Mass Ornament* (Cambridge, Mass.: Harvard University Press, 1995), pp. 58–59.

37. On the differing accounts of the "invention" of photomontage see Brigid Doherty, "Berlin," in Leah Dickerman, *Dada* (Washington: National Gallery of Art, 2005), pp. 84–153.

38. Ibid., p. 93.

39. Rancière, *The Future of the Image*, p. 57.

40. In 1977, the critic Douglas Crimp organized a show titled *Pictures* at Artists Space, New York, which he accompanied with an essay, later revised and reprinted in *October* no. 8 (Spring 1979): 75–88. Crimp used the word "pictures" to describe a new art that relied on the "processes of quotation, excerptation, framing and staging," an art that was "not in search of sources or origins, but structures of signification: underneath each picture there is always another picture," p. 87.

41. Foster, Krauss, Bois, and Buchloh, *Art since 1900*, p. 580.

42. Kriebel, "Theories of Photography," p. 13.

43. Craig Owens, "The Discourse of Others: Feminists and Postmodernism," in Foster, ed., *The Anti-Aesthetic* (New York: New Press, 2002), p. 77.

44. "Sculpture in the Expanded Field" is the title of an essay published by Krauss in *October* 8 (Spring 1979):30–44. Here Krauss uses the term "expanded field" as an extended physical and conceptual terrain for understanding sculpture. For an updated analysis see George Baker, "Photography's Expanded Field," *October* 114 (Fall 2005):120–40.

45. *Sculptures involontaires* (Involuntary sculptures) is the title of a series of photographs taken by Brassaï and Salvador Dalí in 1933. See "Daguerre's Soup: What Is Sculpture?," plate-section 8 in the present volume.

46. Man Ray, quoted in Neil Baldwin, *Man Ray: American Artist* (New York: Da Capo Press, 1988), p. 158.

47. Sarah Hamill, "The World Is Flat: Photography and the Matter of Sculpture," *Camerawork* 36, no. 1 (Spring/Summer 2009):18.

48. Mark Godfrey, "Image Structures: Photography and Sculpture," *Artforum* 43, no. 6 (February 2005):151.

49. Dan Graham, *Articles* (Eindhoven: Van Abbemuseum, 1978), p. 65.

50. Campany, "Survey," in Campany, ed., *Art and Photography* (London: Phaidon, 2003), p. 26.

51. Mark Haworth-Booth, *Photography, an Independent Art: Photographs from the Victoria and Albert Museum 1839–1996* (London: V&A Publications, 1997), p. 181.

AN ALMOST UNLIMITED VARIETY:
PHOTOGRAPHY AND SCULPTURE IN THE NINETEENTH CENTURY

GEOFFREY BATCHEN

A striking aspect of photography's early history is the fact that so many of the first photographers made images of statues and other sculptures. The reasons seem obvious: such specimens were widely available, especially among the social classes from which most of these photographers came. They were immobile, uncomplaining, and easily lit, allowing the photographer to maintain a pronounced chiaroscuro while using a technology that still required long exposure times—too long to easily allow human portraiture. Then there was the question of color: nineteenth-century photographs were monochromatic, but pictures of white plaster casts could transcend this handicap by remaining entirely accurate renditions of their subjects. For those with artistic aspirations, photographing statuary immediately placed these strange new kinds of images into an established tradition, the still life. And images of statues allowed photography's pioneers to make an undeniable case for the medium's usefulness as a way of accurately documenting the appearance of existing artworks. In short, photographs of statues were convenient and persuasive demonstrations of photography in general.

If we stop at this purely instrumental reading of such pictures, however, we may neglect their many other possible meanings. Static and predictable in appearance yet capable of being creatively arranged in front of a camera, statues gave nineteenth-century photographers license to explore the creative capacities of their medium, especially its ability to manipulate space and time. At the same time, the depiction of specimens of sculpture helped to locate photography within an existing economy of copies and reproductions, establishing the pattern of repetition and difference that has modulated the photographic experience ever since. Finally, the specific details of these pictures reveal much about the context in which they were made and first seen, and thus about nascent attitudes to the photograph as an emerging cultural phenomenon.

Consider, for example, the picture now titled *Nature morte* (Still life; plate 8), made in 1839–40 by the French decorator and occasional photographer François-Alphonse Fortier. This is a daguerreotype, created in Paris soon after the announcement of the process by its inventor, Louis-Jacques-Mandé Daguerre, in 1839. In return for a lifetime pension from the French government, Daguerre published an illustrated manual describing how to make daguerreotypes and offered demonstrations and free lessons every week at the Conservatoire national des arts et métiers. Fortier presumably availed himself of this service, since his horizontal still life resembles in size, subject, and composition some of those already made by Daguerre. *Nature morte* comprises casts, Roman-style busts, classical statuettes (figures of Hercules are prominent) and bas-reliefs, decorated shields and boxes, a glass vessel and two vases, and several paper prints, all piled haphazardly on top of one another and against various textured fabrics. The whole ensemble is arranged to look like a casual scene one might see in a typical artist's studio of the time. This appearance is deceptive, however, since in order to catch enough light in the camera for a photographic image to be generated, the photographer would have had to carefully place each of these objects outdoors in full sunlight. Right from its beginnings, then, photography offered itself as both true and false, natural and artificial—as much an art as a science.

Among other things, Fortier's image successfully demonstrates the extraordinary range of detail that the daguerreotype process could capture. Textures, incised designs, drapery, musculature, architectural features, tonal variations, even printed text: everything is inscribed on the plate with the same pitiless clarity. This lack of discrimination, photography's greatest strength as a means of documentation, was actually regarded as a handicap as far as its artistic utility was concerned, precisely because the process was unable to suppress unimportant, secondary visual information.[1] That the first photographers nevertheless had an artistically informed audience in mind is suggested by their

choice of subject matter. The still life, after all, was already a long-established genre of painting, with its own conventions, traditions, and assumed moral values—often turning, for example, on the evocation of decay and mortality (and thus on an incitement of repentance and redemption in the viewer), qualities signaled by a still life's faithful depiction of ephemeral foodstuffs and other material possessions.

What's interesting about Fortier's still life, however, is that it doesn't correspond to any of these conventions or values. He could, after all, have just as easily assembled an artful arrangement of fruit or flowers (as Roger Fenton did in 1860 for a magnificent series of albumen prints). Instead we are presented with an apparently almost arbitrary assortment of sculptural bric-a-brac, densely arranged in a shallow space to allow for the limited depth of field provided by Fortier's relatively primitive photographic technology. At first glance, none of his objects seems to correspond to any other in a meaningful way; they embody no particular taxonomic order, rationale, or style, and as a group convey no discernible narrative or literary reference. So what are these pictures about? What do they represent, other than photography itself?

The question becomes even more pressing when we realize that Fortier's *Nature morte* is in fact typical of many early plates—that remarkably similar compositions were produced not only by Daguerre himself but also by his associates Armand Hippolyte Louis Fizeau, Alphonse Eugène Hubert, and Armand-Pierre Séguier.[2] Séguier's *Still Life with Plaster Casts* (1839–42; fig. 1), for example, again features a selection of plaster statuettes, some classical in origin and some medieval, along with relief panels, architectural fragments, and a shield, all displayed against another of those heavily textured drapes. In October 1839, Séguier had introduced a daguerreotype camera with a tripod attached to it by a ball-and-socket joint "which permits one to place [the camera] in all desirable positions."[3] He seems to have employed his new tripod to make this rather novel vertical composition, simply by turning his camera on its side. The objects are stacked one above the other to fill the available space, with the use of a single hanging backdrop leaving the impression that each cast is floating in a crumpled but continuous plane. Séguier's assemblage of casts includes a small Jupiter with a thunderbolt (as did another still life made by Daguerre).[4] This figure of Jupiter, together with the various other carvings featured, is of a kind that must have appealed to the curator of antiquities at the Louvre, the Comte de Clarac, to whom Séguier gave his daguerreotype, according to an inscription on the back. Indeed Daguerre's, Fortier's, and Séguier's images all feature the kind of plaster reproductions that

fig. 1. Baron Armand-Pierre Séguier (possibly in association with Louis-Jacques-Mandé Daguerre). *Still Life with Plaster Casts*. 1839–42. Daguerreotype, 8 x 6" (20.3 x 15.2 cm). The J. Paul Getty Museum, Los Angeles

were then being made in large numbers, some of them reduced copies of original objects held by the Louvre.

Séguier's decision to give this particular still life, with its conglomeration of architectural details and medieval reliefs, to a curator at the Louvre (following in the footsteps of Daguerre, who had already given one to its director) amounts to a canny appeal to official taste. These are in fact carefully calibrated compositions, designed to offer viewers an eclectic synthesis of historical styles at a time when that kind of balancing act suited the prevailing *juste milieu* ideology of France's so-called "Citizen King" Louis-Philippe and his fragile government. Nationalism was a convenient rhetoric of unification, and history its most potent vehicle.[5] One consequence was a renewed interest, on all sides of the political spectrum, in medieval and Gothic art and architecture, widely seen as the basis of a French national style. As Albert Boime puts it in his book *Hollow Icons*, "There was a right-wing medievalism and a left-wing medievalism," and here, in their deliberated presentation of Gothic objects, appealing equally to adherents of classicism, Romanticism, and realism, these photographers managed to appeal to all sides.[6] In their pluralist gathering of sculptural and architectural fragments, these early photographs adopt the look of a didactic nationalist history.[7]

Another of these daguerreotype still lifes (plate 9), made in 1839 and commonly attributed to Hubert (an architect and Daguerre's assistant), features a small copy of the Venus de Milo. Around 1836, Achille Collas had introduced a sculptural reducing and copying machine and three years later demonstrated its capabilities by producing a two-fifths-size version of this same canonical statue. As Robert Sobieszek tells us, "The Collas machine was the primary vehicle for the proliferation of serial sculpture and sculptural editions of various sizes beginning in the late 1830s and 1840s."[8] Its only competition in this process of accelerated visual proliferation was photography. No wonder two journalists, one English and one French, directly compared the inventions of Daguerre and Collas in reviews of 1839.[9]

In early still lifes like the one by Hubert, daguerreotypy was copying what had already been copied, in the process linking its own mechanical aptitude for picture-making to a three-dimensional analogue.[10] But these sorts of still lifes also link photography to a new economy, an economy that would gradually replace human copiers with machinic ones. The reduced-scale copies of statuettes represent a growing bourgeois market for such things, and with it the commercialization of artmaking itself. But they also represent an effort on the part of sculptors and their agents to find new outlets for their work, outlets outside the

sanctioned system of salon exhibitions and state commissions. These objects, then, are potent signs of the incorporation of art production into capitalism and of the gradual breakdown of state control over artmaking. Photography performed a similarly disruptive function within the economy of two-dimensional image-making (as the critic Gustave Planche disparagingly wrote in 1847, "Casting is to statuary what the daguerreotype is to painting"), and perhaps that shift is another of the things being staged for our perusal in these still lifes.[11]

In each picture we get what seems to be a celebration of copying itself, of the ability to own copies, and of the act of copying those copies; these still lifes are therefore paeans to art as potential property. They are about collecting and display—but a casual, haphazard form of display that treats its objects more like loot or cheap commodities than like revered works of art. The pictures thereby enact the political sensibility of the upper middle class, but also refer to the museum, that class's newly activated temple of artistic

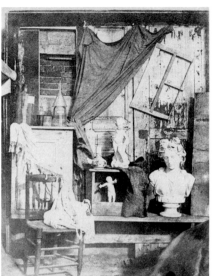

fig. 2. Hippolyte Bayard. *In the Studio of Bayard*. c. 1845.
Salted paper print, 9 ¼ x 6 ⅞" (23.5 x 17.5 cm).
The J. Paul Getty Museum, Los Angeles

consumption. No wonder, then, that museums quickly became favored sites for photography, not only as sources of commissions for reproductions of famous sculptures but also as exemplary settings for the viewing of art of all kinds. Fenton's view of a gallery in the British Museum (c. 1857; plate 28) looks down soothing parallel rows of classical statues, all elevated on plinths. The space is flooded with sunlight from above. Enlightenment is made visible, literally as a shaft of light but also through the order imposed on these fragments of lost civilizations by their reasoned reconstitution in the museum. Fenton's view also encompasses a group of artists, both male and female, busily making copies of what they see. It's a reminder that copying the work of past masters was an essential part of an art education in this period, as if genius could be germinated simply through a repetition of its forms. In 1857 Fenton made a number of photographic studies of sculptures in the collection of this same museum, including the Elgin Marbles. It wouldn't be long before these kinds of photographic copies made the laborious sketching we see here a thing of the past.[12]

That sculptural copies were a common visual currency is further indicated by their frequent appearance in the work of Hippolyte Bayard, a clerk in the French ministry of finance as well as a pioneering photographer. On February 5, 1839, only a

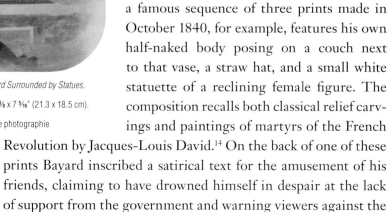

fig. 3. Hippolyte Bayard. *Bayard Surrounded by Statues*.
c. 1845–48. Paper negative, 8 ⅜ x 7 ⁵⁄₁₆" (21.3 x 18.5 cm).
Société française de photographie

month after Daguerre's announcement, Bayard was able to show associates some paper photographs produced by a method of his own invention. By July 14 (Bastille Day) he was sufficiently expert to put thirty of his unique direct-positive prints on exhibit in aid of earthquake victims in Martinique. As his own albums and notebooks indicate, from the very beginning of his experiments Bayard photographed statuettes and sculptures, sometimes individually but often in elaborate groupings arranged by himself.[13] He reportedly owned about forty of these statuettes, which appear both in photographs taken in his home and in compositions he set up on the roof of the ministry of finance. One page of an early album features four separate prints of a single nude female figurine standing on this roof, showing her from four different perspectives. The sequence puts the camera into motion, so that we appear to be circling her. By this means Bayard allows us to note the changing effects of light and shadow that this movement generates. But he has also found a way for photography to transcend some of its own limitations, in particular its tendency to flatten everything it sees into two dimensions. Here he overcomes that limitation by restoring both volume and time to our visual experience.

A view of a corner of Bayard's rustic domestic studio (fig. 2), one of several such views he made in about 1845, shows three plaster statuettes in situ, propped up on wooden shelves and boxes and accompanied by a vase (like these statues, a regular prop in Bayard's photographs), some glass vessels (no doubt full of photographic chemicals), a drawing implement hanging on the wall, and furniture artfully draped with a shawl. A statuette of a small naked child reaches out towards us from inside an open box, as if to welcome us into this personal space. That Bayard was capable of such humor is clear from other photographs: a famous sequence of three prints made in October 1840, for example, features his own half-naked body posing on a couch next to that vase, a straw hat, and a small white statuette of a reclining female figure. The composition recalls both classical relief carvings and paintings of martyrs of the French Revolution by Jacques-Louis David.[14] On the back of one of these prints Bayard inscribed a satirical text for the amusement of his friends, claiming to have drowned himself in despair at the lack of support from the government and warning viewers against the smell of his rotting body. Bayard is one of the few photographers

of this period to pose regularly with and even *as* a piece of sculpture. In an image made in the late 1840s (fig. 3), for example, he self-consciously put himself in a place occupied in another of his images of this same group by a statuette of Antinous, the beautiful young boy of Roman legend who, it is said, drowned himself in order to prolong the life of his lover, the emperor Hadrian. The precise meaning of such juxtapositions remains unclear, but there can be no doubt that Bayard conceived his photographs of sculptural figures as meaningful, setting up complicated conversations among them that we have yet to unravel.

Statuary also figured prominently in the work of William Henry Fox Talbot, the English inventor both of what he called "photogenic drawing" and of the later calotype process. The only subject to appear twice in Talbot's publication *The Pencil of Nature* (1844–46), one of the first photographically illustrated books, was a plaster copy of a Hellenistic bust that Talbot fancifully titled *Bust of Patroclus* (plate 2).[15] A dramatic portrayal of a bearded man's head turning to look over his right shoulder, as if caught by surprise, this piece of sculpture was among the most photographed of all of Talbot's possessions. Fifty-five known individual images of it remain in existence, and he probably made many more that have not survived.[16] Add to that the many prints that would have been made from each of these fifty-five negatives (mostly by Talbot's onetime valet Nicolaas Henneman and his assistants rather than by Talbot himself) and we begin to realize that this single picture is but the tip of a veritable iceberg of photographic activity.[17]

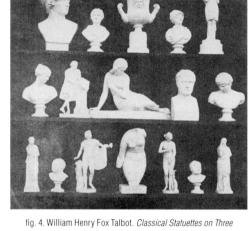

fig. 4. William Henry Fox Talbot. *Classical Statuettes on Three Shelves.* c. 1841. Salted-paper print from a calotype negative, 5 ⅞ x 5 ¾" (15 x 14.6 cm). National Media Museum, Bradford

In this particular view, Talbot has chosen to crop out the bottom of the bust in his camera, so that his Patroclus looms out of the darkness as if alive, animated both by this framing and by the light Talbot has reflected back onto it using a white cloth. Within the confines of the photograph, Patroclus is no longer a piece of sculpture; he is an actor in an extended tableau vivant. For viewers at the time, any picture given this title would have recalled the tale from Homer's *Iliad* describing how Patroclus was killed during the siege of Troy while disguised in the armor of his beloved companion Achilles. Talbot's picture therefore conjures the sublimity of this imminent death, but also a seemingly endless series of substitutions: a legendary Greek hero is a metaphor for self-sacrifice, that sacrifice occurs when Patroclus literally replaces Achilles in Homer's story, the plaster bust stands in for a human figure, a photograph for the plaster bust, and the bust for the original marble carving (now in the British Museum). Even this particular print is actually a substitute for another, as it was issued in later editions of fascicle 5 of *The Pencil of Nature* only after the negative of an earlier, smaller

view of the bust, the source of Talbot's initial inclusion, was lost or damaged.[18]

In *The Pencil of Nature*, Talbot accompanied both prints with a detailed commentary on the practical and creative challenges of photographing specimens of sculpture. He notes that "these delineations are susceptible of an almost unlimited variety" depending on how the statue is positioned in relation to the sun. He suggests turning the statue on its pedestal to produce a different-looking view, as he himself obviously did many times. He also mentions the possibility of moving the camera nearer and farther from the statue to produce shifts in scale. As he says, "It becomes evident how very great a number of different effects may be obtained from a single specimen of sculpture."[19] In short, he proposes that this particular picture be seen as but one example from a series of photographic experiments for which statues are the ideal subjects.

Talbot's experimental approach to his photography is further emphasized when *Bust of Patroclus* is compared to the incredible variety of his many other photographs of statuary. Apart from records of individual pieces of sculpture, he also produced a number of pictures showing a more or less symmetrical array of plaster figurines resting on three shelves (c. 1841; fig. 4). Set up in the courtyard of his house in order to get the photographic benefits of full sunlight, these tableaux nevertheless present themselves as if they were inside, creating an illusion of the real that would soon be a standard trope of photographic image-making. Offered as documents of Talbot's own possessions, and by implication of his wealth, artistic interests, and class values, the images are almost entirely flat, virtually abstract. Indeed they emulate the equally flat and already familiar two-dimensional look of his contact prints of lace and botanicals. Elsewhere, in fact, Talbot even surrounded a camera photograph of a plaster copy of Giambologna's *Rape of the Sabines* with a rectangular frame that he contact-printed from a piece of lace (c. 1844; fig. 5).[20]

Talbot chose to photograph these shelves of statuettes front on, with only a hint of blurred background and without showing the shelves' means of support. The result is a visual slice from a seemingly endless row of shelves, suspended in the picture plane as if floating in midair. Each object here becomes a cipher, clearly separated yet able to be directly compared with its neighbors. In effect Talbot creates a casual but unmistakable grid pattern, stamping the antinatural, antimimetic form of this geometry over the realism of the photographic image. He adopts the aesthetic of modern scientific analysis to the photographing of art objects, but also references the prevailing visual conventions of both academic study and commercial display.

Resting in the center of the composition is a plaster copy of *Eve at the Fountain*, originally carved in marble in 1822 by the English sculptor Edward Hodges Baily. Talbot must have found this statuette appealing, for he made at least twenty-nine different negatives of it (it actually appears in one composition in the company of his bust of Patroclus).[21] Its theme of female narcissism or vanity no doubt affirmed the usual masculine prejudices—and by photographing such sculptures Talbot managed to take an awful lot of pictures of naked female figures without risking offense—but this self-absorbed figurine also represents a person transfixed by her own mirror reflection. (Talbot sometimes photographed the statuette on top of a highly polished tabletop to enhance the effect.) A picture of this statue, in other words, was a representation of an attribute that photography was now claiming as its own special privilege. In addition, Talbot's photographs of this cast in isolation allow her to be momentarily gigantic, or at least scaleless, within the boundaries of the picture. Photography transforms what it depicts, reconciling an exact reflection of the world of three-dimensional things with the creative reconstitution of that world in the form of a two-dimensional picture.

If the flow of mechanical copies of statues was a visible manifestation of the flow of capital in general, photographs showed that flow to be truly international in character. Both Talbot and Bayard, for example, made images of reduced copies of the same statue, the Laocoön (1845; fig. 6), as did Daguerre and Séguier of the statuette of Jupiter, Daguerre and Bayard of a portrait bust of the French architect and designer Charles Percier, and Hubert and Bayard of the Venus de Milo. For historian Michel Frizot, mass-produced copies of sculptures had become part of a kind of visual vocabulary common to the educated classes of Europe.[22] But they are mobilized in another way too, in the sense that we see these objects being moved around by the photographers themselves, reappearing in different configurations and in different settings (outdoors, in the studio, in the home, amongst garden implements, as props in portraits, etc.). This physical mobility suggests an equally mobile set of meanings for the still lifes that contain them.

Speaking of mobility, a number of nineteenth-century photographers took advantage of the camera's portability to seek out sculptural monuments far from home. In 1849, for example,

fig. 5. William Henry Fox Talbot. *Group of the Sabines at Florence.* c. 1844. Salted-paper print from a calotype negative, 6 ⅞ x 4 ⅜" (17.5 x 11.1 cm). National Media Museum, Bradford

fig. 6. William Henry Fox Talbot. *Statuette of Laocoön and His Sons.* 1845. Salted-paper print from a calotype negative, 3 ½ x 3 ¾" (8.9 x 9.5 cm). National Media Museum, Bradford

Maxime Du Camp was charged with an official mission by the French government to record the ancient monuments and hieroglyphic inscriptions of Egypt. Du Camp duly visited Egypt in the company of the novelist Gustave Flaubert, arriving in November 1849, staying eight months, and making an extensive voyage up the Nile. He eventually published an account of his travels, *Egypte, Nubie, Palestine et Syrie*, illustrated with 125 salted-paper prints made from paper negatives. The twenty-eight-year-old Du Camp learned photography especially for this purpose, employing a modified version of the waxed-paper method devised by his countryman Gustave Le Gray. Despite his complaints about the difficulties of taking photographs in the heat and dust of Egypt, requiring exposure times of at least two minutes, he was able to produce at least 216 negatives, many of remarkable quality. As his friend Flaubert unkindly remarked in a letter, "Max's days are entirely absorbed and consumed by photography . . . really, if he doesn't take things easier he'll crack up."[23]

Du Camp's image of a gigantic statue of an ancient ruler, the pharaoh Ramesses II (plate 20), in many ways exemplifies his mission and photography's role in it. He set up his camera directly in front of his subject, intent on capturing it without flourish, as if to underline the objective, dispassionate recording capacities that he clearly relished in his medium. We can scrutinize the print for details as if it were a schematic drawing—even the hieroglyphic inscriptions running above the pharaoh's head have been made discernible. Most of the statue lies buried under centuries of accumulated sand, which Du Camp had his hired Egyptian workers partly remove. A head, impassive in its massive majesty, emerges again from the earth, staring sightlessly back into our eyes. The years of burial have protected the stone from weathering, leaving the face pale in contrast to its surroundings. It's as if we were seeing the pallid complexion of actual flesh, a mummified body on the verge of resuscitation. A native Egyptian, a Nubian named Ishmael, sits incongruously, even disrespectfully, on top of this head, his feet dangling over the stone headdress. Strikingly, Ishmael's face has been deliberately obscured, as if he, not the statue, were the mute effigy in this scene.[24]

The addition of this man as a convenient marker of scale is typical of Du Camp's pictures, but it also sent a message to his French audience on the historical and cultural gulf between

contemporary Egyptians and their ancient ancestors. Widely considered the now decayed source of classical civilization, Egypt was presented by Du Camp as a country of neglected ruins, as a country *in* ruins. Ignoring any signs of contemporary Egypt, such as its modern railways, Du Camp's photographs collectively described it as a culture in dissolution, an attitude that suited not only a Romantic yearning for death and melancholy but also Europe's voracious colonial ambitions. This popular construction was repeated in archaeological photographs by others, showing broken or displaced sculptural artifacts, apparently uncared for by their current owners. Detached by photography from their place and culture of origin, these images of ancient oriental statues both record their discovery *by* Europeans and justify their removal *to* Europe.

The camera conquered the tyranny of distance, allowing sedentary viewers in their armchairs to gaze on the monuments of the ancient world. But it also allowed them to see their own monuments, answering a need driven by a newly kindled sense of national history. In 1851, for example, the French Comité des Monuments Historiques launched a series of *missions héliographiques*, charging five photographers with the task of recording significant historical buildings throughout France, many threatened with demolition or alteration. This effort was emulated in the private sector by individual photographers such as Henri Le Secq, Charles Marville, and Charles Nègre, who set about documenting resonant symbols of French identity, such as the great Gothic cathedrals and their decorative sculptural additions. In that same year of 1851, for example, Nègre took a series of commercial images of Chartres Cathedral before traveling elsewhere in France

fig. 7. Albert Fernique. Frédéric Auguste Bertholdi's Statue of Liberty, under construction at the Gayet-Gauthier foundry, Paris. 1884. Albumen print, 7 15/16 x 5 1/16" (20.2 x 12.9 cm). Musée Carnavalet, Paris

for similar purposes. A view of a carved angel perched on the rooftop of Notre Dame in Paris, as if newly alighted there (plate 23), introduces an innovative element common to this kind of project, the detail snatched from its full context. Nègre's camera mobilizes our otherwise stationary eye, taking us high into the air, where we get to see in comfort things not designed to be seen by anyone but God.

Nègre's picture of Le Secq standing next to a freshly installed gargoyle on the uppermost regions of Notre Dame (c. 1853; plate 119) provides a wry commentary on this new kind of photographic experience. A stone balustrade thrusts deep into the picture from the lower right corner, entering as if from behind us and irresistibly leading our eye forward to the main subject. The placement of this balustrade, making an otherwise static scene seem dynamic and modern, also implies that the photographer is hovering in space, adrift from the building. Le Secq, arm on hip,

top hat firmly in place, shares a moment of contemplation with a horned gargoyle, as both of them look out over the rooftops of Paris. The composition mimics an engraving that had appeared in the 1831 edition of Victor Hugo's *Notre-Dame de Paris* (known in English as *The Hunchback of Notre Dame*). Nègre thus links his picture with a famous novel and its popular Romantic sentiment at the same time that he presents his friend as a deformed Quasimodo, all the while also documenting one of this restored cathedral's extraordinary elevated architectural details.

History is a constant theme in these photographs, despite the static nature of the pictures themselves. The passing of time is made a more overt subject when two or more photographs are seen in sequence, even when they were made by different photographers. We thereby get to see the Statue of Liberty under construction in France (fig. 7) and then towering over New York (plate 131), leaving us to imagine all the events that occurred in between. In another such pairing we are presented with a view of the Vendôme Column (plate 118), topped with a classicized statue of Napoleon Bonaparte placed there as a surrogate by his nephew, the self-styled Emperor Napoleon III. The same photographer, Bruno Braquehais, was present to capture the dismantling of the column on May 8, 1871 (plate 117), pulled down at the suggestion of the painter and Communard Gustave Courbet. Napoleon now lies before us, abjectly fallen and impressively serene in about equal measure. In one of those peculiarly photographic effects, the picture contrasts his stillness with the blurred movement of the restless crowd that surrounds him, measuring the contingency of the present against a majesty that will, the photograph implies, last on into eternity.

They seemed relatively uninteresting at first, these still lifes of statuary, no more than convenient excuses for a technology then incapable of capturing the color and movement of actual life. Yet such images have turned out to be complex and provocative meditations on both photography and the world around it. Capable, as Talbot had wisely suggested, of an almost unlimited variety of effects and meanings, the photographing of sculpture has allowed practitioners to experiment with their medium, shaping time and space as an artist might shape marble or plaster. Indeed, this correspondence of photography and sculpture allows us to see their many unexpected similarities, including a common context of production and dissemination within an emerging industrial and capitalist culture. In that sense, these unassuming photographs remain potent markers of modernity, and of our always tendentious and provisional relationship to it.

Notes

Some elements of this essay derive from my "Light and Dark: The Daguerreotype and Art History," *Art Bulletin* LXXXVI, no. 4 (December 2004): 764–76.

1. In a series of essays published in France between 1850 and 1853, the critic Francis Wey explicitly equated paper photographs with fine-art values and "rejected the possibility that the daguerreotype could be the basis of an aesthetic discourse." Why? "Because it resisted the requisite hierarchy of compositional elements—all were equal in the daguerreotype—and thus thwarted individual, artistic expression or style." See Margaret Denton, "Francis Wey and the Discourse of Photography as Art in France in the Early 1850s," *Art History* 25, no. 5 (November 2002):623–24.

2. For a selection of these early daguerreotype still lifes see Quentin Bajac and Dominique Planchon-de Font-Réaulx, eds., *Le Daguerréotype français. Un Objet photographique* (Paris: Réunion des Musées Nationaux, 2003). On the popularity of this subject matter see Eugenia Parry Janis, "Fabled Bodies: Some Observations on the Photography of Sculpture," in Jeffrey Fraenkel, ed., *The Kiss of Apollo: Photography & Sculpture 1845 to the Present* (San Francisco: Fraenkel Gallery in association with Bedford Arts Publishers, 1991), pp. 9–23, 475–98; Michel Frizot, Dominique Païni, et al., *Photographie/Sculpture* (Paris: Centre National de la Photographie, 1991); and Julia Ballerini, "Recasting Ancestry: Statuettes as Imaged by Three Inventors of Photography," in Anne Lowenthal, ed., *The Object as Subject: Essays on the Interpretation of Still Life* (Princeton: at the University Press, 1996), pp. 41–58.

3. Armand-Pierre Séguier, quoted in Walter A. Johnson, "Photography's Great Moments," *Photographica* XXV, no. 4 (October 1996):12–13.

4. Louis-Jacques-Mandé Daguerre's image was dedicated to Prince Metternich; see Johann Willsberger, *The History of Photography: Cameras, Pictures, Photographers* (Garden City, N.Y.: Doubleday, 1977), n.p.

5. As Stephen Bann has written, "One of the most potent causes, and one of the most widespread effects, of Romanticism was a remarkable enhancement of the consciousness of history." Bann, *Romanticism and the Rise of History* (New York: Twayne Publishers, 1995), pp. 3–4. See also Bann, *The Clothing of Clio: A Study of the Representation of History in Nineteenth-Century Britain and France* (Cambridge: at the University Press, 1984). Roland Barthes puts it even more succinctly: "The same century invented History and Photography." Barthes, *Camera Lucida: Reflections on Photography* (New York: Hill and Wang, 1981), p. 93.

6. Albert Boime, *Hollow Icons: The Politics of Sculpture in Nineteenth-Century France* (Kent, Ohio: Kent State University Press, 1987), p. 2.

7. One also shouldn't overlook a reference in these ensembles of casts to Paris's Ecole des Beaux-Arts, or rather to its buildings, a group only completed in 1840. In Félix Duban's design, the complex amounted to a group of fragments, whether one is considering the actual buildings in which instruction was given or the "immense surface of fragments artistically arranged" (the remnants of Alexandre Lenoir's earlier Musée national des Monuments Français) that greeted visitors as they entered the Ecole's courtyard. See Barry Bergdoll, "Félix Duban, Early Photography, Architecture, and the Circulation of Images," *The Built Surface* 2 (2002):12–30.

8. Robert A. Sobieszek, "Sculpture as the Sum of its Profiles: François Willème and Photosculpture in France, 1859–1868," *Art Bulletin* 62 (December 1980):624.

9. See Bates Lowry and Isobel Barrett Lowry, *The Silver Canvas: Daguerreotype Masterpieces from the J. Paul Getty Museum* (Los Angeles: The J. Paul Getty Museum, 1998), pp. 134, 223–24.

10. Photography and sculpture-carving machines have a long association. James Watt, a friend of Josiah Wedgwood's (whose son Thomas published the first essay on photography in 1802), built a machine for copying sculptures in about 1810. Samuel Morse experimented, unsuccessfully, with a photographic process in 1821, while living in New Haven; he was also engaged in an effort to invent a marble-carving machine to make copies of existing statues. See Carleton Mabee, *The American Leonardo: A Life of Samuel F. B. Morse* (New York: Octagon Books, 1943), p. 82. In 1859 a Frenchman named François Willème invented a process whereby photographs could be turned into sculptural figurines. See Beaumont Newhall, "Photosculpture," *Image* 7, no. 5 (May 1958):100–105; Sobieszek, "Sculpture as the Sum of Its Profiles"; and Philippe Sorel, "Photosculpture: The Fortunes of a Sculptural Process Based on Photography," in François Reynaud et al., eds., *Paris in 3D: From Stereoscopy to Virtual Reality 1850–2000* (Paris: Paris Musées and Booth-Clibborn Editions, 2000), pp. 80–89.

11. Gustave Planche, "Salon de 1847," in *Etudes sur l'école français (1831–1852). Peintre et Sculpture* (Paris: Michel Lévy Frères, 1855), 2:266. The French painter Jean-François Millet also compared photographs and casts: "Photographs are like casts from nature, which can never be equal to a good statue. No mechanism can be a substitute for genius. But photographs used as we use casts may be of the greatest service." Millet, supposedly speaking in 1856, as reported by the American painter Edward Wheelwright in 1876 and quoted in Aaron Sheon, "French Art and Science in the Mid-Nineteenth Century: Some Points of Contact," *Art Quarterly* 34 (Winter 1971):446.

12. On this topic see Joel Snyder, "Nineteenth-Century Photography of Sculpture and the Rhetoric of Substitution," in Geraldine A. Johnson, ed., *Sculpture and Photography: Envisioning the Third Dimension* (Cambridge: at the University Press), pp. 21–34; Mary Bergstein, "Lonely Aphrodites: On the Documentary Photography of Sculpture," *Art Bulletin* LXXIV, no. 3 (September 1992): 475–98; and Bann, *Parallel Lines: Printmakers, Painters and Photographers in Nineteenth-Century France* (New Haven: Yale University Press, 2001). In 1859, Roger Fenton issued some of his images of sculptures from the British Museum as albumen stereographs. This is another form of photography for which sculpture was always a prominent subject. In December 1840, for example, William Henry Fox Talbot is reported to have made some pairs of photogenic drawings of statuettes for use in Charles Wheatstone's reflecting stereoscope apparatus; these views of statues, their sense of volume partly restored, are the earliest known stereo photographs. They also pointed the way to a trade in such cards that was to introduce thousands of middle-class viewers to otherwise inaccessible artworks, in effect offering them a self-directed seminar in the history of sculpture outside the restrictions of academic art history.

13. See Jean-Claude Gautrand and Frizot, *Hippolyte Bayard. Naissance de l'image photographique* (Paris: Trois Cailloux, 1986).

14. See Geoffrey Batchen, *Burning with Desire: The Conception of Photography* (Cambridge, Mass.: The MIT Press, 1997), pp. 157–73, 252–54.

15. This was not necessarily the first photograph of a sculpture to be published in a book, however. In 1844, Nicolaas Henneman photographed a sculptural bust of Catherine Mary Walter using the calotype process. Positive salt prints from this negative were then pasted into a limited-edition memorial publication titled *Record of the Death-Bed of C. M. W.* and distributed among family members. It appeared at about the same time as the first fascicle of *The Pencil of Nature*, which was issued on June 24, 1844.

16. This number was kindly supplied by Larry J. Schaaf from his research for a Talbot catalogue raisonné. See http://foxtalbot.dmu.ac.uk/resources/raison.html.

17. For more on the role of Nicolaas Henneman and the Reading Establishment in the printing of Talbot's work, see Schaaf, *H. Fox Talbot's "The Pencil of Nature" Anniversary Facsimile: Introductory Volume* (New York: Hans Kraus Jr., 1989), pp. 16–20, and Batchen, "The Labor of Photography," *Victorian Literature and Culture* 37, no. 1 (2009):292–96.

18. On the two prints for fascicle 5 see Schaaf, *H. Fox Talbot's "The Pencil of Nature" Anniversary Facsimile*, p. 49. See also Susan L. Taylor, "Fox Talbot as an Artist: The 'Patroclus' Series," *Bulletin of the University of Michigan Museums of Art and Archaeology* 8 (1986–88):38–55, and Schaaf, *The Photographic Art of William Henry Fox Talbot* (Princeton and Oxford: Princeton University Press, 2000), pp. 148–49, 248.

19. Talbot, text opposite plate V, *The Pencil of Nature*, June 1844, as reproduced in Mike Weaver, ed., *Henry Fox Talbot: Selected Texts and Bibliography* (Oxford: Clio Press, 1992), p. 89.

20. See Catherine Coleman, ed., *Huellas de luz: El arte y los experimentos de William Henry Fox Talbot/ Traces of Light: The Art and Experiments of William Henry Fox Talbot* (Madrid: Museo Nacional Centro de Arte Reina Sofía/Aldeasa, 2001), p. 162.

21. On *Eve at the Fountain*, see Schaaf, *The Photographic Art of William Henry Fox Talbot*, pp. 128–29, 246.

22. Frizot, "The Parole of the Primitives: Hippolyte Bayard and French Calotypists," *History of Photography* 16, no. 4 (Winter 1992):358–70.

23. Gustave Flaubert, letter to his mother, Cairo, January 5, 1850, trans. in Francis Steegmuller, ed., *Flaubert in Egypt: A Sensibility on Tour* (Boston: Little, Brown, 1972), p. 74.

24. See Ballerini, "The In-visibility of Hadji-Ishmael: Du Camp's 1850 Photographs of Egypt," in *The Body Imaged*, eds. Kathleen Adler and Marcia Pointon (Cambridge: at the University Press, 1993), pp. 147–60.

FROM SCULPTURE IN PHOTOGRAPHY TO PHOTOGRAPHY AS PLASTIC ART

TOBIA BEZZOLA

The subject of this exhibition—photography of sculpture— seems unproblematic enough in itself: sculpture exists, it is photographed, and the result is photographs of sculpture. If we see photography as simply a form of technology—a combination of optical instruments for apprehending perspective with chemical or electronic processes for recording the impressions of light—the show's topic is merely one part of the history of photography. By this scenario, the only role photography could play in sculpture would be a complementary one, representing and disseminating it through modern media. After all, if we conceive of "the pictorial and the sculptural" as separated by an ontological barrier,[1] how can photography move from observing and depicting sculpture to actively participating in it? Traditionally, sculpture was understood as the translation of content from the realm of ideas (*ordo rerum idearum*) into that of physical objects (*ordo rerum extensarum*).[2] Clearly, in this interpretation, no photograph can ever attain the realm of the sculptural. Whether it is made up of grains or pixels, in the world of three-dimensional objects no photograph can be more than an image—a piece of coated paper with marks distributed across its surface, light, dark, black, gray, or colored. Yet throughout its history, photography has not simply recorded existing realities but has given rise to new ones.[3] Equally, it has not merely documented sculpture but has in many ways given sculpture shape.

In the phrase "Photography of Sculpture," then, "photography" may be read as a kind of genitive of its subject. Photography does more than just *depict* sculpture; ever since its invention, it has influenced the practice of sculpture. Indeed the last century or so has seen the emergence of new formal experiments, new ways of expressing genuinely and originally sculptural intentions, that would never have existed without photography. Sculpture now can do more than carve, model, and cast; it can photograph.

In examining the overlap of the sculptural and photographic sensibilities over the last hundred years, we will often find it hard to isolate two separate entities ("sculpture" and "photography") developing in parallel. There is no *paragone* here; the reality is something more complex than two monads related to and fixed on one another, and acting in competition or in partnership. Unlike the far more direct dispute between photography and painting, the debate between photography and sculpture involves no real rivalry—indeed there is a rich repertory of hybrid forms. At the same time, there is relatively little direct dialogue, for the debate almost always advances in a roundabout way, through triangular or polygonal constellations involving a wide range of other agents (language, painting, film, video, performance, architecture, electronic media). Photography only becomes sculptural indirectly. Because it has extended the history of art to encompass the history of media, limiting our gaze to its bipolar interactions with sculpture will give us only a cropped, underexposed image of the phenomena involved.

Photography has modified and expanded the realm of the sculptural in essentially three ways. The first, of course, is depiction: *taking pictures of it*. Ever since William Henry Fox Talbot's *Bust of Patroclus* (plate 2), made before February 1846, photographers have documented sculpture, interpreted its history, and commented on the sculpture of their own time.

A more important phenomenon for art history, however, is to go beyond merely depicting sculpture *to expand its scope and concept by photographic means*. Long before the invention of photography, Romanticism had fostered a sensitivity to sculpturelike natural phenomena outside and beyond art. Behind that sensitivity lay a long Platonic and Christian tradition asserting the existence of a *vis plastica* in nature,[4] and metaphorically comparing God to the sculptor "wishing to make from his block of marble only the best and that which he considers good."[5] Using the language of German Idealism, Friedrich Wilhelm Joseph Schelling phrased the idea thus: "All art is a direct reproduction of absolute production or absolute self-affirmation."[6] In this tradition, art is no less

than an imitation of the "*ars absoluta*" of the "*artifex divinus*," the "absolute art" of the "divine maker," making art a manifestation of the divine.[7]

Since the Middle Ages, this topos had suggested that all natural creation be interpreted as the result of a striving for sculptural form. And photography proved a magic wand for this capacity to "see sculpture"—to reveal natural forms and objects as quasi-sculptural, or as equivalent to sculpture. Through its ability to control our perception of time and space, whether through the snapshot process, the fragmentation of the visible into details, or the distortion of scale and perspective by telephoto or wide-angle lenses, photography has captured an entire cosmos of sculptural objets trouvés.

From here, to move to *creating sculpture* through photographic techniques is but a small step. From dust specks on the studio table to monumental earthworks, the production of sculptural motifs for and only for the camera gave the twentieth century more than just a wealth of new means of sculptural expression: it enabled and still sustains far-reaching redefinitions of what sculpture is.

How Should We Photograph Sculpture?

The countless photographs of sculpture have much to tell us about how this art form has been received and indeed perceived over the years, and for some sculptors they have been an aid in studio practice, a form of self-promotion, or both (think Constantin Brancusi). Now as then, however, most sculptures are created independently of photographic concerns and considerations. A photograph of a sculpture may be a conventionally produced document aiming at exact depiction, or may be informed by some kind of striving for photographic quality or style, but in either case, it takes its style from the history of photography.[8] Sculpture may be a privileged photographic motif, but it is nevertheless just that, a motif. It does not determine the aesthetic principles involved in its photographic capture and production.

Yet as early as the late nineteenth century, photography's reflection of sculpture began to influence the work of some sculptors in their studios. "Photographisms"[9]—aesthetic perceptions generated by the photographic world view—began to appear in the sculpture of the time, manifesting in reflections on the relationship between the sculptural and the pictorial, experiments with details and fragments, a preoccupation with the snapshot, an enhanced realism, a flowering of the tableau vivant, and experiments with repetitions and seriality—developments that would offer ample material for a study of their own.[10] Surely not by coincidence, it was also in the 1890s that art theory first began to explore the relationship between photography and sculpture. The only earlier literature on the topic consisted of technical instructions, but in 1896, frustrated by the photographs of classical and Renaissance sculpture available to him for research and teaching, Heinrich Wölfflin set out to address the issue of "how one should photograph sculptures," publishing a short text on the fundamental theoretical problems of transferring three-dimensional sculpture to light-sensitized paper.[11]

What is astonishing about Wölfflin's essay is that, to justify a normative position on how classical—by which he means pre-Baroque—sculpture must be photographed, he advocates a monofocal conception of sculpture.[12] (As an aside, one may note that the German word he uses in his essay's title—*aufnehmen*—includes both the concept of taking photographs and, more generally, receiving, absorbing, or taking in.) What does this mean? Acting as an advocate of the "good tradition" and the "educated eye," Wölfflin contends that a classical sculpture is to be viewed from one and only one main angle, "which corresponds to the conception of the artist." He accordingly argues against attempts by "artisan photography" to place its "machine" at some original, deliberately chosen, "painterly" angle to the work. In modern times, Wölfflin recognizes, the eye "wanders around in an undisciplined fashion" when looking at sculpture, becoming engaged in an endless polyfocal quest—but for this he blames sculpture itself: the sculptural sense has "lost its way in our contemporary era," having abandoned the classical path with Michelangelo in an attempt to achieve a "multisided painterly composition."[13] Wölfflin opposes the view, dominant in the art practice and theory of his time, that sculpture can only be made accessible through a polyfocal sequence of perspectives.

For Baudelaire, this inability of sculpture to present a single valid face was precisely the source of its basic inferiority to painting. A form of art in which a chance illumination, or a randomly chosen view, could open up a more interesting perspective than the one intended by the artist—this Baudelaire saw as a degradation of the artistic ideal. "All the sculptor's efforts to set up a single viewpoint are in vain; as the observer moves around the figure, he may choose a hundred different viewpoints, none of them the right one; and, humiliatingly for the artist, it often happens that an accident of light, the effect of a lamp, may uncover a different beauty from the one he was imagining."[14] In this description of the distortion and arbitrariness implicit in the perception of sculpture, Baudelaire may well have been thinking about interpretative photography of classical sculpture. Wölfflin, however, drew a different conclusion: for him, polyfocal polysemy was not a basic quality of the sculptural but a failing on the part of the viewer, the result of an uneducated, ahistorical, anachronistic way of seeing. Wölfflin's ideal classical sculpture, by contrast, can be resolved into line, surface, and contour—in other words, into two-dimensionality. "The great artistic work," he writes, "consisted precisely in arraying the entire sculptural content *on a single plane*, collecting and presenting what in nature must be grasped through successive individual perceptions in a way that can be perceived simply and easily in one go" (my italics).[15] Turned around, this interpretation opens the door for two-dimensional photography to enter the realm of the three-dimensional.

Finding Sculpture Photographically, Creating Sculpture Photographically

Fledgling though it was, the photographic tradition of, in Wölfflin's view, overinterpreting or misinterpreting sculpture through angle of view, focal length, distortion of scale, or fragmentation into details was something he was unable to kill off. Indeed, throughout the twentieth century and right up to the present day, it has remained obvious and unproblematic in photography's engagement with sculpture, whether the intention is the most factual, sober documentation possible or the freest poetic interpretation. Here, photography and sculpture invariably find themselves in conflict, with one perspective swallowing up the other: the photographer's view versus Wölfflin's "artist's conception." Yet the issue of monofocality versus polyfocality is not limited to the premodern understanding of sculpture; the debate flared up again significantly in the mid-1960s, when Minimal art established a conception of sculpture that located its fundamental operations not merely in three-dimensionality but also in its placement in space.[16] The

configuration of the space between the observer and the sculpture became crucial, with the result that artists often chose to authorize only the specific photographs of their work that they thought would best convey the intended configuration of sculpture and space. In this way the monofocal, normative view regained the validity that Wölfflin had ascribed to it for the classical sculpture of antiquity and the Renaissance. If we continue to

fig. 1. Lee Friedlander. *Los Angeles, California*. 1965. Gelatin silver print, 6 ⅜ x 9 ⅝" (16.2 x 24.5 cm). The Museum of Modern Art, New York. Purchase

insist that sculpture is essentially polyfocal, the relationship between sculpture as photographed and sculpture as viewed will inevitably be ruled by a more or less productive arbitrariness. A congruence between these ways of seeing can only be achieved in ironic terms—for example, when the sculpture photographed is itself a photographic, two-dimensional, monofocal object (fig. 1).

In this context, what is remarkable about Wölfflin's thesis is its inversion: it allows us to conceive of creating a piece of sculpture using the technical means of photography. In that ideal situation in which a sculpture may be viewed from a single perspective, and in which only silhouettes, lines, surfaces, and contours are essential—in other words, if we accept Wölfflin's belief in the possibility of "arraying the entire sculptural content on a single plane"—it ultimately becomes conceivable to view, even to create sculptural content using the two-dimensional means of line and surface. In his apparently rigid limitation of the relationships possible between photography and sculpture, Wölfflin actually opened up the theoretical field in which they would develop in the twentieth century.

If we turn Wölfflin's argument around, we see why photography's contribution to the history of sculpture lies only to a minor

extent in the depiction or recording of existing artworks. By determining its own composition, by isolating and fragmenting space and time, by removing or hiding natural relationships of size (especially by monumentalization), the photograph creates a new cosmos of the sculptural—despite sculpture's polyfocality. It can as it were *take* a sculpture rather than *make* a sculpture, representing objects that are not in fact sculptures as if they were the result of a sculptural intention, a striving for sculptural form. In 1969, speaking of the attempt to make objects, Richard Artschwager remarked that it was pointless to compete with God, or with NASA: "The only alternative is to be quietly standing in a corner and to point with your finger."[17]

There are, then, two kinds of photographic sculpture. The camera can *identify* the sculptural quality of configurations in the world, and can display them as such;[18] and it can *create* structures that express their formal sculptural value and content in the photograph and in the photograph only. What the two approaches have in common is the absence of any "work" existing before and outside the photographic—the absence of anything with the status of sculpture beyond its existence in and as a photograph. And here we have defined the two key areas of avant-garde interest in the sculptural potential of photography in the twentieth century. Historically, we can identify two periods of particularly intense activity: the interwar period, when artists elaborated a repertory of options for asserting the autonomy of photography; and the 1960s and '70s, when that repertory emerged in radicalized form, enabling the integration of the potential offered by new photo-plastic procedures into the artistic mainstream.

The Triumph of the Object

The *Film und Foto* (*FiFo*) exhibition, held in Stuttgart in the summer of 1929, was an epochal, multifaceted, international array of modern photography. Almost every practitioner of the new trends in addressing sculptural problems through photographs was represented here, including individuals and groups from a range of artistic backgrounds—from painters and sculptors who no longer wanted to occupy those roles, and had been turning to photography since the 1910s, to professional photographers seeking to overcome the pictorialist reliance on the painterly tradition and to produce instead an aesthetic autonomous to the medium, one that, incidentally, was increasingly open to the realm of the sculptural. The artists reflected the influence of Dada, Surrealism, Constructivism, and the Bauhaus; the photographers ran from American exponents of "straight photography" such as Paul Strand, Imogen Cunningham, Paul Outerbridge, Charles Sheeler, and Edward Weston to German *Neue Sachlichkeit*

(New Objectivity) figures such as Karl Blossfeldt and Albert Renger-Patzsch, all bringing with them their own specific formal and programmatic interests.

The photographic approaches of identifying sculptural formations in the world of objects, whether organic or mineral, and of creating objects from scratch specifically in order to translate them into photographs emerged most powerfully in Surrealism. One might even say, in fact, that Surrealism's best sculptures are photographs. The principle of the explanatory picture governs Surrealist sculpture to the point where for Meret Oppenheim to take a photograph of a fur-covered cup would have been enough. Monofocality here involves no loss, since the formal issues of sculpture—its occupation of the third dimension—were of little interest to the Surrealists. Given their Freudian/Marxist emphasis on content, their formal concern was limited to achieving the highest level of representational clarity that photography could offer. This verism was intended to balance the strangeness of the pictures' contents—to support the plausibility of the absurd.

Erotic and irrational, the Surrealist aesthetic brought found, manipulated, and staged objects together in "hallucinatory arrangements"[19] typified by Man Ray's *Enigme d'Isidore Ducasse* (The enigma of Isidore Ducasse, 1920; plate 177), or Brassaï's *Sculptures involontaires* (Involuntary sculptures, c. 1932; plates 174, 175), inspired by Salvador Dalí. Such classic examples show that for the conquest of "*surréalité*,"[20] the rendering of the world as alien and enigmatic, the photograph could match or even outdo the production of an actual object. In the Surrealist objet trouvé, the goal of achieving the victory of the surreal through photography met the legacy of Dada, which saw in photography (perceived as cold, mechanical, and impersonal) a powerful weapon for its iconoclastic attacks on painting, its "antiart" negation of concepts of artistic originality, individuality, and genius. The founding spirit here was Marcel Duchamp, and his supposition, postulated in the *Bicycle Wheel* of 1913, that in the production of sculpture, random, anonymous selection could replace intentional manufacture controlled by an individual author. The Surrealist object trivialized and psychologized that principle. Duchamp's concept of the readymade might itself have arisen out of a speculation as to how photography could open up the world, for it translates into the third dimension a principle that photographers had long used to challenge painting: selection rather than creation.

A further Surrealist strategy that would prove of enduring importance was the use of found images. Here, for the first time in the avant-garde context, photography was *not* used as an experimental practice for the purpose of pursuing a new style in art. Especially in their journals, the Surrealists used images strategically, exploring the metaphotographic processes of appropriation and *détournement*—processes that would return to artists' focus in the late twentieth century. Surrealism's contribution to sculptural photography, however, always involved methods used in similar ways in poetry and painting: metamorphosis, assembly and juxtaposition, fragmentation and alienation. In realizing Surrealist phantasms and visions, photography had the advantage that, through collage and montage, it could integrate disparate found objects and artifacts (including images), performances and tableaux vivants, into a single layer of reality in a way that was as plausible in terms of form as it was absurd in content.

In addition to Surrealist photography, which was centered in Paris, the interwar period also saw intense experimentation with forms of photographic plasticism in Germany, and especially at the Bauhaus. Combined under the title "*Neues Sehen*" (New Vision), these attempts to transform photography from a reproductive medium into a productive one drew on the Russian Constructivism of Aleksandr Rodchenko and were most notably pursued by László Moholy-Nagy, who disseminated them with much pedagogical zeal. The contribution of the *Neues Sehen* to rendering photography sculptural traces back to the movement's optimistic, socially utopian modernist program. Here, photography was embraced as a modern technology, and as the kind of unsentimental art form appropriate to a modern, rational, technological civilization—an art governed not by the hand, amorphous pigment, or bourgeois navel-gazing but by a machine, the camera, floating freely in space. The dream was of a world of light, electric current, and gleaming steel. Attempts therefore emerged to use dramatic, even startling points of view and perspectives to present the new steel-and-glass architecture of the time as megasculptures—spatial configurations whose functional purposes were subordinated to their role as embodiments of the optimism of a modern world.

It was Moholy-Nagy who coined the word "*Photoplastik*" (photosculpture), but his architectural photographs and photograms enriched the sculptural sensibility of photography more than the collages of graphics, photography, and typography (for that is what they are) to which he applied that term. The resolution of volume into light was a program far more in tune with the essence of photography. Herbert Bayer, appointed to lead the Bauhaus printing and advertising workshop in 1925, pursued Moholy-Nagy's approach vigorously, and his first photographic works, dating from around 1928, use an entirely conventional technique: direct use of the camera. The influence of Moholy-Nagy on these pictures seems clear, though Bayer was initially interested in graphic, two-dimensional networks, patterns, and grids rather than in the kind of capture of three-dimensional space that ensued from Russian Constructivism. In the early 1930s, however, Bayer began to work more to integrate photography into sculptural, painterly, and graphic design. This was when he began to cut out, recombine, and often retouch elements of individual photographs (some found, some he had taken himself) and then shoot the result as a finished montage. In the ensuing, purely photographic spaces, real, abstract, and fantastic sculptural elements, idealized geometric forms, and amorphous natural objects coexist in a formal unity. Moving beyond the sort

of presentation of the plastic values of isolated objects that was common in the Bauhaus, Bayer evoked narrative image worlds that ultimately brought him close to Surrealism.

Alongside the hallucinatory bodies of Surrealist photography and the abrupt perspectives of the *Neues Sehen*, a new type of photograph of objects also appeared in the 1920s, emerging not from artists' studios but from the darkrooms of professional photographers. A key photographic tendency of the time made a fundamental contribution to the medium's sculptural sensorium: in Germany it manifested under the name *Neue Sachlichkeit*, a term borrowed from painting; in the United States, it was called "straight photography." Both approaches involved a rejection of pseudo-painterly, blurry pictorialism in favor of a pure, cool, objective style that its practitioners considered more appropriate to the medium. A taste for formalistic views of isolated industrial products, natural organisms, and pieces of technical apparatus—this Renger-Patzsch, Blossfeldt, Strand, Weston, Outerbridge, and others all share.

fig. 2. Edward Weston. *Tina Modotti Reciting Poetry.* 1924. Platinum print, 9 x 7" (22.9 x 17.8 cm). George Eastman House, International Museum of Photography and Film, Rochester, N.Y.

Renger-Patzsch saw his approach as an explicit antidote to Surrealism. "The absurd, shocking, and contradictory," he argued, should not be made the foundation of a world view; rather, photography should try to describe the factual with sober, mechanical precision.[21] Yet today, despite their differing methodologies and intentions, many "straight" and *Neue Sachlichkeit* photographers no longer seem so far from the Surrealist vision: in their work as in Surrealism, the shapes of things—isolated and illuminated by photography—seem suddenly to find a voice. The sculptural values of objects reveal unexpected meanings, and the observer is often driven toward symbolic readings quite divorced from the photographs' supposedly objective reporting. More technically accomplished and less formally extravagant than Bauhaus photography, avoiding the purely geometrical and semiabstract in favor of tactile illusion and sensual presence, the "straight" photography of Outerbridge and, later, Horst P. Horst (plate 201) explores a fetishization of objects that recalls Surrealism but appears elsewhere, namely in advertising and fashion photography. One curiosity in Weston's work exemplifies both the subliminal striving toward the sculptural and the surrealizing tendencies that lie behind the documentary pathos of straight photography: *Tina Modotti Reciting Poetry* (1924; fig. 2) plays with shadows and contours in such a way that the portrait

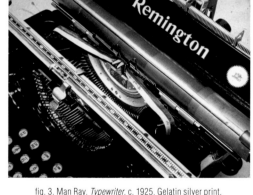

fig. 3. Man Ray. *Typewriter.* c. 1925. Gelatin silver print, 9 15/16 x 11 7/8" (25.2 x 30.2 cm). George Eastman House, International Museum of Photography and Film, Rochester, N.Y.

comes to resemble a montage, transforming a living woman into a bust. Conversely, Man Ray's *Typewriter* (c. 1925; fig. 3) has an objective, laconic coolness—Surrealist "straight photography."

All Is Sculpture

For all the differences in their origins, intentions, and methods, the various schools of photography in the interwar period share an achievement: they made the everyday thing an object of interest, and gave the object of interest the status of sculpture. The triumph of photography in sculpture is the triumph of the object. In Surrealism, *Neue Sachlichkeit*, *Neues Sehen*, and straight photography, the object becomes an autonomous bearer of content. Whether intact or fragmented, when seen through the camera lens it gains a voice, sends a signal, returns the viewer's gaze. Through it, photographers find a way to appeal directly to the viewer, either by plucking from the world something never previously considered worthy of attention or by abandoning familiar perspectives for details or fragments. All of these photographs are based on the same premise: the object has an authority in its own right; it has something to reveal to the trained or attentive eye; beyond its practical, everyday function, it has an aesthetic autonomy—something to say to us.

This discovery was photography's decisive contribution to the concept and development of sculpture before World War II. Its impact is clear in the art of the postwar period, especially beginning around 1957, with the emergence of Neo-Dada, *Nouveau Réalisme*, Pop art, and Fluxus—movements that have in common the prominence of the object. At this point painting could no longer claim to be the avant-garde's defining medium. Since the iconoclastic struggles against the heroic stature of the retinal that Duchamp and Francis Picabia had fought earlier in the century, emotive seeing had lost its power to inspire. In moving into the future, art would no longer be guided by painting, and painting would no longer supply its frame of reference. Classic modernist sculpture had faithfully imitated painting, becoming by turns impressionistic, expressionistic, cubist, futurist, and so on—but now the object triumphed, no longer requiring the spotlight focused on it by a painter's intensified vision and presentation. In Neo-Dada, Pop art, *Nouveau Réalisme*, and Fluxus, the object acquired a privileged status. It had achieved semantic autonomy.

The hegemony of the statuary tradition in the Western

conception of sculpture, however, was not yet broken. The crucial issues turned out not to revolve around the alternatives of figuration and abstraction; both modes continued to supply "statues" in the conventional sense. Indeed, even the object generally remained a figure set on a pedestal in space, or hung on the wall as a relief. The break with retinal modernity did not become further radicalized until the late 1960s, when the sculptural role of the object itself was questioned and the idea of the dematerialization of sculpture began to emerge. In the years around 1968, "processes," "gestures," "attitudes," "situations," and "concepts" become dominant concepts, in what amounted to a redefinition of art. For the young artists of the time, communicating an idea or a thought was more important than creating a work that would last. Just as, earlier in the century, production had been superseded by selection as the creative act of artmaking, now that act was reduced to a mere (often photographic) hint.

An entirely rethought integration of photography into sculptural practice now took place along the faultlines established by this shift. Works of sculpture came into being that owed their permanent existence primarily or indeed solely to the photograph. As early as 1918, Duchamp's *Sculpture de voyage* (Sculpture for traveling; plate 106) had hinted at the idea of a sculpture that, outside the artist's studio, would exist only as its own photographic representation;[22] throughout the 1960s, this incidental suggestion of Duchamp's became an important focus of interest. Moving in an infinite or at least multimedia field, a crowd of new groupings and schools (earthworks, Happenings, performance and body art, Conceptual art, *arte povera*) returned sculpture to the center of artistic attention, for the first time in centuries. And to expand its scope in this way, all of them depended on photography. The new concepts of the sculptural as ephemeral, performative, and conceptual—in fact as "postsculptural"—and the artistic practices that went with them implied a revolutionary enhancement of photography's role, one that, by making the object autonomous, gave it still more prominence than it had achieved before the war.

Paradoxically, photography, the visual medium par excellence, attained this status by abandoning the idea of privileged vision and the "good picture." The advent of Conceptual art, and with it the devisualization even of photography, marked the end

fig. 4. Ute Klophaus. Joseph Beuys in *und in uns . . . unter uns . . . landunter* (and in us . . . beneath us . . . land under), part of the happening *24-Stunden* (24 hours), Galerie Parnass, Wuppertal, 1965

fig. 5. Sigmar Polke. *Bamboostange liebt Zollstockstern* (Bamboo pole loves folding ruler star). 1968–69. Fifteen gelatin silver prints, each: 23 ⅞ x 19 ¹³⁄₁₆" (60.6 x 50.3 cm). Walker Art Center, Minneapolis. T. B. Walker Acquisition Fund

of the road for a methodology implied or developed by Cézanne, or at least distilled from his statements—a methodology that had guided modern art into the sixth decade of the twentieth century. Very generally, three conditions determined the modernist ideology of seeing. First, it was reflexive, observing itself at work, as it were. Second, in so doing it liberated itself from modes of representation that were less seen than simply known, being calculated or handed down by tradition and convention. Third, the results thus achieved fed back into the theory: reinvigorated as a reflection on seeing, form understood itself, and declared itself, as a new conception, a complex of meaning that had a reasoning behind it and was not merely idiosyncratic. Except in Dada and Surrealism, this "heroism of vision" had also set the direction for artistically ambitious photography between the wars.[23] The recognition that objects can speak held within it, transformed, a hangover from the cult of the retinal. Photographers, like painters, defined themselves as having a privileged view.

The waning of this idea, which had dominated classic modernism, made room for the new eminence of photography in the art of the 1970s and for the articulation of postmaterial, postvisual concepts of sculpture. Perhaps the most sophisticated expression of this development is to be found in the work of Joseph Beuys, who famously believed that "everything is sculpture," even language and thought (fig. 4, plate 237). Not just to be communicated to their audience but actually to be implemented, the new art forms of the late 1960s, and especially the new forms of sculpture, depended more than ever on photography (and the still new technology of video). In parallel there began a process of the amateurization, the "deskilling," of photography, a further indication of the devaluation of trained and learned vision.[24] It became possible to entrust the communication of artistic content to images that did not offer the privileged view of an expert.

The individual picture became subordinate to the series; the document, the information, and the concept came to rule. Artistic projects were now often supported by a range of scholarly sciences, as artists, in their own ways and by their own means, addressed questions of economics, ethnology, psychology, linguistic philosophy, sociology, and more. The methods of art entirely opened up. The liberation

from traditional techniques, with their dependence on materials and objects, seemed total—and ultimately extended to liberation from the image. Whether artists were inviting museum visitors to fill out questionnaires, going for lonely walks to arrange stones in remote valleys, dismantling buildings awaiting demolition, spreading out sticks in meadows, injuring themselves, researching their own childhoods, or cutting up the landscape with a bulldozer or wrapping it in cloth, they invariably wanted to record what they had done—and photography was a fine way to do that. (Also, for despite the widespread opposition to the market among artists at the time, they had to live, and photographs could be exhibited and, ultimately, exchanged.) Paradoxically, then, photography recommended itself as art precisely through its ability to deliver "unartistic" images. Art's farmyard duckling could prove a swan. Photographs of Conceptual art did not need to be new, beautiful, unfamiliar, or skillfully shot and printed; they were there as witnesses, fragments of a context, relics, traces, references, confirmations, indexes. Often they looked like the work of amateur photographers, but this didn't matter, for it was precisely the absence of a sophisticated visual aesthetic that made photography a ground for the creation and communication of plastic art. The Conceptual "*fotografia povera*"—like its equivalents in pictures made every day for scientific, industrial, or forensic purposes—made no attempt at stylistic quality. This renunciation of visual pretension was differently reiterated by Bruce Nauman, who, half-ironically, had studies of his own body professionally shot in the anonymous, everyday style of run-of-the-mill commercial photography (plates 250–53).

The realization that photographs could be seen as sculpture, to the same degree that material objects could, unleashed waves of creativity, contributing within just a few years to an enormous enlargement of the vocabulary of plastic art in western Europe and the United States—in Italy with *arte povera*, and the work of such artists as Giuseppe Penone and Giovanni Anselmo; in Vienna, with Rudolf Schwarzkogler and VALIE EXPORT (plate 256); in Britain, with the Land art of Richard Long (plate 160) and Hamish Fulton; in the Netherlands, with the Conceptualism of Bas Jan Ader (plate 261) and Ger van Elk. In France, Christian Boltanski began to integrate photographic remnants into sculptural installations, while in Germany the ever-wayward Sigmar Polke photographed ironic narrative arrangements of the most banal everyday objects (fig. 5), opening up new avenues for a younger generation that would include the Swiss team of Fischli/Weiss (plates 184–88). In the United States, Nauman and Charles Ray (plate 254) used photographs to transform their own bodies into sculpture, Gordon Matta-Clark (plate 163) created deconstructive photographic meta-architectures, and Robert Smithson (plate 158) and Michael Heizer (plate 161) dug earthworks in remote deserts that almost no one physically sees but that have traveled photographically around the world.

As we have seen, the pictures of these "anti-photographers" are often almost parodic in relation to the proud tradition of stylistically aware art photography.[25] Yet Bernd and Hilla Becher's book *Anonyme Skulpturen* (Anonymous sculptures, 1970), which transforms utilitarian industrial architecture into sculptural readymades, makes clear that a conceptual base and pictorial quality need not be mutually exclusive.[26] In the 1990s, a repictorialization of conceptual photography (crucially driven by Bernd Becher's students) in the form of large-format color prints gained a leading voice in the international concert of contemporary art.[27]

The situation today is opaque. The paths opened up in the 1960s and '70s are routinely traveled. Every now and then, someone discovers a different route, but in terms of principles and concepts there have been no large additions in the last thirty years. It is now harder than ever to isolate photography and sculpture as discrete entities and observe their interactions. Contemporary three-dimensional art has come to be typified by a hybrid form: the spatial installation, which over the last fifteen years has presented itself as the artistic discipline of choice. Drawing on the relatively homogeneous "environments" of the 1960s, the installation takes possession of space through every conceivable material means: sculpture, painting, photography, film, sound, text, light, and movement all become means to the end of an all-encompassing, polyfocal, polycontextual, and polysemantic mastery of space, in an insouciant combination of advanced and obsolete techniques. At this point in its long shared history with sculpture, photography reveals itself as a mixed medium, embedded in an ensemble of information media of diverse and heterogeneous origin. As for sculpture, the beautiful Galatea has transformed herself from a statue into a nymph. Photography has tempted her down from her pedestal, allowing her to engage in startling liaisons and a still unbroken, productive promiscuity.

Notes

1. Jacob Burckhardt, *Ästhetik der bildenden Kunst. Der Text der Vorlesung "Zur Einleitung in die Ästhetik der bildenden Kunst"*, ed. Irmgard Siebert (Darmstadt: Wissenschaftliche Buchgesellschaft, 1992), p. 100.

2. See Georg Wilhelm Friedrich Hegel, *Werke in zwanzig Bänden*, vol. 14, *Vorlesungen über die Ästhetik II* (Frankfurt am Main: Suhrkamp, 1970), p. 352 ff.

3. See Bernd Busch, *Belichtete Welt. Eine Wahrnehmungsgeschichte der Fotografie* (Frankfurt am Main: Fischer, 1995).

4. See William B. Hunter, "The Seventeenth-Century Doctrine of Plastic Nature," *The Harvard Theological Review* 43 (1950):197–213.

5. Gottfried Wilhelm von Leibniz, *Theodicee*, based on Johann Christoph Gottsched's translation into German of 1744, ed. and annotated Hubert Horstmann (Berlin: Akademie Verlag, 1996), Part 2, §130, XV.

6. Friedrich Wilhelm Joseph Schelling, *Philosophie der Kunst*, in *Sämtliche Werke*, ed. F. K. A. Schelling (Stuttgart/Augsburg: Cotta, 1856–1861), 5:631.

7. See Werner Beierwaltes, *Negati affirmatio: Welt als Metapher, Zur Grundlegung einer mittelalterlichen Ästhetik durch Johannes Scotus Eriugena*, in *Philosophisches Jahrbuch* 83 (1976):237–65, and Jochen Sander, *Gott als Künstler, der Künstler als Heiliger Lukas, Künstlerische Selbstreflexion und Künstlerselbstbildnis im Kontext christlicher Ikonographie*, in *Wettstreit der Künste, Malerei und Skulptur von Dürer bis Daumier* (Munich: Edition Minerva, 2002), pp. 70–81.

8. See Erika Billeter, ed., *Skulptur im Licht der Fotografie. Von Bayard bis Mapplethorpe* (Bern: Benteli, 1997).

9. See J. A. Schmoll gen. Eisenwerth, "Photographismen in der Kunst des 20. Jahrhunderts," in Billeter, ed., *Malerei und Photographie im Dialog* (Zurich: Kunsthaus Zurich, and Bern: Benteli, 1977), pp. 321–28.

10. For "snapshots," think, for example, of Edgar Degas; for fragments, of Auguste Rodin; for monofocality, of Medardo Rosso; and for photorealism and the tableau vivant, of Jules Dalou, Constantin Meunier, and Vincenzo Vela.

11. Heinrich Wölfflin, "Wie man Skulpturen aufnehmen soll," in *Zeitschrift für bildende Kunst*, Neue Folge 7 (1896):224–28, Neue Folge 8 (1897):294–97, and Neue Folge 26 (1914):237–44.

12. For a comprehensive account of monofocality and polyfocality in Western art history see Werner Hofmann, *Die Moderne im Rückspiegel. Hauptwege der Kunstgeschichte* (Munich: C. H. Beck, 1998).

13. All quotations from Wölfflin, "Wie man Skulpturen aufnehmen soll," passim.

14. Charles Baudelaire, "Pourquoi la sculpture est ennuyeuse (Salon de 1846)," *Oeuvres complètes* (Paris: Pléiade, 1976), 2:487–89.

15. Wölfflin, "Wie man Skulpturen aufnehmen soll," *Zeitschrift für bildende Kunst*, Neue Folge 8, p. 294.

16. See Alex Potts, "The Minimalist Object and the Photographic Image," in Geraldine A. Johnson, ed., *Sculpture and Photography: Envisioning the Third Dimension* (Cambridge: at the University Press, 1998), p. 181 ff.

17. Richard Artschwager, in a video interview with Marlène Belilos during the installation of Harald Szeemann's exhibition *When Attitudes Become Form*, Kunsthalle Bern, 1969. Available online at http://archives.tsr.ch/player/art-attitudeforme.

18. See Michel Frizot, "Le Monument au sculpteur anonyme," in *Sculpter-Photographier, Photographie-Sculpture. Actes du Colloque organisé au Louvre sous la direction de Michel Frizot et Dominique Païni* (Paris: Musée du Louvre, 1993), pp. 67–75.

19. André Breton, *Dictionnaire abrégé du surréalisme*, in Breton, *Oeuvres complètes* (Paris: Gallimard, 1992), 2:817.

20. Breton, *Manifeste du surréalisme*, in Breton, *Oeuvres complètes*, 1:319.

21. Albert Renger-Patzsch, "Ziele," in *Das deutsche Lichtbild. Jahresschau 1927* (Berlin, 1927), p. 18.

22. See T. J. Demos, *The Exiles of Marcel Duchamp* (Cambridge, Mass.: The MIT Press, 2007), pp. 68–126.

23. The phrase is the title of an essay by Susan Sontag, in *On Photography* (New York: Farrar, Straus and Giroux, 1977), p. 83.

24. See Jeff Wall, "'Marks of Indifference': Aspects of Photography in, or as, Conceptual Art," in Ann Goldstein and Anne Rorimer, eds., *Reconsidering the Object of Art: 1965–1975* (Los Angeles: Museum of Contemporary Art, 1995), pp. 247–67, and Hal Foster, Rosalind Krauss, Yve-Alain Bois, and Benjamin H. D. Buchloh, *Art since 1900* (London: Thames & Hudson, 2004), p. 531.

25. Nancy Foote, "The Anti-Photographers," *Artforum* 15, no. 1 (September 1976):46–54.

26. Bernhard and Hilla Becher, *Anonyme Skulpturen. Eine Typologie technischer Bauten* (Düsseldorf: Art-press Verlag, 1970).

27. See Jean-François Chevrier, "Das Abenteuer der Tableau-Form in der Geschichte der Fotografie," in *Photo-Kunst. Arbeiten aus 150 Jahren* (Stuttgart: Staatsgalerie, 1989), pp. 9–46.

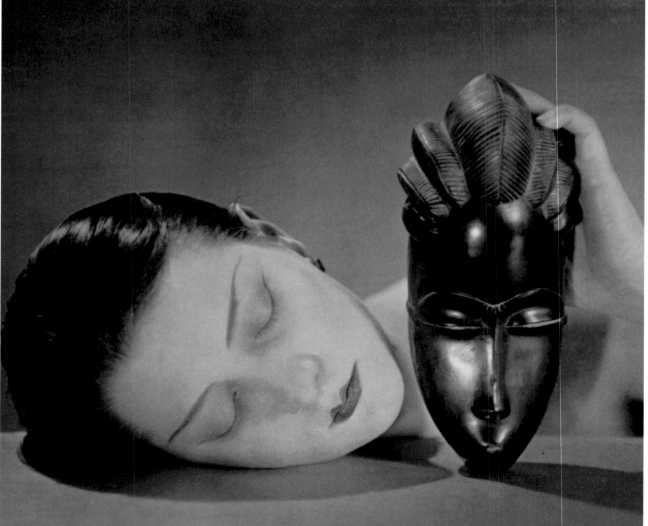

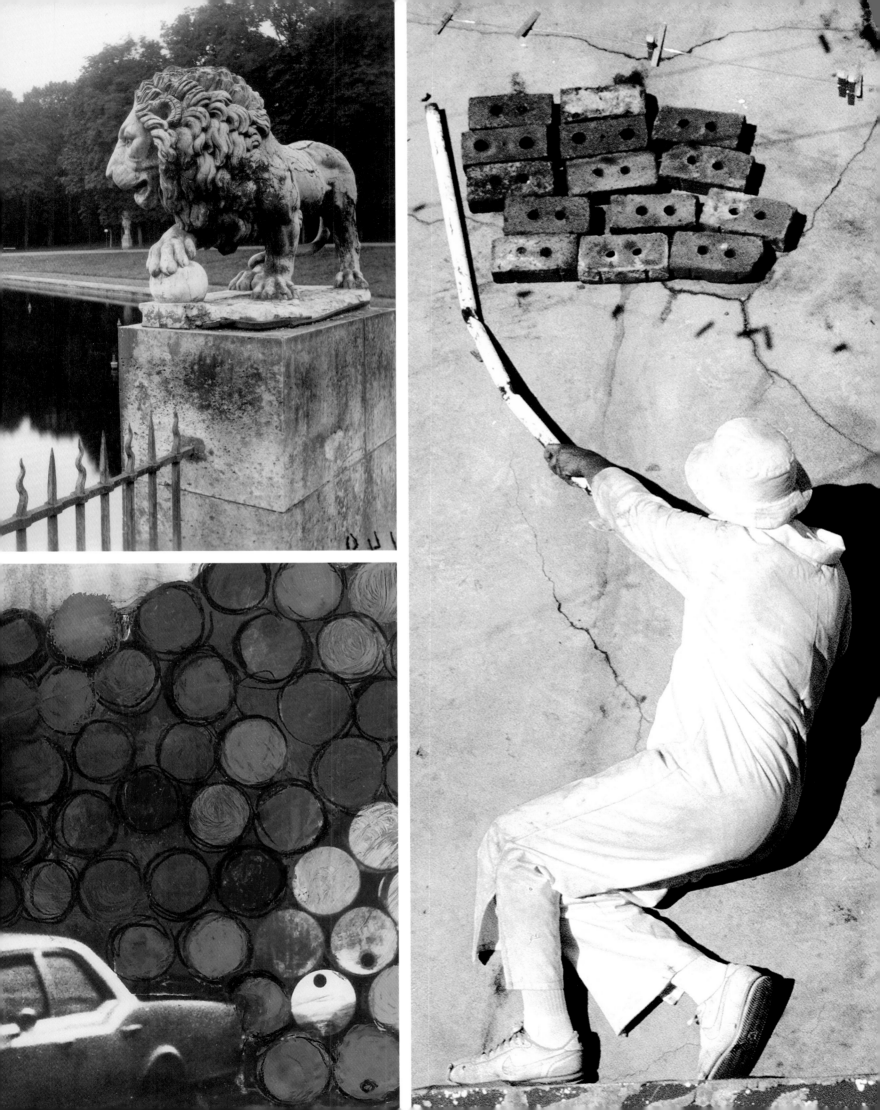

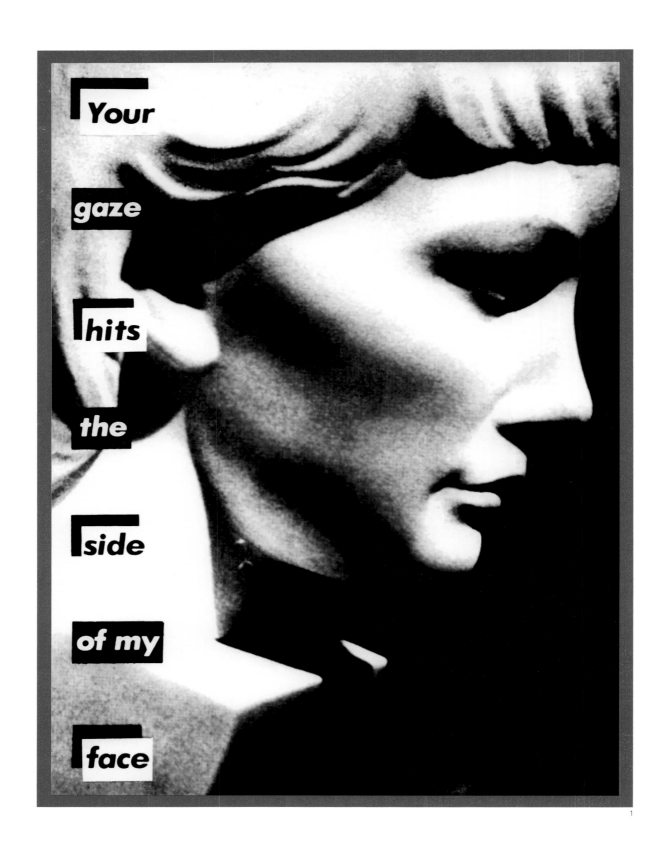

1

1. Barbara Kruger. American, born 1945
Untitled (Your Gaze Hits the Side of My Face). 1981
Gelatin silver print, 66 x 48" (167.6 x 121.9 cm)
The Steven and Alexandra Cohen Collection

I. SCULPTURE IN THE AGE OF PHOTOGRAPHY

In England in 1844, William Henry Fox Talbot began to publish *The Pencil of Nature*, one of the first printed books illustrated with photographs. Holding a total of twenty-four calotype plates, the publication appeared in six fascicles released between June 1844 and April 1846. Talbot carefully selected the plates to identify the new medium's variety of uses, gravitating toward architectural details and sculpture. One of his favorite subjects was a bust of Patroclus, a plaster cast of a Hellenistic marble sculpture excavated in 1769 at Hadrian's Villa, in Tivoli, Italy, that he kept at Lacock Abbey, his home in Wiltshire. Talbot included prints from two negatives taken from distinct angles in *The Pencil of Nature*.[1] In the first sentence of his commentary on the bust, he praised the relationship between photography and sculpture: "Statues, busts, and other specimens of sculpture, are generally well represented by the Photographic Art."[2]

Talbot produced the earliest dated negative of the bust of Patroclus in November 1839, the same year he publicly announced his invention of the photographic process. He would make some fifty more negatives of the bust in the years that followed (plate 2).[3] In all of these he posed the bust against a plain dark background, focusing on the sculpture rather than treating it as a decorative object in an interior. Implying that photography had replaced the time-consuming task of copying the three-dimensional world onto paper, Talbot dubbed the new medium "the royal road to drawing."[4] He used the camera as a sketching tool, photographing the bust at varying distances. He also experimented with light, moving the bust in relation to the sun or posing it in cloudy weather to avoid the sunshine's flattening effect. His exacting analysis of the motif shows that from the

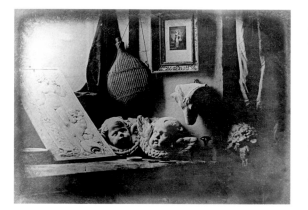

fig. 1. Louis-Jacques-Mandé Daguerre. *Nature morte (Intérieur d'un cabinet de curiosités)* (Still life [Interior of a cabinet of curiosities]). 1837. Daguerreotype, 6 5/16 x 8 1/4" (16 x 21 cm). Société française de photographie

earliest experiments in photography, the study of sculpture was inextricably linked to the medium's history.

Static, reflective, formally complex, and suitably artistic, sculpture was among the first subjects to be photographed. A few years before Talbot published *The Pencil of Nature*, Louis-Jacques-Mandé Daguerre, a painter and the director of a Parisian light theater, Diorama, used the daguerreotype process—which he too made public in 1839, at the Académie des Sciences in Paris—to represent small plaster reliefs and casts lying on the windowsill of his studio (fig. 1). Many of photography's earliest practitioners, including Daguerre's collaborator Alphonse Eugène Hubert (plate 9) as well as Hippolyte Bayard (p. 22, figs. 2, 3), François-Alphonse Fortier (plate 8), and Baron Armand Pierre Séguier (p. 21, fig. 1), assembled plaster casts and statuettes from different periods and schools into elaborate still-life motifs to be photographed. Coinciding with the arrival of the daguerreotype was a vogue for copies of sculpture, evincing the enthusiasm of a growing middle class to collect, own, and make copies of those copies. As such, photography made its impact during a heyday of bourgeois culture. In choosing replicas of sculptures for their still lifes, Geoffrey Batchen notes, photographers "actually hitched their wagon to what were perhaps the most radical by-products of an ongoing industrial, economic and political transformation of European culture, a transformation of which photography itself was a potent embodiment."[5]

The sculptural still life continued to preoccupy photographers well into the twentieth century. With the advent of the hand-held portable camera in the early 1920s, photographers had the flexibility to capture contingent arrangements taken from

elliptical viewpoints. André Kertész, for instance, recorded unexpected juxtapositions between art and common objects in the studios of his artist friends Fernand Léger and Ossip Zadkine (plate 37), among others. His ability to forge heterogeneous materials and objects into visual unity inspired the novelist Pierre Mac Orlan to confer on him the title of "photographer-poet," or alternatively "*révélateur*" (revealer).[6] Kertész encouraged the interplay of all sorts of plastic associations. In *Léger Studio* (1927; plate 36) he simply framed one of the artist's sculptures in a corner of the atelier, surrounded by common objects—a thermometer, a wine bottle, a child's toy, an ashtray, a shoe stretcher, an almanac. The combination proved that the camera could act as a tool of visual transformation.

The question of how photography can do more than merely document a sculptural assemblage continues to be of interest to contemporary artists. In the 1990s, with an eye tuned to small but revelatory details, An-My Lê took a series of pictures in workshops and foundries across Europe and the United States, establishing narratives among disparate objects despite their differences in status, materiality, or stage in the production process. In *Milani Workshop, Vicenza, Italy* (1991; plate 38), for example, she uses the medium to reflect on the nature of production: "Production itself," she says, "became my subject as I looked for telling moments among the various stages of an object's path toward completion. The materiality, craftsmanship, workspace and means of production of sculptural objects ranging from Rodin's *Gates of Hell* to anonymous decorative figures provided opportunities for reflections on photography's ability to activate forms of diverse origins and traditions into original narratives and compositions."[7]

fig. 2. Felice Beato. *Head Quarter House, 1st Division, Pehtang, China.* 1860. Albumen silver print, 9 x 11 ½" (23.4 x 29.3 cm). The Museum of Modern Art, New York. Acquired through the generosity of Shirley C. Burden and the Estate of Vera Louise Fraser

Jan De Cock also explores the ways in which sculpture and photography intersect, whether across historic, aesthetic, or practical lines. In his Studio Repromotion series (2009; plates 39, 40) he uses his studio to bring casts of classical sculptures, pictures of the interior of the George Eastman House photography museum in Rochester, New York, and his own abstract, modular sculptures into a new representational entity. Central to De Cock's project is the use of repetitive framing devices, fragmentation, and the exposure of the same sculptural motif from more than one perspective. With his freely associative approach to image-making he seems to ask, "What is the most important thing that remains: the images or a way of looking?"[8] Constituted as pictures within pictures, De Cock's photographs underscore the idea that there is no closure in interpreting the history of art.

If we consider photography a child of the industrial era—

a medium that came of age alongside the steam engine and the railroad—it is not surprising that one of its critical functions was to bring physically inaccessible worlds closer by means of reproduction. "As soon as photography was invented," Maria Morris Hambourg contends, "travelers equipped themselves with cameras to take on itineraries established by historical tradition and by the parameters of their country's influence."[9] The art critic John Ruskin, one of photography's earliest champions, saw in the new medium an aid to architectural study and a means to raise awareness of landmarks crumbling into ruins. After acquiring a few daguerreotypes in Venice in 1845, Ruskin bought his own camera, which he asked his valet and scribe, John Hobbs, to operate. In a letter to his father written from Venice on October 7, 1845, he described his discovery with excitement: "Daguerreotypes taken by this vivid sunlight are glorious things. It is very nearly the same thing as carrying off the palace itself: every chip of stone and stain is there, and of course there is no mistake about proportions. . . . It is a noble invention."[10]

In 1848, while working on his book *The Seven Lamps of Architecture*, Ruskin noticed that the original fabric of many medieval buildings was rapidly deteriorating or else being destroyed, in his view, through misguided restoration practices. In the preface to the book he directs the attention of photographers to architecture, urging them to document it carefully "not merely when it presents itself under picturesque general forms, but stone by stone, and sculpture by sculpture; seizing every opportunity afforded by scaffolding to approach it closely and putting the camera in any position that will command the sculpture wholly."[11] Ruskin's theories stood in opposition to those of his contemporary Eugène-Emmanuel Viollet-le-Duc, who advocated creative alterations to the original design of historic architecture in order "to reestablish it in a complete condition that may never have existed at any given moment."[12] Nevertheless, Ruskin's ideas found resonance in the photographic missions that took root in France two years later.

In 1851, the Commission des Monuments historiques (founded in 1837 to inventory the remains of medieval France) sent five photographers—Bayard, Edouard Baldus, Henri Le Secq, Gustave Le Gray, and Auguste Mestral—to take pictures of the architectural patrimony. These *missions héliographiques*, as they were called, produced a national photographic archive that fed the country's collective imagination. The taste and concern for the ruins of old France incited photographers to go "sculpture by sculpture," "stone by stone," as Ruskin had put it, divulging details of historic monuments throughout the country. Le Secq,

for instance—assigned to photograph Champagne, Alsace/Lorraine, and then Amiens and Chartres—made exquisite large-scale prints of the French cathedrals, circling them at different levels to capture perspectives of rarely seen details. Other photographers, notably Charles Nègre, who worked for a time with Le Secq, worked on his own, without the official imprimatur of the Commission. He made extensive studies in the Midi region but also took architectural photographs of the cathedrals of Paris and Chartres, including the jewellike *Angel of the Resurrection on the Roof of Notre Dame* (1853; plate 23) and the famous *Le Stryge* (The vampire, c. 1853; plate 119), taken on the north tower of Notre Dame and featuring one of the entirely new, Gothic-style gargoyles added to the building during Viollet-le-Duc's restoration. Following the *missions héliographiques*, many commissions continued to produce photographic albums of sculptures, now made increasingly far afield.

In the second half of the nineteenth century, the quest to document the world photographically intensified. Systematic journeys of photographic exploration reflected not just aesthetic and preservationist concerns but also political agendas; the "need to know," Françoise Heilbrun suggests, "was reinforced by the lure of the exotic, a prevailing taste for the picturesque, colonial expansion, and the growth of tourism."[13] Archaeologist photographers interested in advancing orientalist studies traveled widely: William James Stillman and August F. Oppenheim went to Greece; Théodule Devéria (plate 22), Maxime Du Camp (plate 20), Francis Frith, John Beasley Greene (plate 21), and Félix Teynard to Egypt; Louis De Clercq to Syria; August Salzmann to the Holy Land; Felice Beato (fig. 2) to India and China; and Linnaeus Tripe (plate 25) to India and Burma. The flowering of photographic surveys of architecture, historic sites, public sculpture, and ruins coincided with European dominion and Western imperialist exploits—the so-called *missions civilisatrices* (civilizing missions). Yet many photographers and writers saw these expeditions not so much as "civilizing" than as regenerative of their own ossified lifestyles.

When Du Camp, a journalist, and his friend the novelist Gustave Flaubert traveled up the Nile and to the Near East in 1849–51, the model that had captured the two men's imaginations was the Romantic cult of the East. In his memoirs, Du Camp mentions Victor Hugo's collection of poems *Les Orientales* (Eastern poems, 1829) as a literary stimulus. Upon his return to Paris, Du Camp brought back 216 wax-paper negatives, which he presented to the newly founded Société Héliographique, the world's first photographic society.[14] A year later, Louis-Désiré

fig. 3. Maxime Du Camp. *Temple of Wady Kardassy.* 1849–51. Plate from the album *Egypte, Nubie, Palestine et Syrie* (1852). Salted paper print from a paper negative, 6 ½ x 8 9/16" (16.5 x 21.8 cm). The Museum of Modern Art, New York. Gift of Warner Communications, Inc.

Blanquart-Evrard published 125 of these pictures under the title *Egypte, Nubie, Palestine et Syrie*, the first travel album to be completely illustrated with photographs of archeological monuments. Du Camp's book—like his expedition itself, which he undertook with the support of the Académie des Inscriptions et Belles Lettres—invites consideration of how photography was implicated in the colonial project. As Gregory Derek writes, Du Camp's trip resulted in "a photographic archive produced by and, in some substantial sense, *possessed* by the West," an archive that "surreptitiously and unconsciously [displaced] these ancient monuments from their physical sites in Egypt into 'sights' within a European imaginary."[15] Avoiding the cluttered villages that the fellahin of the countries he visited had built for themselves within or adjoining many of the ruins, Du Camp showed monuments and archaeological sites as uninhabited spaces, free for Europeans to claim. The only human figure to appear regularly in his pictures is that of Hadji-Ishmael (fig. 3), a Nubian sailor whose body he used to provide a sense of scale. Measuring, surveying, and photographing monuments were all colonialist activities used to illustrate the need for intervention on foreign land. Julia Ballerini notes that in Du Camp's pictures, Hadji-Ishmael's pose "is not the Westerner's pervasive bent knee, foot-atop-base-of-monument that accents hundreds of travel images, but a more static one."[16] In *Ibsamboul, colosse occidental du Spéos de Phrè* (Westernmost colossus of the temple of Re, Abu Simbel, 1850; plate 20), for example, the sixty-five-foot-high head of the pharaoh Ramesses II rises from the desert, a minuscule Hadji-Ishmael atop its headdress. In order for Du Camp to take the long exposure, Hadji-Ishmael had to keep immobile. "I told him," Du Camp recollected, "that the brass tube of the lens jutting from the camera was a cannon, that would vomit a hail of shot if he had the misfortune to move—a story that immobilized him completely."[17] Successful in his venture, Du Camp rendered site and figure with the authority of a conqueror.

Contesting the distorting lens and colonizing propensities of the early photographers, contemporary artists seek new ways to interpret historic events and to reclaim a ransacked cultural heritage. Lorraine O'Grady, an artist of African, Caribbean, and Irish descent, whose work focuses mainly on representations of black female subjectivity, questions the views of colonialist photographers as well as the removal of Egypt from the study of Africa. In the iconic sixteen-part photographic series Miscegenated Family Album (1980/94; plate 5), O'Grady paired contemporary pictures of her family and particularly of her sister, Devonia

Evangeline, who had died at the age of thirty-eight, with images of ancient statuary of Queen Nefertiti and her relatives. The word "miscegenation" in the work's title refers not just to the combinatory aesthetic of the album but also to the artist's own mixed ethnic background, and to the ethnic foundations of ancient Egypt, one of the world's great civilizations. Exploring similarities in physiognomy, posture, and modes of representation, the artist uses pictures of contemporary Americans and of ancient Egyptian art to trace a lineage of the African-American diaspora.

The second half of the nineteenth century saw both the birth of modern museology and the rise of art education as an integral part of the academic curriculum. During this period, photography played a major role not only in the development of new interpretive approaches to artworks but in registering and analyzing those changes. The pictures taken by Roger Fenton (plates 4, 28) and Stephen Thompson (plate 27) of the Elgin Marbles and Roman sculpture in the British Museum serve as museographic surveys but also convey a particular fascination with the special role of the museum. Their pictures, Kynaston McShine notes, present the museum as "a major place of convocation, of coming together."[18] Photographed with a long lens to avoid distortion, subtly lit, and at times delineated by natural light filtering through lateral windows or a skylight, the classical display of statuary is strongly suggestive of the new power of these institutions.

The Renaissance scholar Clarence Kennedy began to take pictures in the 1920s while teaching art history at Smith College in Northampton, Massachusetts. Redefining how and why sculpture is photographed, he focused on details of sculpture to reveal its structure, texture, modeling, design, and plasticity. In *The Tomb by Antonio Rossellino for the Cardinal of Portugal* (1933; plates 10–15), a portfolio of thirty-four pictures, Kennedy used the camera as a tool of critical analysis, proceeding from an overall view of a fifteenth-century funerary monument in the chapel at San Miniato al Monte, Florence, to its most minute details. To photograph inside the dimly lit chapel, Kennedy used an intense flashlight—he called it his "pencil of light"—run off a car battery, directing it on each facet of the sculptural ensemble in turn. To shoot inaccessible sections that he could not maneuver his large-format camera to capture, he used mirrors. Isolating close-up passages of intertwined hands, flying drapery, and angelic heads, Kennedy offered a more impassioned vision of the monument than it presented to the unaided eye. His contact prints provided dramatically framed fragments whose artistic definition and impact of proximity renewed human perception.

Focusing on details in this way, photographers have interpreted not only sculpture itself, as an autonomous object, but also the context of its display. The results often show that the meaning of art is not fixed within the work but open to the viewer's reception of it at any given moment. For Elliott Erwitt, for instance, statues make good subjects because they strike poses and directly engage their viewers. Working in museums in which photography is prohibited, he has followed a flawless strategy: "Carry a small and unobtrusive camera that doesn't make much noise. When the guard isn't looking, bring the camera up to your eye and cough as you press the shutter so that the sound is hidden."[19] In a picture taken in the American Wing of The Metropolitan Museum of Art, New York, in 1949 (plate 31), Erwitt photographed Augustus Saint-Gaudens's statue *Diana* (1893–94) from behind, as if the Roman goddess of the hunt were taking aim at a distant visitor. "From these unmemorable occasions," John Szarkowski writes, "Erwitt has distilled, with wit and grace and clarity, the indecisive moment."[20]

Larry Fink has also explored such moments. Following in the tradition of Garry Winogrand and Lee Friedlander, Fink focuses on the museum as social space—on the rituals of its donor parties, benefit galas, and fashionable openings. In a picture taken at a costume ball at the Metropolitan Museum of Art in December 1995 (plate 33), Fink photographed Antonio Canova's idealized neoclassical sculpture *Perseus with the Head of Medusa* (1804–6) presiding over a laboriously festive dinner setup. With a touch of satire, he centered the virile Perseus perfectly within the picture plane—an arrangement pointing to the museum's double role as a place of both aesthetic erudition and social entertainment.

Louise Lawler has focused her camera on the presentation and marketing of artworks since the late 1970s. Her practice became expressly political in the early 1980s, at the height of an art-market boom, when the relationship between the meanings attributed to art and the broader institutional and social frame became a contingent consideration. Taking a place in the tradition of institutional critique, Lawler's pictures foreground the logic of art's display—architecture, labels, pedestals, lighting, wall paint, floorboards, and other environmental details of the museum, commercial gallery, or collector's home—and the system of its circulation, again through the museum, commercial gallery, or collector's home but also through other sites ranging from the corporate lobby to the storage facility. George Baker calls Lawler's work "a project of continual re-presentation."[21] In other words, her pictures re-present what is already presented, staged, displayed, and owned. In *Unsentimental* (1999–2000; plate 32), one of two pictures that she took of the same display in a Christie's showroom just before an auction, she frames a polka dot painting by Damien Hirst, two sculptures by Robert Gober, a Cindy Sherman *Untitled Film Still*, and an ink drawing by Charles Ray to probe the role of a particular presentation in the trade mechanism of sale and purchase. As such, Lawler draws attention to the external factors that determine the aesthetic display and business of art. If, as Thomas Weski suggests, her pictures are "art-sociological comment turned image,"[22] they also reveal photography's engagement in the interpretation of virtually every aspect of art.

Notes

1. Plate 5, fascicle 1, and plate 17, fascicle 4, in William Henry Fox Talbot, *The Pencil of Nature* (London: Longman, Brown, Green and Longmans, 1844–46). The book's six fascicles were published respectively in June 1844; January, May, June, and December 1845; and April 1846. Reprint ed. New York: Da Capo Press, 1969, with an essay by Beaumont Newhall.

2. Ibid., text for plate 5, fascicle 1.

3. See Hans Peter Kraus, Jr., "When Sculpture First Posed for a Photograph," *Sculpture Review* 54, no. 4 (Winter 2005):10.

4. Talbot, *The Pencil of Nature*, text for plate 17, fascicle 4.

5. Geoffrey Batchen, "Light and Dark: The Daguerreotype and Art History," *Art History* 86, no. 4 (December 2004):767.

6. Pierre Mac Orlan, quoted in Sarah Greenough, Robert Gurbo, and Sarah Kennel, *André Kertész* (Washington, D.C.: National Gallery of Art, and Princeton: at the University Press, 2005), p. 73. The artist's studio as a place of production was formerly often fused with the process of creativity and the artist's persona. An offshoot of the photography of sculpture is the posed portrait of the artist paired with his or her work.

7. An-My Lê, e-mail to the author, June 28, 2009.

8. Edwin Carels, "The Cinema and its Afterimage—Projection and Hindsight in: Still/A Novel," *Witte de With Cahier* no. 5 (Düsseldorf: Richter Verlag, 1996), p. 37.

9. Maria Morris Hambourg, "Extending the Grand Tour," in Hambourg, ed., *The Waking Dream: Photography's First Century. Selections from the Gilman Paper Company Collection* (New York: The Metropolitan Museum of Art, 1993), p. 84.

10. John Ruskin, quoted in Michael Harvey, "Ruskin and Photography," *Oxford Art Journal* 7, no. 2 (1985):25.

11. Ruskin, quoted in M. Christine Boyer, "La Mission Héliographique: Architectural Photography, Collective Memory and the Patrimony of France," in Joan M. Swartz and James R. Ryan, eds., *Picturing Place: Photography and the Geographical Imagination* (New York: I. B. Tauris, 2003), p. 38.

12. Eugène-Emmanuel Viollet-le-Duc, *The Architectural Theory of Viollet-le-Duc: Readings and Commentary*, ed. M. F. Hearn (Cambridge, Mass.: The MIT Press, 1990), p. 6.

13. Françoise Heilbrun, "Around the World: Explorers, Travelers, and Tourists," in Michel Frizot, ed., *A New History of Photography* (Cologne: Könemann, 1998), p. 149.

14. In 1854 the Société Héliographique was replaced by the Société française de photographie, an organization that exists to this day. Its official organ was the journal *La Lumière*, the first journal devoted solely to photography.

15. Gregory Derek, "Emperors of the Gaze: Photographic Practices and Productions of Space in Egypt, 1839–1914," in Joan M. Schwartz and James R. Ryan, eds., *Picturing Place: Photography and the Geographical Imagination* (London and New York: I. B. Tauris, 2003), p. 206.

16. Julia Ballerini, "'La Maison démolie': Photographs of Egypt by Maxime Du Camp 1849–50," in Suzanne Nash, ed., *Home and Its Dislocations in Nineteenth-Century France* (Albany: State University of New York Press, 1993), p. 109. Ballerini also notes that although Du Camp identified only Hadji-Ishmael as his model, at times his "measure of scale" was also Gustave Flaubert or their manservant, Sassetti.

17. Du Camp, quoted in Derek, "Emperors of the Gaze," p. 214.

18. Kynaston McShine, *The Museum as Muse: Artists Reflect* (New York: The Museum of Modern Art, 1999), p. 17.

19. Elliott Erwitt, *Museum Watching* (New York: Phaidon, 1999), p. 86.

20. John Szarkowski, "The Erwitt File," *Elliott Erwitt: Photographs and Anti-Photographs* (Greenwich, Conn.: New York Graphic Society, 1972), p. 5.

21. George Baker, in Baker and Andrea Fraser, "Displacement and Condensation: A Conversation on the Work of Louise Lawler," in Philipp Kaiser, ed., *Louise Lawler and Others* (Ostfildern-Ruit: Hatje Cantz, 2004), p. 120.

22. Thomas Weski, "Art as Analysis: On the Photographic Works of Louise Lawler," in Dietmar Elger and Weski, *Louise Lawler for Sale* (Ostfildern-Ruit: Cantz Verlag, 1994), p. 60.

2. William Henry Fox Talbot. British, 1800–1877
Bust of Patroclus. Before February 7, 1846
Salted-paper print from a calotype negative, 7 x 6 ⁵⁄₁₆" (17.8 x 16 cm)
The J. Paul Getty Museum, Los Angeles

3

3. Adolphe Bilordeaux. French, 1807–1875
Gipshand (Plaster hand) from the series *Ecoles municipales, études de dessins d'après l'antique et les grands maîtres* (Public schools, studies in drawing from antiquity and the old masters). 1864
Albumen silver print, 12 ¹/₁₆ x 9 ³/₈" (30.7 x 23.8 cm)
Bibliothèque nationale de France, Paris

4

4. Roger Fenton. British, 1819–1869
Roman Portrait Bust, British Museum, London. c. 1857
Salted-paper print, 13 ¹¹⁄₁₆ x 9 ¾" (34.7 x 24.7 cm)
The Museum of Modern Art, New York. Suzanne Winsberg Collection.
Gift of Suzanne Winsberg

5

5. Lorraine O'Grady. American, born 1934
Sister IV, L: Devonia's sister, Lorraine; R: Nefertiti's sister, Mutnedjmet from
Miscegenated Family Album. 1980/94
Two silver dye bleach prints printed on one sheet, overall: 26 x 37" (66 x 94 cm)
Courtesy the artist and Alexander Gray Associates, New York

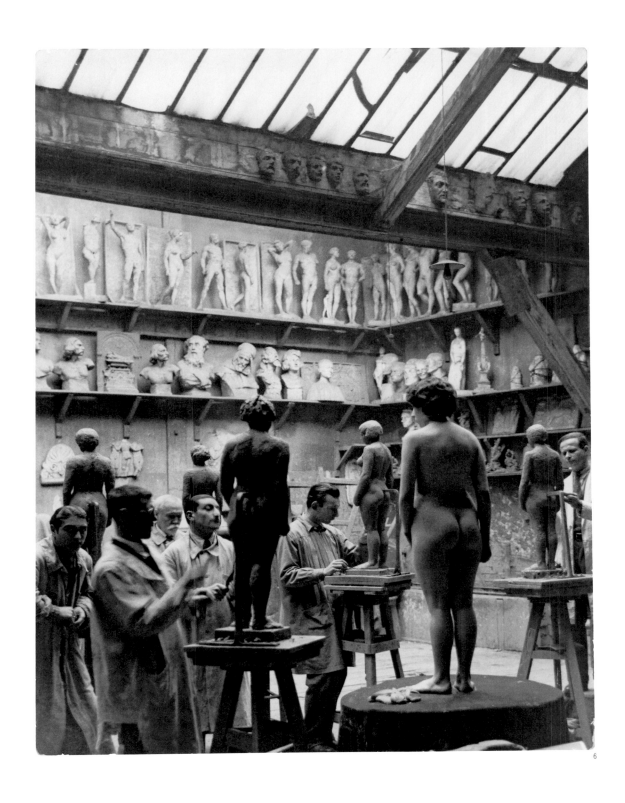

6

6. Brassaï (Gyula Halász). French, born Transylvania, 1899–1984
À l'Académie Julien (At the Académie Julien). 1932
Gelatin silver print, 9 ¼ x 7 ¼" (23.5 x 18.4 cm)
Collection Daile Kaplan and Donna Henes, New York

7

7. Frances Benjamin Johnston. American, 1864–1952
Eastern High School, Washington, D.C. c. 1899
Cyanotype, 9 x 11 ⁵⁄₁₆" (22.7 x 28.7 cm)
Frances Benjamin Johnston Collection, Prints & Photographs Division,
Library of Congress, Washington, D.C.

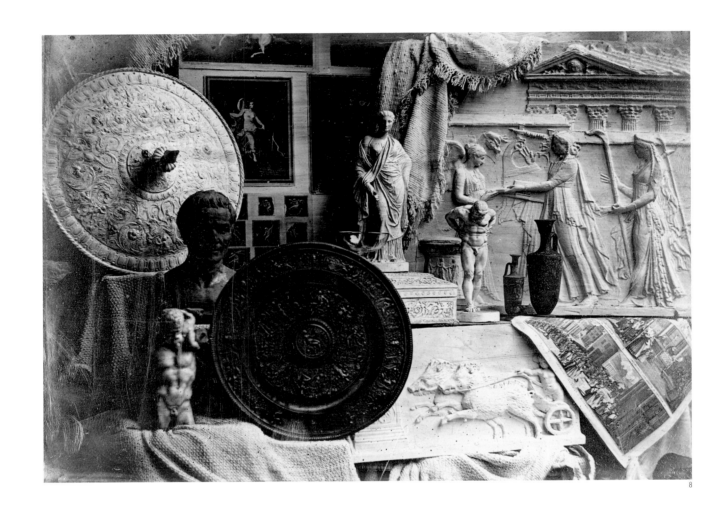

8

8. François-Alphonse Fortier. French, 1825–1882
Nature morte (Still life). 1839–40
Daguerreotype, 6 ⁵⁄₁₆ x 8 ³⁄₈" (16 x 21.3 cm)
Société française de photographie, Paris

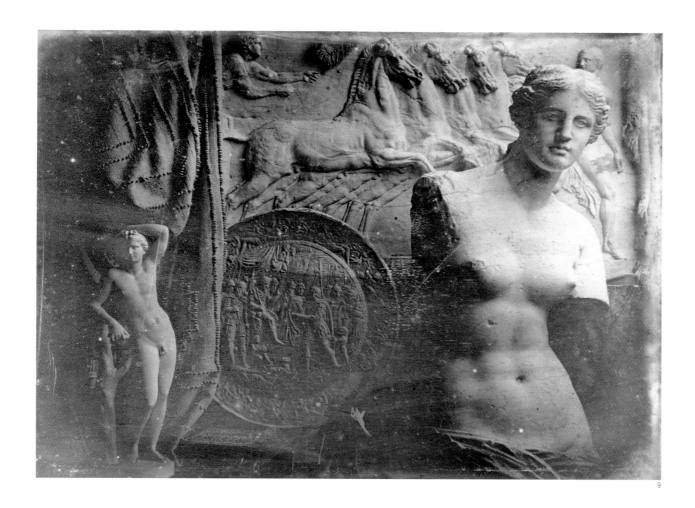

9

9. Alphonse Eugène Hubert. French, 1798–1842
Nature morte, bas-reliefs et sculptures dont la Vénus de Milo (Still life,
bas-reliefs, and sculptures with the Venus de Milo). 1839
Daguerreotype, 6 ⁵⁄₁₆ x 8 ¼" (16 x 21 cm)
Société française de photographie, Paris

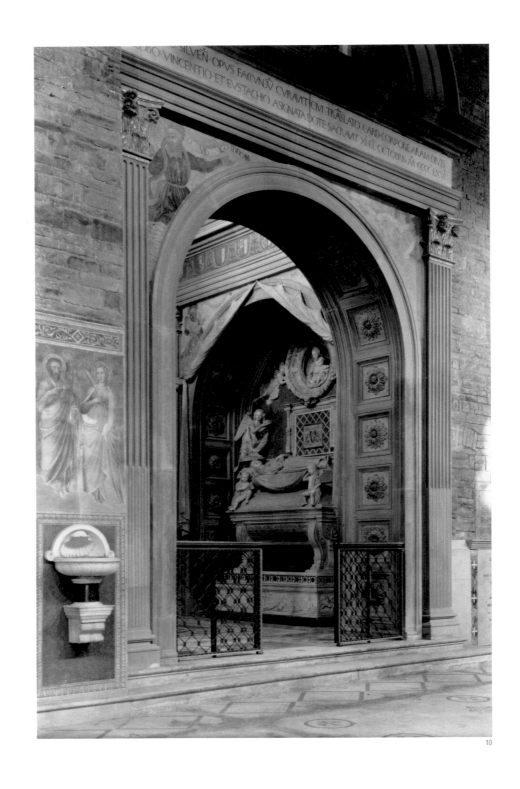

10

10–15. Clarence Kennedy. American, 1892–1972
Plates I, XVIII, XX, XXII, XXV, and XXXI from *The Tomb by Antonio Rossellino for the Cardinal of Portugal.* 1933
Gelatin silver prints, each c. 10 x 6 ½" (25.4 x 16.5 cm) or c. 6 ½ x 10"
(16.5 x 25.4 cm) except plate XXV, 11 x 8 ½" (27.9 x 21.6 cm)
The Museum of Modern Art, New York. Gift of Melinda Norris Kennedy
in memory of her father, Clarence Kennedy

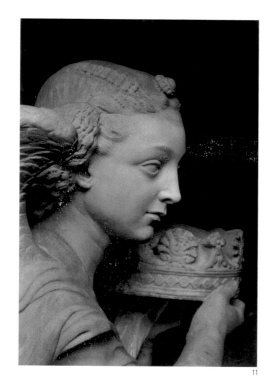

11

13

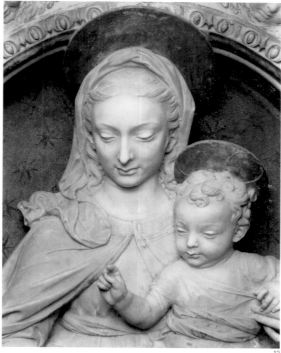

12

14

15

16. Ann Hamilton. American, born 1956
phora 8. 2005
Inkjet print, 33 ¾ x 46 ¼" (85.7 x 117.5 cm)
The Museum of Modern Art, New York. Acquired through
the generosity of Stephen Abramson

17

18

19

17. Ken Domon. Japanese, 1909–1990
Right Hand of the Sitting Image of Buddha Shakyamuni in the Hall of Miroku, Muro-Ji, Nara. c. 1942–43
Gelatin silver print, 12 ⅞ x 9 ½" (32.7 x 24.2 cm)
The Museum of Modern Art, New York. Gift of the photographer

18. Ken Domon. Japanese, 1909–1990
Left Hand of the Sitting Image of Buddha Shakyamuni in the Hall of Miroku, Muro-Ji, Nara. c. 1942–43
Gelatin silver print, 12 ⅞ x 9 ½" (32.7 x 24.2 cm)
The Museum of Modern Art, New York. Gift of the photographer

19. Ken Domon. Japanese, 1909–1990
Detail of the Sitting Image of Buddha Shakyamuni in the Hall of Miroku, Muro-Ji, Nara. c. 1942–43
Gelatin silver print, 16 x 23 ⁵⁄₁₆" (40.7 x 59.2 cm)
The Museum of Modern Art, New York. Gift of the photographer

20. Maxime Du Camp. French, 1822–1894
Ibsamboul, colosse occidental du Spéos de Phrè (Westernmost colossus of the temple of Re, Abu Simbel). 1850. Plate from *Egypte, Nubie, Palestine et Syrie. Dessins photographiques recueillis pendant les années 1849, 1850 et 1851* (Egypt, Nubia, Palestine, and Syria: photographic drawings made during the years 1849, 1850, and 1851). Paris: Gide et J. Baudry, 1852
Salted-paper print from a paper negative, 8 ¹⁵⁄₁₆ x 6 ½" (22.6 x 16.6 cm)
The Museum of Modern Art, New York. Gift of Warner Communications, Inc.

21

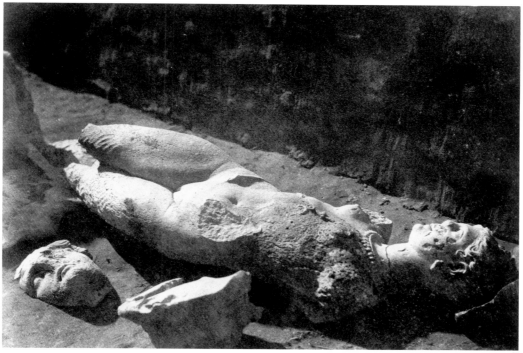

22

21. John B. Greene. American, born France, 1832–1856
Statue Fragments, Museum of Cherchell. 1855–56
Salted-paper print from a paper negative, 11 ⅛ x 9 ¼" (28.3 x 23.5 cm)
The Museum of Modern Art, New York. Gift of Jerome Powell

22. Théodule Devéria. French, 1831–1872
Memphis. Sérapéum grec (Greek serapeum, Memphis). 1859
Albumen silver print from paper negative, 8 ¼ x 11 ⁷⁄₁₆" (21 x 29 cm)
Thomas Walther Collection

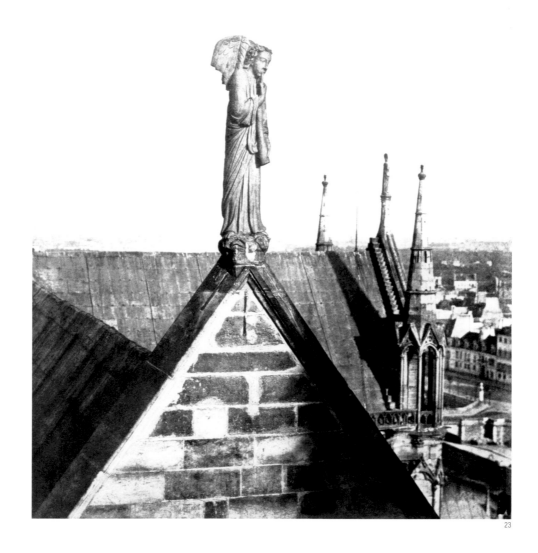

23

23. Charles Nègre. French, 1820–1880
Angel of the Resurrection on the Roof of Notre Dame. 1853
Salted-paper print from a paper negative, 12 ¹³⁄₁₆ x 9 ⅛" (32.6 x 23.2 cm),
mounted on card, 23 ¹¹⁄₁₆ x 18 ¼" (60.2 x 46.4 cm)
Courtesy Hans P. Kraus, Jr., New York

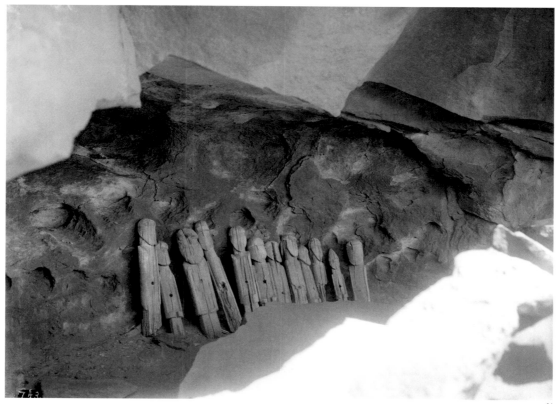

24

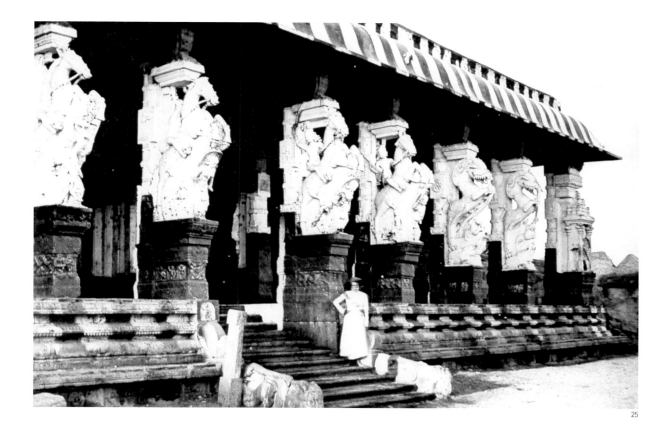

25

24. Adam Clark Vroman. American, 1856–1916
Pueblo of Zuni (Sacred Shrine of Taayallona). 1899
Platinum print, 6 x 8" (15.3 x 20.3 cm)
The Museum of Modern Art, New York. Exchange

25. Linnaeus Tripe. British, 1822–1902
Plate from *Photographic Views of Madura, Parts I to IV.* 1858
Salted-paper print from paper negative (varnished), 10 ¼ x 13 ⁹⁄₁₆" (26 x 34.5 cm)
Thomas Walther Collection

26. Henry Hamilton Bennett. American, born Canada, 1843–1908
Layton Art Gallery, Milwaukee, Wisconsin. c. 1890
Albumen silver print from a glass-plate negative, 17 ³⁄₁₆ x 21 ¾" (43.7 x 55.2 cm)
The Museum of Modern Art, New York. Gift of H. H. Bennett Studios

27

28

27. Stephen Thompson. English
Satyr, British Museum. 1869–72
Albumen silver print from glass negative, 11 x 8 9/16" (28 x 21.8 cm)
The Metropolitan Museum of Art, New York. Gilman Collection,
Purchase, The Horace W. Goldsmith Foundation Gift, through Joyce
and Robert Menschel

28. Roger Fenton. British, 1819–1869
The Third Graeco-Roman Saloon on Artists' Day. c. 1857
Albumen print, 10 5/16 x 11 9/16" (26.2 x 29.3 cm)
National Media Museum, Bradford, West Yorkshire

61

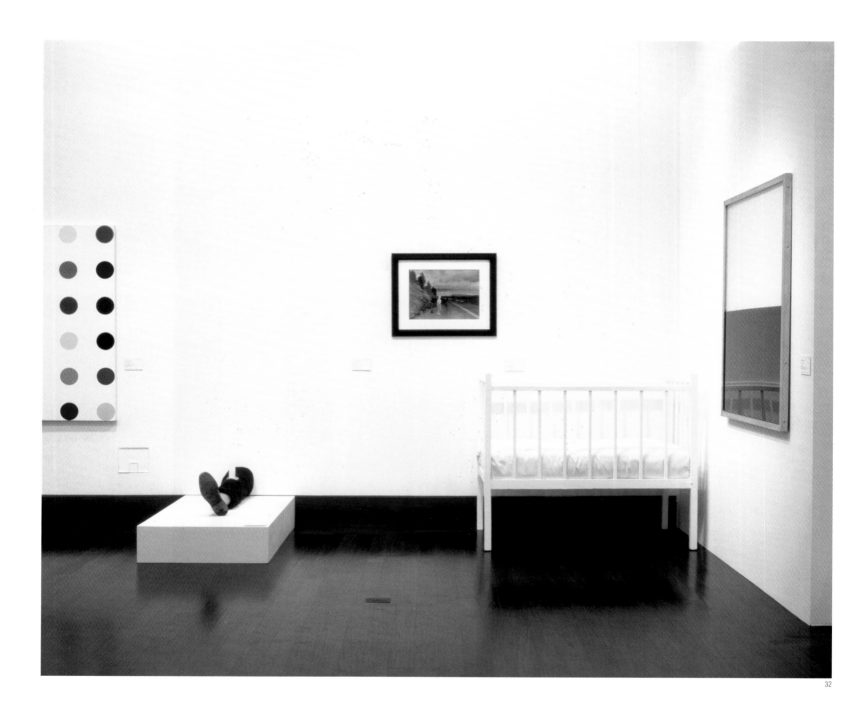

32. Louise Lawler. American, born 1947
Unsentimental. 1999–2000
Silver dye bleach print, 47 ½ x 57" (120.6 x 144.8 cm)
Collection Pamela and Arthur Sanders

33.

34.

33. Larry Fink. American, born 1941
The Metropolitan Museum of Art, New York, Costume Ball. December 1995
Gelatin silver print, 14 ¼ x 14 ¼" (36.2 x 36.2 cm)
Collection Larry Fink

34. André Kertész. American, born Hungary, 1894–1985
Thomas Jefferson. 1961
Gelatin silver print, 12 ⅝ x 16 ⅝" (32.2 x 42.1 cm)
The Museum of Modern Art, New York. Gift of the photographer

35

35. André Kertész. American, born Hungary, 1894–1985
African Sculptures. 1927
Gelatin silver contact print on postcard stock, 3 ⅜ x 3 ¼" (8.6 x 8.3 cm)
Brent R. Harris

36

37

36. André Kertész. American, born Hungary, 1894–1985
Léger Studio. 1927
Gelatin silver print, 4 ⅛ x 3 ⅛" (10.4 x 7.9 cm)
The Museum of Modern Art, New York. Thomas Walther Collection. Gift of Thomas Walther

37. André Kertész. American, born Hungary, 1894–1985
At Zadkine's. 1926
Gelatin silver print, 4 ⅛ x 2 ⅝" (10.5 x 6.7 cm)
The Museum of Modern Art, New York. Thomas Walther Collection. Purchase

38

38. An-My Lê. American, born Vietnam 1960
Milani Workshop, Vicenza, Italy. 1991
Gelatin silver print, 30 x 25" (76.2 x 63.5 cm)
Collection the artist

39

40

39. Jan De Cock. Belgian, born 1976
Studio Repromotion 1563. 2009
Chromogenic color print, 5 ¹⁵⁄₁₆ x 4" (15.1 x 10.1 cm)
Collection the artist

40. Jan De Cock. Belgian, born 1976
Studio Repromotion 1659. 2009
Chromogenic color print, 5 ¹⁵⁄₁₆ x 4" (15.1 x 10.1 cm)
Collection the artist

41. Eugène Atget. French, 1857–1927
Saint-Cloud. 1923
Albumen silver print, 7 ³⁄₁₆ x 8 ¹¹⁄₁₆" (18.2 x 22 cm)
The Museum of Modern Art, New York. Abbott-Levy Collection.
Partial gift of Shirley C. Burden

II. EUGÈNE ATGET: THE MARVELOUS IN THE EVERYDAY

During the first quarter of the twentieth century, Eugène Atget took hundreds of photographs of sculptures—classical statues, reliefs, friezes, fountains, door knockers, and other finely wrought decorative fragments—in Paris and its outlying parks and gardens, especially at Versailles (from 1901), Saint-Cloud (from 1904), and Sceaux (from 1925). Part of an oeuvre comprising over 8,500 pictures, these images amount to a visual compendium of the heritage of French civilization at that time. Atget began taking pictures as a service to archivists and antiquarians who studied the old city, and to artists, craftsmen, and architects in need of memory aids. Although he asserted, "These are simply documents I make,"[1] it is clear that he did not separate documentary intentions from artistic ones. He photographed with a large-format wooden bellows camera using a simple rapid rectilinear lens, or a wide-angle lens recognizable by the vignette visible at the edges of some prints. The images were exposed and developed on 7-by-9 ½-inch glass dry plates. With an eye trained for strange and unsettling images (fig. 1), Atget captured the quintessence of a vanishing world.

fig. 1. Eugène Atget. *Fête de Vaugirard*. 1926. Gelatin silver printing-out-paper print, 6 ¾ x 8 ¹¹⁄₁₆" (17.1 x 22 cm). The Museum of Modern Art, New York. Abbott-Levy Collection. Partial gift of Shirley C. Burden

Atget was not well-known during his lifetime, but his pictures became an inspiration for later photographers who recognized in them a uniquely original vision. In the 1920s, shortly before his death, he was heralded by Man Ray (a neighbor of his in Montparnasse) and the Surrealists for his photographs of deserted cityscapes, and of shop windows haunted by elegant mannequins (fig. 2) whose reflections melded with those of the street, revealing the marvelous in the everyday. The spectral mystery and suggestive mood of his unsettling late work also appealed to writers such as André Breton, Jean Cocteau, and Pierre Mac Orlan. In 1926, four of Atget's photographs were published in *La Révolution surréaliste*, his first acknowledgment in a journal of avant-garde art, but since he did not see his work as aligned with Surrealism, at his request the pictures remained uncredited. The photographer Berenice Abbott, who was at the time Man Ray's assistant, greatly admired Atget's work and sought to help him achieve greater recognition. After his death, in 1927, Abbott, with the help of the art dealer Julien Levy, purchased all of the negatives and prints left in Atget's studio. She preserved the collection until its acquisition by The Museum of Modern Art, in 1969, and through a series of exhibitions and publications organized by this museum, Atget's oeuvre became internationally known.

In January 1898, members of a conservation group called the Commission municipale du Vieux Paris, concerned with the impact of the urban reconstruction projects begun by Napoleon III and his agent Baron Haussmann to modernize Paris, organized a project to document what remained of the past. Atget's interest in preserving the vestiges of old Paris overlapped with this conservationist agenda. Two of the group's founding members, the painter Edouard Détaille and the playwright Victorien Sardou, were old acquaintances of his, and although they did not formally employ him, according to André Calmettes, Atget's executor and friend, Sardou regularly informed the photographer "which houses, which sites and châteaux, which spots were doomed to disappear."[2] Atget began a systematic study of the historic art and architecture of the capital. The following year, a number of institutions, including the Bibliothèque historique de la Ville de Paris, the Musée national

des Monuments Français, the Musée de Sculpture comparée du Trocadéro, and the Musée Carnavalet, began to acquire his albumen contact prints on this subject. Atget tirelessly photographed the old precincts of Paris, scouring them for relics, symbols, and monuments. He roamed through the parks of the ancien régime, surveying their baroque fountains, ornate urns, and statuary of gods and goddesses, whose battered stone surfaces he studied in relationship to their natural environments at different times of day, in different seasons, from different vantage points, and in different lights. Atget knew, John Szarkowski observes, that "the most interesting distinctions were not categorical but plastic and relative," meaning that one sculpture, one fountain, or one urn "was never twice the same." "With this realization he became, surely not intentionally, a modern artist."[3]

At Versailles, most intensely between 1901 and 1906 and again between 1921 and 1926, Atget photographed the gardens that André Le Nôtre, the landscape architect of King Louis XIV, had designed in the second half of the seventeenth century. In twenty-four pictures of allegorical statues punctuating the garden's vistas (plates 50–53), Atget focused on the scenic organization of the sculptures, treating them as characters in a historical play. Commissioned in 1674, the statues had been designed by Charles Le Brun according to a lexicon of gestures drawn from Cesare Ripa's influential *Iconologia* (1593), an emblem book intended for use by artists that was later adapted to teach performers in the theater and the opera how to enhance their communication through body language. The pantomimic effect of the statues' postures clearly appealed to Atget, who in 1880, before turning to photography, had taken acting classes at the Conservatory of the Théâtre national de France and had played with touring theater companies in the suburbs of Paris. Maria Morris Hambourg suggests that as "an habitué of the stage and a sometime painter, Atget had a natural facility for this constructive sort of art."[4] Depicting the white marble statues from low viewpoints, in full length, and against the dark, unified tones of hedges and trees, Atget brought them into dramatic relief, highlighting the theatrical possibilities of sculpture.

Among Atget's most exquisite pictures are those taken in the royal park at Saint-Cloud, laid out as the country residence of Philippe d'Orléans, the younger brother of Louis XIV, on a site overlooking the Seine just west of Paris. In 1870, during the Franco-Prussian War, the château had been destroyed by fire, and when Atget began to explore the park, in 1904, its biggest attraction was the Grande Cascade, a huge fountain decked with figures of classical gods, designed in 1662–64 by the architect

fig. 2. Eugène Atget. *Coiffeur, avenue de l'Observatoire* (Hairdresser, avenue de l'Observatoire). 1926. Gelatin silver printing-out-paper print, 8 11/16 x 6 3/4" (22 x 17.1 cm). The Museum of Modern Art, New York. Abbott-Levy Collection. Partial gift of Shirley C. Burden

Antoine Le Pautre. Where other photographers usually photographed the cascade head-on, Atget positioned his camera at an angle, asymmetrically, unbalancing an architectural monument known for its prescribed symmetry and axial views. Moving to the terrace at the top, Atget took unexpected pictures of the reclining statues of Seine and Marne (plates 41, 48, 49), the river gods presiding over the balustrade. Szarkowski notes that Atget approached the motif in close-up views, breaking it into "a collection of details, and then, duty having been done, proceeded to make deeply evocative pictures on the periphery of its main attraction."[5] Among the pictures taken at Saint-Cloud is a series centered on a melancholy pool (plates 58–61). The pool is surrounded by statues whose tiny silhouettes can be seen from a distance, at once delineated against the masses of dark foliage and reflected in the water's crisp surface. Atget's interest in the variable play between nature and art through minute changes in the camera's angle, or as functions of the effects of light and time of day, is underscored in his notations of the exact month and sometimes even the hour when the pictures were taken. Hambourg perceptively describes the exceptional fecundity of his work during the three-year period 1919–22: "Everywhere unpredicted optical conjunctions replaced expected formulations. Light dissolved, reflections enlarged, and shadows obscured nominal subjects, momentarily removing them from familiar frames of reference. Under the black cloth space was fluid; it warped, fused, and expanded as Atget adjusted and rotated the camera—things normally separate converged, those conjoined became polarized."[6] In this way Atget's photography dissolved the line between seeing and knowing.

The abandoned estate at Sceaux, just south of Paris, provided Atget with a landscape of elegiac beauty during the last years of his life. Built as the domain of Jean-Baptiste Colbert, Louis XIV's minister of finance, the Château du Sceaux had been destroyed during the time of the Directoire, the penultimate stage of the French Revolution, but the park survived. Like Versailles and Saint-Cloud, it had been planned by Le Nôtre, which accounts for the long avenues that Atget photographed many times during his solitary strolls through the park. Two pictures of the same statue taken three months apart, in March and June of 1925 (plates 54, 55), look utterly different: in one case the statue is profiled against the denuded trees of winter, enveloped in the luminescent expanse of the sky; in the other it is absorbed into the trees' foliage. The pictures reveal Atget's keen exploration of optical phenomena, the subtle shifts made by changes in lighting, atmosphere, and the seasons.

Atget's pictures of statues from his last years have less to do with the formal dimensions of art than its metaphorical qualities, and with age and loss. In the summer of 1926, the former actress Valentine Delafosse Compagnon, Atget's partner of thirty years, died. Atget was inconsolable, but he continued to work for another year, until his own death in 1927. Perhaps, as Szarkowski suggests, Atget's work at Sceaux is "a recapitulation in miniature of all his work on the culture of old France, a record of the diminishing souvenirs of a foreign country," or, perhaps it is "a portrait of Atget himself, not excluding petty flaws, but showing most clearly the boldness and certainty—what his old friend Calmettes called the intransigence—of his taste, his method, his vision."[7]

Notes

1. Eugène Atget, quoted in Maria Morris Hambourg, "The Structure of the Work," in John Szarkowski and Hambourg, eds., *The Work of Atget*, vol. 3, *The Ancient Regime* (New York: The Museum of Modern Art, 1983), p. 9. The modest handmade sign on Atget's workshop door read *Documents pour artistes* (Documents for artists).

2. André Calmettes, quoted in James Borcoman, *Eugène Atget: 1857–1927* (Ottawa: National Gallery of Ottawa, 1984), p. 20.

3. John Szarkowski, *Photography until Now* (New York: The Museum of Modern Art, 1989), p. 134.

4. Hambourg, "The Structure of the Work," p. 14. It should also be noted that Atget identified himself as *auteur-éditeur* (author-producer), preferring this title to that of photographer.

5. Szarkowski, *Atget* (New York: The Museum of Modern Art and Callaway, 2000), p. 188.

6. Hambourg, "The Structure of the Work," p. 24.

7. Szarkowski, *Atget*, p. 220.

42

43

42. Eugène Atget. French, 1857–1927
Heurtoir (Door knocker), 120 rue du Faubourg Saint-Honoré. 1901
Albumen silver print, 8 ¹¹⁄₁₆ x 7 ¹⁄₁₆" (22 x 18 cm)
The Museum of Modern Art, New York. Abbott-Levy Collection.
Partial gift of Shirley C. Burden

43. Eugène Atget. French, 1857–1927
Heurtoir (Door knocker), 43 rue Sainte-Anne. 1904–5
Albumen silver print, 8 ⁷⁄₁₆ x 7 ¹⁄₁₆" (21.5 x 18 cm)
The Museum of Modern Art, New York. Abbott-Levy Collection.
Partial gift of Shirley C. Burden

44

45

44. Eugène Atget. French, 1857–1927
Cluny—porte (Cluny—door). 1902
Albumen silver print, 8 ¹¹⁄₁₆ x 7 ¹⁄₁₆" (22 x 18 cm)
The Museum of Modern Art, New York. Abbott-Levy Collection.
Partial gift of Shirley C. Burden

45. Eugène Atget. French, 1857–1927
Cluny—XIIe siècle (Cluny—12th century). 1921
Albumen silver print, 8 ⁷⁄₁₆ x 7 ³⁄₁₆" (21.4 x 18.2 cm)
The Museum of Modern Art, New York. Abbott-Levy Collection.
Partial gift of Shirley C. Burden

46

47

46. Eugène Atget. French, 1857–1927
Versailles, vase. 1906
Albumen silver print, 8 ½ x 7" (21.6 x 17.8 cm)
The Museum of Modern Art, New York. Abbott-Levy Collection.
Partial gift of Shirley C. Burden

47. Eugène Atget. French, 1857–1927
Versailles, vase (détail). 1906
Albumen silver print, 8 ⅝ x 7" (21.9 x 17.8 cm)
The Museum of Modern Art, New York. Abbott-Levy Collection.
Partial gift of Shirley C. Burden

48

49

48. Eugène Atget. French, 1857–1927
Saint-Cloud. 1923
Albumen silver print, 8 7/16 x 7 1/16" (21.5 x 18 cm)
The Museum of Modern Art, New York. Abbott-Levy Collection.
Partial gift of Shirley C. Burden

49. Eugène Atget. French, 1857–1927
Saint-Cloud. 1923
Albumen silver print, 6 7/8 x 8 3/8" (17.5 x 21.3 cm)
The Museum of Modern Art, New York. Anonymous gift

50 51 52

50. Eugène Atget. French, 1857–1927
Versailles—Le Flegmatique par Matthieu Lespagnandelle
(Versailles—The Phlegmatic by Matthieu Lespagnandelle). 1923–24
Albumen silver print, 8 ½ x 7 ⅛" (21.6 x 18.1 cm)
The Museum of Modern Art, New York. Abbott-Levy Collection.
Partial gift of Shirley C. Burden

51. Eugène Atget. French, 1857–1927
Versailles—Artémise par Robert Lefèvre et Martin Desjardins (Versailles—
Artemisia by Robert Lefèvre and Martin Desjardins). 1923–24
Matte albumen silver print, 8 ¾ x 7" (22.2 x 17.8 cm)
The Museum of Modern Art, New York. Abbott-Levy Collection.
Partial gift of Shirley C. Burden

52. Eugène Atget. French, 1857–1927
Versailles—L'Hiver par François Girardon (Versailles—Winter by
François Girardon). 1922
Albumen silver print, 8 ⅝ x 7 ¼" (21.9 x 18.4 cm)
The Museum of Modern Art, New York. Abbott-Levy Collection.
Partial gift of Shirley C. Burden

53

53. Eugène Atget. French, 1857–1927
Versailles—La Fourberie par Louis Le Conte (Versailles—Deceit by
Louis Le Conte). 1923–24
Matte albumen silver print, 8 ⅞ x 7 ¹⁄₁₆" (22.5 x 18 cm)
The Museum of Modern Art, New York. Abbott-Levy Collection.
Partial gift of Shirley C. Burden

54. Eugène Atget. French, 1857–1927
Parc de Sceaux. June 1925
Gelatin silver printing-out-paper print, 7 1/16 x 8 7/8" (18 x 22.5 cm)
The Museum of Modern Art, New York. Abbott-Levy Collection.
Partial gift of Shirley C. Burden

55. Eugène Atget. French, 1857–1927
Parc de Sceaux. 8. h. matin (Parc de Sceaux. 8 o'clock in the morning).
March 1925
Gelatin silver printing-out-paper print, 7 1/16 x 8 13/16" (17.9 x 22.4 cm)
The Museum of Modern Art, New York. Abbott-Levy Collection.
Partial gift of Shirley C. Burden

56

57

56. Eugène Atget. French, 1857–1927
Versailles. 1901
Gelatin silver printing-out-paper print, 7 1/16 x 8 11/16" (17.9 x 22.1 cm)
The Museum of Modern Art, New York. Abbott-Levy Collection.
Partial gift of Shirley C. Burden

57. Eugène Atget. French, 1857–1927
Versailles. 1901
Albumen silver print, 7 1/8 x 8 3/4" (18.1 x 22.2 cm)
The Museum of Modern Art, New York. Abbott-Levy Collection.
Partial gift of Shirley C. Burden

58

59

58. Eugène Atget. French, 1857–1927
Saint-Cloud. 1922
Albumen silver print, 6 ¹⁵⁄₁₆ x 8 ⁹⁄₁₆" (17.6 x 21.7 cm)
The Museum of Modern Art, New York. Abbott-Levy Collection.
Partial gift of Shirley C. Burden

59. Eugène Atget. French, 1857–1927
Saint-Cloud. 7 h. matin. (Saint-Cloud. 7 o'clock in the morning). July 1921
Albumen silver print, 6 ¹⁵⁄₁₆ x 8 ³⁄₈" (17.7 x 21.2 cm)
The Museum of Modern Art, New York. Abbott-Levy Collection.
Partial gift of Shirley C. Burden

60. Eugène Atget. French, 1857–1927
Saint-Cloud. Le soir, 7 h. (Saint-Cloud. Evening, 7 o'clock). 1921
Albumen silver print, 6 ¹⁵⁄₁₆ x 8 ¹¹⁄₁₆" (17.6 x 22 cm)
The Museum of Modern Art, New York. Abbott-Levy Collection.
Partial gift of Shirley C. Burden

61. Eugène Atget. French, 1857–1927
Saint-Cloud. 1915–19
Gelatin silver printing-out-paper print, 7 x 9 ¹⁄₁₆" (17.8 x 23 cm)
The Museum of Modern Art, New York. Abbott-Levy Collection.
Partial gift of Shirley C. Burden

62

62. Eugène Druet. French, 1868–1917
Main crispée surgissant d'une couverture (Clenched hand emerging
from a blanket). c. 1898
Gelatin silver print, 15 ⅝ x 11 ¹³⁄₁₆" (39.7 x 30 cm)
Musée Rodin. Donation Auguste Rodin

III. AUGUSTE RODIN: THE SCULPTOR AND THE PHOTOGRAPHIC ENTERPRISE

Auguste Rodin never took his own pictures of his sculptures but he reserved the creative act for himself, actively directing the enterprise of photographing his work (fig. 1). From 1877 until his death, in 1917, Rodin probed the potential of photography both for personal use and for disseminating and publicizing his art worldwide.[1] Rodin's photographic self-education was impressive. He was one of the first subscribers to Eadweard Muybridge's *Animal Locomotion* (1887), and his library collection included 7,000 photographic prints, an unprecedented source on both his working methods and the history of interpretive photography.[2] Although Rodin had reservations about the new medium as an art form, arguing that pictures could only capture the frozen moment while art suggested emotion, animation, and movement, he was directly involved in the aesthetic aspects of the photographic process. He controlled staging, lighting, background, and point of view, and he was probably the first sculptor to enlist the camera to record the changing stages through which his work passed from initial conception to realization. In the early 1880s, Rodin began to pay untiring attention to the production of these pictures, supervising professional photographers such as Charles Bodmer, Victor Pannelier, E. Freuler, Charles Michelez, and others.

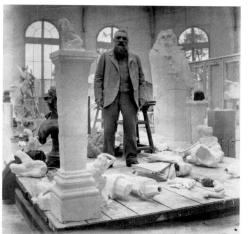

fig. 1. Eugène Druet. *Rodin dans son atelier au milieu de ses œuvres en plâtre* (Rodin in his studio among casts of his work). c. 1902. Gelatin silver print, 9 15⁄16 x 9 13⁄16" (25.3 x 25 cm). Musée Rodin, Paris

The pictures that Rodin produced from 1880 to 1890 are primarily private documents that depict the working life of his studio, in the *Dépôt des marbres* of the French ministry of public works in Paris. In the 1890s, though, realizing that through photography he could make multiple reproductions of his work at low cost, he started to exhibit pictures along with his sculptures, using the new medium to show more sculpture than the actual space would permit.[3] In 1900, Rodin organized what is considered the first retrospective exhibition by a sculptor, erecting his own pavilion in the place de l'Alma and filling it with 150 sculptures, to coincide with the Exposition Universelle on the Champ des Mars. In two small galleries within the entrance to the pavilion he exhibited seventy-one pictures taken by Eugène Druet, a bistro owner who was also an amateur photographer, in fact Rodin's primary photographer for much of the late 1890s and into the first decade of the twentieth century.

Beginning with Druet and with Jacques-Ernest Bulloz in the late 1890s, Rodin's involvement with photography entered an interpretive phase. Although views of the studio still emerged, especially by Bulloz, the emphasis was now placed on individual sculptures. Shot isolated against a fabric backdrop or enveloped into the atmospheric surrounding space, the pictures conveyed a subjective vision of the work. Rodin continued to retain strict control over the photographs, affixing his signature to each of Druet's prints by means of a transparent stencil overlaid on the glass negative and engraving it on the mounts of Bulloz's pictures. Albert E. Elsen notes the probability "that Rodin came to look upon his most frequently used photographers such as Druet and Bulloz as being *practiciens*, like the highly skilled professional sculptors who assisted in the studio."[4] The photographers were contractually obligated to follow Rodin's directions; he approved all photographic proofs and reserved the right to correct or destroy any glass plate he disliked. He edited the proofs using wash and pencil marks, his annotations often leading to creative grafts of drawing and photography.

After 1900, Rodin teamed up with younger photographers such as Edward Steichen, Alvin Langdon Coburn, Stephen Haweis, Henry Coles, and Gertrude Käsebier, whose soft-focus pictures were imbued with misty, sfumato effects characteristic of the Pictorialist style that the sculptor so much admired. In October 1908, Steichen's stylized images inspired Rodin to credit photography as an art form in Alfred Stieglitz's New York journal *Camera Work*:

> I believe that photography can create works of art. No one ever suspected what could be got out of it; one doesn't even know today what one can expect from a process which permits of such profound sentiment, and such thorough interpretation of the model, as has been realized in the hands of Steichen. I consider Steichen a very great artist and the leading, the greatest photographer of the time.[5]

At this point Rodin had entered a new phase in his relationship with photography, in which, feeling more at ease with the medium, he gave others carte blanche to represent his work.

The photographers engaged with Rodin's enterprise were diverse and their images of his work varied greatly, partly through each individual's artistic sensibility and partly through changes in the photographic medium. Druet, for instance, relinquished the warm tones of earlier albumen prints for the colder gelatin silver prints, while Bulloz opted for carbon prints. The size of the pictures also changed, from small format early on to larger prints, 15 by 11 inches becoming the standard size. Generally, as Hélène Pinet points out, the stylistic changes over time reflect a greater sophistication concerning "the importance of natural light, the need to vary the angles from which individual works were photographed, and the interest in depicting sculptural models of works in progress."[6] The radical viewing angles that Druet adopted in his pictures of *Main crispée* (Clenched hand), in around 1898 (plates 62–64), inspired the poet Rainer Maria Rilke (who was for a while Rodin's secretary) to write,

> There are among the works of Rodin hands, single small hands which without belonging to a body, are alive. Hands that rise, irritated and in wrath; hands whose five bristling fingers seem to bark like the five jaws of a dog of Hell. Hands that walk, sleeping hands, and hands that are awakened; criminal hands, tainted with hereditary disease; and hands that are tired and will do no more, and have lain down in some corner like sick animals that know no one can help them.[7]

In other pictures also from around 1898, of *Eve* (1881; plates 70, 71) and *Le Baiser* (The Kiss, 1898; plates 66–69), Druet portrays sculptural figures like characters in a stage performance. Whether dazzlingly lit or swathed in powerful chiaroscuro, the works seem animated with a drama unprecedented in pictures of Rodin's work.

In 1898, Steichen saw a photograph of Rodin's *Balzac* published in a Milwaukee newspaper. Two years later, inspired by this image, the young Steichen, then twenty-one, set out for the French capital, intending to meet the sculptor. The two men did meet a year later, at Rodin's home and studio in Meudon. Taking an immediate liking to Steichen, Rodin invited him back, and Steichen would visit Meudon every week for an entire year to study and photograph the sculptor among his works. Out of these sittings came his famous picture *Rodin—The Thinker* (1902; plate 72), which poses Rodin in dark silhouetted profile contemplating *Le Penseur* (The thinker, 1880–82), his alter ego, against the luminous *Monument à Victor Hugo* (Monument to Victor Hugo, 1901), a source of poetic inspiration and creativity. As Steichen explains in his autobiography, the studio was so crowded with marble blocks and works in clay, plaster, and bronze that it was impossible to take the picture in one shot. Instead he took two exposures, one of Rodin with *Victor Hugo* and another of *The Thinker*. He then printed each image separately. During processing, he reversed the direction of the negative showing Rodin, and having mastered the technique used to combine separate negatives, he sandwiched the two into a single image. The final picture attests to Steichen's control of the gum bichromate process and of its painterly effects.

Late in the summer of 1908, Rodin moved the plaster model for *Balzac* out of his studio and onto a specially built revolving platform outside in the garden at Meudon. Steichen was invited to photograph the sculpture, and when he found the plaster chalky-looking in daylight, Rodin suggested that he photograph it by moonlight instead. According to Steichen, he spent a whole night doing so: "I gave varying exposures from fifteen minutes to an hour and secured a number of interesting negatives."[8] Kirk Varnedoe noted that the three major pictures of the sculpture against the nocturnal landscape—*Balzac, the Open Sky—11:00 P.M.* (plate 74), *Balzac, towards the Light, Midnight* (plate 75), and *Balzac, the Silhouette—4 A.M.* (plate 76)—form a temporal series.[9] Even before seeing the proofs, Rodin offered Steichen 2,000 francs, and shortly thereafter three bronze sculptures, for taking the pictures. He told the young artist, "You will make the world understand my Balzac through your pictures. They are like Christ walking in the desert."[10] In the spring of 1909, Stieglitz's Little Galleries of the Photo-Secession (known as 291) in New York held a special exhibition of Steichen's photographs of *Balzac*. Later, in the issue of April–July 1911, three of these images were published in *Camera Work*, extending Rodin's sculpture fully into the world of art photography.

Notes

1. Albert E. Elsen writes, "In 1898, for example, [Rodin] could exhibit his proposed monument to Balzac and know that in a matter of weeks it would be reproduced photographically in Tokyo, Hanoi, London, New York, Algiers, Berlin, Stockholm, Prague, Buenos Aires and Milwaukee." Elsen, *In Rodin's Studio: A Photographic Record of Sculpture in the Making* (New York: Phaidon, 1980), p. 10.

2. See Hélène Pinet, *Rodin et La Photographie* (Paris: Éditions Gallimard/Musée Rodin, 2007), p. 11. Pinet remarks that since Rodin was born in 1840, just a year after the announcement of photography's invention, the collection of photographs he assembled reflects at once his career as a sculptor and the technical evolution of the photographic medium.

3. See Jane R. Becker, "Auguste Rodin and Photography: Extending the Sculptural Idiom," in Dorothy Kosinski, *The Artist and the Camera: Degas to Picasso* (Dallas: Dallas Museum of Art, 1999), p. 93. Becker specifies that when Rodin first exhibited photographs along with his sculptures, at the Musée Rath, Geneva, in an exhibition of 1896 that he shared with Eugène Carrière and Puvis de Chavannes, his intention was to use photographs to show more sculptures, not to provide additional images of the same subjects.

4. Elsen, *In Rodin's Studio*, p. 14.

5. Auguste Rodin, quoted in Elsen, *In Rodin's Studio*, p. 11. Originally published in *Camera Work*, October 1908.

6. Pinet, "Montrer est la question vitale: Rodin and photography," in Geraldine A. Johnson, ed., *Sculpture and Photography: Envisioning the Third Dimension* (Cambridge: at the University Press, 1998), p. 76.

7. Rainer Maria Rilke, quoted in Elsen, *In Rodin's Studio*, p. 173.

8. Edward Steichen, *A Life in Photography* (New York: Doubleday, 1963), n.p.

9. Kirk Varnedoe, "Rodin and Photography," in Elsen, ed., *Rodin Rediscovered* (Washington, D.C.: National Gallery of Art, 1981), p. 235.

10. Rodin, quoted in Penelope Curtis, *Sculpture 1900–1945: After Rodin* (Oxford and New York: Oxford University Press, 1999), p. 115.

63

64

63. Eugène Druet. French, 1868–1917
The Clenched Hand. Before 1898
Gelatin silver print, 11 ¾ x 15 ⁹⁄₁₆" (29.9 x 39.5 cm)
The Metropolitan Museum of Art, New York. Gilman Collection,
Purchase, Mr. and Mrs. Henry R. Kravis Gift

64. Eugène Druet. French, 1868–1917
Main crispée surgissant des plis d'une couverture (Clenched hand
emerging from the folds of a blanket). c. 1898
Gelatin silver print, 15 ¾ x 11 ¹³⁄₁₆" (40 x 30 cm)
Musée Rodin. Donation Auguste Rodin

65. Eugène Druet. French, 1868–1917
Le Désespoir (Despair). c. 1898
Gelatin silver print, 13 7/16 x 9 5/8" (34.2 x 24.5 cm)
Musée Rodin. Donation Auguste Rodin

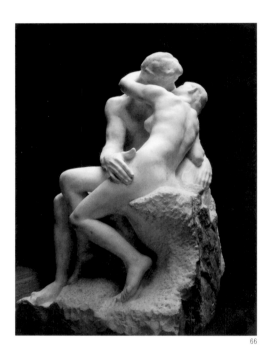

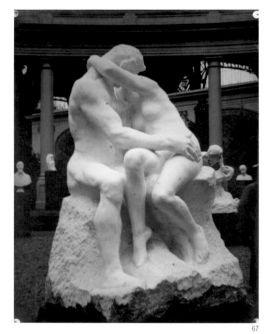

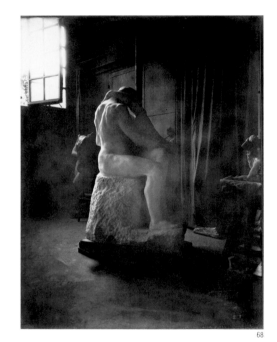

66. Jacques-Ernest Bulloz. French, 1858–1942
Le Baiser (The kiss). After 1903
Carbon print, 13 ⅞ x 10 ⁵⁄₁₆" (35.2 x 26.2 cm)
Musée Rodin. Donation Auguste Rodin

67. Eugène Druet. French, 1868–1917
Le Baiser au Salon de la Société Nationale des Beaux Arts (The
kiss at the salon of the Société Nationale des Beaux Arts). 1898
Gelatin silver print, 15 ⁹⁄₁₆ x 11 ¾" (39.6 x 29.9 cm)
Musée Rodin. Donation Auguste Rodin

68. Eugène Druet. French, 1868–1917
Le Baiser en marbre dans l'atelier du Dépôt des marbres (The
kiss in marble in the studio at the Dépôt des marbres). c. 1898
Gelatin silver print, 15 ¹¹⁄₁₆ x 11 ¹¹⁄₁₆" (39.8 x 29.7 cm)
Musée Rodin. Donation Auguste Rodin

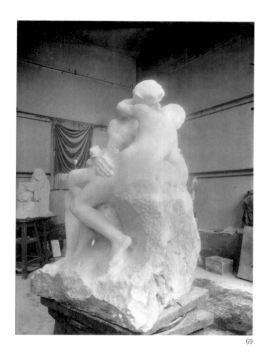

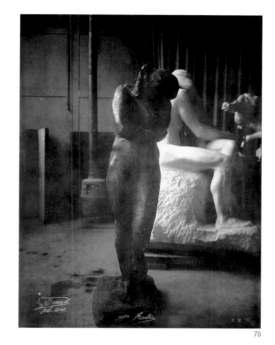

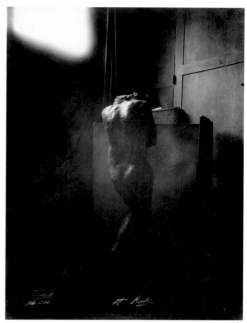

69

70

71

69. Eugène Druet. French, 1868–1917
Le Baiser en marbre dans l'atelier (The kiss in marble in
the studio). c. 1898
Gelatin silver print, 15 ¾ x 11 ⅝" (40 x 29.6 cm)
Musée Rodin. Donation Auguste Rodin

70. Eugène Druet. French, 1868–1917
Eve dans l'atelier du Dépôt des marbres (Eve in the studio
at the Dépôt des marbres). c. 1898
Gelatin silver print, 15 ¹¹⁄₁₆ x 11 ¹¹⁄₁₆" (39.8 x 29.7 cm)
Musée Rodin. Donation Auguste Rodin

71. Eugène Druet. French, 1868–1917
Eve en marbre dans l'atelier (Eve in marble in the studio). c. 1898
Gelatin silver print, 15 ¾ x 11 ⅝" (40 x 29.6 cm)
Musée Rodin. Donation Auguste Rodin

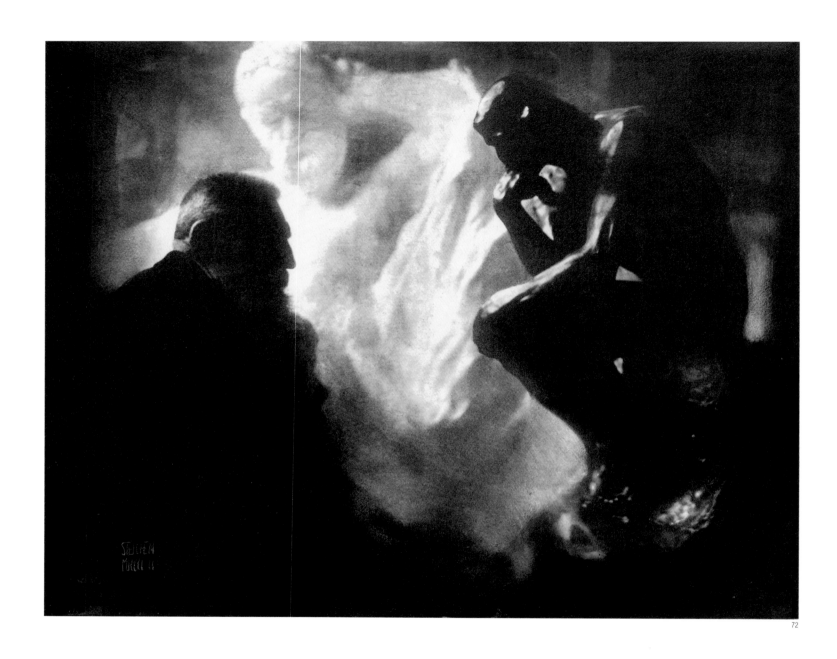

72. Edward Steichen. American, born Luxembourg, 1879–1973
Rodin—The Thinker. 1902
Gum bichromate print, 15 9/16 x 19" (39.6 x 48.3 cm)
The Metropolitan Museum of Art, New York. Gilman Collection,
Purchase, Harriette and Noel Levine Gift

73. Edward Steichen. American, born Luxembourg, 1879–1973
Midnight—Rodin's Balzac. 1908
Pigment print, 12 ⅛ x 14 ⅝" (30.8 x 37.1 cm)
The Museum of Modern Art, New York. Gift of the photographer

74. Edward Steichen. American, born Luxembourg, 1879–1973
Balzac, the Open Sky—11:00 P.M. 1908 (printed 1909)
Direct carbon print, 19 3/16 x 15 3/16" (48.7 x 38.5 cm)
The Metropolitan Museum of Art, New York. Alfred Stieglitz Collection

75. Edward Steichen. American, born Luxembourg, 1879–1973
Balzac, towards the Light, Midnight. 1908
Direct carbon print, 14 3/8 x 19" (36.5 x 48.2 cm)
The Metropolitan Museum of Art, New York. Alfred Stieglitz Collection

76. Edward Steichen. American, born Luxembourg, 1879–1973
Balzac, the Silhouette—4 A.M. 1908
Gum bichromate print, 14 ¹⁵⁄₁₆ x 18 ⅛" (37.9 x 46 cm)
The Metropolitan Museum of Art, New York. Alfred Stieglitz Collection

77

77. Constantin Brancusi. French, born Romania, 1876–1957
Le Nouveau-Né II (bronze poli) (Newborn II [polished bronze]). c. 1925
Gelatin silver print, 9 ⅜ x 11 ¹³⁄₁₆" (23.8 x 30 cm)
Centre Pompidou, Musée national d'art moderne–Centre de création
industrielle, Paris. Brancusi Bequest

IV. CONSTANTIN BRANCUSI: THE STUDIO AS *GROUPE MOBILE* AND THE *PHOTOS RADIEUSES*

On April 12, 1956, less than a year before his death, Constantin Brancusi bequested the holdings of his studio to the government of France, on behalf of the Musée national d'art moderne, Paris, with the following stipulation: "This bequest is made with the understanding that the French government shall reconstruct . . . a studio to contain my works, both finished and roughed out, as well as workbenches, tools, and furniture."[1] The clause is critical: it reveals the importance that Brancusi conferred on the studio as an experimental laboratory. In this combination of home, workshop, and exhibition gallery, the space around the finished and unfinished works— polished, finely tuned sculptures, plaster drums, jagged stone blocks, wooden stools and benches, casts, uncut timbers—was for Brancusi a work of art in its own right. In 1926, during his first trip to New York, on seeing the Manhattan skyline as his ship was approaching the harbor, he remarked, "Why, it is my studio. Nothing fixed, nothing rigid. All these blocks, all these shapes to be shifted and juggled with, as the experiment grows and changes."[2] Clearly Brancusi envisioned his studio as a large-scale site-specific installation.

Brancusi's studio was large, amalgamating not only his first atelier, rented in 1916 on the impasse Ronsin, but four more, all added to the original loft by 1941. This dynamic space was articulated around hybrid, transitory configurations that Brancusi called "*groupes mobiles*" (mobile groups), each comprising several pieces of sculpture, bases, and pedestals grouped in proximity. The American artist Scott Burton, in his inspiring essay "My Brancusi," calls Brancusi's studio a "Duchampian set."[3] This is a perceptive analogy, justifying Brancusi's special

fig. 1. Constantin Brancusi. *Self-Portrait in the Studio*. 1922. Gelatin silver print, 14 5/16 x 11 5/16" (36.4 x 28.8 cm). The Museum of Modern Art, New York. Gift of Elizabeth Lorentz

interest in two of Duchamp's works: *Fountain* (1917; plate 104), which nods to his own androgynous *Princesse X* (Princess X, 1916; plate 82), and *Boîte-en-valise (de ou par Marcel Duchamp ou Rrose Sélavy)* (Box in a valise [From or by Marcel Duchamp or Rrose Sélavy], 1935–41; plate 103), a miniature proxy for the artist's studio, containing reproductions of many of Duchamp's works and one original. The mise-en-scène of both studios reflects the two artists' sensibilities as "*tranformateur(s) Du Champ*."[4]

Furthermore, Brancusi's pictures of his studio (fig. 1) cast light on how his works should be seen and interpreted. Assembling and reassembling his sculptures for the camera, he transformed each unique work into multiples. Temporary configurations such as *Vue d'atelier: L'Enfant au monde, groupe mobile* (View of the studio: The child in the world, mobile group, 1917; plate 96), *Le Coq et La Muse endormie* (Cock and Sleeping muse, 1925), *Tête d'enfant endormi (plâtre coloré)*, *Le Nouveau-Né II* (Head of a sleeping child [colored plaster], Newborn II, c. 1923; plate 101), *L'Atelier avec Eve, Platon, et L'Oiseau d'or* (The artist's studio with Eve, Plato, and Golden bird, 1922; plate 87), and *Socrate et La Coupe* (Socrates and Cup, 1922) are no longer extant but survive in the artist's photographs. Photography serves as a diary of his sculptural permutations. Two sequential views of the studio taken around 1923 (plates 91, 92) look at first glance identical, but on closer scrutiny, subtle displacements and substitutions emerge that reflect the brief existence of his transient groupings. When compared to plate 92, plate 91 is a tighter, close-up frame, which describes the following changes: the rotation of *Princesse X* to the right, the shift of *La Sorcière* (The sorceress, 1916–24) to the

fore, and the addition of a marble version of *L'Oiseau dans l'espace* (Bird in space, 1923). If in the real world a sculpture may belong to one arrangement only, photography enables combinations of the same piece in different configurations, positions, and orientations. Friedrich Teja Bach observes that through photography Brancusi conveyed "the dimension of an *ars combinatoria*." "Only photography," he says, "shows that Brancusi belongs with the great combinatorialists of modernism, [Erik] Satie, [Arnold] Schönberg, [Stéphane] Mallarmé and [James] Joyce."[5]

An enthusiast of film, Brancusi owned a 16mm movie camera, which, however, he used only to produce stills. He subscribed to film and photography journals and his library featured catalogues of photographic supplies and technical treatises. The nearly 700 negatives (565 glass plates and 130 nitrates) and over 1,600 original prints that he left at the time of his death confirm the important role photography played for him as a tool of interpretation. "Why write?" he once queried. "Why not just show the photographs?"[6] It has been noted that Brancusi's photographs of his sculptures constitute a visual journal as integral to the comprehension of his oeuvre "as Delacroix's journal or Van Gogh's letters were to their painting."[7]

Brancusi included many great photographers among his friends—Edward Steichen was one of his early champions in the United States; Alfred Stieglitz organized his first solo exhibition in New York, at 291 in 1914; Man Ray helped him buy photographic equipment; Berenice Abbott studied sculpture under him; and he was on close terms with Bill Brandt, Brassaï, André Kertész, László Moholy-Nagy, Paul Outerbridge, and Charles Sheeler. Yet he declined to have

fig. 2. Man Ray and Constantin Brancusi with Brancusi's *Endless Column* in Edward Steichen's garden in Voulangis, France, fall 1927. Still from a film by Man Ray. Centre Pompidou, Musée national d'art moderne–Centre de création industrielle, Paris

his work photographed by others, preferring instead to take, develop, and print his own pictures. In a possibly apocryphal but often recited episode, a photographer asked Brancusi for permission to document his work. The sculptor agreed but shortly afterward noticed that his polished bronzes had lost their glowing aura. The photographer explained that he had had to cover them with a powder to avoid reflections. Infuriated, Brancusi threw the man out of the studio.[8] He remained famously dissatisfied with pictures taken by professional photographers, arguing that they "did not represent his work."[9]

Pushing photography against its grain, Brancusi developed an aesthetic antithetical to the usual photographic standards. According to Man Ray, he often made "out of focus, over or under exposed, scratched and spotty" prints, insisting that this is "the way his work should be reproduced."[10] In numerous pictures of his gleaming bronzes, such as *Mademoiselle Pogany II* (1920; plate 84), *L'Oiseau dans l'espace (bronze poli)* (Bird in space

[polished bronze], c. 1929, plate 78, and c. 1932, plate 81), *Vue d'atelier: Le Nouveau-Né II (bronze poli)* (View of the studio: Newborn II [polished bronze], c. 1929; plate 85), *L'Oiseau d'or* (Golden bird, c. 1919; plate 80), and *La Négresse blonde vue de face (bronze poli)* (The blond negress viewed from the front [polished bronze], 1926; plate 83), Brancusi calculated the "incidence of light to enhance the effect of a high polish."[11] Known as *photos radieuses* (radiant photos), these pictures are characterized by flashes of light that explode the sculptural gestalt. In other cases, including *Projet d'architecture* (Architectural project, 1918; plate 90) and *Le Commencement du monde* (The beginning of the world, c. 1920; plate 98), Brancusi used several sources of illumination, casting shadows that replicate and disrupt the material integrity of the sculptures. In search of transparency, kineticism, and infinity, Brancusi used photography and polishing techniques to dematerialize the static, monolithic materiality of traditional sculpture, visualizing what Moholy-Nagy called "the new culture of light."[12]

Brancusi's understanding of the transcendent dimensions of his sculptures finds expression in several pictures of the *Colonne sans fin (Endless column)*. In *La Colonne sans fin de Voulangis* (Endless column in Voulangis, 1927; plate 86), a low-angle view taken in Edward Steichen's garden (fig. 2), not far from Paris, Brancusi conveys the idea of infinity by setting the column's rhythmically pulsating modules against the expanse of the sky. Shooting the column from its middle section up, he gives it a soaring stature and a cosmic dimension, the sense of an axis mundi, a connection point between earth and sky. In another picture, *Autoportrait dans l'atelier: Les Colonnes sans fin I à IV, Le Poisson, Leda* (Self-portrait in the studio: Endless Columns I to IV, Fish, Leda, c. 1934; plate 93), Brancusi portrays himself sitting on a plaster drum, facing the camera, a remote shutter-release cable in his hand. Behind him cluster four *Endless Columns*, one of them shooting straight up from the middle of his head. If the image conveys the mental energy necessary for artistic production, it also performs a deliberate infraction of one of the basic rules of photography.[13] In this sense Brancusi prefigures strategies used by Conceptual artists in the 1960s: think of John Baldessari's *Wrong* of 1967, a photograph humorously showing the artist standing in front of a palm tree that seems to grow out of the middle of his head. Beneath the pictures is inscribed the word "wrong."

Brancusi used photography, then, not only as an analytical apparatus but as metaphor. Highly composed, his pictures make visible that which is not immediately perceptible. *Le Nouveau-Né II (bronze poli)* (Newborn II [polished bronze], c. 1925; plate 77)

juxtaposes a close-up view of the polished bronze ovoid with a magnifying glass, an instrument of precision optics. With its handle pointing toward the viewer's side, the glass invites one to look closer at the blurred, anamorphic view of the studio, a world in a perpetual state of flux, here mirrored in the perfectly polished body of *Le Nouveau-Né II*. "The studio as a whole," Teja Bach suggests, "is thus defined as a place of rebirth," which means that "photography endows Brancusi's entire work with the character of something newborn."[14] The image thematizes many of the tensions at the crux of Brancusi's production: purity of sculptural form and pregnant impurity, integrity of structure and incoherence of surface, clarity of the visual field and spatial distortion. If, as often said, Brancusi "invented" modern sculpture,[15] his use of photography belongs to a reevaluation of sculpture's modernity.

Notes

1. Constantin Brancusi, quoted in Pontus Hulten, Natalia Dumitresco, and Alexandre Istrati, *Brancusi* (New York: Harry N. Abrams, 1987), p. 262.

2. Brancusi, quoted in Dorothy Dudley, "Brancusi," *The Dial* LXXXII (February 1927):130.

3. Scott Burton, "My Brancusi," *Artist's Choice*, exh. brochure (New York: The Museum of Modern Art, 1989), n.p.

4. Jean-François Lyotard, quoted in John Rajchman, "Foreword," in Thierry de Duve, *Pictorial Nominalism: On Marcel Duchamp's Passage from Painting to the Readymade* (Minneapolis: University of Minnesota Press, 1991), p. xiii.

5. Friedrich Teja Bach, *Brancusi: Photo Reflexion* (Paris: Didier Imbert Fine Art, 1991), p. 129.

6. Brancusi, quoted in Robert Payne, "Constantin Brancusi," *World Review* (October 1949):63.

7. Isabelle Monod-Fontaine and Marielle Tabart, *Brancusi Photographer* (New York: Agrinde Publications, 1979), p. 12.

8. See, e.g., Isac Pascal, "Atelierul din Paris," *Arta* 19, no. 10 (1972):38.

9. Speaking of a picture taken by Alfred Stieglitz of work in Brancusi's exhibition at 291, the sculptor told Man Ray, "The photograph is beautiful, but it does not represent my work." Brancusi, quoted in Man Ray, *Self Portrait* (Boston: Little, Brown, 1963), p. 208.

10. Man Ray, *Self Portrait*, p. 209.

11. Teja Bach, "Brancusi and Photography," in Teja Bach, Margit Rowell, and Ann Temkin, *Constantin Brancusi, 1876–1957* (Philadelphia: Philadelphia Museum of Art, and Cambridge, Mass., and London: The MIT Press, 1995), p. 314.

12. László Moholy-Nagy, quoted in Paul Paret, "Sculpture and Its Negative: The Photographs of Constantin Brancusi," in Geraldine A. Johnson, *Sculpture and Photography: Envisioning the Third Dimension* (Cambridge: at the University Press, 1998), p. 105.

13. See Elizabeth A. Brown, *Brancusi Photographs Brancusi* (London: Thames & Hudson, 1995), p. 14.

14. Teja Bach, "Brancusi and Photography," p. 314.

15. See, e.g., Tabart, *Brancusi. L'Inventeur de la sculpture moderne* (Paris: Découvertes Gallimard/ Centre Georges Pompidou, 1995).

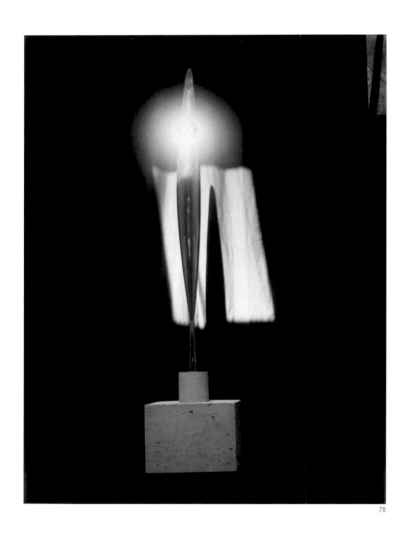

78

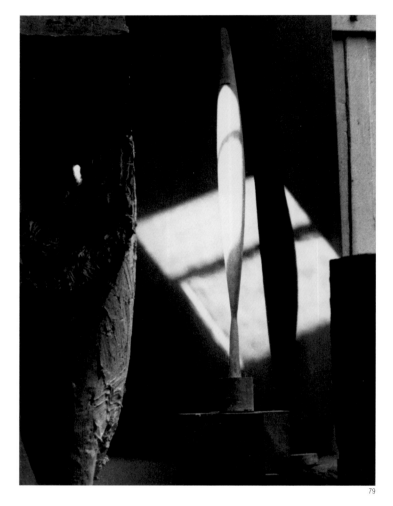

79

78. Constantin Brancusi. French, born Romania, 1876–1957
L'Oiseau dans l'espace (bronze poli) (Bird in space [polished bronze]). c. 1929
Gelatin silver print, 15 ¹¹⁄₁₆ x 11 ¹¹⁄₁₆" (39.8 x 29.7 cm)
Centre Pompidou, Musée national d'art moderne–Centre de création
industrielle, Paris. Brancusi Bequest

79. Constantin Brancusi. French, born Romania, 1876–1957
L'Oiseau dans l'espace (marbre blanc) (Bird in space [white marble]). c. 1932
Gelatin silver print, 9 ⁷⁄₁₆ x 7 ¹⁄₁₆" (23.9 x 18 cm)
Centre Pompidou, Musée national d'art moderne–Centre de création
industrielle, Paris. Brancusi Bequest

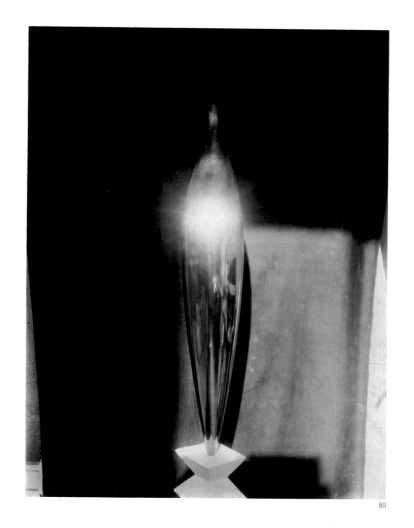

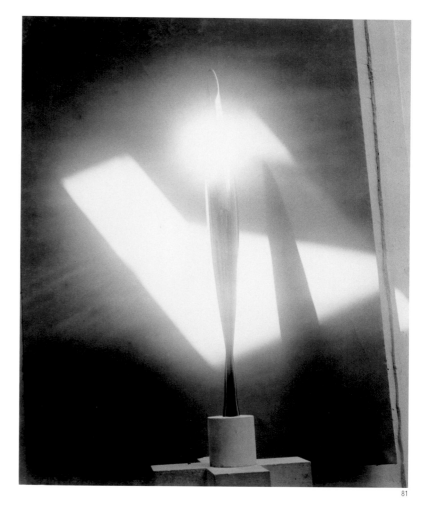

80. Constantin Brancusi. French, born Romania, 1876–1957

L'Oiseau d'or (Golden bird). c. 1919

Gelatin silver print, 9 x 6 ¹¹⁄₁₆" (22.8 x 17 cm)

The Museum of Modern Art, New York. Thomas Walther Collection. Purchase

81. Constantin Brancusi. French, born Romania, 1876–1957

L'Oiseau dans l'espace (bronze poli) (Bird in space [polished bronze]). c. 1932

Gelatin silver print, 10 ⁹⁄₁₆ x 9 ⁷⁄₁₆" (26.9 x 23.9 cm)

Centre Pompidou, Musée national d'art moderne–Centre de création

industrielle, Paris. Brancusi Bequest

82

83

82. Constantin Brancusi. French, born Romania, 1876–1957
Princesse X (Princess X). c. 1930
Gelatin silver print, 15 ¹¹⁄₁₆ X 11 ⅝" (39.8 x 29.6 cm)
Centre Pompidou, Musée national d'art moderne–Centre de création
industrielle, Paris. Brancusi Bequest

83. Constantin Brancusi. French, born Romania, 1876–1957
La Négresse blonde vue de face (bronze poli) (The blond negress viewed
from the front [polished bronze]). 1926
Gelatin silver print, 11 ¼ x 7 ¹⁄₁₆" (28.6 x 17.9 cm)
Centre Pompidou, Musée national d'art moderne–Centre de création
industrielle, Paris. Brancusi Bequest

84

85

84. Constantin Brancusi. French, born Romania, 1876–1957
Mademoiselle Pogany II. 1920
Gelatin silver print, 9 1/16 x 6 3/4" (23 x 17.1 cm)
Private collection

85. Constantin Brancusi. French, born Romania, 1876–1957
Vue d'atelier: Le Nouveau-Né II (bronze poli) (View of the studio: Newborn II
[polished bronze]). c. 1929
Gelatin silver print, 9 7/16 x 7" (23.9 x 17.8 cm)
Centre Pompidou, Musée national d'art moderne—Centre de création
industrielle, Paris. Brancusi Bequest

86. Constantin Brancusi. French, born Romania, 1876–1957
La Colonne sans fin de Voulangis (Endless column in Voulangis). Fall 1927
Gelatin silver print, 19 15/16 x 23 ¾" (50.6 x 60.3 cm)
Centre Pompidou, Musée national d'art moderne–Centre de création
industrielle, Paris. Brancusi Bequest

87. Constantin Brancusi. French, born Romania, 1876–1957
L'Atelier avec Eve, Platon, et L'Oiseau d'or (The artist's studio with Eve,
Plato, and Golden bird). 1922
Gelatin silver print, 15 ¾ x 11 ½" (40 x 29.2 cm)
The Museum of Modern Art, New York. Gift of Elizabeth Lorentz

87

88

89

90

88. Constantin Brancusi. French, born Romania, 1876–1957
Ombres (Shadows). c. 1920
Gelatin silver print, 11 ¾ x 9 ⁷⁄₁₆" (29.8 x 23.9 cm)
Centre Pompidou, Musée national d'art moderne–Centre de création
industrielle, Paris. Brancusi Bequest

89. Constantin Brancusi. French, born Romania, 1876–1957
Le Miracle (Le Phoque) (Miracle [Seal]). 1937
Gelatin silver print, 9 ⅛ x 6 ¹⁵⁄₁₆" (23.1 x 17.6 cm)
Kunsthaus Zürich, Fotosammlung. Donation Carol Giedion-Welcker

90. Constantin Brancusi. French, born Romania, 1876–1957
Projet d'architecture (Architectural project). 1918
Gelatin silver print, 11 ⅜ x 8 ¼" (28.9 x 20.9 cm)
Centre Pompidou, Musée national d'art moderne–Centre de création
industrielle, Paris. Brancusi Bequest

91

91. Constantin Brancusi. French, born Romania, 1876–1957

*Vue d'ensemble de l'atelier: L'Oiseau dans l'espace (plâtre), L'Oiseau dans l'espace
(marbre jaune), La Sorcière, Platon, Socrate, Princesse X* (Overall view of the
studio: Bird in space [plaster], Bird in space [yellow marble], The sorceress,
Plato, Socrates, Princess X). c. 1923–24
Gelatin silver print, 11 ¹¹⁄₁₆ x 9 ⅜" (29.7 x 23.8 cm)
Centre Pompidou, Musée national d'art moderne–Centre de création
industrielle, Paris. Brancusi Bequest

92

92. Constantin Brancusi. French, born Romania, 1876–1957
Vue d'ensemble de l'atelier: L'Oiseau dans l'espace (plâtre), La Sorcière,
Platon, Socrate, Princesse X (Overall view of the studio: Bird in space
[plaster], The sorceress, Plato, Socrates, Princess X). c. 1923–24
Gelatin silver print, 15 ¹¹⁄₁₆ x 11 ¾" (39.9 x 29.8 cm)
Centre Pompidou, Musée national d'art moderne–Centre de création
industrielle, Paris. Brancusi Bequest

93

93. Constantin Brancusi. French, born Romania, 1876–1957
Autoportrait dans l'atelier: Les Colonnes sans fin I à IV, Le Poisson, Leda
(Self-portrait in the studio: Endless Columns I to IV, Fish, Leda). c. 1934
Gelatin silver print, 15 ⅝ x 11 ¹¹⁄₁₆" (39.7 x 29.7 cm)
Centre Pompidou, Musée national d'art moderne—Centre de création
industrielle, Paris. Brancusi Bequest

94. Constantin Brancusi. French, born Romania, 1876–1957
Vue d'atelier: Les Colonnes sans fin I à III, Le Poisson (View of the studio:
Endless columns I to III, Fish). c. 1933
Gelatin silver print, 11 ⅝ x 9 ⅜" (29.6 x 23.8 cm)
Centre Pompidou, Musée national d'art moderne—Centre de création
industrielle, Paris. Brancusi Bequest

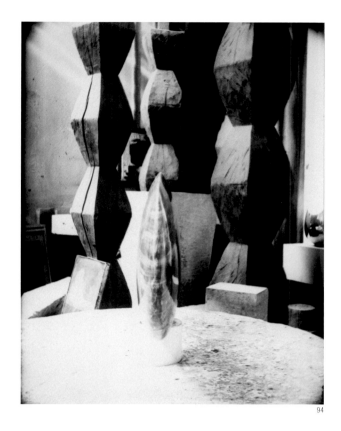

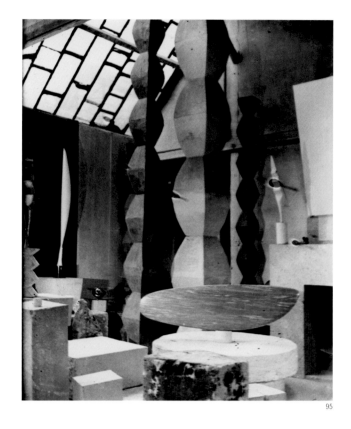

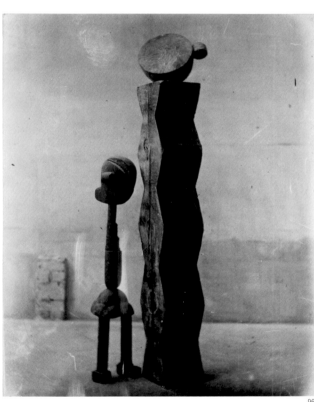

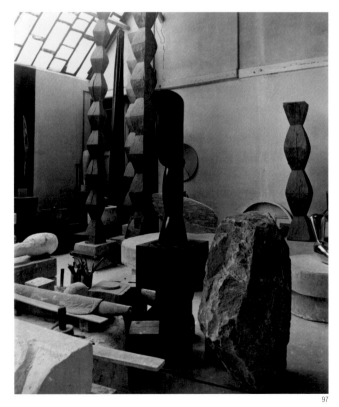

95. Constantin Brancusi. French, born Romania, 1876–1957
Vue d'atelier: Le Coq, L'Oiseau dans l'espace (marbre blanc), Colonnes sans fin I à IV, Le Poisson (View of the studio: The cock, Bird in space [white marble], Endless columns I to IV, Fish). c. 1935
Gelatin silver print, 11 ¾ x 9 ⁵⁄₁₆" (29.8 x 23.7 cm)
Centre Pompidou, Musée national d'art moderne–Centre de création industrielle, Paris. Brancusi Bequest

96. Constantin Brancusi. French, born Romania, 1876–1957
Vue d'atelier: L'Enfant au monde, groupe mobile (View of the studio: The child in the world, mobile group). Before December 27, 1917
Gelatin silver print, 11 ⅞ x 9 ⁷⁄₁₆" (30.1 x 23.9 cm)
Centre Pompidou, Musée national d'art moderne–Centre de création industrielle, Paris. Brancusi Bequest

97. Constantin Brancusi. French, born Romania, 1876–1957
Vue d'atelier: L'Oiseau dans l'espace (bronze poli), Colonnes sans fin I à III, Le Poisson, Mademoiselle Eugene Meyer Jr. (View of the studio: Bird in space [polished bronze], Endless columns I to III, Fish, Mademoiselle Eugene Meyer Jr.). After 1930
Gelatin silver print, 11 ¾ x 9 ⁵⁄₁₆" (29.9 x 23.7 cm)
Centre Pompidou, Musée national d'art moderne–Centre de création industrielle, Paris. Brancusi Bequest

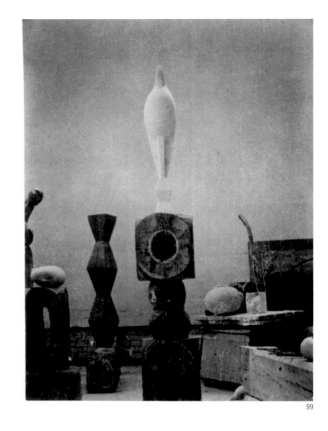

98

99

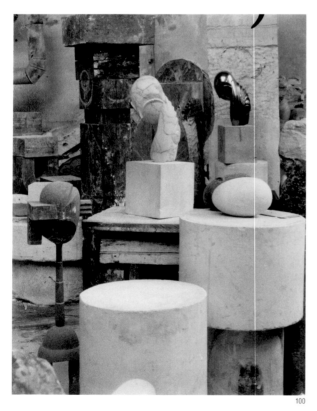

100

101

98. Constantin Brancusi. French, born Romania, 1876–1957
Le Commencement du monde (The beginning of the world). c. 1920
Gelatin silver print, 11 ¾ x 9 ⁷⁄₁₆" (29.8 x 23.9 cm)
Centre Pompidou, Musée national d'art moderne–Centre de création industrielle, Paris. Brancusi Bequest

99. Constantin Brancusi. French, born Romania, 1876–1957
Vue d'atelier: Maiastra, Princesse X, Petite Colonne, La Muse endormie II
(View of the studio: Maiastra, Princess X, Small column,
Sleeping muse II). Before December 1917
Gelatin silver print, 9 ⁷⁄₁₆ x 7" (23.9 x 17.8 cm)
Centre Pompidou, Musée national d'art moderne–Centre de création industrielle, Paris. Brancusi Bequest

100. Constantin Brancusi. French, born Romania, 1876–1957
Vue d'atelier: Mademoiselle Pogany II (marbre veiné), (bronze poli);
Le Baiser (pilastre) (View of the studio: Mademoiselle Pogany II [veined marble], [polished bronze]; The kiss [pilaster]). c. 1920
Gelatin silver print, 9 x 6 ¹¹⁄₁₆" (22.9 x 17 cm)
Centre Pompidou, Musée national d'art moderne–Centre de création industrielle, Paris. Brancusi Bequest

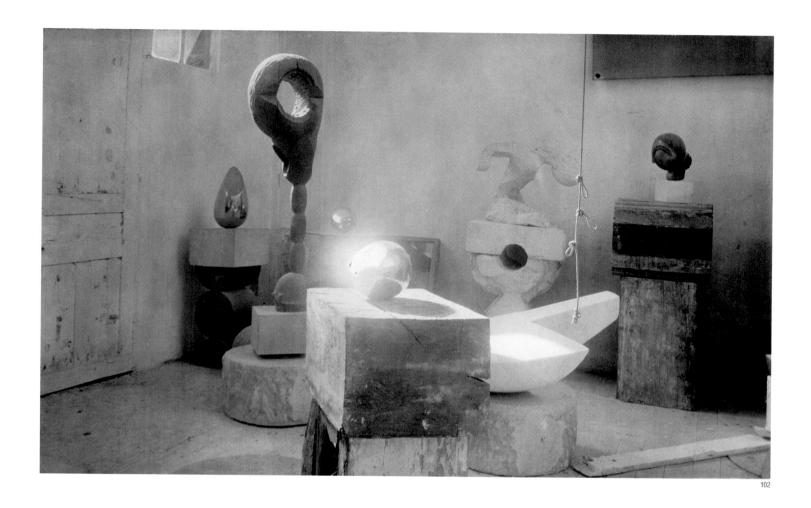

102

101. Constantin Brancusi. French, born Romania, 1876–1957
Tête d'enfant endormi (plâtre coloré), Le Nouveau-Né II (Head of a sleeping child [colored plaster], Newborn II). c. 1923
Gelatin silver print, 7 1/16 x 9 7/16" (18 x 23.9 cm)
Centre Pompidou, Musée national d'art moderne–Centre de création industrielle, Paris. Brancusi Bequest

102. Constantin Brancusi. French, born Romania, 1876–1957
Vue du fond de l'atelier: La Nouveau-Né II, L'Oiselet, Socrate, La Fontaine de Narcisse, La Tortue volante (View of the back of the studio: Newborn II, Young bird, Socrates, Narcissus fountain, Flying turtle). c. 1945–46
Gelatin silver print, 5 7/8 x 9 7/16" (15 x 23.9 cm)
Centre Pompidou, Musée national d'art moderne–Centre de création industrielle, Paris. Brancusi Bequest

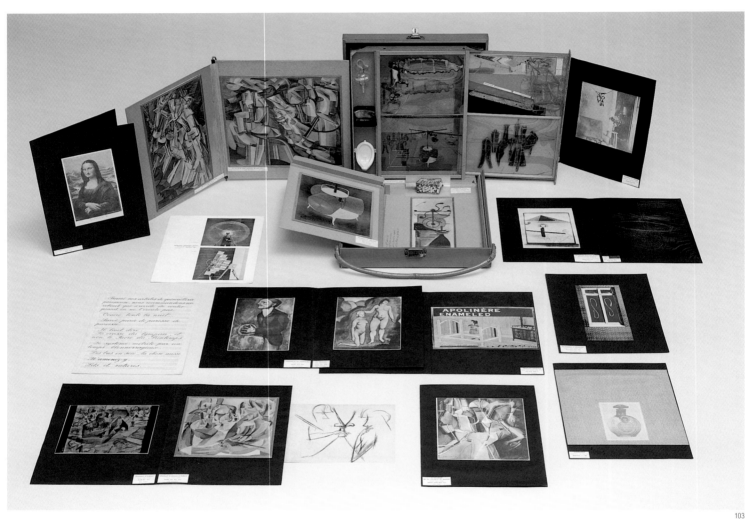

103. Marcel Duchamp. American, born France, 1887–1968
Boîte-en-valise (de ou par Marcel Duchamp ou Rrose Sélavy) (Box in a valise [From
or by Marcel Duchamp or Rrose Sélavy]). 1935–41 (this box inscribed "Jan 1943"
and including an original inscribed "1938")
Leather valise containing miniature replicas, photographs, color reproductions of
works by Duchamp, and one "original" drawing (*Large Glass*, collotype on celluloid,
7 ½ x 9 ½" [19 x 23.5 cm]), 16 x 15 x 4" (40.7 x 38.1 x 10.2 cm)
The Museum of Modern Art, New York. James Thrall Soby Fund

V. MARCEL DUCHAMP'S *BOX IN A VALISE*: THE READYMADE AS REPRODUCTION

In 1913, Marcel Duchamp jotted down the following note: "Can one make works which are not works of 'art'?"[1] That same year he conceived his first readymade, *Bicycle Wheel*, immediately altering the definition of what constitutes an art object. The readymade implies specific terms according to which a common object is transformed into an art object when the artist renames and signs the object, displaces it from its ordinary context, and restricts the frequency of these actions.[2] Since most of the readymades that Duchamp originally chose have been lost, we know them either through later replicas or through photographs. The correlation between the original work and its reproduction in various forms was fully at play in Duchamp's practice by 1916, when he made a full-scale, hand-colored photographic replica of his painting *Nude Descending a Staircase* (1912) for the American art patron Walter Arensberg, who had missed the opportunity to acquire the painting when it was first exhibited, at the New York Armory Show in 1913.[3] In 1918 Duchamp abandoned the traditional medium of oil painting on canvas, focusing instead on the production of readymades, optical experiments (plates 111, 112), and moving images.

Two photographs of Duchamp's studio (located on the third floor of the Arensbergs' apartment building at 33 West 67th Street in Manhattan), taken in 1917–18 (fig. 1, plate 107), provide a fascinating view into how the readymades were installed there: a bicycle wheel was curiously mounted atop a kitchen stool; a hat rack was suspended from the ceiling; a typewriter cover nested nothing but air; a coat rack was treacherously nailed to the floor; and a urinal hung implausibly from a doorjamb. The

fig. 1. Marcel Duchamp. *Marcel Duchamp's Studio at 33 West 67th Street*. 1917–18. Printed in 1958 in *Box in a Valise (From or by Marcel Duchamp or Rrose Sélavy)*, Series C. Collotype with pochoir coloring on tinted card, 4 ¾ x 8 ⁷⁄₁₆" (12 x 21.5 cm). The Museum of Modern Art Library, New York

irrationality of the spatial organization is intensified by the off-kilter view taken by the camera and, in plate 107, by the ghostly presence of Duchamp himself. Photography played a critical role in Duchamp's deployment of readymades and installations. It was a medium he reckoned with in its own right, as proved by his pointed response to a question from Alfred Stieglitz in 1922, "Can a photograph have the significance of art?" "Dear Stieglitz," Duchamp answered,

Even a few words I don't feel like writing. You know exactly what I think of photography. I would like to see it make people despise painting until something else will make photography unbearable. There we are. Affectionately

Marcel Duchamp
17 May 1922, New York.[4]

In 1917, Duchamp submitted a simple, unaltered porcelain urinal—turned upside down, flagrantly signed "R. Mutt," dated, and titled *Fountain*—to an exhibition of the Society of Independent Artists. A board member of the society, Duchamp presumably submitted the piece under the pseudonym R. Mutt to protect his identity. Although the organization—modeled on the Société des Artistes Indépendants of Paris—had stated that it would exhibit all works submitted (its dictum was "No jury, no prizes"), it rejected *Fountain* as a plain piece of plumbing. Censored from the catalogue and the show (though it remained there for a while, behind a partition), at some point *Fountain* was moved to Stieglitz's 291 gallery, where it was put on display for a week. It then disappeared, its subsequent whereabouts being unrecorded and unknown,

but during its time at 291 Stieglitz took the photograph that would become the source for all future analysis of the work (plate 104). Published in the May 1917 issue of the satirical Dada review *The Blind Man* (fig. 2), the picture appeared with the caption "The exhibit refused by the Independents." It was accompanied by an unsigned editorial, "The Richard Mutt Case";[5] a poem by the artist Charles Demuth, "For Richard Mutt"; and an essay by Louise Norton, "The Buddha of the Bathroom." Norton's title referred as much to the picture of the readymade as to the object itself. Stieglitz had photographed *Fountain* against the backdrop of Marsden Hartley's painting *The Warriors* (1913). The canvas was shot at close range, so that its edges remain unseen, but the undulating lines of its composition subtly echo the Buddha-like configuration of the upended urinal. Carefully lighted to reveal its sculptural qualities and enigmatic allure, the porcelain bowl is transformed into an anthropomorphic figure.

The humor manifest in *Fountain* was central to Duchamp's readymades. A couple of years later, he conceived *Readymade malheureux* (Unhappy readymade; plate 114) as a wedding gift for his sister, Suzanne, and his close friend Jean Crotti. Because Duchamp would miss the wedding—he was living in Buenos Aires at the time—he sent the couple instructions on how the piece was to be made. In an interview with Pierre Cabanne, he explained,

fig. 2. Spread from *The Blind Man* no. 2 (May 1917), showing Alfred Stieglitz's photograph of Marcel Duchamp's *Fountain*, 1917. Philadelphia Museum of Art. The Louise and Walter Arensberg Collection

> It was a geometry book, which [Crotti] had to hang by strings on the balcony of his apartment in the rue Condamine; the wind had to go through the book, choose its own problems, turn and tear out the pages. Suzanne did a small painting of it, "Marcel's Unhappy Readymade." That's all that's left, since the wind tore it up. It amused me to bring the idea of the happy and unhappy into readymades, and then the rain, the wind, the pages flying.[6]

Although the work was destroyed by the elements, Suzanne photographed it and sent a print to Duchamp. Like the photograph of Duchamp's *Sculpture de voyage* (Sculpture for traveling, 1918; plate 106),[7] the picture illuminates Duchamp's shift from traditional static sculpture to impermanent moving forms. Duchamp reprinted the photograph in 1940 (plate 114), adding lines of text and geometrical diagrams to the blank pages of the book, and included it in his *Boîte-en-valise (de ou par Marcel Duchamp ou Rrose Sélavy)* (Box in a valise [From or by Marcel Duchamp or Rrose Sélavy], 1935–41; plate 103), his miniature, portable museum of his principal works.

Duchamp also used photography to devise other ideas for sculpture. In 1918, right before leaving New York for Buenos Aires, he produced *Sculpture de voyage*, an assemblage of rubber bathing caps cut into uneven strips and stretched in midair from various corners of his studio. Easy to carry and reassemble, the piece went with Duchamp to Argentina. It was not intended to last, however, and after it fell apart, only a few photographs preserved its transient existence. In these pictures Duchamp highlighted the work's sense of spatial disorientation by cropping out the sections where the strings connect to the walls. Inspired by the spidery, antigestalt shadows that the sculpture cast on the studio's walls, Duchamp thought of taking another picture made entirely of shadows. Turning the entire space into a maze, his photograph *Ombres portées* (Cast shadows, 1918; plate 108)[8] includes the silhouette of *Sculpture de voyage* and the shadows cast by several readymades, including *Bicycle Wheel*, *Hat Rack* (1917), and *With Hidden Noise* (1918).

The disarray of Duchamp's studio did not go unnoticed by his contemporaries. Georgia O'Keeffe notes that during one of her visits "it was a lot of something else in the middle of the room and the dust everywhere was so thick that it was hard to believe."[9] Duchamp delighted in the idea of breeding dust. In a note for *The Green Box* of 1934, he wrote, "to raise dust on Dust Glasses for 4 months. 6 months. Which you close up afterwards hermetically."[10] For *Élevage de poussière* (Dust breeding, 1920; plate 109), Man Ray photographed Duchamp's *Large Glass* after it had accumulated several months-worth of dust. Made using a one-hour exposure in artificial light, the picture is shot in angled close-up, conveying the strange effect of an aerial view of a desertscape. When it was first published, in the Dada journal *Littérature* of October 1922, it included the caption, "Here is the estate of Rrose Sélavy. How arid it is—how fertile it is—how joyous it is—how sad it is!" and was signed "Vue prise en aeroplane by Man Ray" (View taken from an airplane by Man Ray). In another note for *The Green Box*, Duchamp toyed with a subtitle for the *Large Glass* that would suggest a photographic analogy: "Kind of Sub-Title. *Delay in Glass*. Use 'delay' instead of 'picture' or 'painting'; 'picture on glass' becomes 'delay in glass.'"[11] Jean Clair notes that Duchamp's reference to a "delay in glass" is indicative of his view of the *Large Glass* as "a giant photographic plate."[12]

Duchamp's thinking on photography and other forms of mechanical reproduction in relation to his readymades is fully exemplified in the *Boîte-en-valise*. Begun in 1935 and produced as a multiple, the *Boîte-en-valise* contains sixty-nine miniature

replicas and photographic reproductions of Duchamp's works and one original.[13] These copies were meticulously executed using laborious methods, from color lithography to collotypes hand-colored with stencils to scaled-down handmade models of ready-mades such as *Air de Paris, Traveler's Folding Item, Fountain*, and *Why not Sneeze Rrose Sélavy?*. The *Large Glass, Nine Malic Molds*, and *Glider* are reproduced on celluloid. Dawn Ades observes that the elaborate modes of photographic reproduction used in the *Boîte-en-valise* "simultaneously recognize the fundamental change that photography made to the work of art, now endlessly repeatable and thus bereft of its 'aura' of unique presence, and subtly challenges it by manipulating the photograph to isolate the readymade as an icon."[14] An eerie combined album, retro-spective exhibition, and catalogue raisonné of Duchamp's works, the *Boîte-en-valise* blurs the borders between unique object and multiple, original and copy, and deftly manages to include in its title the anagram *Selavi*—Rrose Sélavy, one of Duchamp's punning pseudonyms, echoing the French phrase "Eros, c'est la vie," or "Eros, that's life."

Notes

1. Marcel Duchamp, quoted in Helen Molesworth, "The Everyday Life of Marcel Duchamp's Readymades," *Art Journal* 57, no. 4 (Winter 1998):57.

2. Arturo Schwartz discusses the characteristics of Duchamp's readymades in "The Philosophy of the Readymade and of Its Editions," in Jennifer Mundy, ed., *Duchamp, Man Ray, Picabia* (London: Tate Publishing, 2008), pp. 125–31.

3. Francis M. Naumann writes, "The replica was prominently displayed in the main studio of the Arensberg apartment in New York, and even after the original painting was acquired in 1919, the photographic replica remained on display, as it would in the Arensbergs' Hollywood home during the 1930s and '40s. Today, the two works hang side by side in the galleries of the Philadelphia Museum of Art, where close inspection reveals that they manifest a completely different tactile quality and physical presence." Naumann also points out that as early as 1914, "Duchamp produced a limited-edition photographic facsimile of his notes for the *Large Glass*, the *Box* of 1914." See Naumann, *Marcel Duchamp: The Art of Making Art in the Age of Mechanical Reproduction* (New York: Harry N. Abrams, 1999), p. 20.

4. Duchamp, quoted in Dawn Ades, "Camera Creation," in Mundy, ed., *Duchamp, Man Ray, Picabia*, p. 89.

5. Though unsigned, the editorial was presumably written by Duchamp, by one of the other of his collaborators on *The Blind Man* Beatrice Wood and Henri-Pierre Roché, or by some combination of the three.

6. Duchamp, in Pierre Cabanne, *Dialogues with Marcel Duchamp* (Cambridge, Mass.: Da Capo Press, 1987), p. 61.

7. An inscription on the mat of a photograph of *Sculpture de voyage*, in black ink, reads "Sculpture de voyage/(Caoutchouc)/Marcel Duchamp/1917." The date in the inscription seems to be incorrect; a letter from Duchamp to Jean Crotti of July 8, 1918, indicates that he was at work on the sculpture that month. See Schwartz, *The Complete Works of Marcel Duchamp*, third revised and expanded ed. (New York: Delano Greenidge Editions, 1997), 2:659.

8. The mat bears the ink inscription *ombres portées 1917 N.Y./Marcel Duchamp*; the verso bears the pencil inscription *1918/NY/33 W 67/PHOTO*. On the dating of the work to 1918, see Schwartz, *The Complete Works of Marcel Duchamp*, 2:660.

9. Georgia O'Keeffe, quoted in Anne d'Harnoncourt and Kynaston McShine, eds., *Marcel Duchamp* (New York: The Museum of Modern Art, 1989), p. 214.

10. Duchamp and Richard Hamilton, *The Bride Stripped Bare by Her Bachelors, Even: A Typographic Version by Richard Hamilton of Marcel Duchamp's Green Box* (New York: George Wittenborn, 1960), n.p.

11. Ibid.

12. Discussing the multiple ways in which Duchamp both used and thought about photography, Jean Clair notes, "This begins in 1910 with his interest in [Etienne-Jules] Marey's chronophotography and continues throughout his career, involving him in investigations of such little-known phenomena as the 'Kirlian Effect'—photographs of the electrical 'aura' given off by living matter, and leading him to consider his masterwork—*The Bride Stripped Bare by Her Bachelors, Even*—as a 'Delay in Glass,' a giant photographic plate." Clair, "Opticeries," *October* 5 (Summer 1978):101.

13. For a comprehensive description and analysis of the *Boîte-en-valise* see Ecke Bonk, *Marcel Duchamp: The Box in a Valise. De ou par Marcel Duchamp ou Rrose Sélavy* (New York: Rizzoli, 1989). Duchamp first produced a limited deluxe edition of twenty-four boxes housed in suitcases (twenty signed and numbered copies were made between 1941 and 1949 and four *hors-série* copies [0/XX] were added between 1941 and 1943). This deluxe edition is distinguished from later, standard versions through its leather-covered valise and the addition of an original work.

14. Ades, "Camera Creation," p. 95.

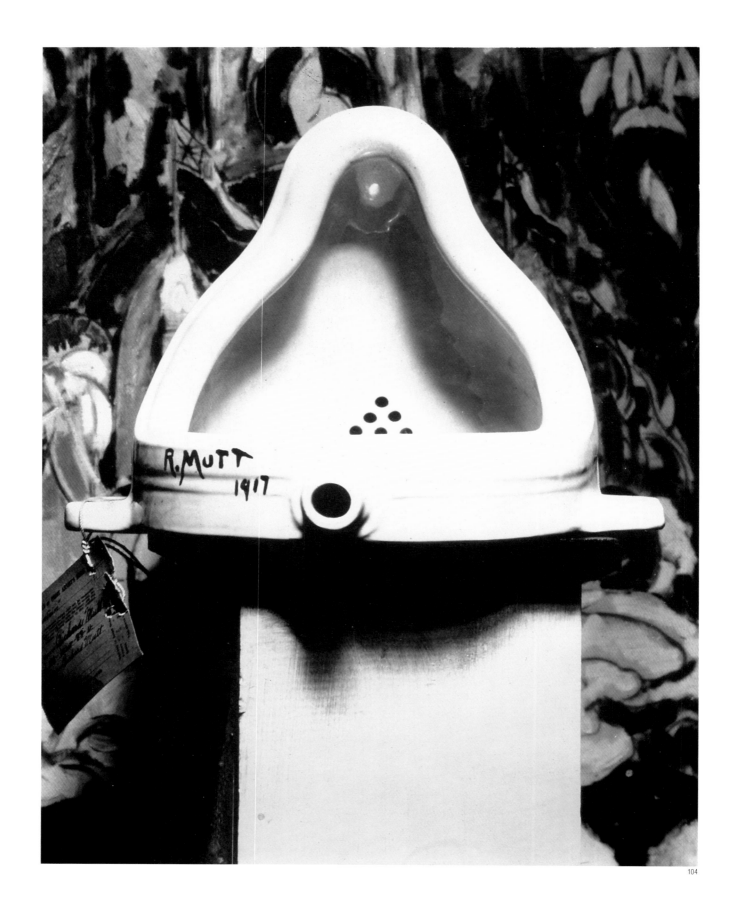

104. Alfred Stieglitz. American, 1864–1946
Fountain, photograph of assisted readymade by Marcel Duchamp. 1917
Gelatin silver print, 9 ¼ x 7" (23.5 x 17.8 cm)
Collection Jacqueline Matisse Monnier

105. Marcel Duchamp. American, born France, 1887–1968
Couverture-cigarettes (Cigarette covers). 1936
Gelatin silver print colored with aniline, 11 ¹³⁄₁₆ x 15 ¾" (30 x 40 cm)
Centre Pompidou, Musée national d'art moderne–Centre de création
industrielle, Paris. Purchase

106. Marcel Duchamp. American, born France, 1887–1968
Sculpture de voyage (Sculpture for traveling). 1918
Gelatin silver print on board, 2 ¾ x 1 ¹⁵⁄₁₆" (7 x 5 cm)
Kunsthaus Zürich, Fotosammlung

107. Henri-Pierre Roché. French, 1879–1959
*33 West 67th Street, New York (Hanging Hat Rack, Fountain,
and In Advance of the Broken Arm).* 1917–18
Gelatin silver print, 2 ⁷⁄₁₆ x 1 ½" (6.2 x 3.8 cm)
Philadelphia Museum of Art. Gift of Jacqueline, Paul, and
Peter Matisse in memory of their mother, Alexina Duchamp

108

108. Marcel Duchamp. American, born France, 1887–1968
Ombres portées (Cast shadows). 1918 (printed 2010 from glass negative)
Gelatin silver print, 8 5/16 x 5 ½" (21.1 x 13.9 cm)
Philadelphia Museum of Art. Gift of Jacqueline, Paul, and Peter Matisse
in memory of their mother, Alexina Duchamp

109

109. Marcel Duchamp. American, born France, 1887–1968.
Man Ray (Emmanuel Radnitzky). American, 1890–1976
Élevage de poussière (Dust breeding). 1920
Gelatin silver contact print, 2 13/16 x 4 5/16" (7.1 x 11 cm)
The Bluff Collection, LP

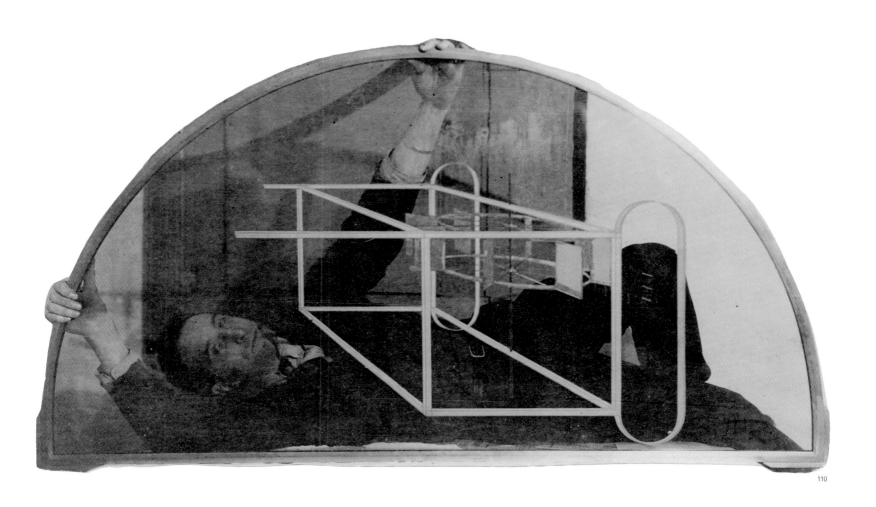

110. Man Ray (Emmanuel Radnitzky). American, 1890–1976
Duchamp with "Water Mill within Glider, in Neighboring Metals". 1917
Gelatin silver print, 3 ⅜ x 6 ⅛" (8.6 x 15.4 cm)
The J. Paul Getty Museum, Los Angeles

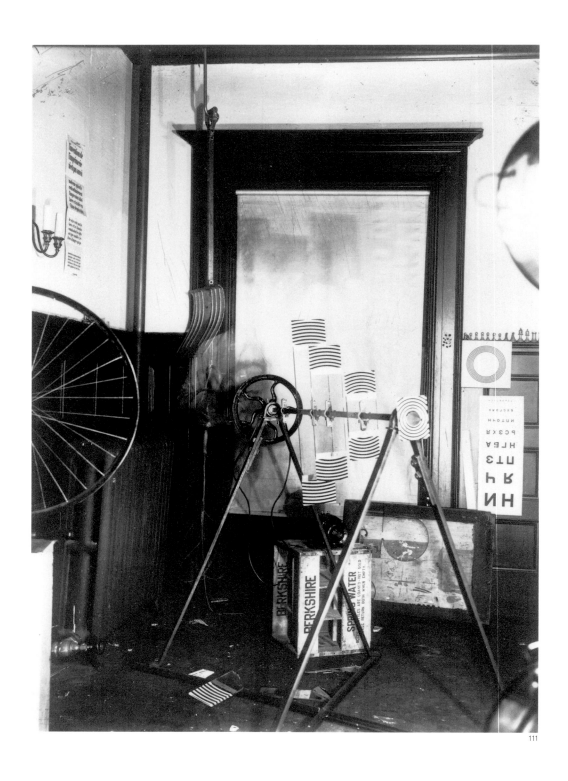

111.

111. Man Ray (Emmanuel Radnitzky). American, 1890–1976
Duchamp's Studio at 246 W. 73rd St., NYC. 1920
Gelatin silver print, 4 ¹⁵⁄₁₆ x 3 ½" (12.5 x 8.9 cm)
Philadelphia Museum of Art. Purchased with the Alice Newton Osborn Fund and with
funds contributed by Alice Saligman, Ann and Donald W. McPhail, and the ARCO
Foundation upon the occasion of the 100th birthday of Marcel Duchamp, 1987

112. Man Ray (Emmanuel Radnitzky). American, 1890–1976
Marcel Duchamp with Rotary Glass Plates Machine (in Motion). 1920
Gelatin silver print, 4 ¹⁵⁄₁₆ x 3" (12.5 x 7.6 cm)
Collection Timothy Baum, New York

113. John D. Schiff. American, born Germany, 1907–1976
The Large Glass Installed Before a Window Overlooking the Garden
at Katherine S. Dreier's Home, Milford, Connecticut. c. 1948
Gelatin silver print, 11 ⅝ x 7 ¼" (29.5 x 18.4 cm)
Philadelphia Museum of Art. Gift of Jacqueline, Paul, and Peter Matisse
in memory of their mother, Alexina Duchamp

114. Marcel Duchamp. American, born France, 1887–1968
Readymade malheureux (Unhappy readymade). 1919. Printed in 1958 in
Box in a Valise (From or by Marcel Duchamp or Rrose Sélavy), Series C
Collotype with pochoir coloring on tinted card, 6 ⅜ x 4 ⅛" (16.2 x 10.5 cm)
The Museum of Modern Art Library, New York

115. Robert Frank. American, born Switzerland 1924
St. Francis, Gas Station and City Hall, Los Angeles. 1956
Gelatin silver print, 7 ¹⁵⁄₁₆ x 11 ¹⁵⁄₁₆" (20.1 x 30.3 cm)
The Museum of Modern Art, New York. Acquired through the generosity
of Susan G. Jacoby in honor of her father, Edward Goldberger

For the last century, the question of memorialization has been salient in thinking on photography. How do we remember the past? What role do photographs play in mediating history and memory? Like the monument, the photograph is simultaneously an aide-mémoire and a testament to loss. In an era resonating with the consequences of two world wars, the construction and then dismantling of the Berlin Wall, the collapse of Communism in Eastern Europe, the Vietnam War, and the aftereffects of the colonialist legacy in South Africa, commemoration has provided a rich subject for photographic investigation. Deeply rooted in a society's cultural practices, public statues and monuments also reflect political changes in that society. As the French sociologist Henri Lefebvre notes, it is not surprising that "conquerors and revolutionaries eager to destroy a society should so often have sought to do so by burning or razing that society's monuments. Sometimes it is true, they contrive to redirect them to their own advantage."[1]

Bruno Braquehais's albumen prints showing the demolition of the Vendôme Column (plates 117, 118) during the brief period of the Paris Commune of 1871—the popular uprising in the wake of France's defeat in the Franco-Prussian War—illustrate the complex function of photography in this context. The Vendôme Column, in the place Vendôme near the Tuileries, commemorates the military conquests of the Emperor Napoleon. Proclaiming it "a monument to barbarism, a symbol of brute force and false glory, an affirmation of militarism, a denial of international law, a permanent insult directed at the conquered by their conquerors, a perpetual attack upon one of the three great principles of the French republic," the Commune decreed its destruction.[2] A Communard sympathizer, Braquehais saw the importance of chronicling this historic event. The pictures he took on May 16, 1871, show the column standing, encircled by rigging and scaffolding; the crowd gathered around the ill-fated monument; and the spectacle of the statue of Napoleon that had stood at its top, now lying on the ground. It is quite likely that Braquehais intended to sell his pictures to the victorious Communards as souvenirs. Neither he nor the insurgents anticipated, however, that only a few weeks later, after the Commune's fall, prosecutors would use his pictures for different political ends: to identify and indict former Communards.[3] The Vendôme Column was subsequently rebuilt.

Photographs, like film and newsreels, are often entangled in politics and in rhetorics of persuasion, where they may be used in an attempt to convey unambiguous messages. Sometimes pictures are commissioned as propaganda; at other times they reflect the artistic convictions of their makers. Nikolai Kuleshov's picture *Moscow* (c. 1938; plate 142) combines these intentions. The photograph shows a close-up view of a colossal sculpture of the red star, hammer, and sickle, prevailing high above a group of Moscow buildings designed in the Stalinist style. Although the picture was not conceived as propaganda, it accords with the idea, embodied in Russian journals of the period such as *Proletarskoe foto* (Proletarian photo), that photography could be instrumental in building socialism in the Soviet Union. Kuleshov's picture communicates the ethos of Soviet power by combining Communist icons (the star, hammer, and sickle) with an urban image (the grandiose Moscow skyline) in a style reminiscent of the montage techniques of Soviet cinema.

Nikolai Kuleshov is thought to have been a cousin of Lev Kuleshov, the pioneer Russian filmmaker and film theorist influential in the development of cinematic editing (he devised the demonstration known as the "Kuleshov effect"). In their impact on Soviet photography and film, Lev Kuleshov's theories of montage presaged the work of Sergei Eisenstein, the first Russian filmmaker to eschew the seamless spatial and temporal continuities of Hollywood movies. Eisenstein saw montage as the nerve of cinema. His epic film *Oktyabr'* (October: Ten days that shook the world, 1928; fig. 1) was conceived as both a

narration of the Russian Revolution of 1917 and a revolutionary film in terms of dialectical montage.[4] The film opens with an image of a monumental statue of Alexander III (father of Nicholas II, the tsar whom the revolution deposed), an icon of the supposedly timeless power of tsarist Russia. Shot at twilight, the scene suggests the end of an era. In the scene that follows, angry masses rush into the square occupied by the monument. A woman climbs the statue, mobilizing the workers to throw ropes around it. The dismembering of the statue begins, and with it personal recollection becomes subservient to Soviet-prescribed memory.

When working to narrate a single theme, still photographers often approach their subject with a filmmaker's eye and subsequently present their images in the layouts of books. The most significant photographic essays of the twentieth century—Walker Evans's *American Photographs* (1938), Robert Frank's *Americans* (1958), or Lee Friedlander's *American Monument* (1976), for example—are not ideological documents but rather perceptive commentaries on the sociocultural landscape of a nation. Evans's *American Photographs*, for instance, published by The Museum of Modern Art in 1938 to coincide with a retrospective exhibition of the photographer's work, provides an unaffected but deeply personal portrait of American society through its individuals, social institutions, burgeoning automobile culture, and civic monuments. The second of the book's two sections opens with *Stamped Tin Relic* (1929; plate 125), an image of a crushed Ionic column made of cheap sheet metal. This capital is not a relic of a classical monument; rather, it is a cookie-cutter image of a national vernacular. A

fig. 1. Sergei Eisenstein. *Oktyabr'* (October: Ten days that shook the world). 1928. Still from black and white film, silent, c. 103 min. The Museum of Modern Art Film Stills Archive, New York

negligible shard of Americana, it reveals Evans's sensitivity to symbolic fragments and is emblematic of the bruised American world in the aftermath of the stock market crash of 1929.

John Szarkowski notes that Evans's influence was "slow and subterranean rather than quick and superficial,"[5] and it was not until two decades later that *American Photographs* received a great successor. Frank, who met Evans in 1953, patterned *The Americans* on the structure of the older photographer's book, but Frank's elliptical, off-kilter style was as personal and controversial as was his innovative treatment of his subject matter to reveal a profound sense of alienation in American life. *The Americans* is the corollary of a journey Frank made across the United States, with the help of a Guggenheim grant, in 1955 and 1956.[6] The book was first published in France in 1958, as *Les Américains*. The American edition, with an introduction by the Beat writer Jack Kerouac, came out the following year. During his road trip, Frank had taken nearly 800 rolls of film, snapshot style, but only eighty-three frames made the final cut of the book, each carefully orchestrated into a

tight sequence, as in a film script. His skeptical, outsider's view of postwar American society earned him comparisons to a modern-day Alexis de Tocqueville, the nineteenth-century French author of *Democracy in America* (published in two volumes, in 1835 and 1840). Frank's pictures capture a shadowy postwar society at odds with itself. Significantly, the only American monument seen in the book—other than the heads of American presidents in shop windows, and images of the ubiquitous American flag—is a statue of St. Francis preaching, cross and Bible in hands, to the bleak vista of a gas station (plate 115).

The humor in Frank's image stems in part from Evans's handling of monuments (plate 127) and reemerges in the 213 pictures of a variety of nondescript statuary (military figures, statesmen, Native Americans, Puritans) that Friedlander published in his book *The American Monument* (plates 120, 128, 132–37, 139). In his comprehensive study of Friedlander's work, Peter Galassi points out, "The disparity between the ideal and the actual had been sharply drawn in the work of Evans and Frank, and Friedlander made it a central theme." "Yet," he specifies, "compared to Evans and Frank, Friedlander is not so much caustic as witty."[7] Friedlander's wit is visible in the numerous pictures of monuments he took while crisscrossing forty different states, mostly between 1971 and 1975. If Friedlander favors the incidental over the momentous, his pictures flesh out a collective sense of American history. In *Mount Rushmore, South Dakota* (1969; plate 139), he shows a tourist couple photographing and contemplating through binoculars the majestic Mount Rushmore National Memorial (1927–1941). The monument itself is barely visible, its image mirrored in a building's glass façade whose surface is disrupted by reflections of people and events in flux. In *Father Duffy. Times Square, New York City* (1974; plate 128) a statue of an Irish-American chaplain who served on the Western Front during World War I is engulfed in the strident cacophony of Times Square's billboards and neon, which threaten to jeopardize the sculpture's patriotic message. With each image in *The American Monument*, Friedlander takes an oblique look at the world that public statues inhabit, offering incisive observations on civic pride, and civic forgetfulness, in America.

Ranging in his work from traces of South Africa's early colonial beginnings through the apartheid period to the present day, David Goldblatt offers a critical exploration of his native country and its public monuments. Many of these monuments memorialize white-nationalist conquest and rule, and the idea of white racial superiority. During the apartheid years and for a few years after, Goldblatt photographed in black and white; since 1999 he

has shot in color. In both mediums he reveals the many ways in which ideology in the form of markers shapes national memory. His book *South Africa: The Structure of Things Then* (1998), a visual history of his country's people and built structures, includes monuments to some of the most potent symbols of Afrikaner triumphalism, such as the meteor-sized globe, with ox-drawn wagons stretched across South Africa, seen in *Monument to Karel Landman, Voortrekker Leader, De Kol, Eastern Cape* (April 10, 1993; plate 145). In his subsequent book, *Intersections* (2005), Goldblatt explored the new postapartheid society, focusing on the vandalism of old monuments (some now caged for protection), the building of new ones, and the accretion of personal commemorations.

Since the end of World War II, the need to recollect has intensified, yet the capacity of traditional monuments to preserve memory has proven ever more precarious. Monuments seem either to extol the deeds of history or to absolve us of responsibility for them, easily sealing the process of remembering. It is as if, James Young writes, once we ascribe "monumental form to memory we have to some degree divested ourselves of the obligation to remember."[8] Even as monuments continue to be commissioned, debates over how to probe the past from critical perspectives have produced more active modes of memory-telling. The staged self-portraits that Anselm Kiefer shot while traveling through Switzerland, France, and Italy in the summer and fall of 1969 suggest that monuments ought to perform a social function within public life. Published under the title *Besetzungen* (Occupations) in the Cologne art journal *interfunktionen* in 1975, the pictures show Kiefer either in the privacy of his apartment or in public spaces—by the Colosseum in Rome, in front of an equestrian statue of Louis XIV framed by the Arc de Triomphe in Montpellier (plate 144)—giving the "Heil Hitler" salute. Performed exclusively for the camera, the pictures attempt a "real working through of German history." For Benjamin H. D. Buchloh, the editor of *interfunktionen* at the time, "working through" means that "you have to inhabit [history] to overcome it."[9] Kiefer's actions suggest that public monuments generate human reactions, and that memory involves acts of resistance against forgetting when confronting an irrecoverable past.

Considered in this light, Ai Weiwei's photographic series *Study of Perspective* (1995–2003; plate 153) reveals a spirited irreverence toward the status of the monument. Traveling to various national landmarks—from the Basilica di San Marco in Venice, through the White House in Washington, D.C., to Beijing's Tiananmen Square (Tiananmen, literally "Gate of Heavenly Peace," was of course the site of prodemocracy protests and a subsequent massacre in 1989)—the artist shoots his own arm extended in front of the camera lens as he gives each site the middle finger. As Charles Merewether notes, this impudent gesture "interrupts the iconic authority invested in each site."[10] As such, the "perspective" Ai proposes no longer acts as a formal exercise in measurement but rather becomes a personal critique

of the markers upon which political power, cultural significance, and national legitimacy are founded.

Notes

1. Henri Lefebvre, "The Production of Space," in Neil Leach, ed., *Rethinking Architecture: A Reader in Cultural Theory* (New York: Routledge, 1997), p. 139.
2. Decree of the Paris Commune, quoted in Gen Doy, "The Camera against the Paris Commune," in Liz Heron and Val Williams, eds., *Illuminations: Women Writing on Photography from the 1850s to the Present* (Durham: Duke University Press, 1996), p. 25.
3. Ibid.
4. For Sergei Eisenstein, dialectical montage was defined as the use of colliding independent shots to constitute thesis and antithesis.
5. John Szarkowski, *Photography until Now* (New York: The Museum of Modern Art, 1989), p. 287.
6. A Swiss émigré, Robert Frank was the first foreign national to be awarded this fellowship.
7. Peter Galassi, *Lee Friedlander* (New York: The Museum of Modern Art, 2005), p. 52.
8. James Young, "The Counter-Monument: Memory against Itself in Germany Today," *Critical Inquiry* 18, no. 2 (Winter 1992):273.
9. Benjamin H. D. Buchloh, quoted in Christine Mehring, "Continental Schrift: the story of *interfunktionen*," *Artforum* 42, no. 9 (May 2004):178.
10. Charles Merewether, "Ai Weiwei: The Freedom of Irreverence," *Art AsiaPacific* no. 53 (May/June 2007):110.

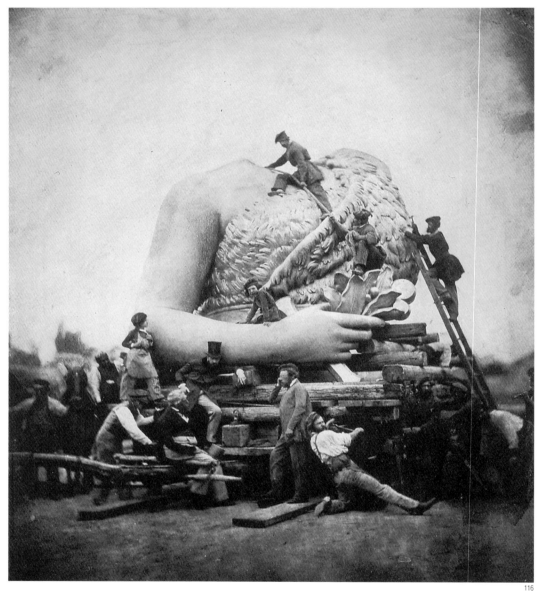

116

116. Alois Löcherer. German, 1815–1862
Der Transport der Bavaria auf die Theresienwiese (Transporting
the Bavaria statue to Theresienwiese). August 7, 1850
Salted-paper print, 9 ¹⁵⁄₁₆ x 9 ⅛" (25.2 x 23.2 cm)
Museum Ludwig, Cologne

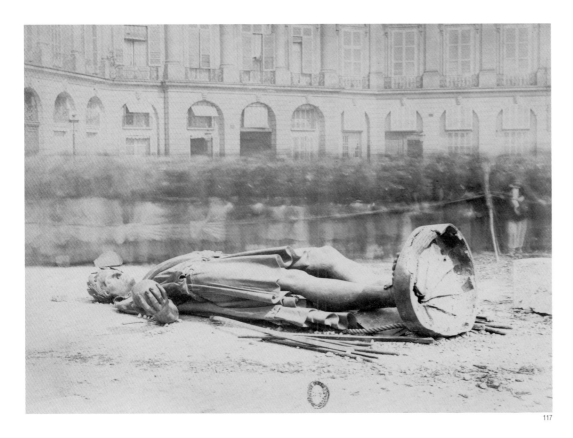

117

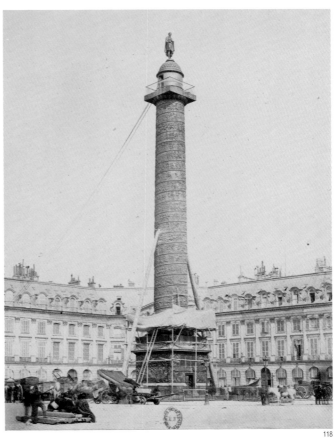

118

117. Bruno Braquehais. French, 1823–1875
Paris pendant la Commune, la destruction de la colonne Vendôme (Paris
during the Commune, the destruction of the Vendôme column). 1871
Albumen silver print from a collodion negative, 6 ⁵⁄₁₆ x 8 ⁷⁄₁₆" (16 x 21.5 cm)
Bibliothèque nationale de France, Paris

118. Bruno Braquehais. French, 1823–1875
Place Vendôme. 1871
Albumen silver print from a collodion negative, 8 ¼ x 6 ⁵⁄₁₆" (21 x 16 cm)
Bibliothèque nationale de France, Paris

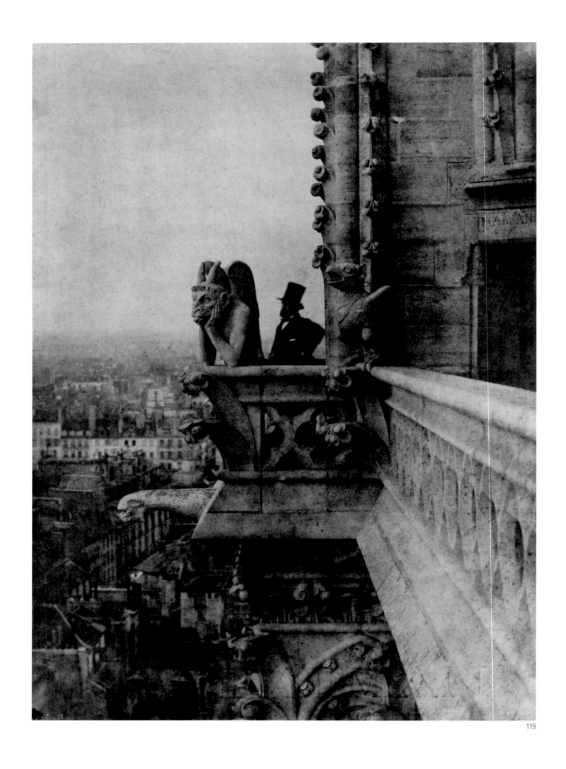

119. Charles Nègre. French, 1820–1880
Le Stryge (The vampire). c. 1853
Salted-paper print, 13 x 9 ³⁄₁₆" (33 x 23.4 cm)
National Gallery of Canada, Ottawa. Purchase

120

120. Lee Friedlander. American, born 1934
To Those Who Made the Supreme Sacrifice. Bellows Falls, Vermont. 1971
Gelatin silver print, 7 9/16 x 11 ¼" (19.1 x 28.5 cm)
The Museum of Modern Art, New York. Acquired through the generosity
of Shirley C. Burden

121

122

121. Rosalind Solomon. American, born 1930
Immersion of Goddess Durga, Calcutta, India. 1982 (printed 1986)
Gelatin silver print, 14 ¾ x 14 ⅞" (37.6 x 37.8 cm)
The Museum of Modern Art, New York. Gift of the photographer

122. Josef Koudelka. Czech, born 1938
France. 1973
Gelatin silver print, 9 ⅜ x 14 ⅛" (23.9 x 36.0 cm)
The Museum of Modern Art, New York. Joseph Strick Fund

123

124

123. Henri Cartier-Bresson. French, 1908–2004
Place de la République, Paris. May 28, 1958
Gelatin silver print, 11 ⅞ x 7 ¹⁵⁄₁₆" (30.1 x 20.2 cm)
Fondation Henri Cartier-Bresson, Paris

124. Henri Cartier-Bresson. French, 1908–2004
Tuskegee, Alabama, United States. 1961 (printed 1970s)
Gelatin silver print, 11 ¹¹⁄₁₆ x 7 ¹⁵⁄₁₆" (29.7 x 20.1 cm)
Fondation Henri Cartier-Bresson, Paris

125

126

125. Walker Evans. American, 1903–1975
Stamped Tin Relic. 1929 (printed c. 1970)
Gelatin silver print, 4 ¹¹⁄₁₆ x 6 ⅝" (11.9 x 16.9 cm)
The Museum of Modern Art, New York. Lily Auchincloss Fund

126. Berenice Abbott. American, 1898–1991
Father Duffy, Times Square. April 14, 1937
Gelatin silver print, 9 ⁵⁄₁₆ x 7 ⅝" (23.7 x 19.4 cm)
The Museum of Modern Art, New York. Gift of Ronald A. Kurtz

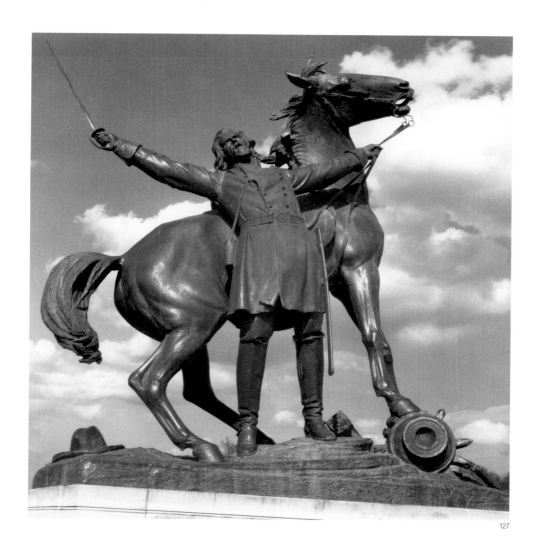

127

127. Walker Evans. American, 1903–1975
Battlefield Monument, Vicksburg, Mississippi. 1936
Gelatin silver print, 7 ⅝ x 9 ⅝" (19.3 x 24.5 cm)
The Museum of Modern Art, New York. Gift of the photographer

128.

128. Lee Friedlander. American, born 1934
Father Duffy. Times Square, New York City. 1974
Gelatin silver print, 7 ½ x 11 ¼" (19.1 x 28.5 cm)
The Museum of Modern Art, New York. Purchase

129

130

131

129. S. L. A. Marshall. American, born 1900–1977
A Trepanning Operation on the Nation's Great Men in a Mountain Memorial. 1938
Gelatin silver print, 9 9/16 x 6 1/4" (24.3 x 15.8 cm)
The Museum of Modern Art, New York. The New York Times Collection

130. Henri Cartier-Bresson. French, 1908–2004
Capitol, Washington, United States. 1957 (printed 1970s)
Gelatin silver print, 11 9/16 x 7 13/16" (29.3 x 19.8 cm)
Fondation Henri Cartier-Bresson, Paris

131. Unknown photographer
Untitled. 1921
Gelatin silver print, 4 1/8 x 2 5/16" (10.5 x 5.8 cm)
The Museum of Modern Art, New York. Gift of Thomas Walther

132. Lee Friedlander. American, born 1934
Theodore Roosevelt. Roosevelt Island, Washington, D.C. 1972
Gelatin silver print, 7 ½ x 11 ¼" (19.1 x 28.6 cm)
The Museum of Modern Art, New York. Purchase

133. Lee Friedlander. American, born 1934
J. S. T. Stranahan and Memorial Arch. Grand Army Plaza, Brooklyn. 1974
Gelatin silver print, 12 ¹/₁₆ x 8 ¹/₁₆" (30.6 x 20.4 cm)
The Museum of Modern Art, New York. Purchase

134. Lee Friedlander. American, born 1934
Volunteer Firemen. Walden, New York. 1972
Gelatin silver print, 7 ⁹/₁₆ x 11 ¼" (19.2 x 28.6 cm)
The Museum of Modern Art, New York. Purchase

135

136

137

135. Lee Friedlander. American, born 1934
Hart's Fifteenth New York Battery. Gettysburg National Military Park, Pennsylvania. 1974
Gelatin silver print, 12 ¹/₁₆ x 8 ¹/₁₆" (30.6 x 20.4 cm)
The Museum of Modern Art, New York. Acquired through the generosity of Shirley C. Burden

136. Lee Friedlander. American, born 1934
Sailors and Soldiers. Kittery, Maine. 1976
Gelatin silver print, 7 ⁹/₁₆ x 11 ¼" (19.1 x 28.5 cm)
The Museum of Modern Art, New York. Acquired through the generosity of Shirley C. Burden

137. Lee Friedlander. American, born 1934
Major General Harry W. Slocum, Napoleon Gun, and Stevens' Fifth Maine Battery Marker. Gettysburg National Military Park, Pennsylvania. 1974
Gelatin silver print, 7 ⁹/₁₆ x 11 ¼" (19.3 x 28.6 cm)
The Museum of Modern Art, New York. Acquired with matching funds from Jo Carole and Ronald S. Lauder and the National Endowment for the Arts

138

138. Garry Winogrand. American, 1928–1984
Forest Lawn Cemetery, Los Angeles. 1964
Gelatin silver print, 8 ⅞ x 13 ⁷⁄₁₆" (22.6 x 34.1 cm)
The Museum of Modern Art, New York. Purchase

139

139. Lee Friedlander. American, born 1934
Mount Rushmore, South Dakota. 1969
Gelatin silver print, 8 1/16 x 12 1/8" (20.5 x 30.8 cm)
The Museum of Modern Art, New York. Gift of the photographer

140. Cindy Sherman. American, born 1954
Untitled Film Still #50. 1979
Gelatin silver print, 6 9⁄16 x 9 7⁄16" (16.7 x 24 cm)
The Museum of Modern Art, New York. Horace W. Goldsmith
Fund through Robert B. Menschel

141

141. Tod Papageorge. American, born 1940
Alice in Wonderland. 1978
Gelatin silver print, 18 ¹¹⁄₁₆ x 12 ¼" (47.5 x 31.2 cm)
The Museum of Modern Art, New York. Gift of Robert L. Smith

142

143

142. Nikolai Kuleshov. Russian
Moscow. c. 1938
Gelatin silver print, 18 ⅛ x 23 ⅜" (46 x 59.4 cm)
The Museum of Modern Art, New York. Gift of Harriette and Noel Levine

143. Igor Moukhin. Russian, born 1961
Gorohovets, the Monument of the Worker. 1992
Gelatin silver print, 13 ¹¹⁄₁₆ x 20 ½" (34.8 x 52.1 cm)
The Museum of Modern Art, New York. Acquired through the generosity
of the Junior Associates of The Museum of Modern Art

144.

144. Anselm Kiefer. German, born 1945
Besetzungen (Occupations). 1969
Shown as reproduced in *interfunktionen* no. 12 (1975),
spread: 11 ¼ x 16 ⅝" (28.6 x 42.2 cm)
The Museum of Modern Art Library, New York

145

146

147

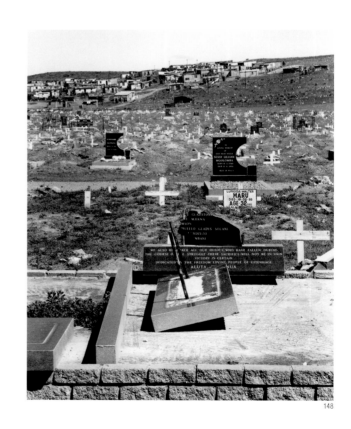

148

145. David Goldblatt. South African, born 1930
Monument to Karel Landman, Voortrekker Leader, De Kol,
Eastern Cape. April 10, 1993
Gelatin silver print, 10 ¹⁵/₁₆ x 13 ¹¹/₁₆" (27.9 x 34.8 cm)
The Museum of Modern Art, New York. Purchase

146. David Goldblatt. South African, born 1930
Monuments to National Party leader and Prime Minister, J. G.
Strijdom and to the Republic of South Africa, unveiled in 1972,
with the headquarters of Volkskas Bank, opened in 1974. Strijdom
Square, Pretoria, Transvaal. April 25, 1982
Gelatin silver print, 10 ¹³/₁₆ x 13 ¾" (27.5 x 35 cm)
Courtesy the artist and The Goodman Gallery, Johannesburg

147. David Goldblatt. South African, born 1930
HF Verwoerd Building, headquarters of the provincial
administration, inaugurated on 17 October 1969, Bloemfontein,
Orange Free State. December 26, 1990
Gelatin silver print, 10 ¹³/₁₆ x 13 ⁹/₁₆" (27.5 x 34.5 cm)
Courtesy the artist and The Goodman Gallery, Johannesburg

149

150

148. David Goldblatt. South African, born 1930
Memorial to those killed in the 'Langa Massacre', 21 March 1985, and
to others who died in the struggle against apartheid; vandalized in 1987
by black vigilantes funded by Military Intelligence, Kwanabuhle
Cemetery, Uitenhage, Cape Province. September 15, 1990
Gelatin silver print, 13 9/16 x 10 5/8" (34.5 x 27 cm)
Courtesy the artist and The Goodman Gallery, Johannesburg

149. David Goldblatt. South African, born 1930
Mother and Child on Nelson Mandela Square, Sandton,
Johannesburg. March 8, 2005
Pigmented inkjet print, 27 5/8 x 22 1/16" (70.2 x 56 cm)
The Museum of Modern Art, New York. Geraldine J. Murphy Fund

150. David Goldblatt. South African, born 1930
Monument Honouring the 'Contribution of the Horse to South African
History,' Erected by the Rapportryers of Bethulie in 1982. Laura Rautenbach
was the Sculptor. After the Theft of Bronze Oxen from a Voortrekker
Monument in the Town, the Rapportryers Caged the Horse in Steel
in 2004. Bethulie, Free State. February 12, 2005
Pigmented inkjet print, 21 5/8 x 27 5/16" (55 x 69.4 cm)
The Museum of Modern Art, New York. Samuel J. Wagstaff, Jr. Fund

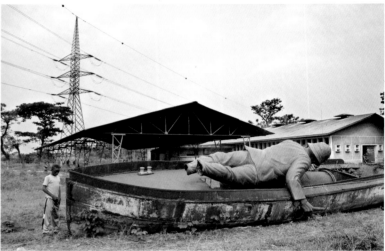

151

152

151. Guy Tillim. South African, born 1962
Statue of Henry Stanley which Overlooked Kinshasa in Colonial Times. 2004
Two pigmented inkjet prints printed on one sheet, overall: 24 x 63 1/16"
(61 x 160.2 cm)
The Museum of Modern Art, New York. Acquired through the generosity
of the Contemporary Arts Council of The Museum of Modern Art

152. Guy Tillim. South African, born 1962
Bust of Agostinho Neto, Quibala, Angola. 2008
Pigmented inkjet print, 17 3/16 x 25 3/4" (43.6 x 65.4 cm)
The Museum of Modern Art, New York. Acquired through the generosity
of the Contemporary Arts Council of The Museum of Modern Art

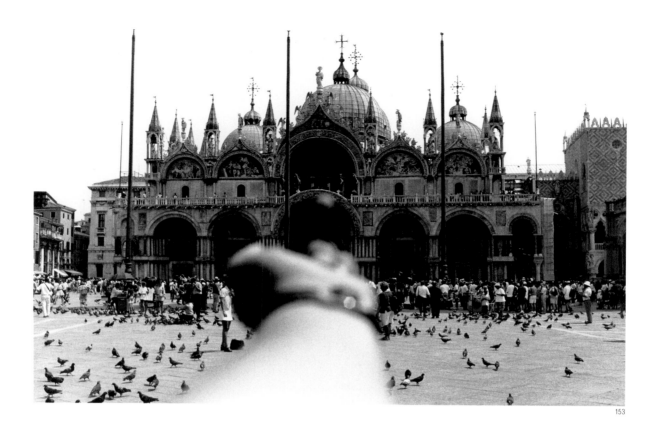

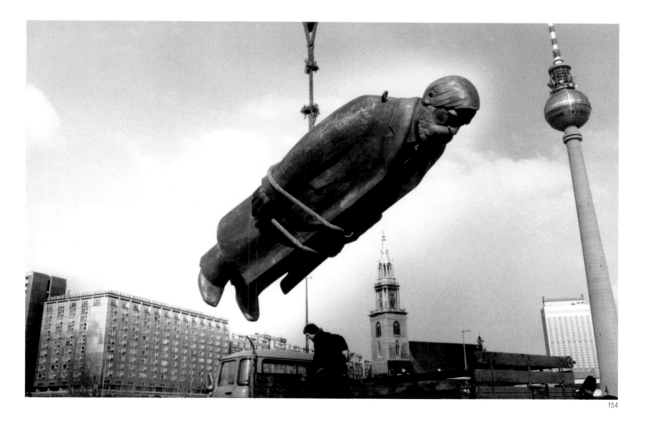

153. Ai Weiwei. Chinese, born 1957
Study of Perspective—San Marco. 1995–2003
Gelatin silver print, 15 5⁄16 x 23 ¼" (38.9 x 59 cm)
The Museum of Modern Art, New York. Acquired through the generosity
of the Photography Council Fund and the Contemporary Arts Council of
The Museum of Modern Art

154. Sibylle Bergemann. German, born 1941
Das Denkmal, East Berlin (The monument, East Berlin). 1986
Gelatin silver print, 19 11⁄16 x 23 5⁄8" (50 x 60 cm)
Sibylle Bergemann/Ostkreuz Agentur der Fotografen, Berlin

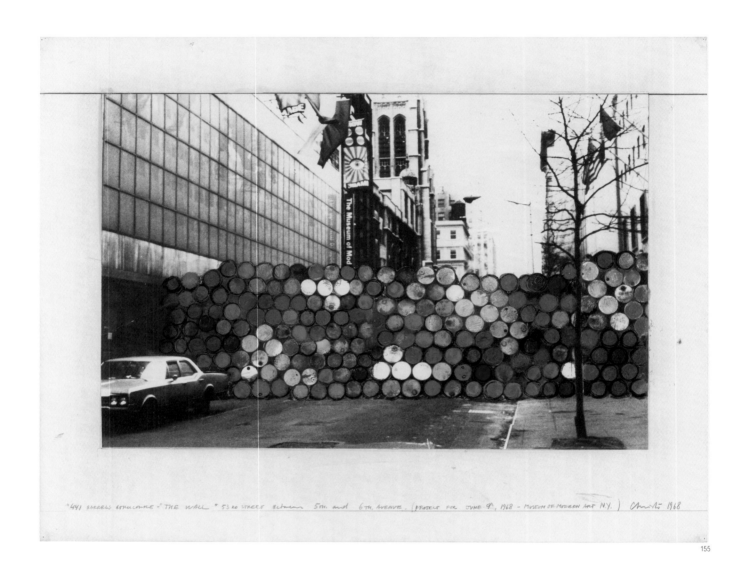

155. Christo (Christo Javacheff). American, born Bulgaria 1935
*441 Barrels Structure—"The Wall" (Project for 53rd between
5th and 6th Avenues).* 1968
Pasted photographs and synthetic polymer paint on cardboard,
22 ⅛ x 28" (56 x 71.1 cm)
The Museum of Modern Art, New York. Gift of Louise Ferrari

In the late 1960s a radical aesthetic change altered both the definition of the sculptural object and the ways in which that object was experienced. The change had to do with the role of photography in the reception of sculptural practices that engaged what Rosalind Krauss called an "expanded field" of operation.[1] A number of artists who did not consider themselves photographers in the traditional sense began using the camera to rework the idea of what sculpture is, dispensing with the immobile object in favor of an altered site: the built environment, the remote landscape, or the studio or museum space in which the artist intervened. This engagement with site and architecture—undoubtedly a function of early critiques of art's institutional status—meant that sculpture no longer had to be a permanent three-dimensional object; it could, for instance, be a configuration of debris on the studio floor (plate 156), a dematerialized vapor released into the Mojave Desert, a suburban home sliced in two, a coil of land bound to the laws of entropy on the Great Salt Lake in Utah, or an ephemeral trail made by walking back and forth in a straight line in a field of daisies in rural Somerset, England. These interventions were in each case visually mediated by photographs, signs, maps, and sometimes geological specimens presented in their stead, positing a dialectical relationship between sculpture and its representation, or in Robert Smithson's words the "Site" and the "Non-Site."

Smithson, Robert Barry, Michael Heizer, Richard Long, Gordon Matta-Clark, and Dennis Oppenheim made extensive use of photography, collecting and taking hundreds of pictures as raw material for other pieces, such as collage and montage works.

fig. 1. Cover of *Artforum* 8, no. 1 (September 1969), showing a detail of Robert Smithson's *Yucatan Mirror Displacements (1–9)*, 1969. The Museum of Modern Art Library, New York

Smithson took an Instamatic camera everywhere he went. In his essay "Art through the Camera's Eye," he speaks of the camera's gift: "the power to invent many worlds."[2] In a later passage he extols the camera's effectiveness as an image-maker, adding, "Let's face it, the 'human' eye is clumsy, sloppy, and unintelligible when compared to the camera's eye. It appears that abstraction and nature are merging in art, and that the synthesizer is the camera."[3]

Photography held a central, integral position in the research, production, and postproduction phases of Smithson's work. In 1969 he traveled across the Yucatán Peninsula to orchestrate *Yucatan Mirror Displacements (1–9)* (plate 158), scattering twelve square mirrors across each of nine sites. At each location Smithson photographed the mirrors' "displacement" of color, their reflection of sky, grass, and earth. Robert A. Sobieszek notes that he used the camera in the classic manner of landscape photography, "to explore and record various terrains in the hope of comprehending them."[4] Yet *Yucatan Mirror Displacements* actually conveys "the impossibility of ever understanding the world in its entirety."[5] Smithson's earliest Non-Site presentation of the "mirror displacements" took the form of nine color transparencies published in the September 1969 issue of *Artforum* (fig. 1).[6] The photographs evoke an experience of the absent sculptural object through the camera's multiple points of view, situating the viewer on top of and at various angles to the mirror arrangements and thus conveying a shifting rather than a static relationship between sculpture and site.

Smithson's friend Matta-Clark also used the camera in creative ways. He had trained as an architect at Cornell University,

studying with Colin Rowe, a preeminent theorist of architectural modernism. Yet Matta-Clark did not practice architecture, which he considered a pretentious enterprise; instead he devised a notion of "anarchitecture," an alternative use of buildings entailing a rejection of "the functionalist aspect of past-due Machine Age moralists."[7] Matta-Clark's interest in entropy (a scientific term used to describe a state of decreasing order, of systemic breakdown, of decay and ruin), and his strategy of reusing preexisting architectural structures in his work, were triggered when he met Smithson, in 1969, at an exhibition titled *Earth Art* organized by Willoughby Sharp at Cornell. A few months later, Smithson "built" *Partially Buried Woodshed* (1970; fig. 2) by dumping dirt on an empty shed on the campus of Kent State University in Ohio. Intended as an illustration of entropy, the project retroactively became an unofficial memorial to four students killed by the National Guard at Kent State during a protest against the American invasion of Cambodia.

fig. 2. Robert Smithson. *Partially Buried Woodshed*. 1970.
Gelatin silver prints, each: 40 x 40" (101.6 x 101.6 cm).
Estate of Robert Smithson. Courtesy James Cohan Gallery, New York

Matta-Clark's incursions into abandoned vernacular buildings constituted a denunciation not just of the functions of architecture but of the American dream of progress. In his best-known works, such as *Splitting* (1974; fig. 3), *Conical Intersect* (1975), and *Circus—The Caribbean Orange* (1978; plate 163), he literally dissected buildings, cutting and carving them into gravity-defying walk-through sculptures. The photographs and photocollages he made of these pieces dovetail with the experimental, disorienting quality of his architectural cuts. For Joseph Kosuth, Matta-Clark "used the camera like a buzz saw,"[8] and this was also how he constructed his photographic works: first, he cut up strips of developed 35mm film, excising each frame with a surgeon's precision but sometimes preserving the sprocket holes along the edges; next, he organized the resulting minuscule fragments into celluloid collages fixed with colored Scotch tape; and last he magnified the photocollages on an enlarger before finally printing them on Cibachrome paper.

Sharing Matta-Clark's critical attitude toward the permanence of traditional architecture, Christo has also perturbed the fabric of public spaces. He made his first temporal sculpture in 1962, in opposition to the construction of the Berlin Wall: without the consent of city authorities, he built *Wall of Barrels, Iron Curtain*, a fence of 240 oil barrels blocking off the rue Visconti in Paris. In 1968, Christo

fig. 3. Gordon Matta-Clark. *Splitting*. 1974. Collage of gelatin silver prints, 40 x 30" (101.6 x 76.2 cm). The Museum of Modern Art, New York. Acquired through the generosity of Walter J. Brownstone and The Family of Man Fund

proposed a similar obstruction for West Fifty-Third Street in New York, outside The Museum of Modern Art, producing detailed photocollage studies of the altered site for the occasion (plate 155). Other proposals involved wrapping the Museum itself, and these too were presented in the form of photocollages and three-dimensional scale models. Although the interventions went unrealized, the photographs and models became the subject of an exhibition that opened at MoMA on June 5, 1968. In Christo's practice both the drafts and proposals for projects and the records of a project's realization include photography as an essential part of the work.

In many of Barry's projects, photographs replace the object altogether. The artist's radical decision to work with invisible materials—carrier waves, inert gases, radioactive substances—pushes to the limit the idea of exposure through concealment manifested in Christo's wrappings. In his Inert Gas Series of 1969 (plate 157), Barry released different gases, such as helium, neon, or krypton, from glass vials at different spots in Southern California and the Mojave Desert. Exhibiting the unseen, each work comprises a typewritten statement describing the action and photographs of the location. Unlike the photocollages of Smithson, Christo, and Matta-Clark, which record the marks of their interventions, Barry's pictures show untouched landscape, as if nothing had happened there. As such, the photographs do not so much record his actions as define their conceptual structure.

The widespread acceptance of photography as the lingua franca of Conceptual art opened new avenues for artists based outside the Western hemisphere, in contexts often lacking exhibition spaces or an infrastructure for contemporary art. Zhang Dali's work, for instance, reflects the massive urban transformations in Chinese society over the last two decades. Taking the idea of the site beyond its physical coordinates, exploring it, rather, as cultural and political framework, Zhang identifies buildings in Beijing marked for demolition and hires workers to carve holes into their walls in the shape of his head. He then takes photographs of these interventions, highlighting the dramatic contrast between the bulldozed traditional neighborhoods and the monotonous high-rise architecture now emerging in China's cities. In *Demolition: Forbidden City, Beijing* (1998; plate 165), an empty, half-destroyed house, its wall incised with Zhang's

trademark profile head, above which the golden roof of one of the imperial pavilions of the Forbidden City rises in the distance, underscores photography's dialogue with the broader world of city planning and social mobility, urban violence and artistic expression. In the first decade of the twenty-first century, artists such as Cyprien Gaillard have continued this dialogue through photographs (plate 162) and films contemplating examples of architecture and sculpture in states of dilapidation and entropy, remnants of a society in demise.

Notes

1. See Rosalind Krauss, "Sculpture in the Expanded Field," *October* 8 (Spring 1979):30–44.

2. Robert Smithson, "Art through the Camera's Eye," in Eugenie Tsai, *Robert Smithson Unearthed: Drawings, Collages, Writings* (New York: Columbia University Press, 1996), p. 88.

3. Ibid., p. 91.

4. Robert A. Sobieszek, *Robert Smithson: Photo Works* (Los Angeles: Los Angeles County Museum of Art, 1993), p. 16.

5. Ibid., p. 36.

6. Smithson, "Incidents of Mirror-Travel in the Yucatan," *Artforum* 8, no. 1 (September 1969):20–33.

7. Gordon Matta-Clark, quoted in James Wines, *De-Architecture* (New York: Rizzoli, 1987), p. 139.

8. Joseph Kosuth, quoted in Thomas Crow, "Away from the Richness of Earth, Away from the Dew of Heaven," in Corinne Diserens, ed., *Gordon Matta-Clark* (New York and London: Phaidon Press, 2003), p. 113.

156. Bruce Nauman. American, born 1941
Composite Photo of Two Messes on the Studio Floor. 1967
Gelatin silver print, 40 ½" x 10' 3" (102.9 x 312.4 cm)
The Museum of Modern Art, New York. Gift of Philip Johnson

Inert Gas Series: Neon, from a measured volume to indefinite expansion. On March 4,1969, on a hill near a valley in Los Angeles, overlooking the Pacific Ocean, one liter of Neon was returned to the atmosphere.

R.BARRY '69

157

157. Robert Barry. American, born 1936
Inert Gas Series: Neon. 1969
Gelatin silver prints and text, prints: each 8 x 10" (20.3 x 25.4 cm), text: 11 x 8 ½" (27.9 x 21.6 cm)
Collection Aaron and Barbara Levine

158. Robert Smithson. American, 1938–1973
Yucatan Mirror Displacements (1–9). 1969
Chromogenic color prints from 35mm slides, each:
24 x 24" (61 x 61 cm)
Solomon R. Guggenheim Museum, New York. Purchased with
funds contributed by the Photography Committee and with funds
contributed by the International Director's Council and Executive
Committee Members: Edythe Broad, Henry Buhl, Elaine Terner

Cooper, Linda Fischbach, Ronnie Heyman, Dakis Joannou, Cindy
Johnson, Barbara Lane, Linda Macklowe, Brian McIver, Peter Norton
Foundation, Willem Peppler, Denise Rich, Rachel Rudin, David Teiger,
Ginny Williams, Elliot K. Wolk

159. Dennis Oppenheim. American, born 1938
Annual Rings. 1968
Mixed media, 40 x 30" (101.6 x 76.2 cm)
The Metropolitan Museum of Art, New York. The Horace W.
Goldsmith Foundation Gift, through Joyce and Robert Menschel

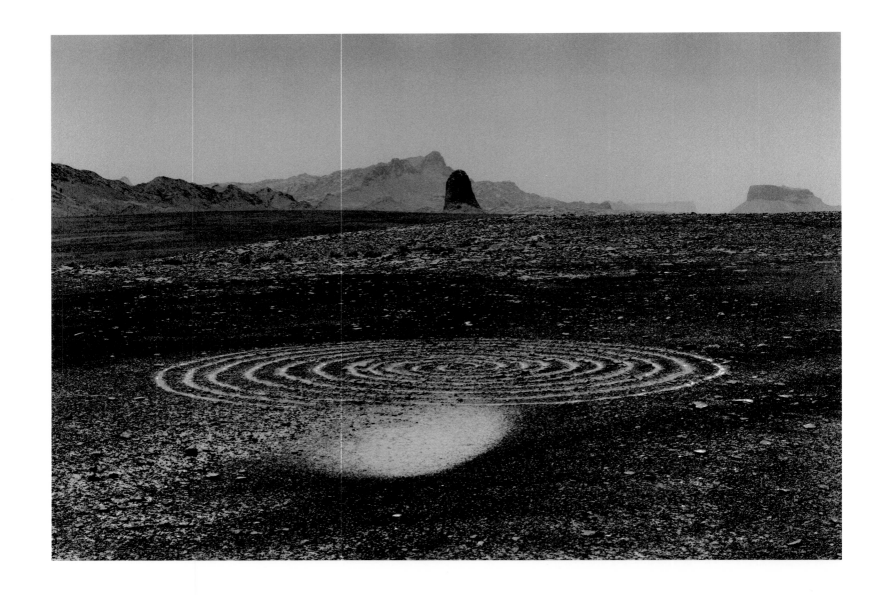

WHIRLWIND SPIRAL

THE SAHARA 1988

160. Richard Long. British, born 1945
Whirlwind Spiral. The Sahara. 1988
Gelatin silver print, 18 ¹¹⁄₁₆ x 27 ³⁄₁₆" (47.5 x 69 cm)
Kunsthaus Zürich, Fotosammlung

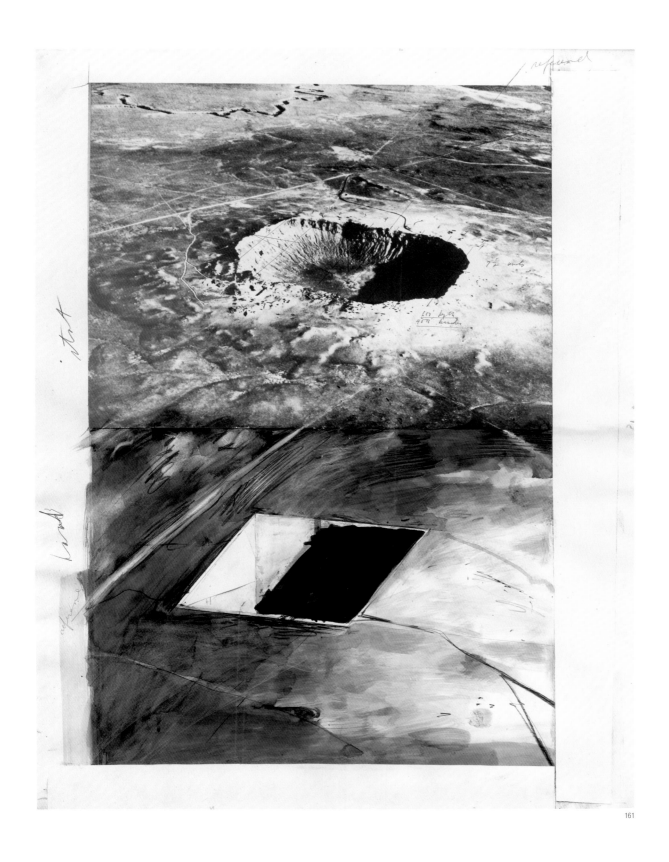

161. Michael Heizer. American, born 1944
Untitled. 1969
Photograph, pencil, ink, watercolor, and paper collage element on
paper, 39 1/16 x 30" (99.2 x 76.2 cm)
Whitney Museum of American Art, New York. Gift of Norman Dubrow

162. Cyprien Gaillard. French, born 1980
Geographical Analogies (Alton Estate, Roehampton, England; La Noé,
Chanteloup les Vignes, Château d'Oiron, France). 2006–9
Dye diffusion transfer prints (Polaroids), wood, glass, and cardboard,
25 9⁄16 x 18 7⁄8 x 3 15⁄16" (65 x 48 x 10 cm)
Courtesy the artist and Laura Bartlett Gallery, London/Bugada & Cargnel, Paris

163. Gordon Matta-Clark. American, 1945–1978
Circus—The Caribbean Orange. 1978
Silver dye bleach print, 39 ½ x 29 ⅞" (100.3 x 75.9 cm)
The Museum of Modern Art, New York. Acquired through the generosity of
The Junior Associates of The Museum of Modern Art, with contributions
from Robert Beyer, Ellen R. Herman, Scott J. Lorinsky, Steven T. Mnuchin
and Muffy Perlbinder

164. Rachel Whiteread. British, born 1963
Drawing for Water Tower, V. 1997
Tape, ink, varnish, and correction fluid on color photographs,
19 ⅞ x 17 ½" (50.5 x 44.5 cm)
The Museum of Modern Art, New York. Purchase

165

165. Zhang Dali. Chinese, born 1963
Demolition: Forbidden City, Beijing. 1998
Chromogenic color print, 35 9/16 x 23 11/16" (90.3 x 60.1 cm)
The Museum of Modern Art, New York. Gift of Larry Warsh

166

167

168

169

170

171

166–71. Alina Szapocznikow. Polish, 1926–1973
Fotorzeźby (Photosculptures). 1971
Gelatin silver prints, each: 7 1/16 x 9 7/16" (18 x 24 cm) or 9 7/16 x 7 1/16" (24 x 18 cm)
Centre Pompidou, Musée national d'art moderne–Centre de création
industrielle, Paris. Purchase

VIII. DAGUERRE'S SOUP: WHAT IS SCULPTURE?

In the aftermath of World War I, when many aspects of European culture were drastically revised, artists involved with Dada, Surrealism, and other avant-garde manifestations explored photography with newfound flexibility, taking up the camera to capture the mystery of found objects, readymades, and other constructions that challenged established notions of what is or is not art. Man Ray and his contemporaries manipulated photography's documentary status as a source of playfulness. As Arturo Schwarz writes, "Up to the late 1940s most of Man Ray's objects were assembled chiefly to provide unusual subjects for unconventional photographs. Once they had served this purpose they were discarded, dismantled, forgotten or lost."[1] The first readymade in Man Ray's oeuvre is *L'Homme* (Man, 1918; plate 172), a rotary eggbeater, and the first assisted readymade is *La Femme* (Woman, 1918), an assemblage of photographer's tools including two spherical metal reflectors, a strip of glass, and six clothespins (used to hold drying negatives). Robbed of their familiar contexts, both objects are bathed in isolation, a photogenic strangeness amplified by the uncertainty between the forms of the objects and their shadows. In 1920, Man Ray made two more prints of *L'Homme* and *La Femme* but titled

SCULPTURES INVOLONTAIRES

fig. 1. Page from *Minotaure* nos. 3–4 (December 1933), showing six of Brassaï's *Sculptures involontaires*, with captions by Salvador Dalí. The Museum of Modern Art Library, New York

them the opposite way, adding to the confusion of genders. In yet another print he flipped the photograph of the photographer's tools, so that the clothespins now appeared to the right of the composition, and renamed it *Integration of Shadows* (1918; plate 173). In all of these cases Man Ray's use of photography called into question the notion of traditional sculpture, instead assembling simple objects as subjects for pictures that no professional photographer would previously have considered shooting.

Visual mystery likewise defines *L'Enigme d'Isidore Ducasse* (The enigma of Isidore Ducasse, 1920; plate 177), another work Man Ray made for the camera. The object in the picture—a sewing machine wrapped in army sacking and tied with rope—alludes to an image in the fourth canto of *Les Chants de Maldoror* (The songs of Maldoror), written by the poet Isidore Ducasse in 1868–69 under his pen name of the Comte de Lautréamont: "beautiful as the chance encounter, on a dissecting table, of a sewing machine and an umbrella." The photograph fits squarely within Man Ray's Surrealist period and, appropriately, it was reproduced on the first page of the first issue of the magazine *La Révolution surréaliste*, dated December 1, 1924.

Although Brassaï was never officially a Surrealist, his circle in the early 1930s included Man Ray and many others affiliated with Surrealism, such as André Breton, Paul Eluard, Benjamin Péret, Jacques Prévert, and Albert Skira. He was also involved with Surrealist-oriented journals including *Minotaure*, *Verve*, and *Labyrinthe*. Brassaï viewed photography as the art of giving "things the chance to express themselves."[2] This desire to awaken the marvelous through automatist and aleatory processes was strong in Surrealist thinking. In 1932, Brassaï collected and photographed a series of found objects—tiny castoff scraps of paper that had been unconsciously rolled, folded, or twisted by restless hands, strangely shaped bits of bread, smudged pieces of soap, and accidental blobs of toothpaste. He titled these photographs *Sculptures involontaires* (Involuntary sculptures; plates 174, 175), and published six of them in the December 1933 issue of *Minotaure* (fig. 1) as the foreword to an article on Art Nouveau by Salvador

Dalí, who also wrote the captions for the pictures. Shot close up, magnified, and presented out of context, the objects communicate involuntary human gestures, offering a visual foil to verbal automatism.

In the United States in the 1930s, David Smith displayed a similar desire to stay at the edge of avant-garde experimentation by inventing independent sculptural images through the camera lens. As it had for Auguste Rodin and Constantin Brancusi before him, photography became a tool with which he could construe the sculptural. The proof that Smith conceived his photographs as artworks is that in 1939 he sent examples of them to László Moholy-Nagy, the champion of *Neue Optik* or "New Vision" photography, who had moved two years earlier to Chicago to become the director of the New Bauhaus. Extolling the camera's capacity to create a whole new way of seeing beyond the power of the human eye, Moholy-Nagy called photography the medium of the future: "It is not the person ignorant of writing, but the one ignorant of photography who will be the illiterate of the future."[3] Smith's prints of the mid-1930s bear a resemblance to pictures by Moholy-Nagy and Man Ray in which multiple negatives were sandwiched to produce photographic collages. In the summer of 1932 and the spring of 1933, at Bolton Landing in upstate New York, Smith made assemblages out of discarded industrial parts as well as pieces of coral, stone, wire, and aluminum rod. He then photographed these objects, both focusing on specific details and producing complex photomontages by cutting up negatives and other celluloid material (plates 178–80). Combining frontal and overhead views, he pasted the bits together before printing them.[4] During these formative years Smith enlisted photography not to document sculpture but to translate his improvised, easily disposable sculptural structures into two dimensions.

In the 1960s and '70s, artists engaging with various forms of reproduction, replication, and repetition used the camera to explore the limits of sculpture. The word "sculpture" itself was somewhat modified, no longer signifying something specific but rather indicating a polymorphous objecthood. Brassaï's *Sculptures involontaires* provide an interesting precursor to a whole strand of postwar production based on compulsive processes and the diversification of object types. Alina Szapocznikow's *Fotorzeźby* (Photosculptures, 1971; plates 166–71) plays out this heterogeneity; a series of twenty gelatin silver prints, it shows chewing gum marked by her teeth, making the simple act of mastication produce sculptural objects. Each picture shows an elastic gob of gum set on a concrete or wooden perch, stretched, formless, and distended, revealing a materiality that alternately sags, sprawls, and slumps. In poetic prose prefacing the pictures, Szapocznikow writes,

> Last Saturday, the sun was shining, weary with polishing my Rolls-Royce made of pink marble from Portugal, I sat down and began to dream, chewing mechanically on my chewing-gum. While I was pulling astonishing and bizarre forms out of my mouth I suddenly realized what an extraordinary collection of abstract sculptures was passing through my teeth. It suffices to photograph and enlarge my chewed discoveries to create the event of a sculptural presence. Chew well and look around! The creation lies between dream and everyday work.[5]

Szapocznikow's work suggests a new kind of sculpture, skewed toward Surrealism through the filter of mid-century Nouveau Réalisme. At the same time, the abject connotations of her materials announce the bodily transgressions of a generation of artists emerging a decade later.

At the forefront of this generation is Robert Gober. In Gober's hands, photography extends the Surrealist assault on common sense into an exploration of the space between the banal object and its disquieting emotive impulses. Gober's pictures of drains (plate 181), mousetraps (plate 182), and other vernacular fixtures reveal an alternate representation of gender and a present-day equivalent to the fusion of sexual and mechanical elements in photographs by Man Ray and Marcel Duchamp. In *Untitled* (1988; plate 183), a collaboration with Christopher Wool, Gober photographed a woman's dress, patterned with one of Wool's stencils of entwined foliage, hanging from a tree in the woods. The image toys with illusion and reality, claiming its own eerie atmosphere. Although impermanent as sculpture, the work's surreal presence endures in the photographic image.

Similar tactics appear in the pursuits of Gober's contemporaries. During over thirty years of collaboration, Peter Fischli and David Weiss have often combined photography with wacky, ingeniously choreographed assemblages of objects. Their Equilibres series (1984–87; plates 184–88) exemplifies the playful effect and disquieting feeling that they call on the camera to create. To make these tongue-in-cheek color and black and white pictures, subtitled "Equilibrium is best shortly before it gives way," Fischli/Weiss assembled kitchen appliances, pieces of studio debris, and fresh vegetables. Shot on the verge of entropy, each construction bears its own absurd title. In *Mrs. Pear Bringing Her Husband a Freshly Ironed Shirt for the Opera. The Boy Smokes* (1984; plate 187), miscellaneous household items counterbalanced on an upended hammer interconnect with a feminine-looking pear, a stretched rubber glove in the guise of an ironed shirt, and an anthropomorphized old sneaker that is held vertical by an iron rod. The camera arrests these precariously balanced sculptures in perfect tension, conveying a sense of animated suspension and deadpan comedy.

Gabriel Orozco similarly jettisons the permanent or durable aura of traditional sculpture in favor of provisional and recyclable structures. In capturing transitory encounters, his pictures celebrate the unintentional presence of objects in everyday life. "What is most important," the artist notes, "is not so much what people see in the gallery or the museum, but what people see after

looking at these things, how they confront reality again. Really great art regenerates the perception of reality, the reality becomes richer, for better or not, just different."[6] *Cats and Watermelons* (1992; plate 190) conveys the point: to take the photograph, the artist improvised a sculpture of cat-food cans set on a heap of green watermelons in a supermarket bin. Teasingly aligned on top of the large melons, with each cat's face posed directly facing the camera, the cans undergo a displacement that at once subverts their original intention and renews their signifying possibilities.

Orozco's critical strategy nods to a line of thought also present in the absurdist taxonomies of Marcel Broodthaers's *Musée d'art moderne, département des aigles* (Museum of modern art, department of eagles). Initiated in 1968, Broodthaers's fictitious "museum" was conceived as comprised of "departments," each mixing historical objects with items of utter banality in order to sanction the museological principle of ordering according to the classifying terms of cultural history. Several years before inaugurating his *Musée d'art moderne*, at the documenta 5 exhibition in Kassel in 1972, Broodthaers declared, "The idea of inventing something insincere finally crossed my mind and I set to work at once."[7] He adopted a similar approach in photographic works, combining images and words not to clarify meaning but to displace it. *La Soupe de Daguerre* (Daguerre's soup, 1975; plate 189), a collage of twelve photographs showing food—whether real vegetables or fish made of tissue paper—includes a label at the bottom, as if the work were a museum exhibit. If the work's title ironically hints at the various fluids and chemical processes used by Louis Daguerre to invent photography in the nineteenth century, it also brings into play experimental ideas about language and the realm of everyday objects.

In 2007, Rachel Harrison drew on Broodthaers's illogical systems of classification and parodic collections of objects to produce *Voyage of the Beagle* (plates 191–200), a series of fifty-seven photographs that collectively raise the question "What is sculpture?" The work of course takes its title from Charles Darwin's voyage on HMS *Beagle*, begun in 1831 to chart the coasts of Patagonia and Tierra del Fuego. Darwin's observations on the natural history of plants and animals, in places little known to European naturalists, led to his development of the theory of evolution that he would publish in *On the Origin of Species* in 1859. Taking the concept of origins as a point of departure for a taxonomy of sculptural forms, Harrison's photographs in *Voyage of the Beagle* begin and end with images of menhirs, prehistoric standing stones. The menhirs stand on equal footing with mass-produced Pop mannequins and topiaries, which are in turn followed by sculptures made by modernist masters such as Rodin, Brancusi, and Alberto Giacometti. Gaining meaning from the pictures' cumulative effect, the work constitutes an oblique quest for the origins and contemporary manifestations of sculpture. Speaking of Harrison's work, John Kelsey suggests that sculpture seems to begin and end everywhere: "in the park, the street, shop windows, yard sales, magazines, the Internet, etc." "To produce sculpture," he concludes, "is sometimes merely to notice it, to find it, usually not in the museum."[8]

Notes

1. Arturo Schwarz, *Man Ray: The Rigour of Imagination* (New York: Rizzoli, 1977), p. 158.
2. Brassaï, quoted in Katharine Conley, "Modernist Primitivism in 1933: Brassaï's 'Involuntary Sculptures' in *Minotaure*," *Modernism/Modernity* 10, no. 1 (2003):132.
3. László Moholy-Nagy, "Photography in Creation with Light," 1928, quoted in Walter Benjamin, "News about Flowers," in *Walter Benjamin: Selected Writings*, ed. Michael W. Jennings, Howard Eiland, and Gary Smith (Cambridge, Mass.: Harvard University Press, 1999), 2:156.
4. Joan Pachner notes that Smith explored his collage instincts in photographic projects before realizing them in three-dimensional work. See Pachner, *David Smith Photographs 1931–1965* (New York: Matthew Marks Gallery, and San Francisco: Fraenkel Gallery, 1998), p. 132.
5. Alina Szapocznikow, typewritten text accompanying the photographs, inscribed "92 Malakoff, 22 June 1971."
6. Gabriel Orozco, in *Clinton is Innocent* (Paris: Musée d'Art Moderne de la Ville de Paris, 1998), p. 61.
7. Marcel Broodthaers, quoted in Brigit Pelzer, "Recourse to the Letter," in *October* 42 (Fall 1987):163. This is a special issue of *October* devoted to Broodthaers, titled *Broodthaers: Writings, Interviews, Photographs* and edited by Benjamin H. D. Buchloh.
8. John Kelsey, "Sculpture in an Abandoned Field," in Rachel Harrison, Heike Munder, Ellen Seifermann, and Kelsey, *Rachel Harrison: If I did it* (Zurich: JRP Ringier, 2007), p. 123.

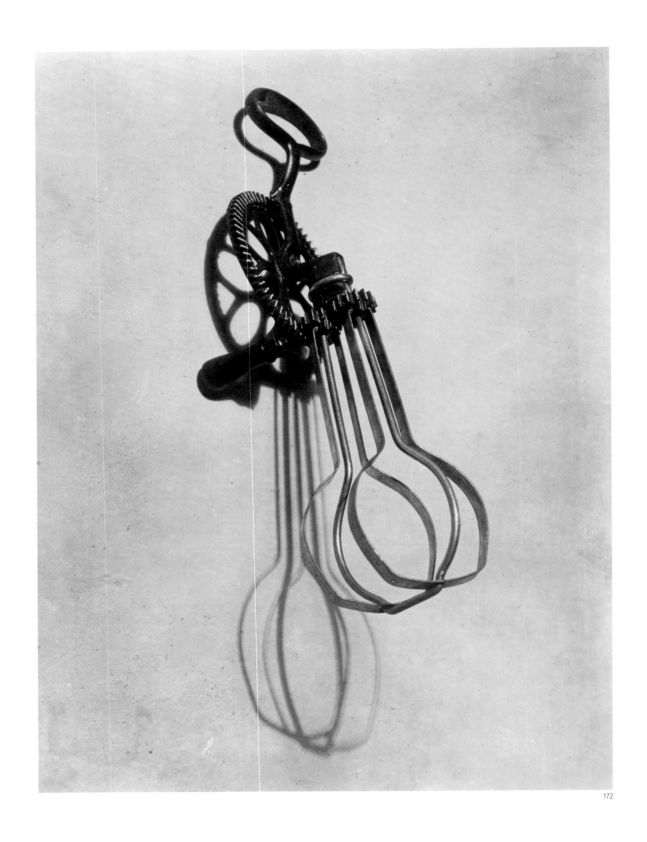

172. Man Ray (Emmanuel Radnitzky). American, 1890–1976
L'Homme (Man). 1918
Gelatin silver print, 19 x 14 ½" (48.3 x 36.8 cm)
Private collection, New York

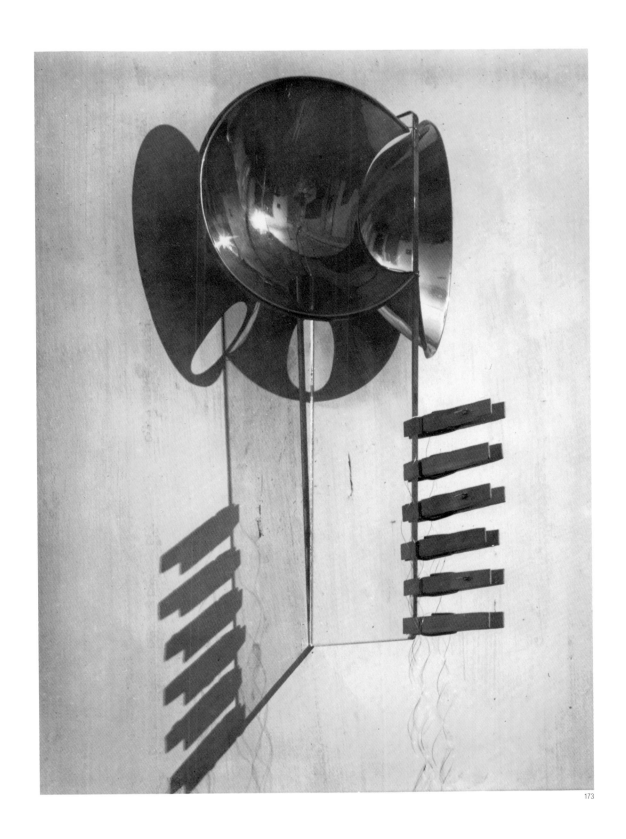

173

173. Man Ray (Emmanuel Radnitzky). American, 1890–1976
Integration of Shadows. 1918
Gelatin silver print, 9 ⁹⁄₁₆ x 6 ¾" (23.3 x 17.2 cm)
Private collection, San Francisco

174

175

174. Brassaï (Gyula Halász). French, born Transylvania, 1899–1984
Sculptures involontaires: billet d'autobus roulé (Involuntary
sculptures: rolled-up bus ticket). c. 1932
Gelatin silver print, 6 ¹¹⁄₁₆ x 9 ¼" (17 x 23.5 cm)
The Beth and Uri Shabto Collection, courtesy Edwynn Houk Gallery, New York

175. Brassaï (Gyula Halász). French, born Transylvania, 1899–1984
Sculptures involontaires: dentifrice répandu (Involuntary sculptures:
smeared toothpaste). c. 1932
Gelatin silver print, 7 x 9 ¼" (17.8 x 23.5 cm)
Courtesy Edwynn Houk Gallery, New York

176

177

176. Brassaï (Gyula Halász). French, born Transylvania, 1899–1984
Torse de femme (ciseau) (Woman's torso [scissors]). c. 1930–31
Gelatin silver print, 9 ¼ x 6 ¾" (23.5 x 17.1 cm)
The Beth and Uri Shabto Collection, courtesy Edwynn Houk Gallery, New York

177. Man Ray (Emmanuel Radnitzky). American, 1890–1976
L'Enigme d'Isidore Ducasse (The enigma of Isidore Ducasse). 1920
(printed early 1950s)
Gelatin silver print, 3 ⅞ x 4 ⅝" (9.9 x 11.7 cm)
Collection Andrew Strauss, Paris

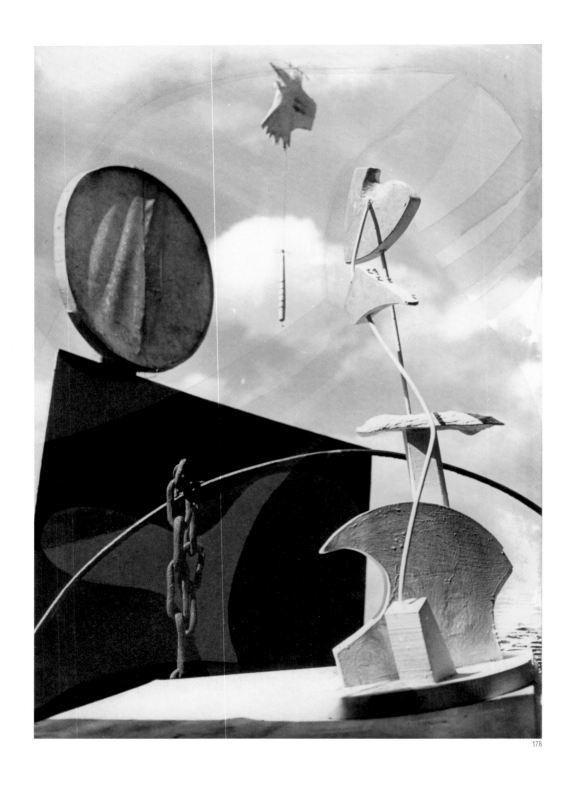

178. David Smith. American, 1906–1965
Untitled (Bolton Landing Tableau) with Construction. 1932
Gelatin silver print with applied varnish, 10 x 7 ³⁄₁₆" (25.4 x 18.3 cm)
Private collection, San Francisco

179

180

179. David Smith. American, 1906–1965
Untitled. c. 1932–35
Gelatin silver print, 6 ½ x 4 ¾" (16.5 x 12.1 cm)
Private collection, San Francisco

180. David Smith. American, 1906–1965
Untitled. c. 1932–35
Gelatin silver print, 3 ⁷⁄₁₆ x 4 ⅞" (8.7 x 12.4 cm)
Private collection, San Francisco

181

182

181. Robert Gober. American, born 1954
Untitled. 1999
Gelatin silver print, 9 ¹³⁄₁₆ x 12 ⅜" (25 x 31.5 cm)
The Metropolitan Museum of Art, New York. Purchase, The Horace W.
Goldsmith Foundation Gift, through Joyce and Robert Menschel

182. Robert Gober. American, born 1954
Untitled. 1999
Gelatin silver print, 14 ⅝ x 11 ¼" (37.1 x 28.6 cm)
The Metropolitan Museum of Art, New York. Purchase, The Horace W.
Goldsmith Foundation Gift, through Joyce and Robert Menschel

183

183. Robert Gober. American, born 1954. In collaboration with Christopher
Wool. American, born 1955
Untitled. 1988
Gelatin silver print, 13 ⅛ x 10 ⅛" (33.3 x 25.7 cm)
The Museum of Modern Art, New York. Gift of Werner and Elaine Dannheisser

184

185

186

184. Fischli/Weiss (Peter Fischli. Swiss, born 1952. David Weiss. Swiss, born 1946)
Outlaws. 1984
Chromogenic color print, 15 ¾ x 11 ¹³⁄₁₆" (40 x 30 cm)
Courtesy the artists and Matthew Marks Gallery, New York

185. Fischli/Weiss (Peter Fischli. Swiss, born 1952. David Weiss. Swiss, born 1946)
Father. 1986
Gelatin silver print, 15 ¾ x 11 ¹³⁄₁₆" (40 x 30 cm)
Courtesy the artists and Matthew Marks Gallery, New York

186. Fischli/Weiss (Peter Fischli. Swiss, born 1952. David Weiss. Swiss, born 1946)
The Three Sisters. 1984
Chromogenic color print, 11 ¹³⁄₁₆ x 15 ¾" (30 x 40 cm)
Courtesy the artists and Matthew Marks Gallery, New York

187

188

187. Fischli/Weiss (Peter Fischli. Swiss, born 1952. David Weiss. Swiss, born 1946)
Mrs. Pear Bringing Her Husband a Freshly Ironed Shirt for the Opera. The Boy Smokes. 1984
Chromogenic color print, 11 ¹³⁄₁₆ x 15 ¾" (30 x 40 cm)
Courtesy the artists and Matthew Marks Gallery, New York

188. Fischli/Weiss (Peter Fischli. Swiss, born 1952. David Weiss. Swiss, born 1946)
The Proud Cook. 1984
Gelatin silver print, 15 ¾ x 11 ¹³⁄₁₆" (40 x 30 cm)
Courtesy the artists and Matthew Marks Gallery, New York

La Soupe
de
Daguerre

189. Marcel Broodthaers. Belgian, 1924–1976
La Soupe de Daguerre (Daguerre's soup). 1975
Chromogenic color prints mounted on paper, 21 x 20 ½" (53.3 x 52.1 cm)
Kunsthaus Zürich, Grafische Sammlung

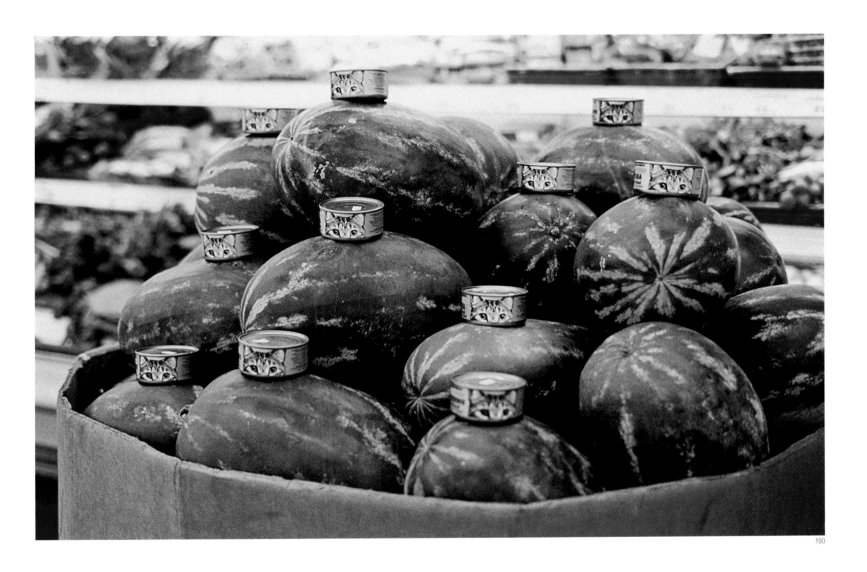

190

190. Gabriel Orozco. Mexican, born 1962
Cats and Watermelons. 1992
Silver dye bleach print, 12 ⁷⁄₁₆ x 18 ⁵⁄₈" (31.6 x 47.3 cm)
Collection of Jill Sussman and Victor Imbimbo

181

191 192 193 194 195

191–200. Rachel Harrison. American, born 1966
Voyage of the Beagle. 2007
Pigmented inkjet prints from a suite of fifty-seven, each: 16 x 12" (40.6 x 30.5 cm)
The Museum of Modern Art, New York. Fund for the Twenty-First Century

196 197 198 199 200

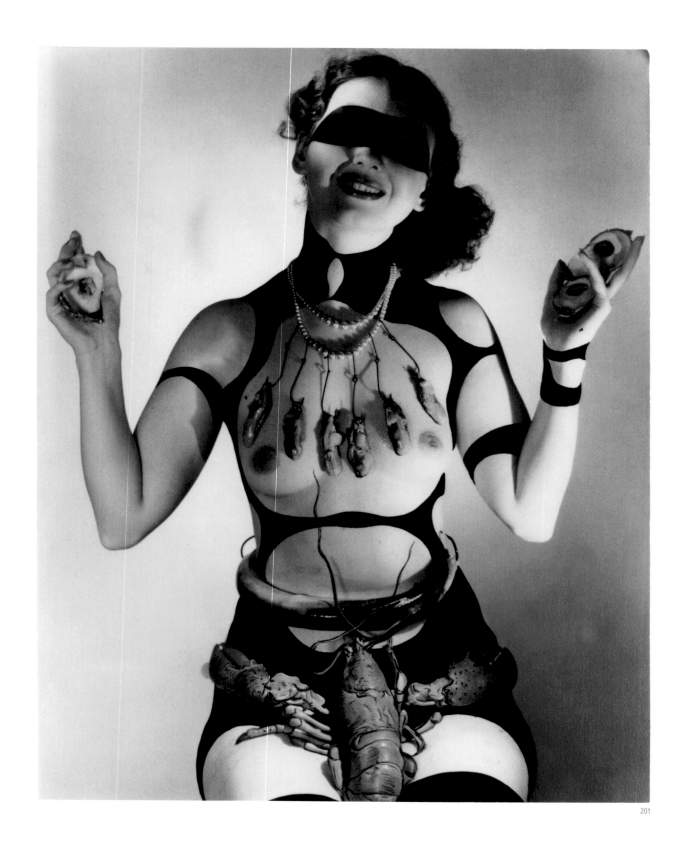

201

201. Horst P. Horst. American, born Germany, 1906–1999
Costume for Salvador Dali's "Dream of Venus". 1939
Gelatin silver print, 10 x 7 ½" (25.4 x 19 cm)
The Museum of Modern Art, New York. Gift of James Thrall Soby

IX. THE PYGMALION COMPLEX: ANIMATE AND INANIMATE FIGURES

In *The Dream of the Moving Statue*, Kenneth Gross enlists the opening shot of Charlie Chaplin's classic film *City Lights* (1931) to introduce his subject: "the fantasy of an animated statue—a statue that moves or speaks, responds to a gesture, calls out, looks back at the person looking at it—coming to life as oracle, enemy, guest, mocker, or monster."[1] Released four years after the start of the talkies era, Chaplin's film—as its subtitle, *A Comedy Romance in Pantomime*, suggests—is an accolade to the "sculptural" art of body language, whether in dance, acting, or slapstick comedy. The film opens with the unveiling of a Greco-Roman–style public monument, *Peace and Prosperity* (figs. 1–3), before a decorous civic group. When the dust sheet is lifted from the monument, Chaplin's black-clothed tramp is found sleeping in the central figure's lap. Waking up to the shouts of the surprised crowd, he tries to escape, only to realize that the lifeless statue seems to have become animated: as he slides off the lap of the stone figure, the sword of another catches the back of his pants, comically suspending him in midair. Continuing his ballet-like crawl down the central statue, the tramp finds himself with his nose against the upraised hand of a third figure in a classic nose-thumbing gesture.

The subject of the animated statue spans the history of avant-garde film and photography. In the Surrealist Manifesto of 1924, André Breton cites "the modern mannequin," a lifeless object that makes viewers wonder whether it may not be in fact animate, as an example of the "marvelous." Artists interested in Surrealist tactics used the camera to tap the uncanniness of puppets, wax dummies, mannequins, and automata, producing pictures that both transcribe and alter ap-

figs. 1–3. Charles Chaplin. *City Lights*. 1931. Stills from black and white film, silent, 83 min. The Museum of Modern Art Film Stills Archive, New York

pearances. Laura Gilpin explores this perturbing mix of stillness and living, alluring lifelikeness in her mysterious portrait *George William Eggers* (1926; plate 224), in which Eggers, the director of the Denver Art Museum, keeps company with a fifteenth-century Florentine bust whose polychrome charm is enhanced by the glow of the candle he holds next to her face. So does Edward Weston, in his whimsical *Rubber Dummies, Metro Goldwyn Mayer Studios, Hollywood* (1939; plate 204), showing two elastic dolls caught in a pas de deux on a movie-studio storage lot; and Clarence John Laughlin, in his eerie photomontage *The Eye That Never Sleeps* (1946; plate 211), in which the negative of an image taken in a New Orleans funeral parlor has been overlaid with an image of a mannequin—one of whose legs, however, is that of a flesh-and-blood model.

The tension between animate object and inanimate female form lies at the crux of many of Man Ray's photographs, such as *Noire et blanche* (Black and white, 1926; plate 216), which provocatively couples the head of the legendary model, artist, and cabaret singer Alice Prin, a.k.a. Kiki of Montparnasse, with an African ceremonial mask. The emblematic pairing between white woman and black sculpture invites viewers to see the two in terms of other cultural pairings: Europe/Africa, modernism/ritual, animate/inanimate, flesh/ebony. Man Ray was obviously interested in the play between the two heads as sculptural analogues. Kiki's passive pose, with closed eyes and polished cheek laid horizontally, akin to Constantin Brancusi's *Muse endormie* (Sleeping muse) sculptures of the same period, petrifies her into an object, a perfect mask.

In another iconic picture, *Le Violon d'Ingres* (Ingres's violin; plate 217), published in 1924 as the frontispiece of the last issue of the Surrealist periodical *Littérature*, Man Ray portrays Kiki with her back made up as the body of a violin.[2] He produced this image in several versions, using different techniques: in one, he painted the violin's f-holes directly onto the photographic print; in another, he added the f-holes during the printing process, exposing the print to light in the darkroom under a paper mask. As Paul Messier remarks, this latter version mixes conventional photography with the cameraless technique of Man Ray's rayographs.[3] Kiki's pose is inspired by a bather in Ingres's *Baigneuse Valpinçon* (The Valpinçon bather, 1808), and the picture's title translates literally as "Ingres's violin," but in French the term is an idiomatic expression for "hobby." Equating the female body with a musical instrument, Man Ray transforms a classical nude into an object that can be played.

fig. 4. Luis Buñuel. *L'Age d'or*. 1930. Still from black and white film, sound, 61 min. The Museum of Modern Art Film Stills Archive, New York

In the zany *Satiric Dancer* (1926; plate 221), a picture that in the quality of its formal invention functions as a pendant to *Le Violin d'Ingres*, André Kertész addressed the subject of dance with similar aplomb. In a low-cut dress and high heels, the Hungarian cabaret dancer Magda Förstner reclines kinetically on an oval sofa. The photograph was taken in the Paris studio of the sculptor István Beöthy, and one of his modernist marble sculptures, a torqued male torso, stands on a table beside her. The picture's downward, wide-angle perspective accentuates the visual rhyme between the twisted poses of the model and of the sculpture, treating the two as equivalents.

The animation fantasy finds a peak in several works by Salvador Dalí. The screenplay that he wrote with Luis Buñuel for the film *L'Age d'or* (The golden age, 1930), directed by Buñuel, delivers a deliriously provocative take on *l'amour fou*, the Surrealist concept of mad, obsessional love. When a couple's passionate, lustful tryst is torn apart by the codes of public morality,

fig. 5. Spread from *Minotaure* 6 (December 1934), showing eighteen photographs of Hans Bellmer's doll. The Museum of Modern Art Library, New York

their sexual desire is displaced by fetishes: the man is captivated by the naked foot of a marble statue of Venus, and in one memorable scene his lover sucks the statue's big toe (fig. 4) while fantasizing about her father. The petrification of female body into sculptural form is a familiar trope in Dalí's iconography. In *Costume for Salvador Dalí's "Dream of Venus"* (1939; plate 201), conceived for the Surrealist pavilion of the 1939 New York World's Fair, Dalí teamed up with the *Vogue* photographer Horst P. Horst to shoot a series

of pictures of a nude model adorned with sculptural accessories made of crustaceans. Her eyes concealed by a black velvet mask, the model holds oysters in both hands and wears a pearl necklace from which mussels are suspended by fishing hooks. A lobster covers her genitalia. A trompe l'oeil bathing suit carefully inked in by Dalí on the original print, which was then rephotographed by Horst, enhances the woman's mannequinlike guise—she becomes a female-object, or as Dalí put it, a "being object."[4]

The cultural climate of the 1930s affected the way in which many photographers approached the human body, responding to the disturbing politics of the period by creating anatomical dictionaries of only ambivalently animate forms. Hans Bellmer's photographs of dolls (plates 209, 210) were particularly disturbing to any familiar sense of corporeality. Bellmer constructed his first doll in 1933 in Berlin. Executed partly in protest of Hitler's ascent to power, the doll, Bellmer said, was "an artificial girl with multiple anatomical possibilities."[5] He conceived it under the erotic spell of his young cousin Ursula, but he was also inspired by Jacques Offenbach's fantasy opera *Les Contes d'Hoffmann* (The tales of Hoffmann, 1880), in which the hero, maddened by love for an uncannily lifelike automaton, ends up committing suicide. A year later, at his own expense, Bellmer published *Die Puppe* (The doll), a book of ten photographs documenting the stages of the doll's construction. He sent a copy of the book to Breton, creating a stir among the Surrealists, who recognized its subversive nature. Paul Eluard decided to publish eighteen photographs of the doll in the December 1934 issue of *Minotaure* (fig. 5). In 1935, Bellmer constructed a second, more flexible doll, which he photographed in various provocative scenarios involving acts of dismemberment. These transformations of the doll's body dispensed with the idea of the unitary self, instead proposing a series of selves and offering an alternative to the unyielding image of the body and psyche popularized in German fascist propaganda of the 1930s.

The widespread use of collage and photomontage in the late 1920s and early '30s, in the works of artists such as Herbert Bayer, Johannes Theodor Baargeld, Hannah Höch, and Claude Cahun, evinced a similar opposition to the idealized stereotype of the Aryan body found in Nazi art and mass culture. Bayer's photomontages, made for the most part after his departure from

the faculty of the Bauhaus, in 1928, combine elements from pictures of classical sculpture with pictures of his own body to create fragmented and hybrid anatomies. In his self-portrait *Menschen unmöglich* (Humanly impossible, 1932; plate 212), Bayer observes himself in a mirror that turns his reflected double into marble. It also severs a slice of his arm from his torso, so that he appears in the mirror as an armless Greek statue. The slice of faux marble that he holds in his hand was actually an overpainted sponge. Although playful, the expression of horror on Bayer's face points to the physical and psychological traumas suffered by many artists and photographers during World War I: László Moholy-Nagy was severely injured; Josef Sudek was injured by a shell blast and had his right arm amputated; and Kertész suffered a bullet wound to his left arm, which led to partial paralysis.

The irreverent collages that Baargeld produced in Cologne as part of his left-wing and Dadaist activities similarly invoke the unstable subjectivity and breakdown of boundaries in the aftermath of the Great War.[6] In the androgynous self-portrait *Typische Vertikalklitterung als Darstellung des Dada Baargeld* (Typical vertical mess as depiction of the Dada Baargeld, 1920; plate 232), the artist tops a reproduction of the torso of the Venus de Milo with a photograph of his own truncated head framed by the brim of a military hat. Simultaneously imagining himself as a classic sculpture, a woman, and an amputee, Baargeld, as Leah Dickerman notes, transforms "the oft-romanticized aesthetics of classical ruins, which themselves are dismembered, into a condemnation of war."[7]

In the provocative montages she made between the mid-1920s and the mid-'30s, Höch developed a critical language that challenged European gender definitions and racist and colonialist ideas. In her influential *Schnitt mit dem Küchenmesser Dada durch die letzte Weimarer Bierbauchkulturepoche Deutschlands* (Cut with the Dada kitchen knife through the last Weimar beer-belly cultural epoch in Germany, 1919–20), for example, Höch likens the scissors of her photocollage métier to the domestic kitchen knife of a housewife and cuts through the traditionally masculine field of politics. Höch's most critical photomontages are those in the series *Aus einem ethnographischen Museum* (From an ethnographic museum, 1925–30; plate 228), which combine cutout pictures of Weimar women with pictures of tribal masks and sculptures, offering a critique of the ways in which women were equated with the foreign and underdeveloped "other" during an epoch obsessed with eugenics.

A witty observer of the multifaceted and conflicting sociopolitical conditions of the interwar period, Cahun too understood the importance of masks in creating identity. "Under this mask, another mask," she wrote. "I will never finish removing all these faces." Cahun jotted these words on one of the photomontages in her 1930 book *Aveux non avenus* (Disavowals), which outlines her interest in role-playing, masking, and doubling.[8] She shaved her head and posed in a variety of male costumes, ranging from a stylish dandy to a conventionally suited civil servant, but also fashioned a feminine, puppetlike persona through the artifice of dress, makeup, and, again, masks. An untitled work from around 1925 (plate 214) is one in a series of nine self-portraits in which Cahun photographed her head under a bell jar, apparently disembodied, like a sculptural relic. Because her work is only known to have been exhibited on three occasions during her lifetime, her unconventional pictures only gained recognition in the early 1990s.

Conceptually reminiscent of Cahun's photographs, Gillian Wearing's self-portraits of the late 1990s and early 2000s use masks and prosthetic devices to expose the theatrical makeup of identity. In the series Album (2003–6), Wearing probed the idea of difference and sameness among people who share the same heritage: drawing on the traditions of documentary film as well as of performance, she impersonated members of her family, re-creating photographs of them from the family album. Using masks, wigs, body suits, and clothing (made in part by a group of assistants, some of whom had worked for the wax museum Madame Tussaud's), Wearing posed as her mother at the age of twenty-one; her father, young and tuxedo clad; herself aged seventeen (plate 229); her sister Jane; her tattooed, shirtless brother Richard; and her smiling uncle Bryan. She also made images of herself as a toddler and as each of her maternal grandparents. The painstaking process of producing the masks, and of taking up to forty rolls of film for each image, underscores Wearing's interest not just in portraiture but in its different styles, from the improvisational quality of a color snapshot to the sober format of the black-and-white studio portrait. Exploring the relationship between living figure and sculpture, her acutely observed portrayals confound us, for even though her own eyes peer out from behind the masks of these characters, our ability to recognize an identity, hers or that of another, is compromised.

Notes

1. Kenneth Gross, *The Dream of the Moving Statue* (Ithaca and London: Cornell University Press, 1992), p. 6.

2. *Littérature* no. 13 (June 1924). The journal had been founded in 1919, by André Breton with Philippe Soupault and Louis Aragon.

3. On the techniques Man Ray used to make this print see Paul Messier, "A Technical Analysis of *Le Violon d'Ingres*," in *The Long Arm of Coincidence: Selections from The Rosalind and Melvin Jacobs Collection* (Göttingen: Steidl, 2009).

4. Salvador Dalí, quoted in Fèlix Fanés, "Mannequins, Mermaids and the Bottoms of the Sea. Salvador Dalí and the New York World's Fair of 1939," in *Salvador Dalí: Dream of Venus* (Figueres: Fundació Gala-Salvador Dalí, 1999), p. 87.

5. Hans Bellmer, quoted in Peter Webb with Robert Short, *Hans Bellmer* (London, Melbourne, and New York: Quartet Books, 1985), p. 28.

6. "Johannes Theodor Baargeld" was in fact a pseudonym devised by the artist, whose real name was Alfred Emanuel Ferdinand Grunenwald, to satirize the ascendent capitalist culture of his hometown of Cologne. In German the word *Bargeld* means "cash money."

7. Leah Dickerman, *Dada: Zurich, Berlin, Hannover, Cologne, New York, Paris* (Washington, D.C.: National Gallery of Art, and New York: D.A.P./Distributed Art Publishers, 2006), p. 229.

8. Claude Cahun, *Aveux non avenus* (Paris: Éditions du Carrefour, 1930), published in English as *Disavowals or Cancelled Confessions*, trans. Susan de Muth (Cambridge, Mass.: The MIT Press, 2008), p. 183.

202

202. Manuel Alvarez Bravo. Mexican, 1902–2002
Plática junto a la estatua (Conversation near the statue). 1933
Gelatin silver print, 7 x 8 ¾" (17.8 x 22.2 cm)
The Museum of Modern Art, New York. Mr. and Mrs. Clark Winter Fund

203

203. Henri Cartier-Bresson. French, 1908–2004
Martigues, France. 1932
Gelatin silver print, 9 ¾ x 6 ⅝" (24.7 x 16.9 cm)
The Museum of Modern Art, New York. Gift of Paul F. Walter

204

204. Edward Weston. American, 1886–1958
Rubber Dummies, Metro Goldwyn Mayer Studios, Hollywood. 1939
Gelatin silver print, 7 9/16 x 9 5/8" (19.3 x 24.4 cm)
The Museum of Modern Art, New York. Gift of Edward Steichen

205

206

205. Walker Evans. American, 1903–1975
Votive Candles, New York City. 1929–30
Gelatin silver print, 8 ½ x 6 ¹⁵⁄₁₆" (21.6 x 17.7 cm)
The Museum of Modern Art, New York. Thomas Walther Collection. Purchase

206. Iwao Yamawaki. Japanese, 1898–1987
Articulated Mannequin. 1931
Gelatin silver print, 9 ¹⁄₁₆ x 6 ¹³⁄₁₆" (23 x 17.3 cm)
The Museum of Modern Art, New York. Thomas Walther Collection.
Gift of Thomas Walther

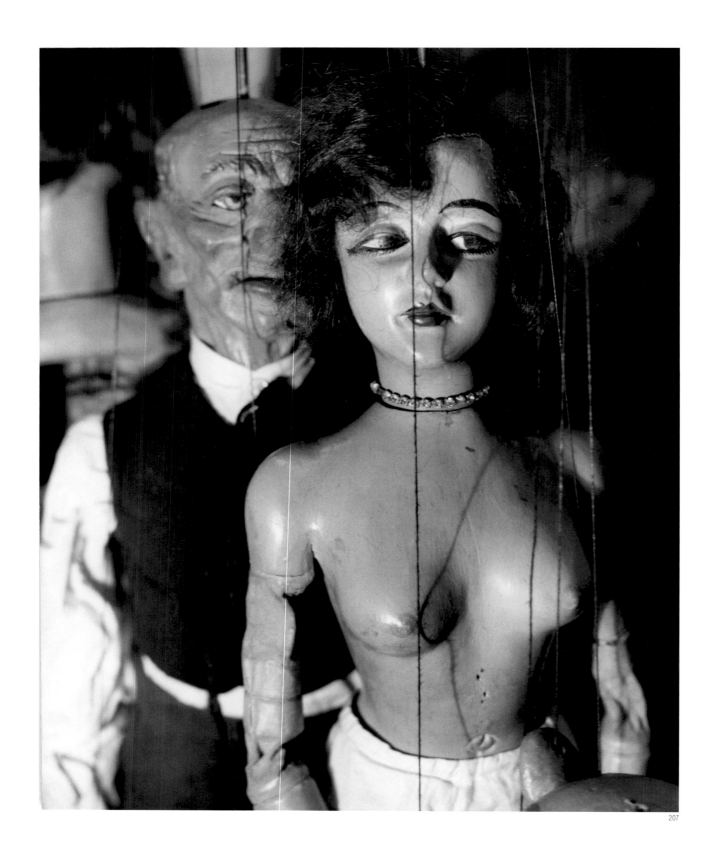

207. André Kertész. American, born Hungary, 1894–1985
Marionnettes de Pilsner. 1929
Gelatin silver print, 9 ⅝ x 7 ⅞" (24.4 x 20 cm)
The Museum of Modern Art, New York. Purchase

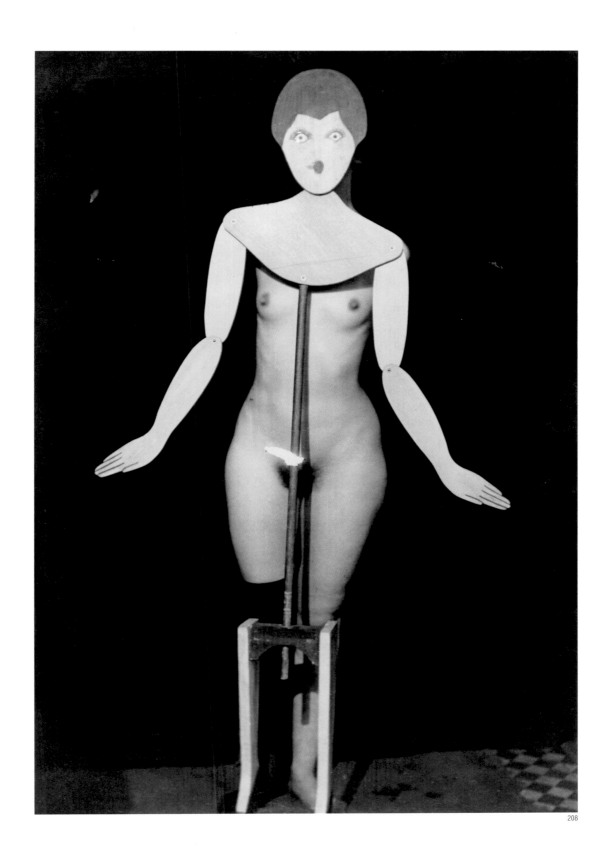

208

208. Man Ray (Emmanuel Radnitzky). American, 1890–1976
Porte-manteau (Coat stand). 1920
Gelatin silver print, 15 ⅞ x 10 ⁹⁄₁₆" (40.4 x 26.9 cm)
Centre Pompidou, Musée national d'art moderne–Centre de création
industrielle, Paris. Purchase

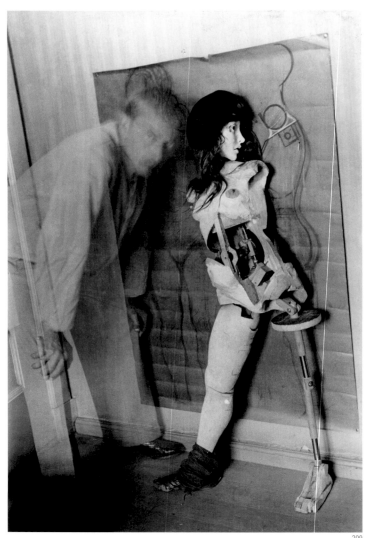

209

210

209. Hans Bellmer. German, 1902–1975
The Doll (Self-Portrait with the Doll). 1934
Gelatin silver print, 11 ¾ x 7 ¾" (29.9 x 19.7 cm)
Collection Carla Emil and Rich Silverstein

210. Hans Bellmer. German, 1902–1975
The Doll. 1935–37
Gelatin silver print, 9 ½ x 9 ⁵⁄₁₆" (24.1 x 23.7 cm)
The Museum of Modern Art, New York. Samuel J. Wagstaff, Jr. Fund

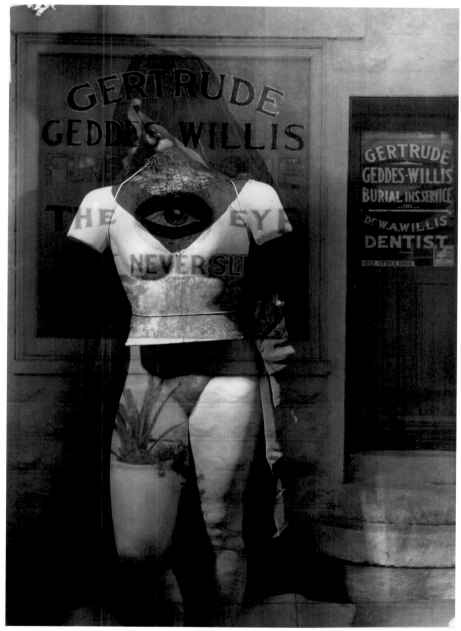

211

211. Clarence John Laughlin. American, 1905–1985
The Eye That Never Sleeps. 1946
Gelatin silver print, 12 ⅜ x 8 ¾" (31.4 x 22.2 cm)
The Museum of Modern Art, New York. Purchase

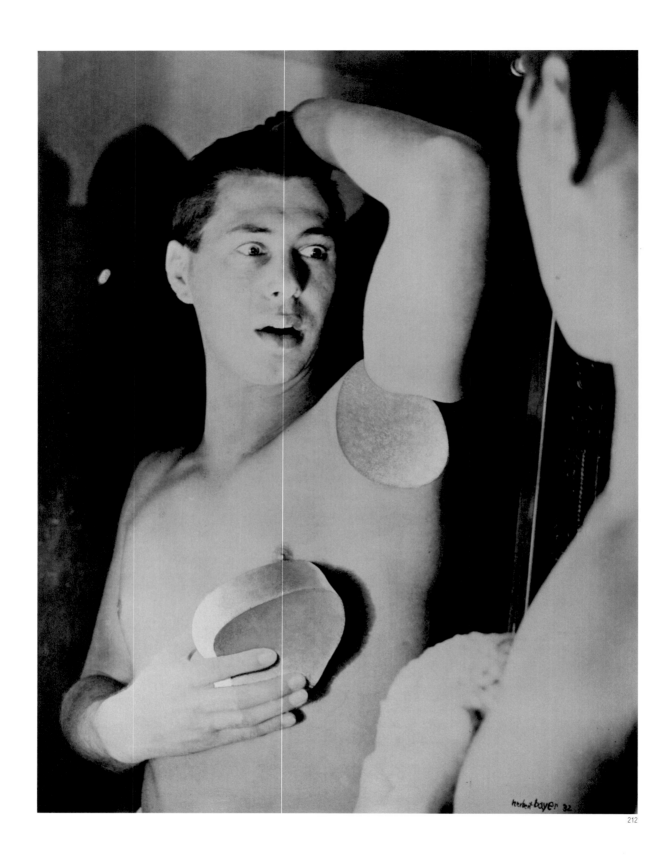

212

212. Herbert Bayer. American, born Austria. 1900–1985
Menschen unmöglich (Humanly impossible). 1932
Gelatin silver print, 15 ⅜ x 11 ⁹⁄₁₆" (39 x 29.3 cm)
The Museum of Modern Art, New York. Thomas Walther Collection. Purchase

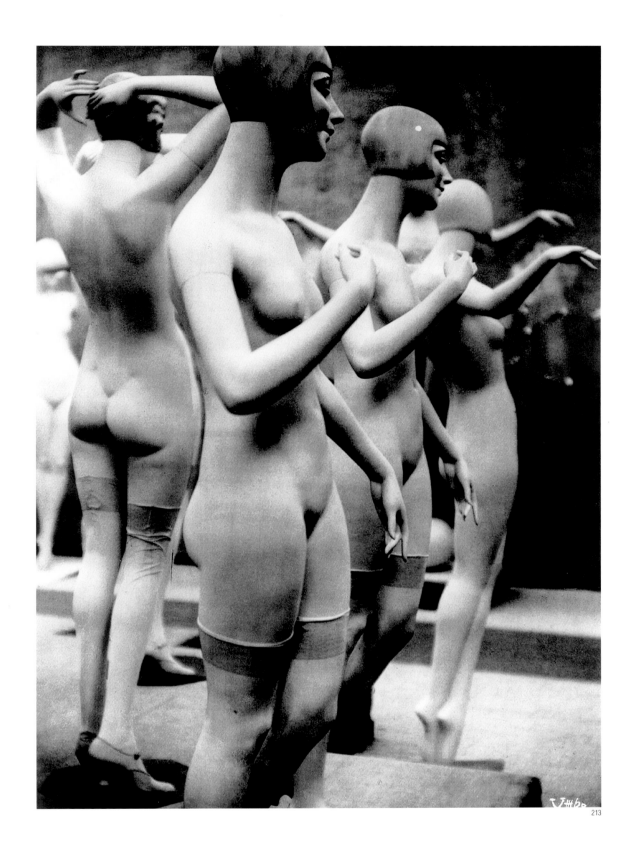

213

213. Umbo (Otto Umbehr). German, 1902–1980
Das neueste Angebot en profil (The latest offer in profile). 1928
Gelatin silver print, 11 7⁄16 x 8 ¼" (29 x 21 cm)
Collection Sylvio Perlstein, Antwerp

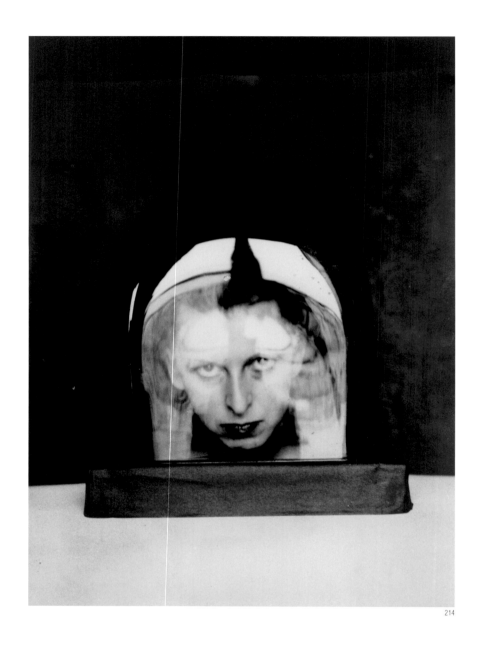

214. Claude Cahun (Lucy Schwob). French, 1894–1954
Untitled. c. 1925
Gelatin silver print, 4 1/16 x 2 15/16" (10.3 x 7.4 cm)
The Museum of Modern Art, New York. Thomas Walther Collection. Purchase

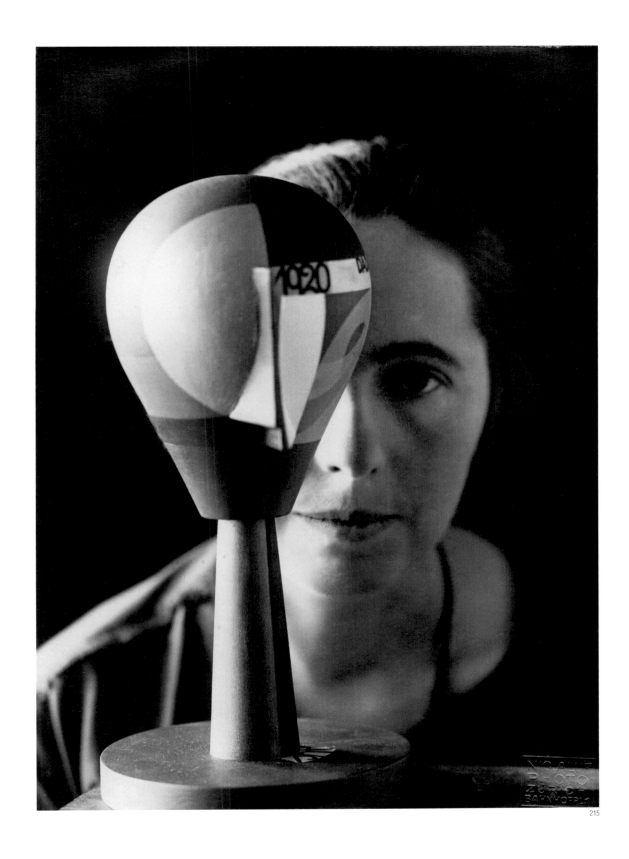

215. Sophie Taeuber-Arp. Swiss, 1889–1943
Sophie Taeuber-Arp behind Dada Head. 1920
Gelatin silver print, 6 7/16 x 4 1/2" (16.3 x 11.5 cm)
Bibliothèque Kandinsky, Centre de Documentation et de Recherche
du Musée national d'art moderne, Centre Pompidou, Paris

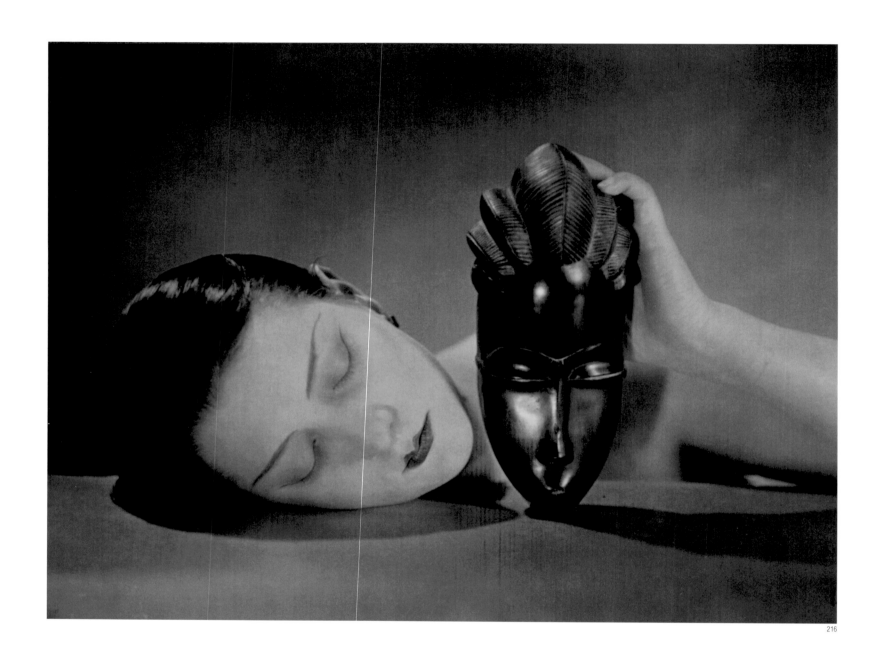

216

216. Man Ray (Emmanuel Radnitzky). American, 1890–1976
Noire et blanche (Black and white). 1926
Gelatin silver print, 6 ¾ x 8 ⅞" (17.1 x 22.5 cm)
The Museum of Modern Art, New York. Gift of James Thrall Soby

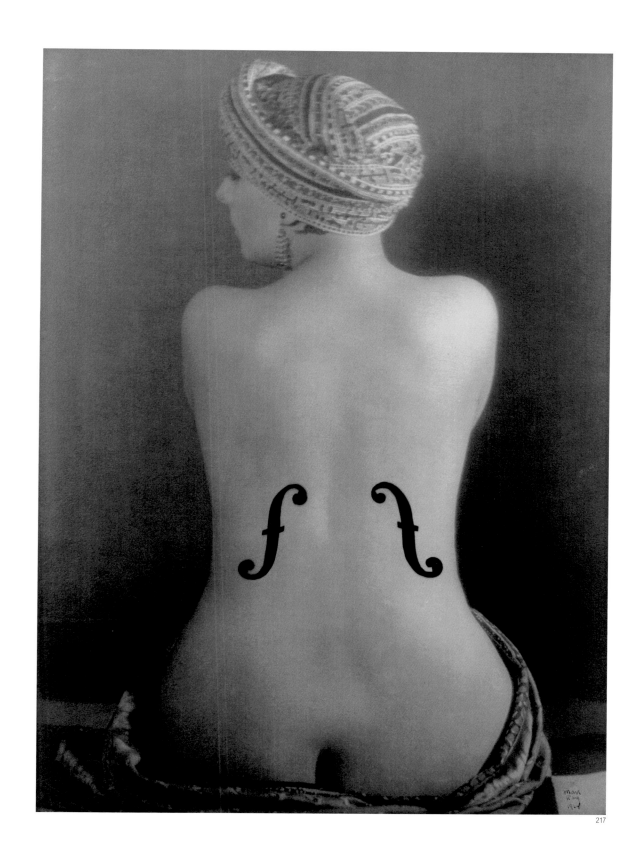

217

217. Man Ray (Emmanuel Radnitzky). American, 1890–1976
Le Violon d'Ingres (Ingres's violin). 1924
Gelatin silver print mounted on paper, 19 x 14 ½" (48.3 x 36.8 cm)
Collection Rosalind and Melvin Jacobs

218

218. Man Ray (Emmanuel Radnitzky). American, 1890–1976
Francis Picabia Imitating Rodin's Sculpture of Balzac. 1923
Gelatin silver print, 9 ½ x 7 1⁄16" (24.1 x 17.9 cm)
Richard and Ellen Sandor Family Collection

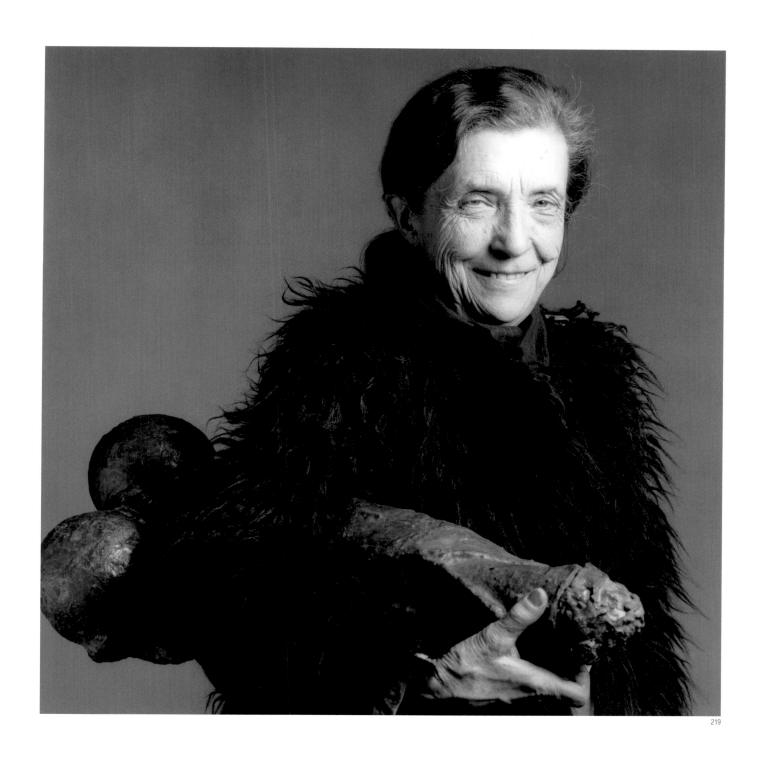

219

219. Robert Mapplethorpe. American, 1946–1989
Louise Bourgeois. 1982
Gelatin silver print, 20 x 16" (50.8 x 40.6 cm)
Robert Mapplethorpe Foundation

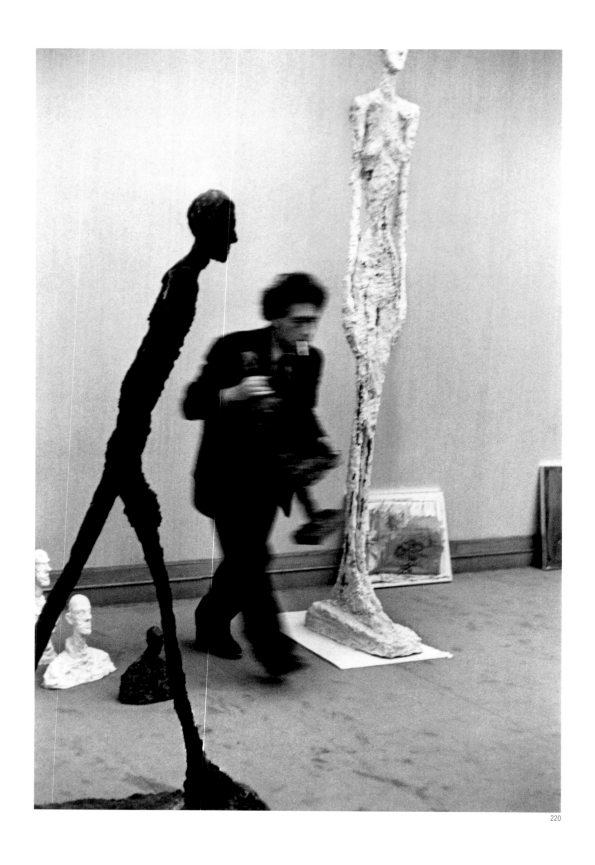

220. Henri Cartier-Bresson. French, 1908–2004
Alberto Giacometti in the Galerie Maeght, Paris. 1961 (printed 1973)
Gelatin silver print, 14 x 9 ⁷⁄₁₆" (35.5 x 24 cm)
Fondation Henri Cartier-Bresson, Paris

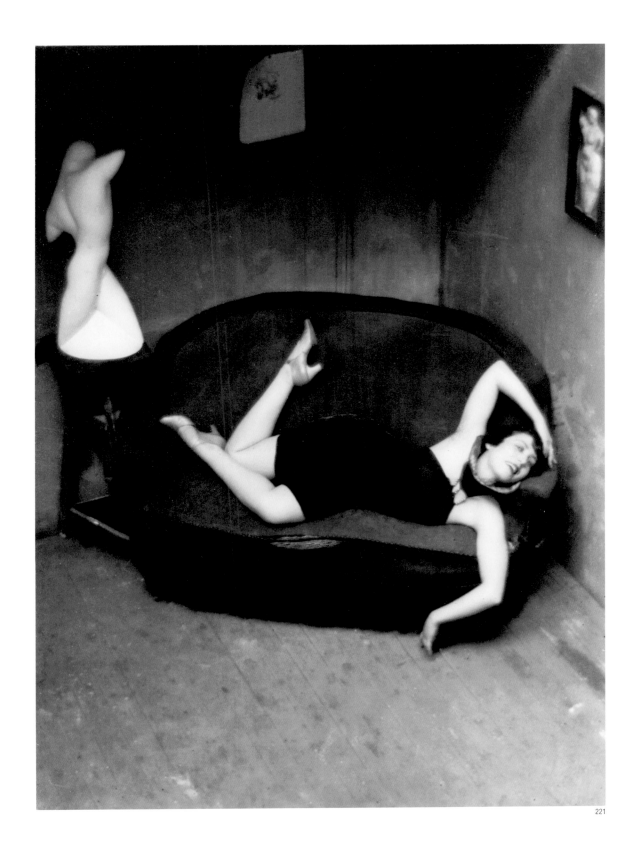

221

221. André Kertész. American, born Hungary, 1894–1985
Satiric Dancer. 1926
Gelatin silver print, 6 ⅝ x 4 ⅝" (16.8 x 11.7 cm)
Courtesy Edwynn Houk Gallery, New York

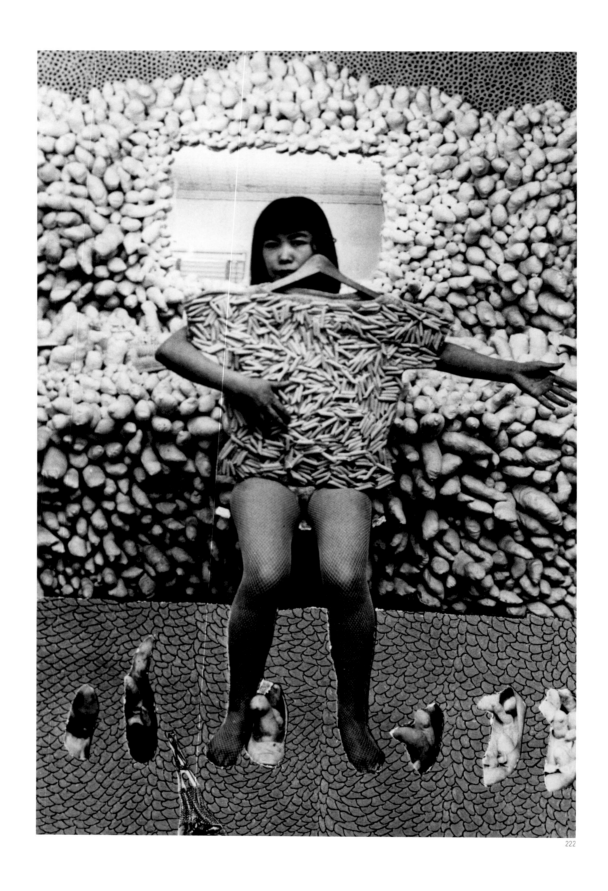

222. Yayoi Kusama. Japanese, born 1929
Sex Food Obsession & Net Accumulation. 1959–63
Gelatin silver print (photograph, by Peter Moore, of a
photocollage by Kusama), 10 x 8 ⅟₁₆" (25.4 x 20.5 cm)
Collection Jon and Joanne Hendricks

223

223. Jindřich Štyrský. Czech, 1899–1942
Untitled. 1930s
Gelatin silver print, 3 ½ x 3 ⅜" (9 x 8.5 cm)
The Museum of Modern Art, New York. Gift of Rudolf Kicken

224

224. Laura Gilpin. American, 1881–1979
George William Eggers. 1926 (printed 1929)
Palladium print, 4 ¹³⁄₁₆ x 5 ½" (12.3 x 14 cm)
Amon Carter Museum, Forth Worth, Texas. Bequest of the artist

225. André Kertész. American, born Hungary, 1894–1985
Géza Blattner. 1925
Gelatin silver print, 3 1/16 x 3 3/16" (7.7 x 8.1 cm)
The Museum of Modern Art, New York. Thomas Walther Collection.
Gift of Thomas Walther

226

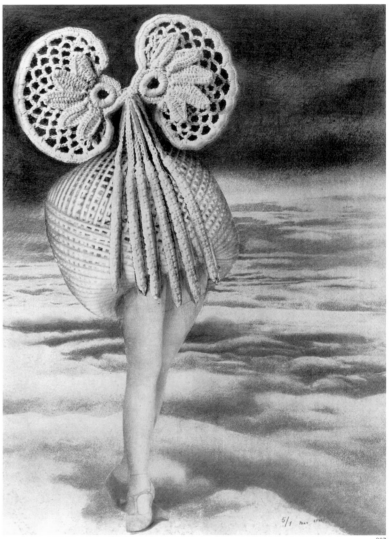

227

226. Max Ernst. French, born Germany, 1891–1976
La Santé par le sport (Health through sport). c. 1920
Photographic enlargement after the collage with the same title
and watercolor, 37 13/16 x 23 5/8" (96 x 60 cm)
Kunsthaus Zürich, Grafische Sammlung

227. Max Ernst. French, born Germany, 1891–1976
Au-dessus des nuages marche la minuit (Midnight passes above the clouds). 1920
Collage of cut photographs and printed reproductions on photographic
reproduction, 28 3/4 x 21 5/8" (73 x 55 cm)
Kunsthaus Zürich, Grafische Sammlung

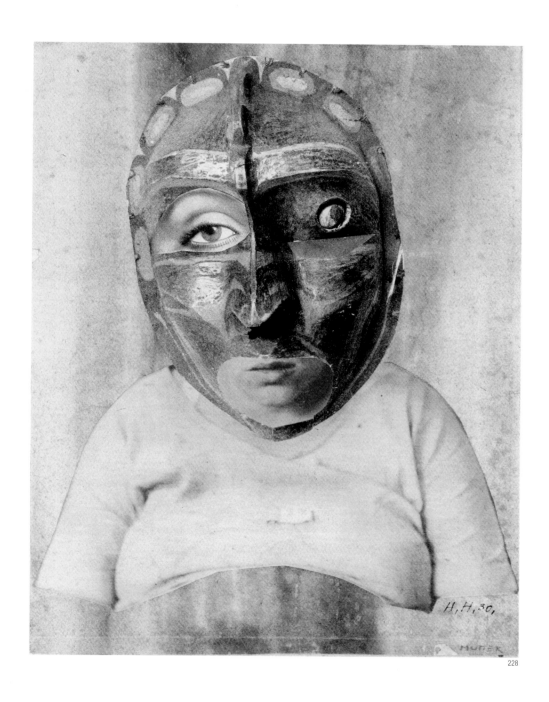

228

228. Hannah Höch. German, 1889–1978
Mutter (Mother) from the series *Aus einem ethnographischen Museum*
(From an ethnographic museum). 1930
Photomontage with watercolor and magazine illustrations cut out and
pasted on paper, 10 ⅟₁₆ x 7 ⅞" (25.6 x 20 cm)
Centre Pompidou, Musée national d'art moderne–Centre de création
industrielle, Paris. Purchase

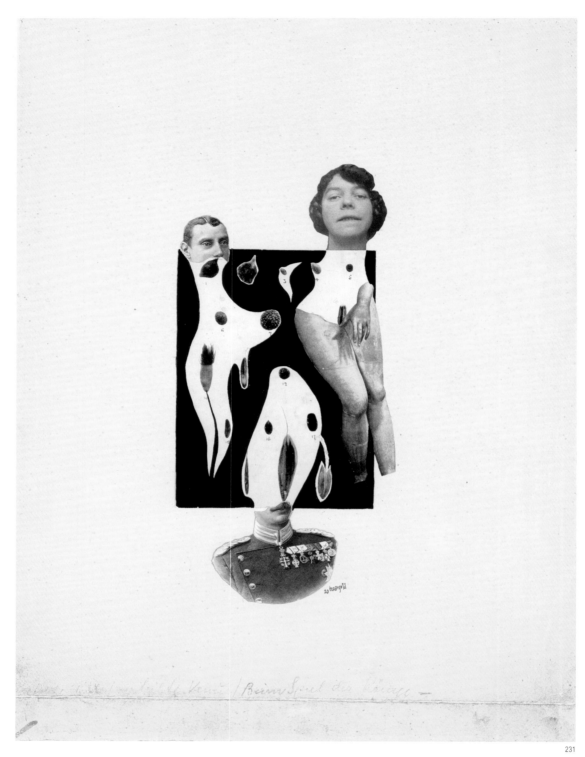

231. Johannes Theodor Baargeld (Alfred Emanuel Ferdinand Gruenwald).
German, 1892–1927
Venus beim Spiel der Könige (Venus at the game of kings). 1920
Photomontage, collage, ink, and pencil on paper, 14 ⁹⁄₁₆ x 10 ¹³⁄₁₆" (37 x 27.5 cm)
Kunsthaus Zürich, Grafische Sammlung

232. Johannes Theodor Baargeld (Alfred Emanuel Ferdinand Gruenwald).
German, 1892–1927
Typische Vertikalklitterung als Darstellung des Dada Baargeld
(Typical vertical mess as depiction of the Dada Baargeld). 1920
Photomontage, 14 ⅝ x 12 ³⁄₁₆" (37.1 x 31 cm)
Kunsthaus Zürich, Grafische Sammlung

233. Hans Finsler. Swiss, 1891–1972
Gropius und Moholy-Nagy als Goethe und Schiller [v.r.n.l.] (Gropius and Moholy-Nagy as Goethe and Schiller [f.r.t.l.]). 1925
Photograph and photomontage on gelatin silver paper, 9 ⅛ x 6 ¾" (23.2 x 17.2 cm)
Kunsthaus Zürich, Fotosammlung

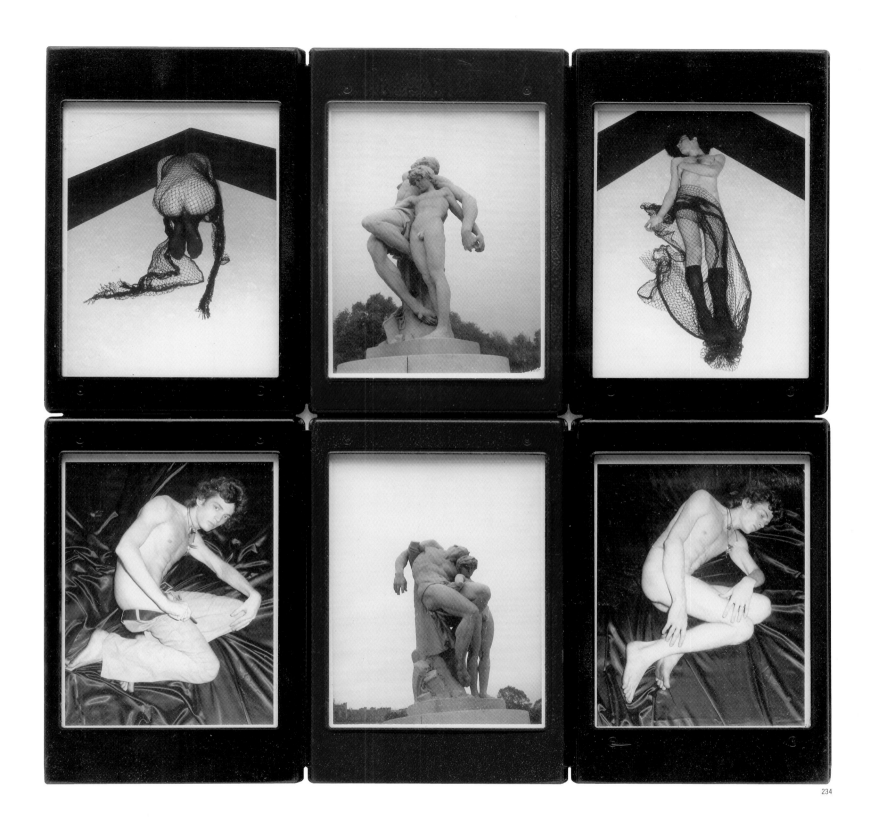

234

234. Robert Mapplethorpe. American, 1946–1989
Untitled. 1973
Dye diffusion transfer prints (Polaroid), in painted plastic mounts
and acrylic frame, overall: 10 ⅞ x 11 ⁵⁄₁₆" (27.6 x 28.7 cm)
Solomon R. Guggenheim Museum, New York. Gift, The Robert
Mapplethorpe Foundation

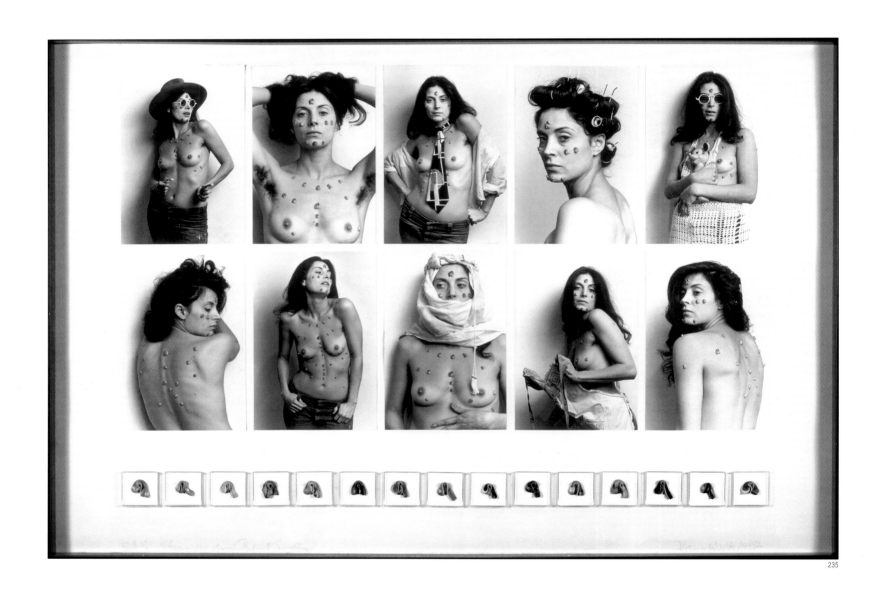

235

235. Hannah Wilke. American, 1940–1993
S.O.S.—Starification Object Series. 1974–82
Gelatin silver prints with chewing gum sculptures,
40 x 58 ½ x 2 ¼" (101.6 x 148.6 x 5.7 cm)
The Museum of Modern Art, New York. Purchase

X. THE PERFORMING BODY AS SCULPTURAL OBJECT

The performative address of Dada, Fluxus, Happenings, Vienna Actionism, and recent participatory art relies conspicuously on photographic or, more recently, electronic reproduction. If performance of this kind is for the most part experienced live, in the present tense, what documents it, and so ensures its enduring life, is above all photography. Yet photography plays a constitutive role, not merely a documentary one, when performance is staged expressly for the camera. In 1921, Marcel Duchamp shaved the hair on the back of his head into a five-pointed star with an elongated tail, like a comet.[1] Titled *Tonsure* (plate 236), this emblematic self-portrait was consciously constructed with the photographic referent in mind. The chronological proximity of *Tonsure* to Man Ray's pictures of Duchamp in drag as the elusive Rrose Sélavy suggests that in the flux of the artist's expatriation (after the outbreak of World War I, in 1914, he had decided to emigrate to the then neutral United States), he was contemplating a change of identity. Arriving in New York in 1915, he realized to his surprise that he was already a celebrity there. The "star" image of *Tonsure* played out his idea of converting himself into a cult object. With this Dada gesture, Duchamp articulated photography as performance and the body as sculptural material. This kind of representation of the artist's body would manifest in distinct forms of self-portrayal during the 1920s, paving the way toward strategies successfully explored in performances conceived for the camera in the 1960s and '70s.

In the first issue of the American avant-garde magazine *Avalanche*, in 1970, the critic Willoughby Sharp defined a concept of "body work": the "use of the artist's own body as sculptural material."[2] Since then, artists as diverse as Bas Jan Ader, Eleanor

fig. 1. Cover of *Dimanche—Le Journal d'un Seul Jour*, November 27, 1960, showing Yves Klein's *Leap into the Void*, 1960. The Museum of Modern Art Library, New York

Antin, VALIE EXPORT, Gilbert & George, Ana Mendieta, Otto Mühl, Bruce Nauman, Dennis Oppenheim, Charles Ray, and Hannah Wilke have engaged in the "rhetoric of pose"—a pose enacted for and mediated through the camera's lens.[3] As has often been said, photography is more than a transparent recording of reality: "It is a mode of representation and, in the visual realm, a cultural dominant."[4] After seeing Duchamp's retrospective at the Pasadena Art Museum in 1963, Bruce Nauman took a series of photographs of himself enacting simple, tasklike exercises in his studio. Collectively the images would come to be known as *Eleven Color Photographs* (1966–1967/1970). Several of these images, including *Feet of Clay*, *Bound to Fail* (which relates to Nauman's sculptural relief *Henry Moore Bound to Fail*, 1967), and *Waxing Hot* (plates 251–53), spoof the classic tradition of sculpture. Yet the signature image of the group—*Self-Portrait as a Fountain* (plate 250), in which a stripped-to-the-waist Nauman spews water from his mouth like a medieval gargoyle—is a deadpan salute to Duchamp's *Fountain* (1917; plate 104). *Eleven Color Photographs* establishes Nauman's lasting engagement with the body as sculptural object. A year later, in 1968, he would expand these ideas to video in *Walk with Contrapposto*, in which he paced back and forth along a narrow corridor, his hands behind his head, his torso twisting off axis from his hips—a pose in the classical sculptural tradition of Praxiteles.

The idea that the artist can in effect stand in for the artwork proved instrumental in broadening the definition of sculptural practice. In 1969, Gilbert & George covered their heads and hands in metallic powders to sing Flanagan and Allen's vaudeville number "Underneath the Arches" in live performance.

Declaring themselves living sculptures, they claimed the status of an artwork (plate 249), a role they used photography to express. Both Ray and Oppenheim, placing a premium on their training as sculptors, articulated the body as a prop that could be picked up, bent, or deployed instead of more traditional materials as a system of weight, mass, and balance. In *Plank Piece I and II* (1973; plate 254), Ray hung limply from a plank wedged diagonally against a wall. And in *Parallel Stress* (1970; plate 255), Oppenheim performed two actions void of drama yet obdurate in their physicality: first, defying the pull of gravity, he stretched his body like a bridge between two parallel brick walls, a position he held for ten minutes; next he lay prostrate inside the large V-shaped concavity between two mounds of earth, his body flexing to conform to the shape of the slopes.

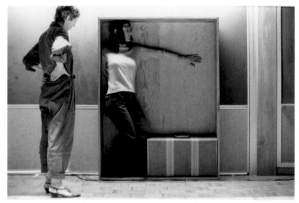

fig. 2. Yvonne Rainer. *Performance.* Hofstra University, Hempstead, New York, 1972. Photograph: Babette Mangolte

Other artists, including Yves Klein, Claes Oldenburg, and Robert Morris, have also experimented with the body as sculptural material. In 1960 in Paris, dressed in a three-piece suit, Klein jumped from a second-story window to the ground (plate 238). Accounts conflict as to whether he made his leap with or without a net, and the action in fact had no audience; it was staged for a photograph, published in a kind of one-day newspaper, *Dimanche—Le journal d'un seul jour*, on Sunday November 27, 1960 (fig. 1), and sold on newsstands throughout the city.[5] Morris's introduction to the physicality of the body came through his affiliation with the Judson Dance Theater and a group of New York choreographers, including Simone Forti, Yvonne Rainer (fig. 2), and Trisha Brown, who opposed the conventions of theatrical dance to investigate the body's ordinary, matter-of-fact movements and positions. Its scale based on the human body, Morris's *I-Box* (1962; plate 239) is a full-length nude photograph of himself set in a Minimalist box with a hinged, I-shaped door. Playing with the pun of "I" and "eye," Morris proposed a mode of meaning for sculpture and performance that corresponded closely to that of the photograph—a mode in which the physical self is at once encoded by the camera and treated as an uninflected sculptural object in space.

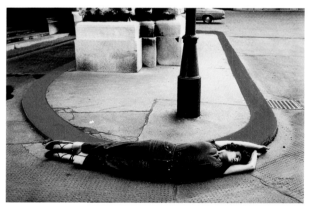

fig. 3. Valie Export. *Einkreisung* (Encirclement) from the series *Körperkonfigurationen* (Body configurations). 1976. Gelatin silver print with red watercolor drawing, 21 15/16 x 29 1/16" (55.7 x 73.8 cm). Courtesy Charim Galerie, Vienna.

In the radicalized climate of the 1970s, when the women's-liberation movement took center stage, artists such as Wilke, Antin, and Export refigured their bodies in the spirit of activism to comment on the power structure of gender difference. To make what she called "performalist self-portraits" such as

S.O.S.—Starification Object Series (1974–82; plate 235), Wilke hired a commercial photographer to take pictures of her posed like a fashion mannequin in various states of undress, sporting here an Arab headdress, there sunglasses and a cowboy hat, there curlers in her hair. She also "scarred" her naked flesh with a swarm of labia-shaped sculptures made of chewing gum. Wilke's pose as a stigmatized star in *S.O.S.* underscores the key role of photography in the intersection of performance, sculpture, and portraiture.

A self-proclaimed feminist, Export subjected her body to actions designed to defy the conformist post–World War II culture of her native Austria. Working in Vienna alongside the Actionist artists—principally Günter Brus, Otto Mühl, Hermann Nitsch, and Rudolf Schwarzkogler—who emerged there in the 1960s, she, like them, enlisted photography to register the psychological effects of the built and natural environments. In the *Körperkonfigurationen* (Body configurations) series of the early 1970s (plate 256, fig. 3), she used her body as a measuring and pointing device—encircling the curve of a curb, conforming to the angle of a corner, pressing against a wall, or lying down inside a narrow ditch. Most of the pictures are accentuated with red or black lines, either produced in the darkroom or added to the print. The artificial match among the architectural structures, the geometric lines applied to the photographs, and the figure's uneasy gymnastics emphasize the dissension between the individual and the ideological forces that shape social reality.

In recent years, artists have continued to use the camera to act out symbolic and concrete gestures of political dissent and to question issues of gender and racial identity. One artist engaged with the incorporation of performance principles into photography is Robin Rhode, who has tapped his familiarity with the rough, segregated neighborhoods of Cape Town and Johannesburg, where he grew up, to address aspects of the troubled South African landscape in the postapartheid age. *Stone Flag* (2004; plate 263) is a sequence of pictures shot from a single, bird's-eye viewpoint in simulated stop-action. They show the artist apparently wielding a flag—actually a sculpture of red-clay bricks, which he seems to bend into the wind in an ode to his nation's newfound democracy. His stark-white boiler suit was initially designed for a dance show, a collaboration with the rap group Black Noise in 2001, in which performers threw handfuls of charcoal dust on the floor, slowly

becoming smeared with dust themselves. Rhode's outfit relates the subcultural codes of urban youth culture to an economy of difference. A meditation on the nature of national representation that extends into questions of personal identity, *Stone Flag* is a work in which photography is a constitutive agent.

Notes

1. This photograph, part of a series, also appears in the literature with the date of 1919. Below one of the variants of the photograph, Marcel Duchamp wrote that it was taken that year, during his first visit to Paris after spending four years in New York and nine months in Argentina. See Arturo Schwarz, *The Complete Works of Marcel Duchamp*, third rev. and expanded ed. (New York: Delano Greenidge Editions, 1997), 2:673–74. But Schwarz has also attributed the picture to Man Ray, and if Duchamp is correct that it was taken in Paris (an easier thing to remember than a photograph's date), it cannot have been made before July 1921, when Man Ray moved there. See Schwarz, *Man Ray: The Rigour of Imagination* (New York: Rizzoli, 1977), pp. 243, 289. James W. McManus too attributes the picture to Man Ray, stating that the negative was discovered in Man Ray's archives. See Anne Collins Goodyear and McManus, eds., *Inventing Marcel Duchamp: The Dynamics of Portraiture* (Washington, D.C.: National Portrait Gallery Smithsonian Institution, and Cambridge, Mass., and London: The MIT Press, 2009), p. 154. Finally, it has also been suggested that the haircut was administered in 1921 by the Mexican caricaturist Georges de Zayas, during Duchamp's second return to Paris. See Robert Lebel, *Marcel Duchamp* (New York: Grove Press, 1959), pp. 24, 98, and Anne d'Harnoncourt and Kynaston McShine, eds., *Marcel Duchamp* (Philadelphia: Philadelphia Museum of Art and New York: The Museum of Modern Art, 1989), p. 18. In their *Marcel Duchamp: Ephemerides in and about Marcel Duchamp and Rrose Sélavy, 1887–1968* (London: Thames & Hudson, 1993), Jennifer Gough-Cooper and Jacques Caumont note that Duchamp enhanced Francis Picabia's *L'Oeil cacodylate* of 1921 with two small cutout photographs of his head, one showing it completely shaved, the other with the comet tonsure, which may reinforce the 1921 dating.

2. Willoughby Sharp, "Body Works," *Avalanche* 1 (Fall 1970):14.

3. See Craig Owens, "The Medusa Effect, or, The Spectacular Ruse," in Scott Bryson et al., eds, *Beyond Recognition: Representation, Power, and Culture* (Los Angeles and Berkeley: University of California Press, 1992), p. 192.

4. Carrie Lambert, "Moving Still: Mediating Yvonne Rainer's Trio A," in *October* 89 (Summer 1999):92.

5. The photographer with whom Yves Klein worked, Harry Shunk, actually shot not one but two pictures: one was taken with a net beneath the airborne artist, the other a few moments later, from the same angle, but with the net removed to show an empty street. Shunk then montaged the upper half of one picture with the lower half of the other in the darkroom to capture Klein's famous leap into the void. The photographer János (John) Kender, who worked with Shunk from around 1957 to around 1973, appears in the picture on a bicycle. According to Sidra Stich, Shunk "thought the bicyclist would add greatly to the photograph by performing a role similar to that of the people in Bruegel's *Landscape with the Fall of Icarus*." See Stich, *Yves Klein* (London: Hayward Gallery, 1994), p. 274, n. 35.

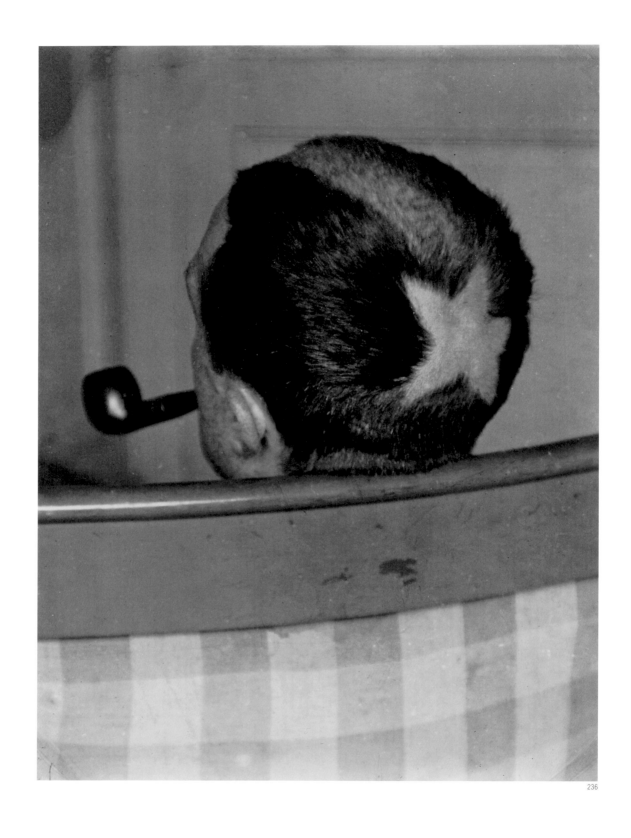

236. Marcel Duchamp. American, born France, 1887–1968.
Photograph by Man Ray (Emmanuel Radnitzky). American, 1890–1976
Tonsure. 1921
Gelatin silver print on postcard, 4 ¾ x 3 ½" (12.1 x 8.9 cm)
Private collection. Courtesy Sean Kelly Gallery, New York

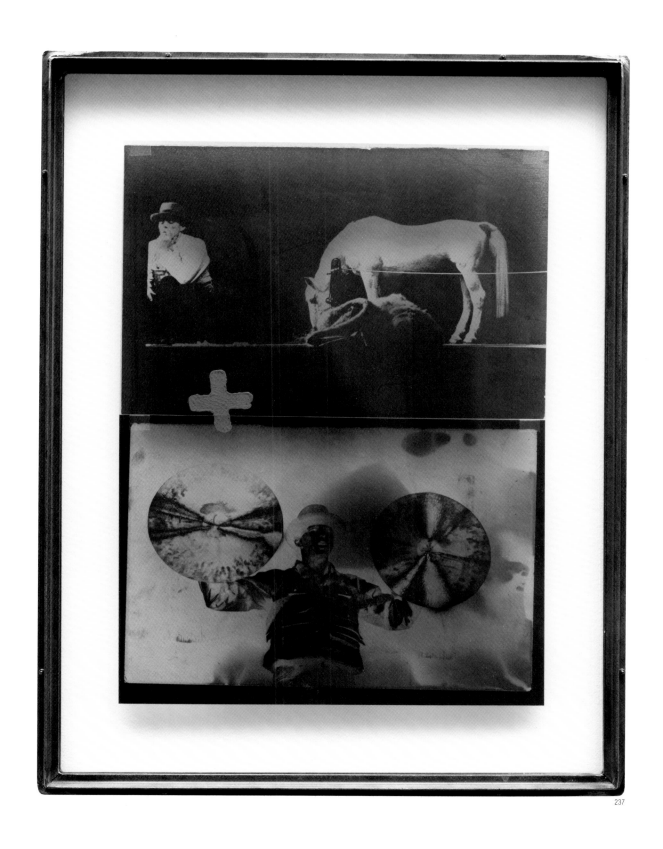

237. Joseph Beuys. German, 1921–1986
Iphigenia/Titus Andronicus. 1984
Photographic negatives stamped with brown paint between glass
plates in iron frame, 28 ⅛ x 21 ⁹⁄₁₆" (71.4 x 54.8 cm)
The Museum of Modern Art, New York. Gift of Edition Schellmann,
Munich and New York

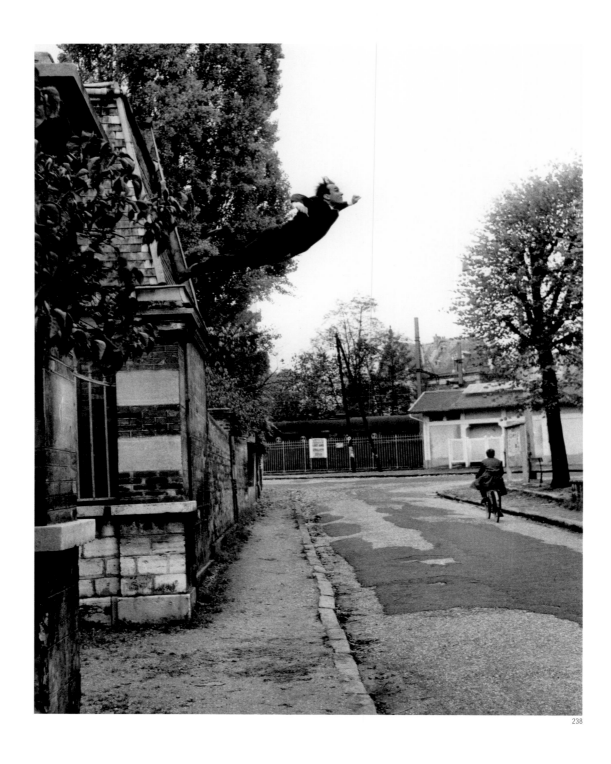

238

238. Yves Klein, French, 1928–1962. Photograph by Harry Shunk,
French, 1924–2006, and János Kender, Hungarian, 1937–1983
Leap into the Void. 1960
Gelatin silver print, 13 ¹¹⁄₁₆ x 10 ⅞" (34.8 x 27.6 cm)
The Museum of Modern Art, New York. David H. McAlpin Fund

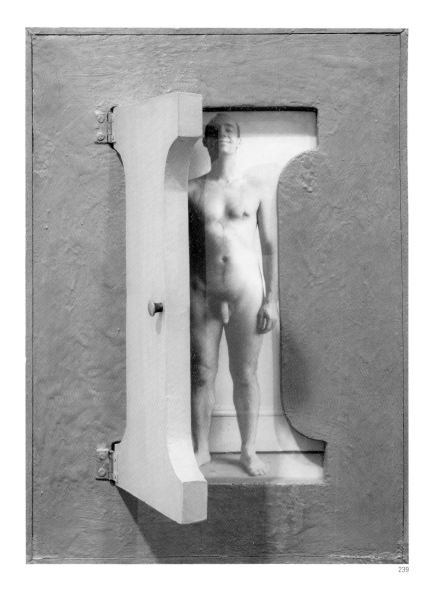

239

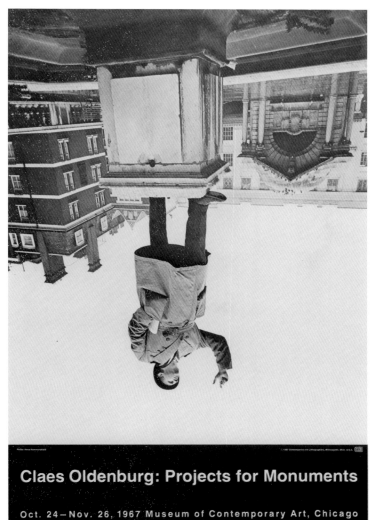

240

239. Robert Morris. American, born 1931
I-Box. 1962
Painted plywood cabinet, Sculptmetal, and gelatin silver print,
19 x 13 x 1 ½" (48.3 x 33 x 3.8 cm)
Collection Barbara Bertozzi Castelli

240. Claes Oldenburg. American, born Sweden 1929
Claes Oldenburg: Projects for Monuments. 1967
Offset lithograph, 34 ¹¹⁄₁₆ x 22 ½" (88.0 x 57.2 cm)
The Museum of Modern Art, New York. Gift of Barbara Pine

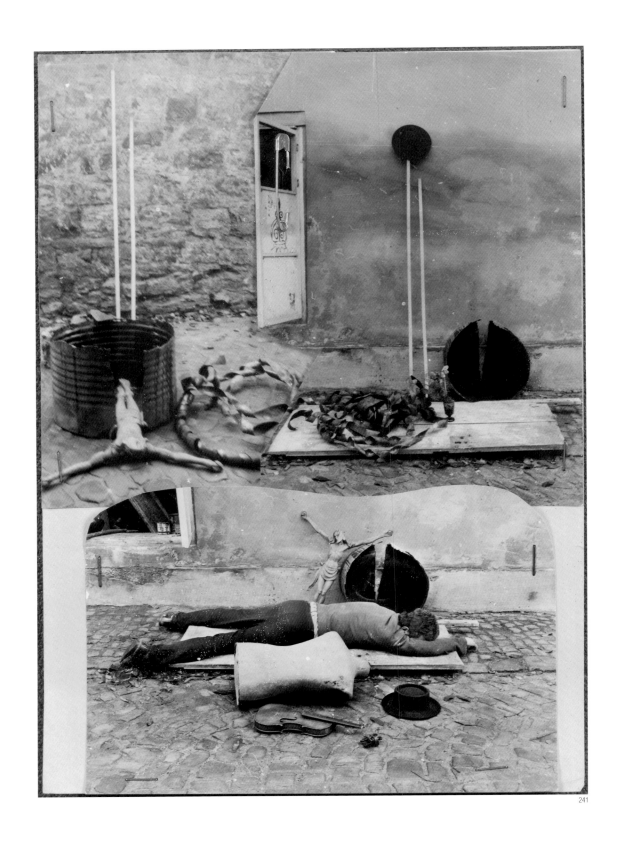

241

241. Milan Knížák. Czech, born 1940
Z prostředi na ulici (Small environments on the street). 1962–63
Collage of gelatin silver prints, safety pin, and staples on paper,
11 ¹¹⁄₁₆ x 8 ¼" (29.7 x 21 cm)
Collection Jon and Joanne Hendricks

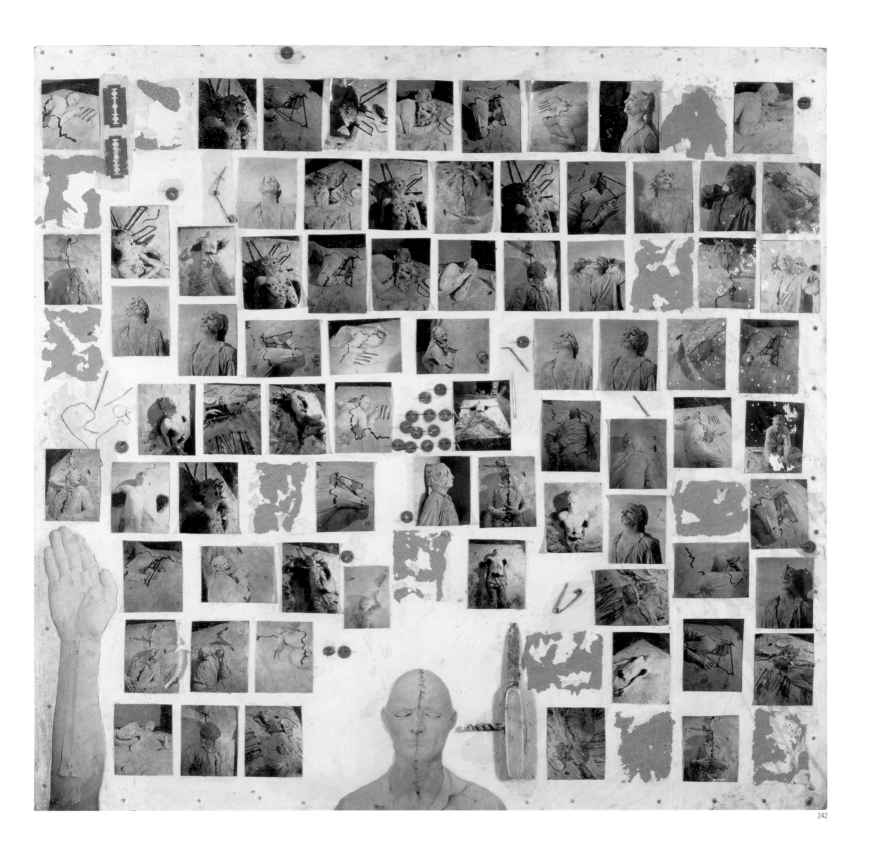

242. Günter Brus. Austrian, born 1938
Untitled. 1965
Mixed media on board mounted on wood, 30 ⁵⁄₁₆ x 30 ⁵⁄₁₆" (77 x 77 cm)
Scottish National Gallery of Modern Art, Edinburgh

243. Robert Whitman. American, born 1935
Flower. 1963
Gelatin silver print, 8 ⅛ x 9 ¹⁵⁄₁₆" (20.4 x 25.3 cm)
Collection Jon and Joanne Hendricks

244. Robert Whitman. American, born 1935
Water. 1963
Gelatin silver print, 7 x 10 ³⁄₁₆" (17.8 x 25.9 cm)
Collection Jon and Joanne Hendricks

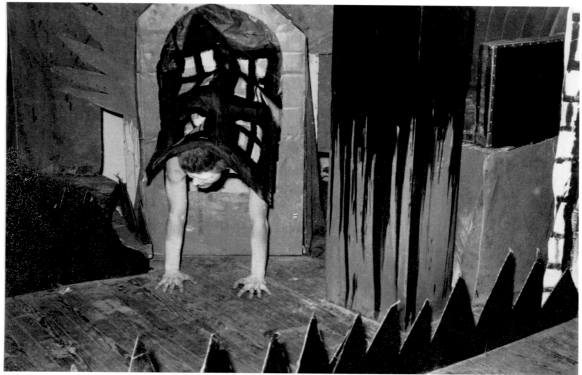

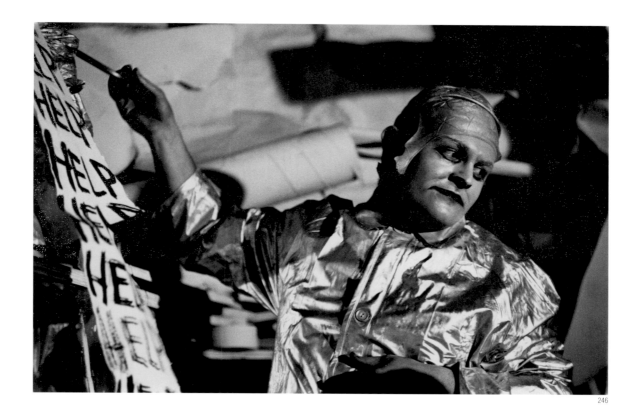

245. Red Grooms. American, born 1937
The Burning Building. 1959
Gelatin silver print, 8 1/16 x 10 1/4" (20.4 x 26 cm)
Collection Jon and Joanne Hendricks

246. Jim Dine. American, born 1935
The Car Crash. 1960
Gelatin silver print, 8 1/16 x 9 15/16" (20.4 x 25.3 cm)
Collection Jon and Joanne Hendricks

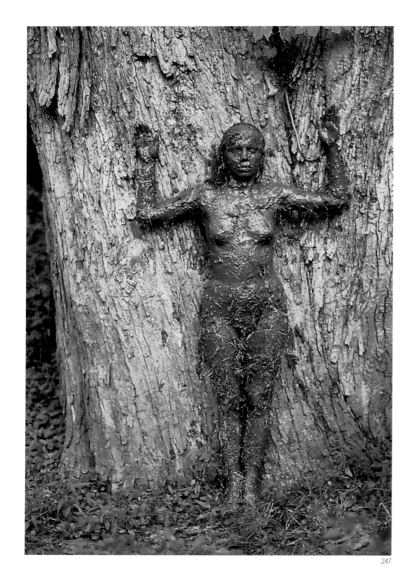

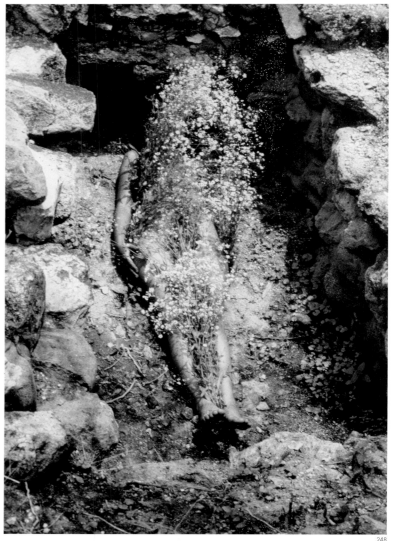

247. Ana Mendieta. American, born Cuba, 1948–1985
Arbol de la Vida (Tree of Life). 1976
Lifetime color photograph, 20 x 13 ¼" (50.8 x 33.7 cm)
Courtesy The Collection Raquelín Mendieta Family Trust and
Galerie Lelong, New York

248. Ana Mendieta. American, born Cuba, 1948–1985
Imagen de Yagul (Image from Yagul). 1973
Lifetime color photograph, 19 x 12 ½" (48.3 x 31.8 cm)
Glenstone

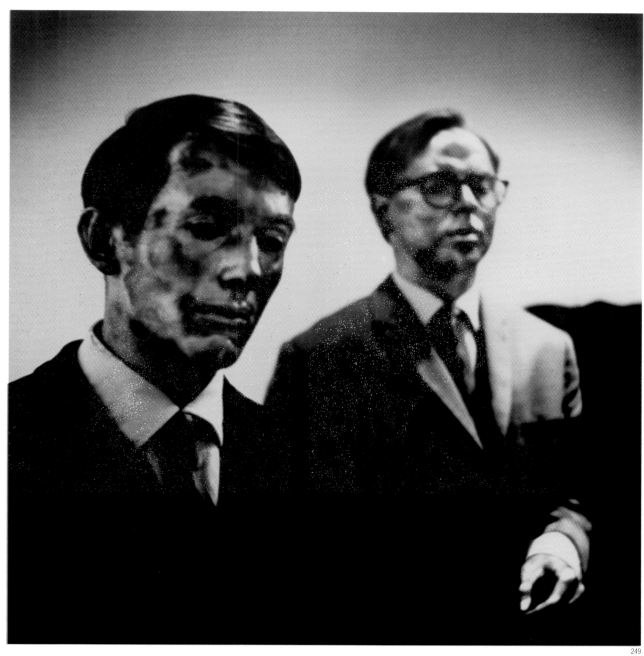

249. Gilbert & George (Gilbert Proesch. British, born Italy 1943.
George Passmore. British, born 1942)
Great Expectations. 1972
Dye transfer print, 11 9/16 x 11 ½" (29.4 x 29.2 cm)
The Museum of Modern Art, New York. Art & Project/Depot VBVR

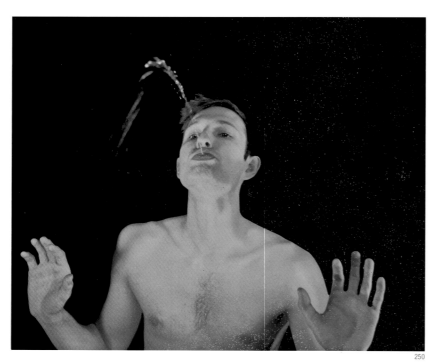

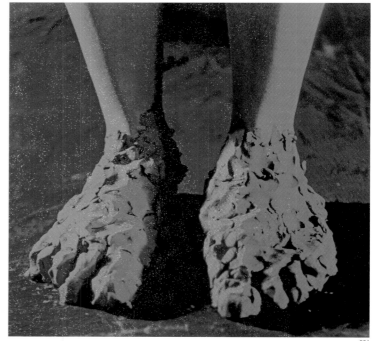

250

251

250–53. Bruce Nauman. American, born 1941
Self-Portrait as a Fountain, *Feet of Clay*, *Bound to Fail*, and *Waxing Hot* from the
portfolio *Eleven Color Photographs*. 1966–67/1970/2007
Inkjet prints (originally chromogenic color prints), each: c. 19 ¹¹⁄₁₆ x 23 ⅝" (50 x 60 cm)
Museum of Contemporary Art, Chicago. Gerald S. Elliott Collection

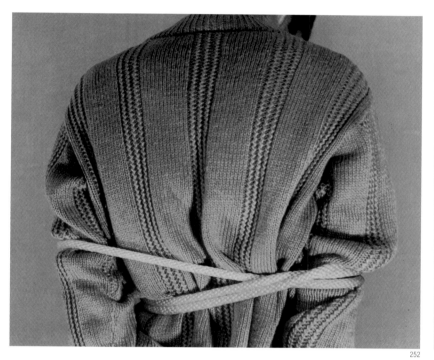

252

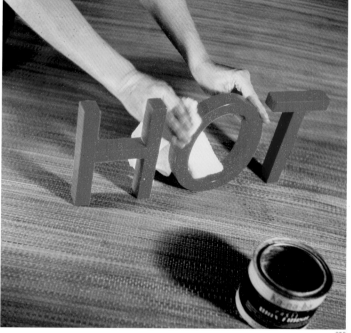

253

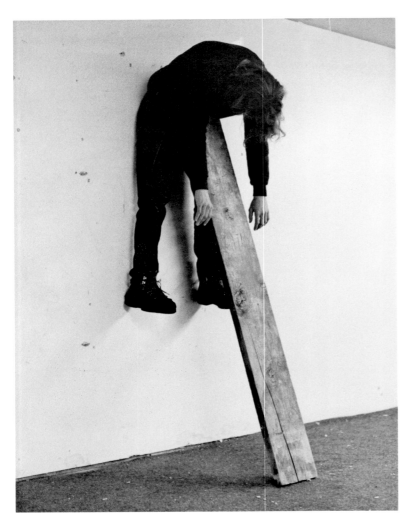 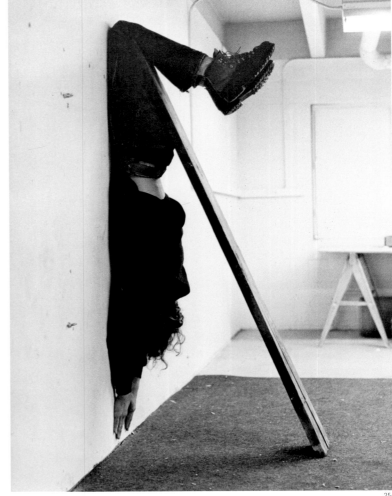

254. Charles Ray. American, born 1953
Plank Piece I and II. 1973 (printed 1992)
Gelatin silver prints, each: 40 x 30" (101.7 x 76.3 cm)
The Museum of Modern Art, New York. Samuel J. Wagstaff, Jr.,
Fund and Purchase

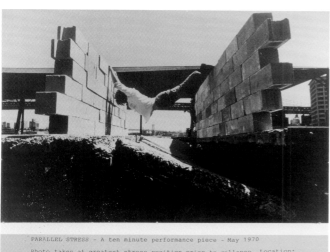

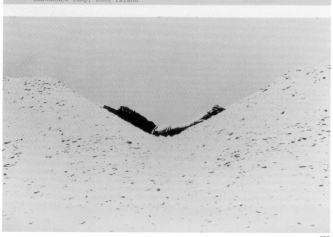

PARALLEL STRESS - A ten minute performance piece - May 1970

Photo taken at greatest stress position prior to collapse. Location: Masonry block wall and collapsed concrete pier between Brooklyn and Manhattan bridges. Bottom photo: Stress position reassumed Location: Abandoned sump, Long Island

255

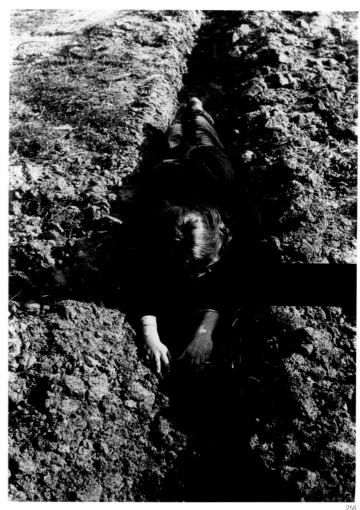

256

255. Dennis Oppenheim. American, born 1938
Parallel Stress. 1970
Chromogenic color prints, collage, and text on paper and board,
7' 6" x 5' 11⁄16" (228.6 x 154.2 cm)
Courtesy the artist

256. VALIE EXPORT. Austrian, born 1940
Verkreuzung (Intersection) from the series *Körperkonfigurationen*
(Body configurations). 1972
Gelatin silver print, 23 9⁄16 x 15 7⁄8" (59.9 x 40.4 cm)
The Museum of Modern Art, New York. Acquired through the
generosity of Agnes Gund

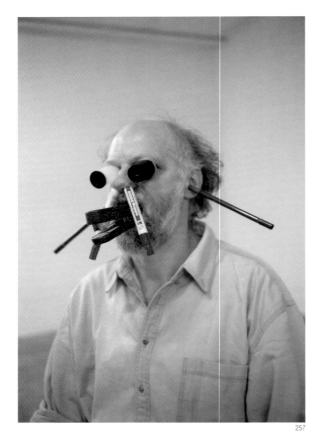

257

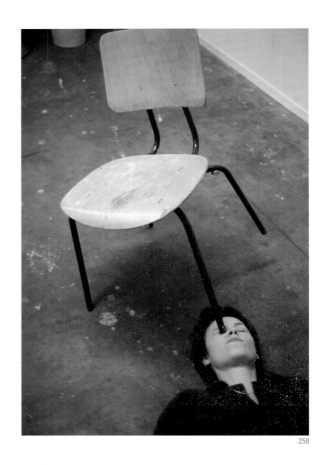

258

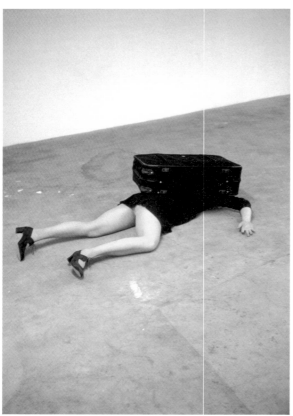

259

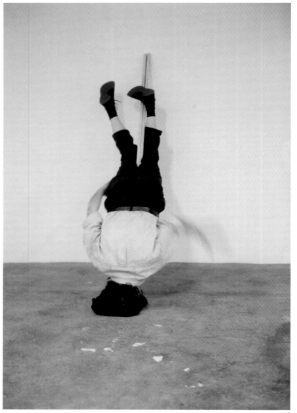

260

257–60. Erwin Wurm. Austrian, born 1954
One Minute Sculptures. 1997–98
Chromogenic color prints, each: 17 ¹¹⁄₁₆ x 11 ¹³⁄₁₆" (45 x 30 cm)
Centre Pompidou, Musée national d'art moderne–Centre de création
industrielle, Paris. Purchase

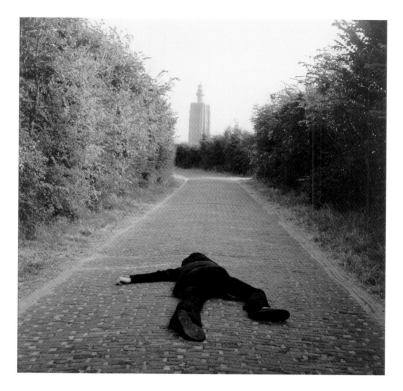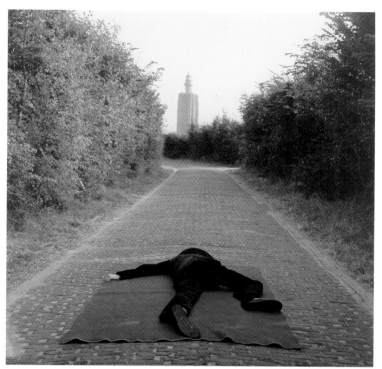

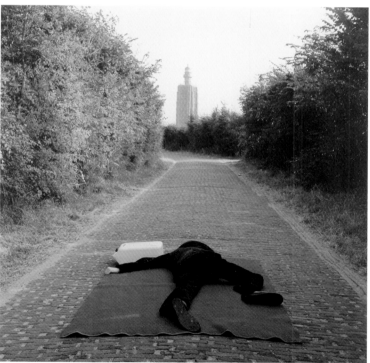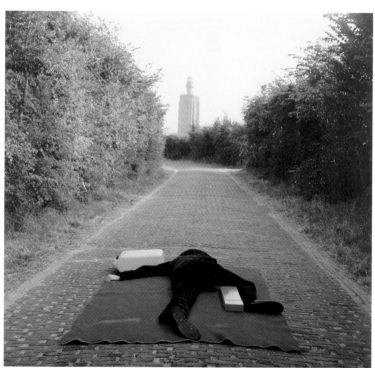

261

261. Bas Jan Ader. Dutch, 1942–1975
On the Road to a New Neo Plasticism, Westkapelle, Holland. 1971
Chromogenic color prints, each: 11 ¹³⁄₁₆ x 11 ¹³⁄₁₆" (30 x 30 cm)
Museum Boijmans Van Beuningen, Rotterdam

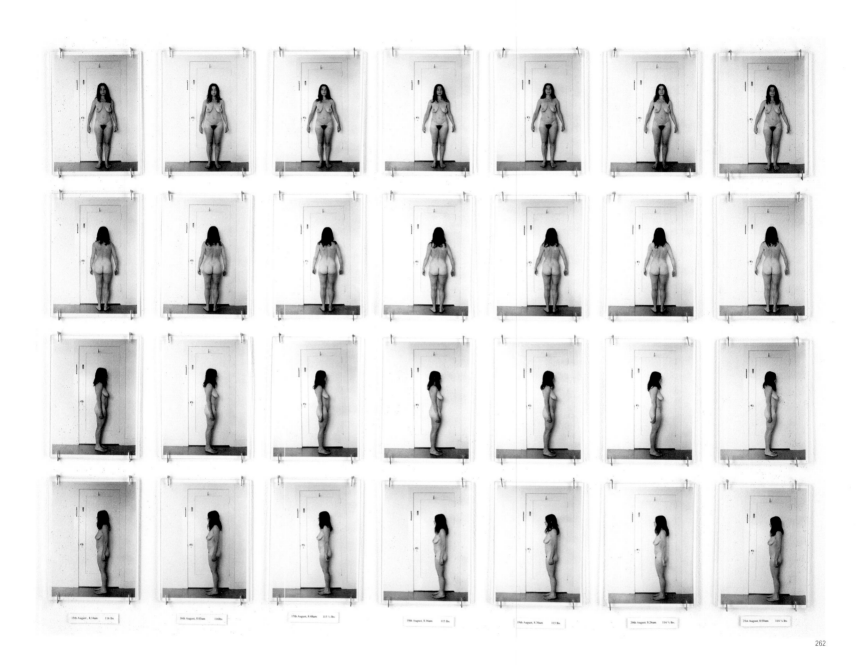

262. Eleanor Antin. American, born 1935
"The Last Seven Days" from *Carving: A Traditional Sculpture.* 1972/99
28 gelatin silver prints with labels and wall text,
each: 7 x 5" (17.8 x 12.7 cm)
Courtesy the artist and Ronald Feldman Fine Arts, New York

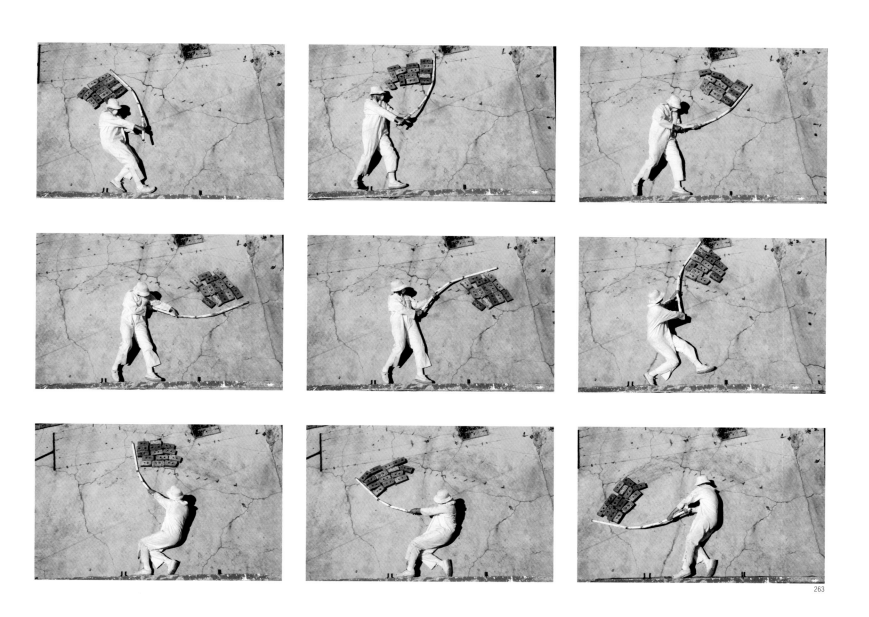

263

263. Robin Rhode. South African, born 1976
Stone Flag. 2004
Chromogenic color prints, each: 12 ⅟₁₆ x 18 ⅟₁₆" (30.6 x 45.8 cm)
The Museum of Modern Art, New York. Fund for the Twenty-First Century

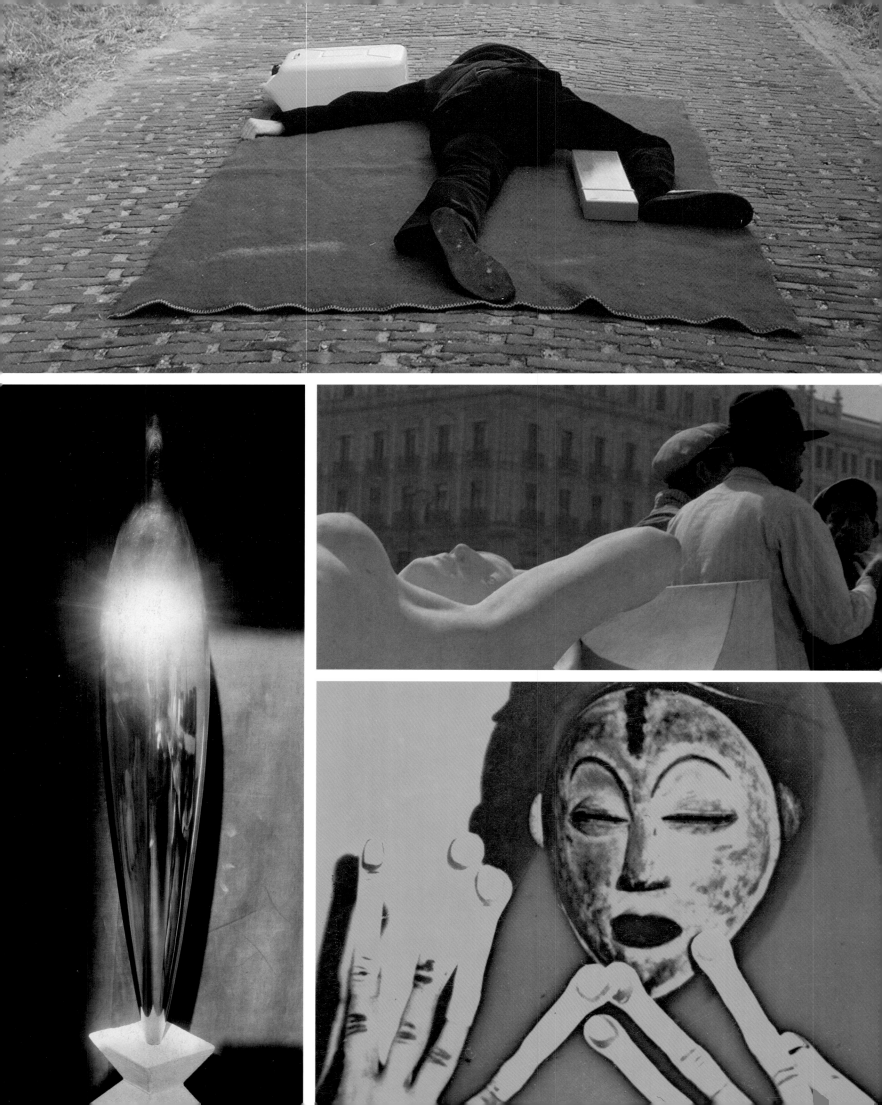

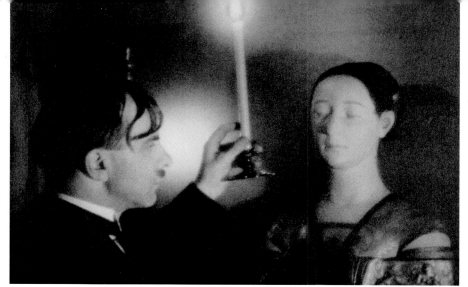

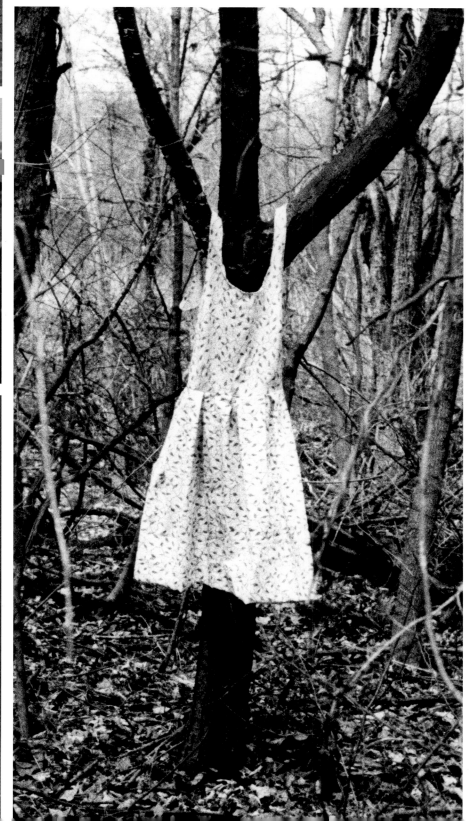

Selected Bibliography

General

Allan, Derek. "André Malraux and the Challenge to Aesthetics." *Journal of European Studies* 33, no. 1 (March 1, 2003):23–40.

Allington, Edward, and Ben Dhaliwal. *Reproduction in Sculpture: Dilution or Increase?* Leeds: Henry Moore Institute, 1994. Exh. cat.

Bajac, Quentin, and Clément Chéroux. *Collection Photographs: A history of photography through the collections of the Centre Pompidou, Musée National d'Art Moderne*. Paris: Éditions du Centre Pompidou, and Göttingen: Steidl, 2007.

Baldwin, Neil. *Man Ray: American Artist*. New York: Da Capo Press, 1988.

Barthes, Roland. *Camera Lucida: Reflections on Photography*. Trans. Richard Howard. New York: Hill and Wang, 1981.

———. *Mythologies*. Trans. Annette Lavers. New York: Noonday Press, 1972.

Batchen, Geoffrey. *Burning with Desire: The Conception of Photography*. Cambridge, Mass.: The MIT Press, 1997.

———. *Each Wild Idea: Writing, Photography, History*. Cambridge, Mass.: The MIT Press, 2001.

———. *Forget Me Not: Photography & Remembrance*. New York: Princeton Architectural Press, and Amsterdam: Van Gogh Museum, 2004. Exh. cat.

———. *Photography's Objects*. Albuquerque: University of New Mexico Art Museum, 1997. Exh. cat.

Baudelaire, Charles. *Art in Paris, 1845–1862: Salons and Other Exhibitions*. Ed. and trans. Jonathan Mayne. Ithaca: Cornell University Press, 1981.

———. "Pourquoi la sculpture est ennuyeuse (Le Salon de 1846)." In *Oeuvres complètes*, 2:487–89. Ed. Claude Pichois. Paris: Gallimard, 1976.

Beierwaltes, Werner. "*Negati affirmatio*: Welt als Metapher: Zur Grundlegung einer mittelalterlichen Ästhetik durch Johannes Scotus Eriugena." *Philosophisches Jarhbuch* 83 (1976):237–65.

Benjamin, Walter. *Illuminations*. Ed. Hannah Arendt. Trans. Harry Zohn. New York: Schocken Books, 1969.

Bergstein, Mary. "Lonely Aphrodites: On the Documentary Photography of Sculpture." *The Art Bulletin* 74, no. 3 (September 1992):475–98.

Bezzola, Tobia. *Henri Cartier-Bresson and Alberto Giacometti. La Décision de l'oeil/ The Decision of the Eye*. Zurich: Scalo, 2005. Exh. cat.

Billeter, Erika. *Malerei und Photographie im Dialog. Von 1847 bis heute*. Bern: Benteli, 1977. Exh. cat.

Billeter, Erika, and Christoph Brockhaus. *Skulptur im Licht der Fotografie. Von Bayard bis Mapplethorpe*. Bern: Benteli, 1997. Exh. cat.

Bloomfield, Julia, Kurt W. Forster, and Thomas F. Reese, eds. *Empathy, Form, and Space: Problems in German Aesthetics, 1873–1893*. Santa Monica: The Getty Center for the History of Art and the Humanities, 1994.

Bolton, Richard, ed. *The Contest of Meaning: Critical Histories of Photography*. Cambridge, Mass.: The MIT Press, 1989.

Buchloh, Benjamin H. D. "Gerhard Richter's *Atlas*: The Anomic Archive." *October* 88 (Spring 1999):117–45.

Burckhardt, Jacob. *Ästhetik der bildenden Kunst*. Darmstadt: Wissenschaftliche Buchgesellschaft, 1992.

Busch, Bernd. *Belichtete Welt. Eine Wahrnehmungsgeschichte der Fotografie*. Frankfurt: Fischer, 1995.

Buskirk, Martha. *The Contingent Object of Contemporary Art*. Cambridge, Mass.: The MIT Press, 2003.

Campany, David. *Art and Photography*. London: Phaidon Press, 2003.

———. *Photography and Cinema*. London: Reaktion Books, 2008.

Campany, David, ed. *The Cinematic*. London: Whitechapel, and Cambridge, Mass.: The MIT Press, 2007.

Castello di Rivoli. *Da Brancusi a Boltanski. Fotografie d'artista*. Milan: Charta, 1993. Exh. cat.

Chevrier, Jean-François, ed. *Photo-Kunst: Arbeiten aus 150 Jahren. Du XXème au XIXème siècle, aller et retour*. Stuttgart: Staatsgalerie/Edition Cantz, 1989. Exh. cat.

Crimp, Douglas. "Pictures." *October* 8 (Spring 1979):75–88.

Crow, Thomas E. *Modern Art in the Common Culture*. New Haven: Yale University Press, 1996.

Cutler, Ellen B. "Sculpture through the Lens." *Sculpture Review* 54, no. 4 (Winter 2005):12–17.

Dickerman, Leah. *Dada: Zurich, Berlin, Hannover, Cologne, New York, Paris*. Washington, D.C.: National Gallery of Art, and New York: D.A.P./ Distributed Art Publishers, 2005. Exh. cat.

Elkins, James, ed. *Photography Theory*. New York: Routledge, 2007.

Enwezor, Okwui. *Archive Fever: Uses of the Document in Contemporary Art*. New York: International Center of Photography, 2008. Exh. cat.

Fer, Briony, David Batchelor, and Paul Wood. *Realism, Rationalism, Surrealism: Art between the Wars*. New Haven: Yale University Press, 1993.

Flügge, Matthias, Robert Kudielka, and Angela Lammert, eds. *Raum. Orte der Kunst*. Berlin: Akademie der Künste, and Nuremberg: Verlag für moderne Kunst Nürnberg, 2007. Exh. cat.

Fogle, Douglas, ed. *The Last Picture Show: Artists Using Photography, 1960–1982*. Minneapolis: Walker Art Center, 2003. Exh. cat.

Font-Réaulx, Dominique de, and Joëlle Bolloch. *The Work of Art and Its Reproduction*. Paris: Musée d'Orsay, and Milan: 5 Continents Editions, 2006. Exh. cat.

Foote, Nancy. "The Anti-Photographers." *Artforum International* 15, no. 1 (September 1976):46–54.

Foster, Hal. "The Archive without Museums." *October* 77 (Summer 1996):97–119.

Foster, Hal, ed. *The Anti-Aesthetic: Essays on Postmodern Culture*. New York: New Press, 2002.

Foster, Hal, Rosalind Krauss, Yve-Alain Bois, and Benjamin H. D. Buchloh. *Art since 1900: Modernism, Antimodernism, Postmodernism*. London: Thames & Hudson, 2004.

Fried, Michael. *Why Photography Matters as Art as Never Before*. New Haven: Yale University Press, 2008.

Frizot, Michel. *1839. La Photographie révélée*. Paris: Centre national de la photographie, 1989. Exh. cat.

Frizot, Michel, and Dominique Païni, eds. *Sculpter-Photographier, Photographie-Sculpture. Actes du colloque organisé au Louvre sous la direction de Michel Frizot et Dominique Païni*. Paris: Marval/Musée du Louvre, 1993.

Galassi, Peter. *American Photography, 1890–1965, from the Museum of Modern Art, New York*. New York: The Museum of Modern Art, 1995. Exh. cat.

Galerie Daniel Blau. *Gegossenes Licht, Cast Light: Sculpture in Photography, 1845–1860*. Munich: Galerie Daniel Blau, 2008. Exh. cat.

Gernsheim, Helmut. *Focus on Architecture and Sculpture: An Original Approach to the Photography of Architecture and Sculpture*. London: Fountain Press, 1949.

Gombrich, E. H., and Fritz Saxl. *Aby Warburg: An Intellectual Biography*. Chicago: at the University Press, 1986.

Green, Jonathan. *American Photography: A Critical History 1945 to the Present*. New York: Harry N. Abrams, 1984.

Hambourg, Maria Morris, and Christopher Phillips. *The New Vision: Photography between the World Wars. The Ford Motor Company Collection at The Metropolitan Museum of Art, New York*. New York: The Metropolitan Museum of Art and Harry N. Abrams, 1989. Exh. cat.

Hamill, Sarah. "'The World Is Flat': Photography and the Matter of Sculpture." *Camerawork* 36, no. 1 (Spring/Summer 2009):14–19.

Haverkamp Begemann, Egbert. *Creative Copies: Interpretative Drawings from Michelangelo to Picasso*. New York: The Drawing Center, 1988. Exh. cat.

Haworth-Booth, Mark. *Photography, an Independent Art: Photographs from the Victoria and Albert Museum 1839–1996*. London: V & A Publications, 1997.

Hegel, Georg Wilhelm Friedrich. *Werke*. Vol. 14, *Vorlesungen über die Ästhetik II*. Frankfurt: Suhrkamp, 1970.

Hofmann, Werner. *Die Moderne im Rückspiegel. Hauptwege der Kunstgeschichte*. Munich: C. H. Beck, 1998.

Homburg, Cornelia. *The Copy Turns Original: Vincent van Gogh and a New Approach to Traditional Art Practice*. Amsterdam: John Benjamins, 1996.

Honnef, Klaus, Rolf Sachsse, and Karin Thomas, eds. *German Photography 1870–1970: Power of a Medium*. Cologne: DuMont Buchverlag, 1997. Exh. cat.

Howarth, Sophie, ed. *Singular Images: Essays on Remarkable Photographs*. New York: Aperture, 2005.

Hunter, William B. "The Seventeenth-Century Doctrine of Plastic Nature." *Harvard Theological Review* 43 (1950):197–213.

Jammes, André, and Eugenia Parry Janis. *The Art of French Calotype: With a Critical Dictionary of Photographers, 1845–1870*. Princeton: at the University Press, 1983.

Johnson, Geraldine A., ed. *Sculpture and Photography: Envisioning the Third Dimension*. Cambridge: at the University Press, 1998.

———. "The Very Impress of the Object": *Photographing Sculpture from Fox Talbot to the Present Day*. Leeds: Henry Moore Institute, 1995. Exh. cat.

Jonge, Piet de, and Gerard Forde, eds. *Album*.

De Fotoverzameling van Museum Boymans-van Beuningen/The Photographic Collection of Museum Boymans-van Beuningen. Rotterdam: Museum Boymans-van Beuningen, 1995.

Kosinski, Dorothy M., ed. The Artist and the Camera: Degas to Picasso. Dallas: Dallas Museum of Art, and New Haven: Yale University Press, 1999. Exh. cat.

Krauss, Rosalind E. The Originality of the Avant-Garde and Other Modernist Myths. Cambridge, Mass.: The MIT Press, 1985.

———. Passages in Modern Sculpture. New York: The Viking Press, 1977.

Leibniz, Gottfried Wilhelm. Theodicee. Das ist, Versuch von der Güte Gottes, Freiheit des Menschen, und vom Ursprunge des Bösen (Nach der Ausgabe von 1744). Berlin: Akademie Verlag, 1996.

Lemagny, Jean-Claude, and André Rouillé, eds. A History of Photography: Social and Cultural Perspectives. Cambridge: at the University Press, 1987.

Mabee, Carleton. The American Leonardo: A Life of Samuel F. B. Morse. New York: Octagon Books, 1943.

Mai, Ekkehard. Wettstreit der Künste. Malerei und Skulptur von Dürer vis Daumier. Wolfratshausen: Edition Minerva, and Munich: Haus der Kunst, 2002. Exh. cat.

Malraux, André. Museum without Walls. New York: Pantheon Books, 1949.

———. The Voices of Silence. Garden City, New York: Doubleday, 1953.

Man Ray. Self Portrait. Boston: Little, Brown, 1963.

Mason, Rainer Michael, et al. Pygmalion photographe: la sculpture devant la caméra, 1844–1936. Geneva: Le Cabinet des estampes du Musée d'art et d'histoire, 1985. Exh. cat.

Melville, Stephen W., ed. The Lure of the Object. Williamstown: Sterling and Francine Clark Art Institute, 2005.

Merewether, Charles, ed. The Archive. London: Whitechapel, and Cambridge, Mass.: The MIT Press, 2006.

Michaud, Philippe-Alain. Aby Warburg and the Image in Motion. New York: Zone Books, 2004.

Mundy, Jennifer, ed. Duchamp, Man Ray, Picabia. London: Tate Publishing, 2008. Exh. cat.

Naumann, Francis M. "Marcel Duchamp's L.H.O.O.Q.: The Making of an Original Replica." In Achim Moeller and Naumann, eds. Marcel Duchamp: The Art of Making Art in the Age of Mechanical Reproduction. New York: Achim Moeller Fine Art, 1999. Exh. cat.

———. New York Dada, 1915–23. New York: Harry N. Abrams, 1994.

Naumann, Francis M., and Beth Venn, eds. Making Mischief: Dada Invades New York. New York: Whitney Museum of American Art, 1996. Exh. cat.

Newhall, Beaumont, ed. Photography: Essays & Images. Illustrated Readings in the History of Photography. London: Secker & Warburg, 1981.

North, Michael. "Authorship and Autography." PMLA 116, no. 5 (October 2001):1377–85.

Oramas, Luis Pérez. An Atlas of Drawings: Transforming Chronologies. New York: The Museum of Modern Art, 2006. Exh. cat.

Parry Janis, Eugenia. The Kiss of Apollo: Photography & Sculpture, 1845 to the Present. San Francisco: Fraenkel Gallery/Bedford Arts Publishers, 1991. Exh. cat.

Phillips, Christopher, ed. Photography in the Modern Era: European Documents and Critical Writings, 1913–1940. New York: The Metropolitan Museum of Art/Aperture, 1989.

Picaudé, Valérie, and Philippe Arbaïzar, eds. La Confusion des genres en photographie. Paris: Bibliothèque nationale de France, 2001.

Piguet, Philippe. "La Reproduction: simple copie ou véritable création?" L'Oeil no. 582 (July–August 2006):36.

Potts, Alex. "The Minimalist Object and the Photographic Image." In Geraldine A. Johnson, ed. Sculpture and Photography. Cambridge: at the University Press, 1998.

Preciado, Kathleen. Retaining the Original: Multiple Originals, Copies, and Reproductions. Washington, D.C.: National Gallery of Art, 1989.

Preziosi, Donald. Rethinking Art History: Meditations on a Coy Science. New Haven: Yale University Press, 1989.

Rampley, Matthew. "Archives of Memory: Walter Benjamin's Arcades Project and Aby Warburg's Mnemosyne Atlas." In Alex Coles, ed. The Optic of Walter Benjamin, pp. 94–117. London: Black Dog Publishing, 1999.

Rancière, Jacques. The Future of the Image. London: Verso, 2007.

Reynaud, François, et al., eds. Paris in 3D. Paris: Paris Musées and Booth-Clibborn Editions, 2000.

Rose, Louis. The Survival of Images: Art Historians, Psychoanalysts, and the Ancients. Detroit: Wayne State University Press, 2001.

Savedoff, Barbara E. Transforming Images: How Photography Complicates the Picture. Ithaca: Cornell University Press, 2000.

Schaffner, Ingrid, Matthias Winzen, Geoffrey Batchen, and Hubertus Gassner. Deep Storage: Collecting, Storing, and Archiving in Art. Munich: Prestel, 1998. Exh. cat.

Schelling, Friedrich Wilhelm Joseph. "Philosophie der Kunst." In Sämtliche Werke, Vol. 5. Ed. F. K. A. Schelling. Stuttgart: Cotta, 1856–61.

Schwartz, Joan M., and James R. Ryan, eds. Picturing Place: Photography and the Geographical Imagination. London: I. B. Tauris, 2003.

Snyder, Joel, and Neil Walsh Allen. "Photography, Vision, and Representation." Critical Inquiry 2, no. 1 (Autumn 1975): 143–69.

Sontag, Susan. On Photography. New York, Farrar, Straus and Giroux, 1973.

Stoichita, Victor Ieronim. The Pygmalion Effect: From Ovid to Hitchcock. Chicago: at the University Press, 2008.

———. A Short History of the Shadow. London: Reaktion Books, 1997.

Storr, Robert. On the Edge: Contemporary Art from the Werner and Elaine Dannheisser Collection. New York: The Museum of Modern Art, 1997. Exh. cat.

Szarkowski, John. Looking at Photographs: 100 Pictures from the Collection of The Museum of Modern Art. New York: The Museum of Modern Art, 1973.

———. The Photographer's Eye. New York: The Museum of Modern Art, 1966. Exh. cat.

———. Photography until Now. New York: The Museum of Modern Art, 1989. Exh. cat.

Trachtenberg, Alan, ed. Classic Essays on Photography. New Haven: Leete's Island Books, 1980.

Vaizey, Marina. The Artist as Photographer. London: Sidgwick & Jackson, 1982.

Warburg, Aby. Der Bilderatlas Mnemosyne. Ed. Martin Warnke and Claudia Birnk. Berlin: Akademie Verlag, 2008.

Witkovsky, Matthew S., ed. Foto: Modernity in Central Europe, 1918–1945. Washington, D.C.: National Gallery of Art, and London: Thames & Hudson, 2007. Exh. cat.

Wölfflin, Heinrich. "Wie man Skulpturen aufnehmen soll." Zeitschrift für bildende Kunst, part 1: n.s. 7 (1896):224–28; part 2: n.s. 8 (1897):294–97; part 3: n.s. 26 (1914): 237–44.

I. Sculpture in the Age of Photography

Bajac, Quentin. "Photographic Exploration: Travellers, Archaeologists and Reporters, 1850–1880." In Bajac, ed. Orsay Photography, pp. 59–72. Paris: Editions Scala, 2000.

Bajac, Quentin, and Dominique Planchon-de Font-Réaulx, eds. Le Daguerréotype français. Un Objet photographique. Paris: Réunion des Musées Nationaux, 2003. Exh. cat.

Baldwin, Gordon, Malcolm R. Daniel, and Sarah Greenough. All the Mighty World: The Photographs of Roger Fenton, 1852–1860. New York: The Metropolitan Museum of Art, 2004. Exh. cat.

Ballerini, Julia. "The Invisibility of Hadji-Ishmael: Maxime Du Camp's 1850 Photographs of Egypt." In Kathleen Adler and Marcia R. Pointon, eds. The Body Imaged: The Human Form and Visual Culture since the Renaissance, pp. 147–97. Cambridge: at the University Press, 1993.

———. "'La Maison Démolie': Photographs of Egypt by Maxime Du Camp 1849–50." In Suzanne Nash, ed. Home and Its Dislocations in Nineteenth-Century France, pp. 103–24. Albany: State University of New York Press, 1993.

———. "Recasting Ancestry: Statuettes as Images by Three Inventors of Photography." In Anne W. Lowenthal, ed. The Object as Subject: Studies in the Interpretation of Still Life, pp. 41–57. Princeton: at the University Press, 1996.

Bann, Stephen. The Clothing of Clio: A Study of the Representation of History in Nineteenth-Century Britain and France. Cambridge: at the University Press, 1984.

———. Parallel Lines: Printmakers, Painters and Photographers in Nineteenth-Century France. New Haven: Yale University Press, 2001.

———. Romanticism and the Rise of History. New York: Twayne Publishers, 1995.

Batchen, Geoffrey. "The Labor of Photography." Victorian Literature and Culture 37, no. 1 (March 2009):292–96.

———. "Light and Dark: The Daguerreotype and Art History." Art History 86, no. 4 (December 2004):764–76.

Bergdoll, Barry. "Félix Duban, Early Photography, Architecture, and the Circulation of Images." In Karen Koehler, ed. The Built Surface. Vol. 2, Architecture and the Pictorial Arts from Romanticism to the Twenty-first Century, pp. 12–30. Aldershot, England: Ashgate, 2002.

Bergstein, Mary. "'The Artist in His Studio': Photography, Art, and the Masculine Mystique." Oxford Art Journal 18, no. 2 (1995):45–58.

Black, Claire Christian. "Edward Steichen's Rodin—Le Penseur: The Rhetoric of a Photograph." Cantor Arts Center Journal 2 (2000–2001):32–47.

Boime, Albert. Hollow Icons: The Politics of Sculpture in Nineteenth-Century France. Kent, Ohio: Kent State University Press, 1987.

Bondi, Inge. "Some Relationships between Photography and Artists." Archives of American Art Journal 9, no. 2 (April 1969):1–18.

Borcoman, James. Charles Nègre 1820–1880. Ottawa: National Gallery of Canada, 1976. Exh. cat.

Carels, Edwin. "The Cinema and Its Afterimage: Projection and Hindsight in Still/A Novel." In Cahier #5, p. 37. Rotterdam: Witte de With, and Düsseldorf: Richter Verlag, 1996.

Castleberry, May, Martha A. Sandweiss, and John Chávez. Perpetual Mirage: Photographic Narratives of the Desert West. New York: Whitney Museum of American Art and Harry N. Abrams, 1996. Exh. cat.

Coleman, Catherine, Larry J. Schaaf, Mike Ware, et al. Huellas de Luz: El Arte y los Experimentos de William Henry Fox Talbot/Traces of Light: The Art and Experiments of William Henry Fox Talbot. Madrid: Museo Nacional Centro de Arte Reina Sofía and Aldeasa, 2001. Exh. cat.

Dahlberg, Laurie. Larry Fink. London: Phaidon Press, 2005.

Denton, Margaret. "Francis Wey and the Discourse of Photography as Art in France in the Early 1850s." Art History 25, no. 5 (November 2002):622–48.

Dewan, Janet. Linnaeus Tripe: Photographs of Burma and Madura in the 1850s. Toronto: Art Gallery of Ontario, 1997. Exh. cat.

Dewitz, Bodo von. Tatsachen. Fotografien des 19. und 20. Jahrhunderts. Die Sammlung Agfa im Museum Ludwig Köln/Facts: Photography from the 19th and 20th Century. Agfa Collection in the Museum Ludwig Cologne. Göttingen: Steidl, 2006. Exh. cat.

Dewitz, Bodo von, and Karin Schuller-Procopovici. Die Reise zum Nil, 1849–1850. Maxime Du Camp und Gustave Flaubert in Ägypten, Palästina und Syrien. Göttingen: Steidl, 1997. Exh. cat.

Erwitt, Elliott. Museum Watching. New York: Phaidon, 1999.

Feeke, Stephen, and Jon Wood. Close Encounters: The Sculptor's Studio in the Age of the Camera. Leeds: Henry Moore Institute, 2001. Exh. cat.

Frankel, David. "Studio Poses: Photographs by Constantin Brancusi and Kiki Smith." Aperture 145 (Fall 1996):18–27.

Freitag, Wolfgang M. "Early Uses of Photography in the History of Art." Art Journal 39, no. 2 (Winter 1979–80):117–23.

Frizot, Michel. "The Parole of the Primitives: Hippolyte Bayard and the French Calotypists." History of Photography 16, no. 4 (Winter 1992):358–70.

Gautherin, Véronique. L'Œil et la main: Bourdelle et la photographie. Paris: E. Koehler, 2000. Exh. cat.

Gautrand, Jean-Claude, and Michel Frizot. Hippolyte Bayard. Naissance de l'image photographique. Paris: Trois Cailloux, 1986. Exh. cat.

Greenough, Sarah. *Alfred Stieglitz: The Key Set. The Alfred Stieglitz Collection of Photographs.* Washington, D.C.: National Gallery of Art, 2002.

Greenough, Sarah, ed. *Modern Art in America: Alfred Stieglitz and His New York Galleries.* Washington, D.C.: National Gallery of Art, 2000. Exh. cat.

Greenough, Sarah, Robert Gurbo, and Sarah Kennel. *André Kertész.* Washington, D.C.: National Gallery of Art, and Princeton: at the University Press, 2005. Exh. cat.

Hambourg, Maria Morris, et al. *The Waking Dream: Photography's First Century. Selections from the Gilman Paper Company Collection.* New York: The Metropolitan Museum of Art, 1993. Exh. cat.

Harvey, Michael. "Ruskin and Photography." *Oxford Art Journal* 7, no. 2 (1985):25–33.

Heilbrun, Françoise. "Around the World: Explorers, Travelers, and Tourists." In Michel Frizot, ed. *A New History of Photography*, pp. 148–73. Cologne: Könemann, 1998.

Howe, Kathleen Stewart. *Excursions along the Nile: The Photographic Discovery of Ancient Egypt.* Santa Barbara: Santa Barbara Museum of Art, 1994. Exh. cat.

Johnson, Walter A. "Photography's Great Moments." *Photographica* 25, no. 4 (October 1996):12–13.

Kaiser, Philipp, ed. *Louise Lawler and Others.* Ostfildern-Ruit, Germany: Hatje Cantz, 2004. Exh. cat.

Kitagawa, Momoo, and Domon Ken. *The Muro-Ji. An Eighth Century Japanese Temple, Its Art and History.* Tokyo: Bijutsu Shuppan-sha, 1958.

Kraus, Hans Peter. "When Sculpture First Posed for a Photograph." *Sculpture Review* 54, no. 4 (Winter 2005):10.

L'Ecotais, Emmanuelle de, and Alain Sayag, eds. *Man Ray: Photography and Its Double.* Ed. English-language edition Herbert R. Lottman. Trans. Deke Dusinberre from the French and Donna Wiemann from the German. Corte Madera, Calif.: Gingko Press, 1998. Exh. cat.

Lowry, Bates, and Isobel Barrett Lowry. *The Silver Canvas: Daguerreotype Masterpieces from the J. Paul Getty Museum.* Los Angeles: The J. Paul Getty Museum, 1998. Exh. cat.

McCauley, Elizabeth Anne. *Industrial Madness: Commercial Photography in Paris, 1848–1871.* New Haven: Yale University Press, 1994.

McShine, Kynaston. *The Museum as Muse: Artists Reflect.* New York: The Museum of Modern Art, 1999. Exh. cat.

Newhall, Beaumont. "Photosculpture." *Image* 7, no. 5 (May 1958):100–105.

Nixon, Mignon. "Posing the Phallus." *October* 92 (Spring 2000):98–127.

O'Grady, Lorraine. "Nefertiti/Devonia Evangeline." *Art Journal* 56, no. 4 (Winter 1997):64–65.

Phillips, Sandra S., David Travis, and Weston J. Naef. *André Kertész: Of Paris and New York.* Chicago: Art Institute of Chicago, 1985. Exh. cat.

Planche, Gustave. "Salon de 1847." In *Etudes sur l'école française (1831–1852). Peinture et Sculpture*, 2:266. Paris: Michel Lévy Frères, 1855.

Rogers, Sarah J. "Ann Hamilton: Details." In *The Body and the Object: Ann Hamilton*

1984–1996, pp. 8–51. Columbus: Wexner Center for the Arts and Ohio State University, 1996. Exh. cat.

Schaaf, Larry. *H. Fox Talbot's "The Pencil of Nature": Anniversary Facsimile. Introductory Volume.* New York: Hans Kraus, Jr., 1989.

Schaaf, Larry J. *The Photographic Art of William Henry Fox Talbot.* Princeton: at the University Press, 2000.

Schulmann, Didier, ed. *Ateliers. L'Artiste et ses lieux de création dans les collections de la Bibliothèque Kandinsky.* Paris: Éditions du Centre Pompidou, 2006. Exh. cat.

Sheon, Aaron. "French Art and Science in the Mid-Nineteenth Century: Some Points of Contact." *Art Quarterly* 34 (Winter 1971):434–55.

Smith College Museum of Art. *Photographs by Clarence Kennedy.* Northampton, Mass.: Smith College Museum of Art, 1967. Exh. cat.

Sobieszek, Robert A. "Sculpture as the Sum of Its Profiles: François Willème and Photosculpture in France, 1859–1868." *Art Bulletin* 62 (December 1980):617–30.

Solomon-Godeau, Abigail. "A Photographer in Jerusalem, 1855: August Salzmann and His Times." In Solomon-Godeau. *Photography at the Dock: Essays on Photographic History, Institutions, and Practices*, pp. 150–68. Minneapolis: University of Minnesota Press, 1991.

Steegmuller, Francis, ed. *Flaubert in Egypt: A Sensibility on Tour. A Narrative Drawn from Gustave Flaubert's Travel Notes and Letters.* Boston: Little, Brown, 1972.

Steichen, Joanna T. *Steichen's Legacy: Photographs, 1895–1973.* New York: Alfred A. Knopf, 2000.

Swenson, Christine. *The Experience of Sculptural Form: Photographs by Clarence Kennedy.* Detroit: The Detroit Institute of Arts, 1987. Exh. cat.

Szarkowski, John. "The Erwitt File." In Elliott Erwitt, ed. *Elliott Erwitt: Photographs and Anti-Photographs.* Greenwich, Conn.: New York Graphic Society, 1972.

Talbot, William Henry Fox. *The Pencil of Nature.* London: Longmans, Brown, Green & Longmans, 1844–46. Reprint ed., with essay by Beaumont Newhall. New York: Da Capo Press, 1969.

Taylor, Roger, and Larry J. Schaaf. *Impressed by Light: British Photographs from Paper Negatives, 1840–1860.* New York: The Metropolitan Museum of Art, and New Haven: Yale University Press, 2007. Exh. cat.

Taylor, Susan L. "Fox Talbot as an Artist: The 'Patroclus' Series." *Bulletin of the University of Michigan Museums of Art and Archaeology* 8 (1986–88):38–55.

Ware, Katherine, and Emmanuelle de l'Ecotais. *Man Ray 1890–1976.* Ed. Manfred Heiting. Cologne: Taschen, 2000.

Ware, Katherine, and Peter Barberie. *Dreaming in Black and White: Photography at the Julien Levy Gallery.* Philadelphia: Philadelphia Museum of Art, and New Haven: Yale University Press, 2006. Exh. cat.

Weski, Thomas. "Art as Analysis: On the Photographic Works of Louise Lawler." In Dietmar Elger and Weski. *Louise Lawler: For Sale*, pp. 59–63. Ostfildern-Ruit, Germany: Reihe Cantz, 1994.

Whelan, Richard, and Sarah Greenough, eds. *Stieglitz on Photography: His Selected Essays and Notes.* New York: Aperture, 2000.

Zakon, Ronnie L. *The Artist and the Studio in the Eighteenth and Nineteenth Centuries.* Cleveland: Cleveland Museum of Art, 1978. Exh cat.

II. Eugène Atget: The Marvelous in the Everyday

Abbott, Berenice. *The World of Atget.* New York: Horizon Press, 1964.

Adams, William Howard. *Atget's Gardens: A Selection of Eugène Atget's Garden Photographs.* Garden City, N.Y.: Doubleday, 1979.

Aubenas, Sylvie, and Guillaume Le Gall. *Atget. Une Rétrospective.* Paris: Bibliothèque nationale de France, 2007. Exh. cat.

Borcoman, James. *Eugène Atget: 1857–1927.* Ottawa: National Gallery of Canada, 1984. Exh. cat.

Bouchami-Paquelet, Muriel. *Atget à Sceaux. Inventaire avant disparition.* Paris: Somogy Editions, 2008. Exh. cat.

Nesbit, Molly. *Atget's Seven Albums.* New Haven: Yale University Press, 1992.

Szarkowski, John. *Atget.* New York: The Museum of Modern Art, 2000.

Szarkowski, John, and Maria Morris Hambourg. *The Work of Atget.* 4 vols. New York: The Museum of Modern Art, 1981.

III. Auguste Rodin: The Sculptor and the Photographic Enterprise

Elsen, Albert Edward. *In Rodin's Studio: A Photographic Record of Sculpture in the Making.* Oxford: Phaidon Press, 1980.

Pinet, Hélène. *Les Photographes de Rodin. Jacques-Ernest Bulloz, Eugène Druet, Stephen Haweis et Henry Coles, Jean-François Limet, Eduard Steichen.* Paris: Musée Rodin, 1986. Exh. cat.

———. *Rodin sculpteur et les photographes de son temps.* Paris: P. Sers, 1985.

Pinet, Hélène, ed. *Rodin et la photographie.* Paris: Gallimard, 2007. Exh. cat.

Potts, Alex. "Dolls and Things: The reification and disintegration of sculpture in Rodin and Rilke." In John Onians, ed. *Sight and Insight: Essays on Art and Culture in Honour of E. H. Gombrich at 85*, pp. 355–78. London: Phaidon Press, 1994.

Steichen, Edward. *A Life in Photography.* New York: Doubleday, 1963.

Varnedoe, Kirk. "Rodin and Photography." In Albert Edward Elsen and Albert Alhadeff, eds. *Rodin Rediscovered*, pp. 203–47. Washington, D.C.: National Gallery of Art, 1981. Exh. cat.

IV. Constantin Brancusi: The Studio as Groupe Mobile and the Photos Radieuses

Bach, Friedrich Teja. *Brancusi: Photo Reflexion.* Paris: Didier Imbert Fine Art, 1991. Exh. cat.

———. *Constantin Brancusi: Metamorphosen plastischer Form.* Cologne: DuMont Buchverlag, 1987.

Bach, Friedrich Teja, Margit Rowell, and Ann Temkin. *Constantin Brancusi, 1876–1957.* Philadelphia: Philadelphia Museum of Art, and Cambridge, Mass.: The MIT Press, 1995. Exh. cat.

Brown, Elizabeth A. *Brancusi Photographs Brancusi.* London: Thames & Hudson, 1995.

Burton, Scott. "My Brancusi." In *Artist's Choice: Burton on Brancusi.* New York: The Museum of Modern Art, 1989. N.p.

de Duve, Thierry. *Pictorial Nominalism on Marcel Duchamp's Passage from Painting to the Readymade.* Minneapolis: University of Minnesota Press, 1991.

Dudley, Dorothy. "Brancusi." *The Dial* 82 (February 1927):130.

Frizot, Michel. "Les Photographies de Brancusi, une sculpture de la surface." *Cahiers du Musée National d'Art Moderne* 54 (Winter 1995):34–49.

Hammer, Martin, Christina Lodder, Sebastiano Barassi, and Geraldine A. Johnson. *Immaterial: Brancusi, Gabo, Moholy-Nagy.* Cambridge: Kettle's Yard, 2004. Exh. cat.

Hulten, Pontus, Natalia Dumitresco, and Alexandre Istrati. *Brancusi.* New York: Harry N. Abrams, 1987.

Kramer, Hilton. *Brancusi, the Sculptor as Photographer.* Lyme, Conn.: Callaway Editions, 1979.

Marcoci, Roxana. "Brancusi in Camouflage." In Patricia G. Berman and Gertje R. Utley, eds. *A Fine Regard: Essays in Honor of Kirk Varnedoe*, pp. 166–81. Aldershot, England: Ashgate, 2008.

Mola, Paola. *Brancusi: The White Work.* Milan: Skira, 2005.

Monod-Fontaine, Isabelle, and Marielle Tabart. *Brancusi Photographer.* New York: Agrinde Publications, 1979.

Pascal, Isac. "Atelierul din Paris." *Arta* 19, no. 10 (1972):37–38.

Payne, Robert. "Constantin Brancusi." *World Review* (October 1949):63.

Penders, Anne-Françoise. *Brancusi, la photographie ou l'atelier comme "groupe mobile."* Brussels: La Lettre volée, 1995.

Schneider, Pierre. *Brancusi et la photographie. Un Moment donné.* Paris: Hazan, 2007.

Tabart, Marielle. *Brancusi. L'Inventeur de la sculpture moderne.* Paris: Découvertes Gallimard and Centre Georges Pompidou, 1995. Exh. cat.

V. Marcel Duchamp's Box in a Valise: The Readymade as Reproduction

Ades, Dawn. "Duchamp's Masquerades." In Graham Clarke, ed. *The Portrait in Photography*, pp. 94–114. London: Reaktion Books, 1992.

Baker, George. "The Artwork Caught by the Tail." *October* 97 (Summer 2001):51–90.

Bonk, Ecke. *Marcel Duchamp: The Box in a Valise, de ou par Marcel Duchamp ou Rrose Sélavy. Inventory of an Edition.* New York: Rizzoli, 1989.

Buskirk, Martha. "Thoroughly Modern Marcel." *October* 70, *The Duchamp Effect* (Autumn 1994):113–25.

Cabanne, Pierre. *Dialogues with Marcel Duchamp.* Cambridge, Mass.: Da Capo Press, 1987.

Camfield, William. "Duchamp's Fountain: Aesthetic Object, Icon, or Anti-Art?" In Thierry de Duve, ed. *The Definitively Unfinished Marcel Duchamp*, pp. 134–71. Halifax: Nova Scotia College of Art and Design, 1991.

Clair, Jean. *Duchamp et la photographie. Essai d'analyse d'un primat technique sur le développement d'une oeuvre.* Paris: Éditions du Chêne, 1977.

———. "Opticeries." *October* 5 (Summer 1978):101.

de Duve, Thierry, and Rosalind Krauss. "Echoes of the Readymade: Critique of Pure Modernism." *October* 70, *The Duchamp Effect* (Autumn 1994):60–97.

Demos, T. J. *The Exiles of Marcel Duchamp.* Cambridge, Mass.: The MIT Press, 2007.

D'Harnoncourt, Anne, and Kynaston McShine, eds. *Marcel Duchamp.* New York: The Museum of Modern Art, 1989. Exh. cat.

Duchamp, Marcel, and Richard Hamilton. *The Bride Stripped Bare by Her Bachelors, Even: A Typographic Version by Richard Hamilton of Marcel Duchamp's Green Box.* Trans. George Heard Hamilton. New York: George Wittenborn, 1960.

Goodyear, Anne Collins, James W. McManus, Janine A. Mileaf, et al. *Inventing Marcel Duchamp: The Dynamics of Portraiture.* Washington, D.C.: National Portrait Gallery, 2009. Exh. cat.

Gough-Cooper, Jennifer, and Jacques Caumont. *Marcel Duchamp: Ephemerides in and about Marcel Duchamp and Rrose Sélavy, 1887–1968.* London: Thames & Hudson, 1993.

Hopkins, David. "Men before the Mirror: Duchamp, Man Ray and Masculinity." In Hopkins. *Dada's Boys: Masculinity after Duchamp*, pp. 43–63. New Haven: Yale University Press, 2007.

Howard, Seymour. "Hidden Naos: Duchamp Labyrinths." *Artibus et Historiae* 15, no. 29 (1994):153–80.

Jones, Amelia. *Postmodernism and the En-Gendering of Marcel Duchamp.* Cambridge: at the University Press, 1994.

Joselit, David. *Infinite Regress: Marcel Duchamp, 1910–1941.* Cambridge, Mass.: The MIT Press, 1998.

Kachur, Lewis. *Displaying the Marvelous: Marcel Duchamp, Salvador Dalí, and Surrealist Exhibition Installations.* Cambridge, Mass.: The MIT Press, 2001.

Lebel, Robert. *Marcel Duchamp.* New York: Grove Press, 1959.

Molesworth, Helen. "The Everyday Life of Marcel Duchamp's Readymades." *Art Journal* 57, no. 4 (Winter 1998):51–61.

Naumann, Francis M. *Marcel Duchamp: The Art of Making Art in the Age of Mechanical Reproduction.* New York: Harry N. Abrams, 1999.

Nesbit, Molly. "Ready-Made Originals: The Duchamp Model." *October* 37 (Summer 1986):53–64.

Schwarz, Arturo. *The Complete Works of Marcel Duchamp.* New York: Delano Greenidge Editions, 1997.

Spieker, Sven. "1913. 'Du hasard en conserve': Duchamp's Anemic Archives." In Sven Spieker, ed. *The Big Archive: Art from Bureaucracy*, pp. 51–83. Cambridge, Mass.: The MIT Press, 2008.

Troy, Nancy. "The Readymade and the Genuine Reproduction." In Troy. *Couture Culture: A Study in Modern Art and Fashion*, pp. 266–326. Cambridge, Mass.: The MIT Press, 2003.

VI. Cultural and Political Icons

Bajac, Quentin. *La Commune photographiée.* Paris: Réunion des musées nationaux, 2000. Exh. cat.

Bal, Mieke. *Acts of Memory: Cultural Recall in the Present.* Hanover, N.H.: University Press of New England, 1999.

Barron, Stephanie, Sabine Eckmann, and Eckhart Gillen. *Art of Two Germanys—Cold War Cultures.* New York: Harry N. Abrams, 2009. Exh. cat.

Barsch, Barbara. *Zeitgenössische Fotokunst aus Moskau/Contemporary Photographic Art from Moscow.* Munich: Prestel, 1995. Exh. cat.

Burtt, Theodore C. *Monuments and Memory: Reflections on the Former Soviet Union.* Fairfield, Conn.: Sacred Heart University, 1994. Exh. cat.

Danese, Renato, and John R. Gossage. *14 American Photographers: Walker Evans, Robert Adams, Lewis Baltz, Paul Caponigro, William Christenberry, Linda Connor, Cosmos, Robert Cumming, William Eggleston, Lee Friedlander, John R. Gossage, Gary Hallman, Tod Papageorge, Garry Winogrand.* Baltimore: Baltimore Museum of Art, 1975. Exh. cat.

Dickerman, Leah. "Camera Obscura: Socialist Realism in the Shadow of Photography." *October* 93 (Summer 2000):138–53.

Doy, Gen. "The Camera against the Paris Commune." In Liz Heron and Val Williams, eds. *Illuminations: Women Writing on Photography from the 1850s to the Present*, pp. 21–32. Durham, N.C.: Duke University Press, 1996.

Evans, Walker. *American Photographs.* With an essay by Lincoln Kirstein. New York: The Museum of Modern Art, 1938. Exh. cat.

Flügge, Matthias, Cees Nooteboom, and Jutta Voigt. *Sibylle Bergemann. Photographien.* Heidelberg: Edition Braus, 2006.

Frank, Robert. *The Americans.* With an introduction by Jack Kerouac. New York: Grove Press, 1959.

Friedlander, Lee. *The American Monument.* New York: The Eakins Press Foundation, 1976.

Galassi, Peter. *Henri Cartier-Bresson: The Early Work.* New York: The Museum of Modern Art, 1987. Exh. cat.

———. *Henri Cartier-Bresson: The Modern Century.* New York: The Museum of Modern Art, 2010. Exh. cat.

———. *Lee Friedlander.* New York: The Museum of Modern Art, 2005. Exh. cat.

———. *Walker Evans & Company.* New York: The Museum of Modern Art, 2000. Exh. cat.

Goldblatt, David, and Neville Dubow. *South Africa: The Structure of Things Then.* New York: The Monacelli Press, 1998.

Goldblatt, David, Mark Hayworth-Booth, Christoph Danelzik-Brüggemann, and Michael Stevenson. *Intersections.* Munich: Prestel, 2005. Exh. cat.

Goldblatt, David, Ulrich Loock, and Ivor Powell. *Intersections Intersected.* Porto: Fundação de Serralves, 2008. Exh. cat.

Greenough, Sarah, ed. *Looking In: Robert Frank's* The Americans. Washington, D.C.: National Gallery of Art, 2009. Exh. cat.

Haaften, Julia Van. *Berenice Abbott, Photographer: A Modern Vision. A Selection of Photographs and Essays.* New York: New York Public Library, 1989. Exh. cat.

Hambourg, Maria Morris. *Walker Evans.* New York: The Metropolitan Museum of Art, and Princeton: at the University Press, 2000. Exh. cat.

Heiferman, Marvin. "In Front of the Camera, behind the Scene: Cindy Sherman's *Untitled Film Stills.*" *MoMA* no. 25 (Summer 1997):16–19.

Huyssen, Andreas. *Twilight Memories: Marking Time in a Culture of Amnesia.* New York: Routledge, 1995.

Keller, Judith. "American Photographs: Evans in Middletown." In Keller. *Walker Evans: The Getty Museum Collection*, pp. 129–78. Malibu: J. Paul Getty Museum, 1995.

Lawson, Lesley, and David Goldblatt. *David Goldblatt.* London: Phaidon Press, 2001.

Lefebvre, Henri. "The production of space." In Neil Leach, ed. *Rethinking Architecture: A Reader in Cultural Theory*, pp. 139–46. New York: Routledge, 1997.

Marcoci, Roxana. "The Vanishing Monument and the Archive of Memory." In Kirk Varnedoe, Paola Antonelli, and Joshua Siegel, eds. *Modern Contemporary: Art at MoMA since 1980*, pp. 524–26. New York: The Museum of Modern Art, 2000.

Mehring, Christine. "Continental Schrift: The Story of *Interfunktionen.*" *Artforum International* 42, no. 9 (May 2004):178–83, 233.

Merewether, Charles. "Ai Weiwei: The Freedom of Irreverence." *Art AsiaPacific* no. 53 (May/June 2007):110.

Mitchell, W. J. Thomas. "The Ends of American Photography. Robert Frank as National Medium." In Mitchell. *What Do Pictures Want?: The Lives and Loves of Images*, pp. 272–93. Chicago: at the University Press, 2005.

Nickel, Douglas R. "'American Photographs' Revisited." *American Art* 6, no. 2 (Spring 1992):78–97.

Osborne, Peter D. *Travelling Light: Photography, Travel and Visual Culture.* Manchester and New York: Manchester University Press, 2000.

Papageorge, Tod. *Passing through Eden: Photographs of Central Park.* Göttingen: Steidl, 2007.

———. *Walker Evans and Robert Frank: An Essay on Influence.* New Haven: Yale University Art Gallery, 1981. Exh. cat.

Pohlmann, Ulrich, and Dirk Halfbrodt. *Alois Löcherer: Photographien 1845–1855.* Munich: Schirmer/Mosel, 1998. Exh. cat.

Sherman, Cindy. *Cindy Sherman: The Complete Untitled Film Stills.* New York: The Museum of Modern Art, 2003. Exh. cat.

Sire, Agnès, et al. *Manuel Alvarez Bravo, Henri Cartier-Bresson and Walker Evans: Documentary and Anti-Graphic Photographs.* Göttingen: Steidl, 2004. Exh. cat.

Solomon, Rosalind. *Chapalingas.* Göttingen: Steidl, 2003.

Stack, Trudy Wilner. *Winogrand: 1964.* Santa Fe: Arena Editions, 2002. Exh. cat.

Sviblova, Olga. *Sowjetische Fotografie der 20er und 30er Jahre/Soviet Photography of the 1920s and 1930s.* Moscow: Moscow House of Photography, and Winterthur: Fotomuseum, 2004. Exh. cat.

Szarkowski, John. *Walker Evans.* New York: The Museum of Modern Art, 1971. Exh. cat.

Tillim, Guy, and Adam Hochschild. *Leopold and Mobutu.* Trézélan, France: Filigranes Editions, 2004. Exh. cat.

Yochelson, Bonnie. *Berenice Abbott: Changing New York.* New York: New Press, 1997.

Young, James E. "The Counter-Monument: Memory against Itself in Germany Today." *Critical Inquiry* 18, no. 2 (Winter 1992):267–96.

———. "Memory, Counter-memory, and the End of the Monument." In Shelley Hornstein and Florence Jacobowitz, eds. *Image and Remembrance: Representation and the Holocaust*, pp. 59–78. Bloomington: Indiana University Press, 2003.

———. *The Texture of Memory: Holocaust Memorials and Meaning.* New Haven: Yale University Press, 1993.

VII. The Studio without Walls: Sculpture in the Expanded Field

Alloway, Lawrence. *Christo.* New York: Harry N. Abrams, 1969.

Baker, George. "Photography's Expanded Field." *October* 114 (Fall 2005):120–40.

Beardsley, John. *Earthworks and Beyond: Contemporary Art in the Landscape.* New York: Abbeville Press, 1984.

Bois, Yve-Alain, and Rosalind E. Krauss. *Formless: A User's Guide.* New York: Zone Books, 1997.

Bourdon, David. *Christo.* New York: Harry N. Abrams. 1970.

Crimp, Douglas. "Redefining Site Specificity." In Crimp and Louise Lawler, *On the Museum's Ruins*, pp. 150–86. Cambridge, Mass.: The MIT Press, 1993.

Del Lago, Francesca, Song Dong, Zhang Dali, et al. "Site Specificity in Beijing." *Art Journal* 59, no. 1 (Spring 2000):75–87.

Diserens, Corinne, Thomas E. Crow, Judith Russi Kirshner, and Christian Kravagna. *Gordon Matta-Clark.* London: Phaidon Press, 2003.

Ferris, Alison. "Disembodied Spirits: Spirit Photography and Rachel Whiteread's *Ghost.*" *Art Journal* 62, no. 3 (Autumn 2003):45–55.

Godfrey, Mark. "Image Structures: Mark Godfrey on Photography and Sculpture." *Artforum International* 43, no. 6 (February 2005):146–53.

Graham, Dan. "Subject Matter." In Graham. *Articles*, pp. 61–71. Eindhoven: Van Abbemuseum, 1978).

Heiss, Alanna, and Thomas McEvilley. *Dennis Oppenheim: And the Mind Grew Fingers. Selected Works 1967–1990.* New York: The Institute for Contemporary Art, P.S. 1 Museum, in association with Harry N. Abrams, 1992. Exh. cat.

Krauss, Rosalind. "Sculpture in the Expanded Field." *October* 8 (Spring 1979): 30–44.

Kwon, Miwon. *One Place after Another: Site-Specific Art and Locational Identity.* Cambridge, Mass.: The MIT Press, 2002.

Lee, Pamela M. *Object to Be Destroyed: The Work of Gordon Matta-Clark.* Cambridge, Mass.: The MIT Press, 2000.

Morgan, Robert C. "Mistaken Documents: Photography and Conceptual Art." In Morgan. *Art into Ideas: Essays on Conceptual Art*, pp. 165–211. Cambridge: at the University Press, 1996.

Owens, Craig. "Earthwords." *October* 10 (Autumn 1979):120–30.

Sayre, Henry M. *The Object of Performance: The American Avant-Garde Since 1970.* Chicago: at the University Press, 1989.

Seifermann, Ellen, and Beat Wismer, eds. *Robert Barry: Some places to which we can come . . .* Bielefeld: Kerber, 2003. Exh. cat.

Smithson, Robert. "Incidents of Mirror-Travel in the Yucatan." *Artforum International* 8, no. 1 (September 1969):20–33.

Smithson, Robert, and Jack D. Flam. *Robert*

Smithson: The Collected Writings. Berkeley: University of California Press, 1996.

Sobieszek, Robert A. *Robert Smithson: Photo Works.* Los Angeles: Los Angeles County Museum of Art, 1993. Exh. cat.

Sussman, Elisabeth. *Gordon Matta-Clark: You Are the Measure.* New York: Whitney Museum of American Art, 2007. Exh. cat.

Tsai, Eugenie. *Robert Smithson Unearthed: Drawings, Collages, Writings.* New York: Columbia University Press, 1996.

Tsai, Eugenie, Cornelia H. Butler, Thomas E. Crow, et al. *Robert Smithson.* Los Angeles: The Museum of Contemporary Art, and Berkeley: University of California Press, 2004. Exh. cat.

Wines, James. *De-Architecture.* New York: Rizzoli, 1987.

VIII. Daguerre's Soup: What Is Sculpture?

Basilico, Stefano, ed. *Rachel Harrison.* Milwaukee: Milwaukee Art Museum, 2002. Exh. cat.

Becher, Bernd and Hilla. *Anonyme Skulpturen, Eine Typologie technischer Bauten.* Düsseldorf: Art-Press Verlag, 1970.

Benjamin, Walter. "News about Flowers." In *Walter Benjamin: Selected Writings.* Vol. 2, *1927–1934,* part 1, pp. 155–57. Ed. Michael W. Jennings, Howard Eiland, and Gary Smith. Cambridge, Mass.: Harvard University Press, 1999.

Buchloh, Benjamin H. D. "Conceptual Art 1962–1969: From the Aesthetic of Administration to the Critique of Institutions." *October* 55 (Winter 1990):105–43.

Buchloh, Benjamin H. D., Abraham Cruzvillegas, Gabriel Kuri, et al. *Gabriel Orozco.* Los Angeles: The Museum of Contemporary Art, 2000. Exh. cat.

Conley, Katharine. "Modernist Primitivism in 1933: Brassaï's 'Involuntary Sculptures' in *Minotaure.*" *Modernism/Modernity* 10, no. 1 (January 2003):127–40.

David, Catherine, and Véronique Dabin. *Marcel Broodthaers.* Paris: Éditions du Jeu de Paume and Réunion des musées nationaux, 1991. Exh. cat.

De Salvo, Donna, ed. *Open Systems: Rethinking Art c. 1970.* London: Tate Publishing, 2005. Exh. cat.

Ellegood, Anne, and Johanna Burton. *The Uncertainty of Objects and Ideas: Recent Sculpture.* Washington, D.C.: Hirshhorn Museum and Sculpture Garden, 2006. Exh. cat.

Flood, Richard, Gary Garrels, and Ann Temkin. *Robert Gober: Sculpture+Drawings.* Minneapolis: Walker Art Center, 1999. Exh. cat.

Goldstein, Ann, and Anne Rorimer. *Reconsidering the Object of Art: 1965–1975.* Los Angeles: The Museum of Contemporary Art, and Cambridge, Mass.: The MIT Press, 1995. Exh. cat.

Iversen, Margaret. "Readymade, Found Object, Photograph." *Art Journal* 63, no. 2 (Summer 2004):44–57.

Molesworth, Helen Anne, ed. *Part Object Part Sculpture.* Columbus: Wexner Center for the Arts and Ohio State University, and University Park, Pa.: Penn State University Press, 2005. Exh. cat.

Munder, Heike, and Ellen Seifermann, eds. *Rachel Harrison: If I Did It.* Zurich: JRP Ringier, 2007. Exh. cat.

Orozco, Gabriel, and Ann Temkin. *Gabriel Orozco: Photogravity.* Philadelphia: Philadelphia Museum of Art, 1999. Exh. cat.

Pachner, Joan. *David Smith Photographs 1931–1965.* New York: Matthew Marks Gallery, and San Francisco: Fraenkel Gallery, 1998.

Pelzer, Brigit. "Recourse to the Letter." *October* 42 (Fall 1987):157–81.

Schimmel, Paul, and Hal Foster. *Robert Gober.* Los Angeles: The Museum of Contemporary Art, and Zurich: Scalo, 1997. Exh. cat.

Vischer, Theodora, ed. *Robert Gober: Sculptures and Installations, 1979–2007.* Basel: Schaulager, and Göttingen: Steidl, 2007. Exh. cat.

IX. The Pygmalion Complex: Animate and Inanimate Figures

Aliaga, Juan Vicente, Elisabeth Lebovici, Catherine Gonnard, and François Leperlier. *Claude Cahun.* Valencia: Institut Valencià d'Art Modern, 2001. Exh. cat.

Bate, David. *Photography and Surrealism: Sexuality, Colonialism and Social Dissent.* London: I. B. Tauris, 2004.

Beaumelle, Agnès de la, ed. *Hans Bellmer. Anatomie du désir.* Paris: Gallimard and Centre Pompidou, 2006. Exh. cat.

Bernadac, Marie-Laure, and Bernard Marcadé. *Fémininmasculin. Le Sexe de l'art.* Paris: Éditions du Centre Georges Pompidou, Gallimard, and Electa, 1995. Exh. cat.

Boswell, Peter W., Maria Martha Makela, Carolyn Lanchner, and Kristin Makholm. *The Photomontages of Hannah Höch.* Minneapolis: Walker Art Center, 1996. Exh. cat.

Cahun, Claude, with preface by Pierre Mac-Orlan. *Disavowals: or, Cancelled Confessions.* Trans. Susan de Muth. Cambridge, Mass.: The MIT Press, 2008.

Chadwick, Whitney, and Dawn Ades. *Mirror Images: Women, Surrealism, and Self-Representation.* Cambridge, Mass.: The MIT Press, 1998.

Cohen, Arthur Allen. *Herbert Bayer: The Complete Work.* Cambridge, Mass.: The MIT Press, 1984.

Coke, Van Deren. *Avant-Garde Photography in Germany, 1919–1939.* New York: Pantheon Books, 1982. Exh. cat.

Downie, Louise, ed. *Don't Kiss Me: The Art of Claude Cahun and Marcel Moore.* New York: Aperture, 2006.

Fanés, Fèlix. "Mannequins, Mermaids and the Bottoms of the Sea. Salvador Dalí and the New York World's Fair of 1939." In Montse Aguer, Fanés, and Sharon-Michi Kusunoki. *Salvador Dalí: Dream of Venus,* pp. 8–117. Figueres: Fundació Gala-Salvador Dalí, 1999. Exh. cat.

Foster, Hal. *Compulsive Beauty.* Cambridge, Mass.: The MIT Press, 1993.

Gross, Kenneth. *The Dream of the Moving Statue.* Ithaca: Cornell University Press, 1992.

Grossman, Wendy, Paul Messier, and Francis M. Naumann. *The Long Arm of Coincidence: Selections from the Rosalind and Melvin Jacobs Collection.* Göttingen: Steidl, 2009. Exh. cat.

Hiepe, Richard, and Carl Albrecht Haenlein. *Dada: Photographie und Photocollage.* Hannover: Kestner-Gesellschaft, 1979. Exh. cat.

Hopkins, David. "London and New York. Surrealism: Desire Unbound." *The Burlington Magazine* 143, no. 1185 (December 2001):774–77.

Jaguer, Edouard. *Les Mystères de la chambre noire. Le Surréalisme et la photographie.* Paris: Flammarion, 1982.

Kamien-Kazhdan, Adina, Dawn Ades, and Werner Spies. *Surrealism and Beyond in the Israel Museum.* Jerusalem: Israel Museum, 2007. Exh cat.

Kozloff, Max. "Pygmalion Reversed." *Artforum International* 14, no. 3 (November 1975):30–37.

Krauss, Rosalind. "Claude Cahun and Dora Maar: By Way of Introduction." In Krauss. *Bachelors,* pp. 1–50. Cambridge, Mass.: The MIT Press, 1999.

Krauss, Rosalind E., Jane Livingston, and Dawn Ades. *L'Amour fou: Photography and Surrealism.* Washington, D.C.: Corcoran Gallery of Art, 1985. Exh. cat.

Laughlin, Clarence John. "Sculpture Seen Anew." *College Art Journal* 14, no. 1 (Autumn 1954):2–6.

Lavin, Maud. *Cut with the Kitchen Knife: The Weimar Photomontages of Hannah Höch.* New Haven: Yale University Press, 1993.

Luyken, Gunda. *Hannah Höch: Album.* Ostfildern-Ruit, Germany: Hatje Cantz, 2004.

Manor-Fridman, Tamar. *Dreaming with Open Eyes: The Vera, Silvia and Arturo Schwarz Collection of Dada and Surrealist Art in the Israel Museum.* Jerusalem: Israel Museum, 2000. Exh. cat.

Molderings, Herbert. *Umbo. Vom Bauhaus zum Bildjournalismus.* Düsseldorf: Richter, 1995.

Moure, Gloria, and Donald B. Kuspit. *Ana Mendieta.* Barcelona: Fundació Antonio Tàpies, 1997. Exh. cat.

Pitts, Terence R. *The Early Work of Laura Gilpin 1917–1932.* Tucson: University of Arizona, Center for Creative Photography, 1981.

Rosemont, Penelope, ed. *Surrealist Women.* Austin: University of Texas Press, 1998.

Rosenberg, David. *The Perlstein Collection: From Dada to Contemporary Art.* Ghent: Ludion, 2006.

Sandweiss, Martha A. *Laura Gilpin: An Enduring Grace.* Fort Worth: Amon Carter Museum, 1986. Exh. cat.

Sawelson-Gorse, Naomi, ed. *Women in Dada: Essays on Sex, Gender, and Identity.* Cambridge, Mass.: The MIT Press, 1998.

Schneede, Uwe M. *Begierde im Blick. Surrealistische Photographie.* Ostfildern-Ruit, Germany: Hatje Cantz, 2005. Exh. cat.

Spies, Werner. *Max Ernst Collages: The Invention of the Surrealist Universe.* New York: Harry N. Abrams, 1988.

Squiers, Carol, ed. *Over Exposed: Essays on Contemporary Photography.* New York: New Press, 1999.

Taylor, Sue. *Hans Bellmer: The Anatomy of Anxiety.* Cambridge, Mass.: The MIT Press, 2000.

Vayzman, Liena. "The Self-Portraits of Claude Cahun." Ph.D. diss., Yale University, 2002.

Walker, Ian. *City Gorged with Dreams: Surrealism and Documentary Photography in Interwar Paris.* Manchester: at the University Press, 2002.

Webb, Peter, and Robert Short. *Hans Bellmer.* London: Quartet Books, 1985.

Wood, Ghislaine. *Surreal Things: Surrealism and Design.* London: V&A Publications, 2007. Exh. cat.

X. The Performing Body as Sculptural Object

Avalanche no. 1 (Fall 1970).

Avalanche no. 2 (Spring 1971).

Benezra, Neal David, Kathy Halbreich, and Joan Simon. *Bruce Nauman.* Minneapolis: Walker Art Center, 1994. Exh. cat.

Blaut, Julia. *Identity: Representations of the Self.* New York: Whitney Museum of American Art, 1988. Exh. cat.

Blessing, Jennifer. *Rrose is a Rrose is a Rrose: Gender Performance in Photography.* New York: Guggenheim Museum, 1997. Exh. cat.

Butler, Cornelia H., and Lisa Gabrielle Mark, eds. *WACK! Art and the Feminist Revolution.* Los Angeles: The Museum of Contemporary Art, and Cambridge, Mass.: The MIT Press, 2007. Exh. cat.

Firstenberg, Lauri. "Autonomy and the Archive in America: Reexamining the Intersection of Photography and Stereotype." In Coco Fusco and Brian Wallis, eds. *Only Skin Deep: Changing Visions of the American Self,* pp. 313–33. New York: International Center of Photography, 2003. Exh. cat.

Fischli, Peter, David Weiss, and Bice Curiger. *Fischli Weiss: Flowers & Questions. A Retrospective.* London: Tate Publishing, 2006. Exh. cat.

Fox, Howard N., Eleanor Antin, and Lisa Bloom. *Eleanor Antin.* Los Angeles: Los Angeles County Museum of Art, 1999. Exh. cat.

Froment, Jean-Louis. *Attitudes/Sculptures. Gilbert & George, Barry Le Va, Robert Morris, Bruce Nauman, Reiner Ruthenbeck, Richard Serra, Robert Smithson, Franz Erhard Walther.* Bordeaux: CAPC Musée d'art contemporain de Bordeaux, 1995. Exh. cat.

Gilbert & George. *Gilbert & George: The Complete Pictures, 1971–2005.* 2 vols. London: Tate Publishing, and New York: Aperture, 2007.

Goldberg, RoseLee. *Performance Art: From Futurism to the Present.* New York: Thames & Hudson, 2001.

Grenier, Catherine, Howard N. Fox, and David E. James. *Los Angeles, 1955–1985. Naissance d'une capitale artistique.* Paris: Éditions du Centre Pompidou, 2006. Exh. cat.

Jones, Amelia. *Body Art/Performing the Subject.* Minneapolis: University of Minnesota Press, 1998.

Kirby, Michael, ed. *Happenings, An Illustrated Anthology.* New York: E. P. Dutton, 1965.

Kultermann, Udo. *Art-Events and Happenings.* London: M. M. Dunbar, 1971.

Lambert, Carrie. "Moving Still: Mediating Yvonne Rainer's *Trio A.*" *October* 89 (Summer 1999):87–112.

Marcoci, Roxana. "Robin Rhode." In *Vitamin Ph,* pp. 222–23. London: Phaidon Press, 2006.

Maude-Roxby, Alice. *Live Art on Camera: Performance and Photography.* Southampton, England: John Hansard Gallery, 2007. Exh. cat.

McEvilley, Thomas, Carol C. Mancusi-Ungaro, Pierre Restany, and Nan Rosenthal. *Yves Klein, 1928–1962: A Retrospective.* Houston: Institute for the Arts, Rice University, 1982. Exh. cat.

Morineau, Camille, ed. *Yves Klein. Corps, couleur, immatériel.* Paris: Éditions du Centre Pompidou, 2006. Exh. cat.

Morris, Robert. *Robert Morris: The Mind/Body Problem.* New York: Guggenheim Museum, 1994. Exh. cat.

Mueller, Roswitha. *VALIE EXPORT: Fragments of the Imagination*. Bloomington: Indiana University Press, 1994.

Nauman, Bruce. *Bruce Nauman: Work from 1965 to 1972*. Los Angeles: Los Angeles County Museum of Art, 1972. Exh. cat.

Nemser, Cindy. "Subject-Object: Body Art." *Arts Magazine* 46, no. 1 (1971):38–42.

O'Dell, Kathy. "Displacing the Haptic: Performance Art, the Photographic Document and the 1970s." In Claire MacDonald, Richard Gough, and Ric Allsopp, eds. *Letters from Europe*, pp. 73–81. London: Routledge, 1997.

Oldenburg, Claes, and Germano Celant. *Claes Oldenburg: An Anthology*. New York: Guggenheim Museum, 1995. Exh. cat.

Owens, Craig. "The Medusa Effect, or, The Spectacular Ruse." In Scott Bryson, ed. *Beyond Recognition: Representation, Power, and Culture*, pp. 191–200. Berkeley: University of California Press, 1992.

Pultz, John. *The Body and the Lens: Photography 1839 to the Present*. New York: Harry N. Abrams, 1995.

Ratcliff, Carter, and Robert Rosenblum. *Gilbert & George: The Singing Sculpture*. New York: A. McCall, 1993.

Rhode, Robin, Stephanie Rosenthal, Thomas Boutoux, and André Lepecki. *Walk Off: Robin Rhode*. Ostfildern-Ruit, Germany: Hatje Cantz, 2007. Exh. cat.

Sandford, Mariellen R. *Happenings and Other Acts*. London: Routledge, 1995.

Schellmann, Jörg. *Joseph Beuys: The Multiples*. New York: Edition Schellmann, 1997.

Schimmel, Paul, and Kristine Stiles, eds. *Out of Actions: Between Performance and the Object, 1949–1979*. Los Angeles: The Museum of Contemporary Art, 1998. Exh. cat.

Schimmel, Paul, and Lisa Phillips. *Charles Ray*. Los Angeles: The Museum of Contemporary Art, 1998. Exh. cat.

Schwanberg, Johanna, Karlheinz Essl, Günter Brus, and Gabriele Bösch. *Günter Brus. Werke aus der Sammlung Essl*. Klosterneuburg, Germany: Sammlung Essl, 1998. Exh. cat.

Schwarz, Arturo. *Man Ray: The Rigour of Imagination*. New York: Rizzoli, 1977.

Sharp, Willoughby. "Body Works." *Avalanche* 1 (Fall 1970):14.

Stich, Sidra. *Yves Klein*. Ostfildern, Germany: Cantz, 1994. Exh. cat.

Szeemann, Harald. *Live in Your Head. When Attitudes Become Form: Works, Concepts, Processes, Situations, Information*. Bern: Kunsthalle Berne, 1969. Exh. cat.

Verwoert, Jan. *Bas Jan Ader: In Search of the Miraculous*. London: Afterall Books, 2006.

Warr, Tracey, ed. *The Artist's Body*. London: Phaidon Press, 2000.

Weibel, Peter, ed. *Erwin Wurm*. Ostfildern-Ruit, Germany: Hatje Cantz, 2002. Exh. cat.

Whitman, Robert, Lynne Cooke, Karen Kelly, and Bettina Funcke. *Robert Whitman: Playback*. New York: Dia Art Foundation, 2003. Exh. cat.

Wolf, Sylvia. *Polaroids: Mapplethorpe*. New York: Prestel, 2008. Exh. cat.

Printed Material in the Exhibition

The exhibition includes issues of a number of journals and magazines in which certain of its photographs circulated publicly for the first time. Those journals are as follows:

Artforum 8, no. 1 (September 1969)
Front cover and p. 29, showing Robert Smithson, *Yucatan Mirror Displacements (1–9)*, 1969 (see p. 153, plate 158). 10 ⅝ x 10 ⅝" (27 x 27 cm). The Museum of Modern Art Library, New York

The Blind Man no. 2 (May 1917)
P. 4, showing Alfred Stieglitz, *Fountain, photograph of assisted readymade by Marcel Duchamp*, 1917 (see p. 114, plate 104). 11 x 8" (27.9 x 20.3 cm). Francis Naumann Fine Art, New York

Dimanche. November 27, 1960
Front page, showing Yves Klein, *Leap into the Void*, 1960. Photograph by Harry Shunk and János Kender; (see p. 219, plate 238). 21 ⅞ x 14 ¹⁵⁄₁₆" (55.6 x 38 cm). The Museum of Modern Art Library, New York

Illustrated. April 28, 1951
P. 23, showing Henri Cartier-Bresson, *Polonaruvia, Ceylon*, March 1950 (not reproduced). 13 ⁹⁄₁₆ x 10 ³⁄₁₆" (34.4 x 25.8 cm). The Museum of Modern Art, New York. Purchase

Interfunktionen: Zeitschrift für neue Abeiten und Vorstellungen no. 12 (1975)
N.p., showing Anselm Kiefer, *Besetzungen* (Occupations), 1969 (see plate 144). 11 ⅜ x 8 ³⁄₁₆" (28.9 x 20.8 cm). The Museum of Modern Art Library, New York

Littérature no. 13 (June 1924)
N.p., showing Man Ray, *Le Violon d'Ingres* (Ingres's violin), 1924 (see plate 217). 8 ¾ x 6 ⁹⁄₁₆" (22.2 x 16.6 cm). The Museum of Modern Art Library, New York

Minotaure no. 3–4 (1933)
P. 68, showing Brassaï, *Sculptures involontaires: billet d'autobus roulé* (Involuntary sculptures: rolled-up bus ticket) and *Sculptures involontaires: dentifrice répandu* (Involuntary sculptures: smeared toothpaste), both c. 1932 (see p. 167, plates 174, 175). 11 ¹⁵⁄₁₆ x 9 ¹⁄₁₆" (30.3 x 23 cm). The Museum of Modern Art Library, New York

Minotaure no. 6 (December 1934)
Pp. 30–31, showing Hans Bellmer, *The Doll (Self-Portrait with the Doll)*, 1934 (see p. 186, plate 209). 11 ¹⁵⁄₁₆ x 9 ¹⁄₁₆" (30.3 x 23 cm). The Museum of Modern Art Library, New York

New York Dada. 1921
N.p., showing Man Ray, *Porte-manteau* (Coat stand), 1920 (see plate 208). 14 ½ x 10 ¹⁄₁₆" (36.8 x 25.6 cm). Francis Naumann Fine Art, New York

Paris Match. May 10, 1958
Pp. 33–34, showing Henri Cartier-Bresson, *Capitol, Washington, United States*, 1957 (see plate 130). 13 ¾ x 10 ⁷⁄₁₆" (35 x 26.5 cm). The Museum of Modern Art, New York. Purchase

La Révolution surréaliste no. 1 (December 1924)
P. 1, showing Man Ray, *L'Enigme d'Isidore Ducasse* (The Enigma of Isidore Ducasse), 1920 (see plate 177). 11 ½ x 8" (29.2 x 20.3 cm). The Museum of Modern Art Library, New York

Vogue (Paris) 7, no. 5 (May 1926)
P. 37, showing Man Ray, *Noire et blanche* (Black and white), 1926 (see plate 216). 12 ¾ x 9 ½" (32.4 x 24.1 cm). Collection Steven Manford, Toronto

Vu Journal de la Semaine no. 15 (June 17, 1928)
P. 376, showing André Kertész, *African Sculptures*, 1927 (see plate 35). 14 ⁹⁄₁₆ x 10 ¹³⁄₁₆" (37 x 27.4 cm). Collection Jindrich Toman